Romanesque Signs

ROMANESQUE SIGNS

Early Medieval Narrative and Iconography

STEPHEN G. NICHOLS, JR.

Yale University Press
New Haven and London

Published with assistance from Dartmouth College.

Designed by Nancy Ovedovitz
and set in VIP Trump Medieval type.
Printed in the United States of America by Vail-Ballou Press, Binghamton, N.Y.

Library of Congress Cataloging in Publication Data

Nichols, Stephen G.
 Romanesque signs.

 Includes index.
 1. Arts, Romanesque. I. Title.
NX 449.N5 700′.9′021 82–7028
ISBN 0–300–02833–4 AACR2

10 9 8 7 6 5 4 3 2 1

For Edith,
toujours Mélusine

Contents

Illustrations

Preface

Eleventh-century Europe had an innovative culture. A germinal period in the history of Western civilization, it established medieval art, historiography, and literature as we recognize them today. In advancing this revitalized world of art and letters, the monks who led the movement were not simply making life more pleasant, more varied, more informed. They had in mind a definite program to be fulfilled by art, architecture, and literature.

They wanted to make the past present to show that the present belonged to a coherent cosmogony, that it manifested a divine plan of the universe. The key to this plan lay in certain transcendent events in the past, particularly the Christ story, which they interpreted as revealing the whole trajectory of Salvation history, from the beginning to the end of the world. They had elaborated a philosophical anthropology, building on the work of philosophers like Saint Augustine, Pseudo-Dionysius, and John Scottus Eriugena, which allowed them to make connections and comparisons between what might appear, to us at least, to be widely divergent domains, events and phenomena. The comparison between history and theology, for example, led to a theory of historical meaning with profound implications for the development of narrative. By showing that historical events—including the present—could be represented as resembling and thus rephrasing significant past events, notably those found in religious texts, one might then demonstrate that secular history did indeed belong to Salvation history. Life could then be seen as part of a larger picture, a divine plan, rather than as simply a formless accident.

Such a program obviously possessed clear religious and political implications. The activity of representing history according to this logocentric telos must be seen as a function of the social, institutional, and ideological situation of the monks who initiated it. Although we will not pursue this theme, we must recognize its implications at the outset in order to understand the energy invested in the projects discussed. Specifically, the monks sought to reinforce the concept of Church and State as divinely ordained institutions of social governance by portraying them as bulwarks standing between two worlds: one marked by discontinuity and chaos, one characterized by a historically continuous, transcendent order.

Narrative obviously played a key role in the effort to historicize the past in the present. Not surprisingly, then, it was one of the areas where renewal may be observed most clearly. In the year 1000, art was still primarily private, limited for the most part to such miniature forms as ivory carvings and book illuminations produced for wealthy aristocrats and ecclesiastics. To all intents

and purposes, literature was accessible only to those who read and understood Latin. During the course of the century, all this changed rapidly, thanks to the emergence of a narrative tradition that sought to develop a discourse whereby the word and the world could be read as texts.

The development revitalized the concept of public and monumental art and literature on a scale not seen in the West since Roman times. The historiated sculptural programs we take so much for granted in the décor of Romanesque churches began only toward the end of the eleventh century as part of the plan to make these edifices convey the combined thrust of history and Salvation on the quotidian. By representing biblical stories on the *outside* of churches, ecclesiastics merged the concepts of monument and text in an explicit manner that also served to remind the community that biblical stories offered cogent lessons for worldly existence.

Literature, in the form of exemplary stories of great leaders, also began to take on "monumental" proportions in terms of length and scope. Chronicles became "universal" histories seeking to recount, sometimes in considerable detail, the events of contemporary history according to a coherent plan. Just as the décor on the exterior of churches and the revival of monumental sculpture suggest an awareness of audience, and consequently of an evolving social role for art, so in literature one observes signs which point in the same direction. The development of history-as-story, what we might call history-telling, shows a progressive concern for reaching and holding an audience. Ultimately, it led to the adoption of the language of the community, the vernacular, and to a popular narrative mode, the epic, as a vehicle for a new kind of historiated narrative, the *chanson de geste.*

The revitalization of these forms—monumental art, universal history, and epic—in the eleventh century may be seen as a manifestation of a new mode of discourse, a new genre: a peculiarly medieval phenomenon known in Latin as *historia* and in Old French as *estoire.* As a word, *historia* did not originate in the eleventh century. But as a narrative concept, a focal point for themes, forms, attitudes, and assumptions about the reasons for telling stories and the way in which they could and should be told, we do find a new connotation for the term in the period from roughly 1000 to 1150.

The following chapters seek to explore different aspects of the mode of discourse fostered by *historia,* from the "universal history" of the late tenth century to the legendary exploits of Charlemagne and Roland recounted in the *Historia Karoli Magni et Rotholandi* and the *Chanson de Roland* late in the eleventh and in the first part of the twelfth centuries. After noting the kind of narrative *historia* generated, we will see how it encouraged a sacred and heroic view of the monarch as leader in the representation of contemporary kings and emperors like Robert the Pious of France (996–1031) and Otto III of Germany (996–1002). The treatment of contemporary historical figures will help us to understand the reciprocal phenomenon of the rise and spread of the legend of a great figure from the more remote past, the emperor Charlemagne, who had ruled as king of the Franks and emperor of the West two centuries earlier.

Charlemagne became a model for history and politics in the Middle Ages. Consequently, the growth of this legend in the eleventh century is one of the most fascinating aspects of the cultural renewal at this time. Since it was one

of the most popular and universal narrative topics of the entire Middle Ages—in history, art, and literature—the legend of Charlemagne provides a perfect laboratory for studying the dialectics of *historia*. By juxtaposing the Latin legend of Charlemagne between contemporary chronicles, on the one hand, and vernacular epic, on the other, we can see how, in all these modes, *historia* utilizes figurative language to render history as metaphor.

But even as we observe the subtle shading from chronicle to prose legend to *chanson de geste*, we also discover the tensions inherent in this narrative experimentation; ultimately the poetic discourse of the *chanson de geste* succeeds more powerfully, at least from our perspective, in rendering the agonistic struggle of the hero. It finally becomes evident why the poetic paradigm, with its capacity to emphasize the ambivalence of thought and desire through the opacity of language, seems more compelling—and ultimately more "historical"—than the programmatic clarity of a didactic narrative.

Many colleagues and friends have generously contributed to the evolution of this book by reading portions of the manuscript and making invaluable suggestions at moments that could not have been professionally convenient for them. Charles Wood, Hoyt Alverson, and Kevin Brownlee, in particular, have helped me work out theoretical and methodological problems. Robert Oden assisted me with aspects of biblical scholarship. Marina Brownlee, John Lyons, and Nancy Vickers provided intellectual support and encouragement at crucial stages. The concepts of the book were tested, in part, in two Summer Seminars for College Teachers which I directed under the auspices of the National Endowment for the Humanities in 1975 and 1978. The enthusiasm and insights of both groups helped me enormously. I am particularly grateful to Roland Pepin of the Community College of Greater Hartford, a 1975 seminar participant, for his translation of the difficult text of a sermon preached in 1064 that appears in chapter 5.

Ellen Graham of the Yale University Press took an early interest in the manuscript. She made perceptive suggestions for revisions and supervised a thorough process of review. The book benefited from the meticulous attention of another sympathetic reader, Lawrence Kenney, senior manuscript editor for the Press.

Material support for the project came from the National Endowment for the Humanities, which awarded me a fellowship in 1978–79, when most of the writing was accomplished, and Dartmouth College, which supported my research and writing at important junctures. I would like to thank Dean Hans H. Penner for arranging publication assistance from Dartmouth. Finally, I want to acknowledge the role of my wife, Edith, to whom this book is dedicated. Without her unique blend of scepticism and supportiveness, the book might have continued to be spoken, rather than written.

S. G. N., Jr.

Norwich, 23 March 1982

1

The Discourse of History

Shortly before the year 1000, the writing of history underwent a renascence that had a profound effect on the way Western Europeans viewed their world, not only in and through the writing of history, but also in public and monumental art and literature. This new dimension to history writing sought to demonstrate a systematic view of the world from the perspective of a controlling principle, that of universal history. Universal history aspired to tell the story of the cosmos as a unified and related construct testifying to the continuing creative power of the divinity. Scripture provided the model for this view, and a primary purpose for writing history lay in demonstrating the extent to which the physical and social world conformed to the scriptural model, when each was properly understood.[1]

The desire to view the universe as a teleological whole tends, as M. D. Chenu observes, to presage a general renewal of cultural activity and institutions:

> The first indication of the coming of history in a given cultural cycle is the awareness, in a universal or quasi-universal view, of human activity considered as a whole. In the first place there is a noteworthy quantitative enlargement; but this in turn leads, beyond a description of the facts, beyond a recitation—*vitae, gesta, annales*—to still unsophisticated but very intelligent consideration of the ties between facts. Historical causality becomes perceptible with social awareness.[2]

One of the first great historians to give evidence of this renewal was Richer, a monk of Saint-Rémy of Rheims who wrote a fascinating history of his times in the last decade of the tenth century.[3] Lost for over eight hundred years, the manuscript came to light again in 1833 in the library of Saint Michael's monastery in Bamberg, Germany.

Tendentious and partisan, Richer's work provides an account of some of the most significant events of its time, such as the political machinations leading to the overthrow of the Carolingian dynasty and the elevation of Hugh Capet to the throne of France. Rheims figured prominently in the political and cultural life of the period, and Richer was close to people like Gerbert, archbishop of Rheims from 991 to 998 (later Pope Sylvester II), who participated actively in many of the events described. From its accounts of kings and emperors of Europe at this time to its description of the hardships of travel and the curriculum of a monastic school, Richer's work justly deserves to be called a precious witness to this important period of French history.

Richer begins his story of the "struggles of the Gauls [Franks]" by outlining a vast tripartite schema of the known world, Africa, Asia, and Europe, with

1

the "umbilicus of the earth [Jerusalem]" at its center.[4] By a metonymic substitution, the significant part of the world that will also be the object of the narrative, namely Gaul, becomes a microcosm of the whole, not simply physically but symbolically.

Acknowledging that each of the other parts of the world has its subdivisions, Richer says that only Gaul mirrors the larger universe by its own tripartite division—recognized since Roman times (he takes Julius Caesar as his authority)—and the significance of its name, *Gallia*, which means "whiteness." Richer "explains" this etymology by referring to a fanciful suggestion by Isidore of Seville attributing the name to the fairness of the Gauls, who were noticeably whiter than other peoples in the known world.[5]

What appears to be simply an external set of facts instead lays the groundwork for metaphorical and metaphysical constructions. For Richer transforms this eponymous color symbolism from an externally distinguishing trait to a metaphor for inner qualities which assert the special relationship of the Gauls with the Logos. Although the Gauls share with all humans the capacity for unruly behavior, says Richer, they are more readily persuaded to conduct themselves according to the rules of reason. In other words, to place themselves under the rule of the Logos, the conventional language enunciated by the divinity for the rational ordering of the world.[6]

The authority for this claim comes from no less a figure than Saint Jerome, the translator of the Vulgate: "Gaul is the only country which has not produced monsters, but has always illuminated the world by wise and learned men."[7] In a world where Scripture constituted the foundation of all history, no more obvious a signal needed to be given as regards the claims made for the Franks by Richer in these statements. By saying that the Gauls have a special disposition to place themselves under the law, Richer meant that they were more evolved as a people within the universe.

We should not be surprised to find an assertion of social evolution based upon the degree of understanding of divine law. Richer and his contemporaries espoused a philosophical anthropology that was both doctrinal—they *were* Christians—and imbued with doctrines of Christian Platonism. In Richer's intellectual world, humans who understood and construed by their actions the grammar and syntax of the Logos more completely would, inevitably, demonstrate their greater evolution toward the celestial order of Revelation. For there was, at this time, a progressively emerging consciousness "of the historicity of the Bible, and thus of religious man, a historicity whose principle was the supremacy of God, not only over all the cosmos, but over all earthly events."[8]

This viewpoint entailed an anthropology which privileged *candor*, the Latin term for whiteness, or illumination, precisely the quality Richer ascribed to the Gauls. The divisions of humanity were based not upon physiological characteristics, but upon metaphysical ones which were believed to imprint themselves on the flesh of individuals as distinctive physical traits.

Thus, like the divisions of the earth—and for that matter, the cosmos—"the human race was divided into three kinds according to whether it rejects, partially accepts, or totally receives the Revelation: pagan, Jew, and Christian. Pagans become Jews by renouncing sacrifices but retaining circumcision, and eventually Christians ascend from sensible to intelligible symbols by aban-

doning circumcision."[9] Similarly, by a process of analogizing human history to scriptural history, the evolution of postlapsarian humanity could be cast as a progressive movement of certain humans toward a more perfect capacity for reflecting the Revelation. When Richer underlines the greater capacity of the Gauls for internalizing and expressing the Law, he has behind him a specific program of social selection and election.

According to this program, the history of humanity was divided into

> three purificative-illuminative-perfective stages linking the approach to the ulti-
> mate truth with the three stages of man's development: pagan, Jew, and Christian
> . . . for the abandonment of idols and revelation of the Father constitute the ascent
> from paganism to the monotheism of the Law; the abandonment of sacrifices and
> the revelation of the Son, the ascent from the Law to the Gospel upon which the
> Church is founded.[10]

Richer's history deals with the more recent struggles of the Franks, but he does not fail to mention the evolution of this new elect of God from paganism to Christianity, in accord with the above schema. The "ascent to the Law" took place under the aegis of a religious man, himself illustrative of the per-fective stage of illumination, Saint Rémy (the patron saint of Rheims and thus a direct precursor of Richer's monastic community). What is more, the adop-tion of the Law coincided with a "brilliant and illustrious victory" under the guidance of their first king, Clovis. Thus, under the leadership of enlightened leaders the Franks ascend from the Law to the Gospel, simultaneously found-ing both the Church and the monarchy.[11]

Humans were thus seen as signifiers whose value depended upon their abil-ity to imitate more or less clearly—and to demonstrate through their actions interpreted in narrative—a truth at once revealed *and* hidden in Scripture. Their actions and manner of life could be summed up in histories as witness to their understanding and interpretation of the Law, just as the Hebrew Bible provided a kind of running commentary on the manner in which the Jews adhered to or deviated from the Law at given moments in their history. The purpose of history writing at this time, then, was less to provide an account of events per se than to sum up the acts of leaders and peoples in order to show them as dialectical reflections of divine intention as given in Scripture.[12]

This helps to explain why the terms used to designate these accounts tend to be polysemous, connoting both deeds and discourse, acts and writing. Richer says that he wants to recount the *congressus* of the Franks, a word that connotes "social assembly" and "discourse" as well as "hostile encounter." Now the *congressus* of a doctrinally grounded social community have a dual purpose: by facing hostility from without, the inner dynamics of the society become more precisely articulated; inevitably, such accounts perform a doubly specular function.

They constitute a definite kind of statement about the way the society's belief structures help to define its sense of purpose and to differentiate it from the rest of the world. In short, they provide a language of *societas*, of commu-nity, and an image. Similarly, they demonstrate how the transcendent values the society predicates through its belief structures can be refined and tested in response to hostile challenges from outside—and inside—the community. The

concept of challenge, of opposition, will be a constant in the narrative forms developed in the eleventh and twelfth centuries, along with the idea of a cohesive but fragile *societas*.

The exposition of the *congressus gallorum* sought to enhance the self-awareness of the Franks as a divinely privileged group in the order of the cosmos. But it is the conjunction of word and deed, of "act" as gesture and expression projected upon the world as a whole that will form the basis of the narrative: "I will begin the account after having briefly shown the divisions of the globe and the parts of Gaul, since it is the customs and acts [actus] of these people that it is proposed to describe."[13]

"Actus" connoted a particular kind of conjunction between word and deed, referring not only to the aggregate of the acts of a people, the "official" deeds as it were, but also, by association with the book of the Bible, the *Actus Apostolorum*, a narrative of deeds bearing witness to a transcendent truth; the confirmation of a doctrine in the world expressed through the actions of a *societas*, and even defining that *societas* vis-à-vis its *congressus* with and in the world at large.

The Gospel prefaces, particularly those of Luke, made very clear to Richer and his contemporaries that the recording and reading of such deeds helped to affirm and establish the teleological principles justifying the privileged self-image the community held of itself, and to demonstrate by the accumulation of empirical "evidence," the truth and efficacy of the belief system by which it linked itself to the divine order.

Now the problem for the Franks, and for other Europeans, in the year 1000 lay not simply in affirming themselves as a *societas* linked to the divine order, but also, and more compellingly, in demonstrating their preeminent position in the historical dispensation, the order of time. Other peoples before them had produced monuments showing their position in Salvation history, so now they had not only to tell the story of their own situation as true believers within a hostile world, but also to demonstrate their right to represent themselves as the legitimate worldly and spiritual heirs of a religious and temporal authority that had originated in another part of the world with other peoples.

The historical continuity they evoked to authenticate their religion also showed that other peoples in other places had been the original interlocutors of divine Revelation. Again Richer instructs us, for he makes a sharp distinction in the history of the Franks prior to the baptism of Clovis, when they were, so to speak, nameless and in a void: "the histories report that all these peoples [hos omnes populos], intrepid by nature, were fortunate in their undertakings even though they were pagans" (I, 3).

In this early stage of its existence, the community was inchoate as such, without name ("hos omnes populos") or special place. The baptism of Clovis, "the first Christian king," by Saint Rémy, at Rheims, changed all that: after him there was a Christian state, in a specific place, with its own succession of eminent emperors (the Carolingians) down to the present, 888, where Richer's own universal history can begin: "After [Clovis] their state was governed through successive periods by illustrious emperors up to Charles, with whom we shall begin our histories" (I, 3).

Richer's account opens with a transfer of power by divine intervention in

the sacred past—the baptism of Clovis, which established the Franks as a ⅄
privileged Christian *societas*—and it will recount another transfer of power
from the Carolingian dynasty to the Capetian, again seen as a response to and
strengthening of the destiny of the Franks. We cannot but perceive a contra-
diction in the insistence upon continuity on the one hand: the succession in
history of a divinely ordained state ruled by illustrious emperors; and, on the
other, an assertion for the necessity of change: of transferal and renewal not
just from one dynasty to another, but in time—from the ancient times to the
present, from the present to the future—and place—from one part of the world
to another, and from one people to another.

This apparent contradiction provides the starting point for our inquiry into
the nature of narrative in the period from 1000 to 1150. For the accounts of a
Richer, or his contemporary historians, do not simply concern themselves
with a succession of worldly events. Their narratives imply, indeed insist, that
worldly events incorporate a dialectic with the transcendent powers they be-
lieved to shape their world. Thus the narrative of worldly events as a kind of
proof or demonstration of the entelechy of a privileged group of believers,
struggling to define themselves in a hostile world, provides a constant theme
for the rhetorically grounded, historical storytelling that evolved during this
period, ultimately defining and characterizing what we call the Romanesque.[14]

What precisely do we find as a general descriptive principle underlying this
apparent contradiction of continuity and change, of dynamic stasis that Richer
and others assert so pointedly? First, there is a recognition of the universality
of the Logos as a discourse which shapes and transforms the material world. A
principle transcending space and time, it takes as a given the ongoing nature
of creation. Consequently, this dialectic demonstrates a flexible and dynamic
capacity for inclusion and exclusion to its center of meaning. Thus groups
originally incorporated within the dialectic might, with the passage of time,
be excluded, while new groups, like the Franks, might be included or even
incorporated as privileged interlocutors. But such change always stresses the
continuity of the new with the old, just as Richer likens the tripartite nature
of the Gauls, their history, and their land to the tripartite nature of the earth,
with Jerusalem, the umbilicus, at the center.

This logocentric dialectic, with its capacity to universalize *and* set apart its
subjects from the rest of humanity, originated in the Hebrew Bible when Yah-
weh distinguished the Jews by means of direct and privileged discourse. From
the beginning, then, this discourse tended to be one of differentiation, both in
metaphysical and worldly terms. It served to reinforce, in various ways, the
specialness of the group, its identity and the relationship of that identity with
a specific territory. All of these traits occur from the outset of Richer's narra-
tive, where, besides localizing his story very specifically in place and time, he
also apologizes in advance for being obliged occasionally to talk about the
deeds of other peoples.[15]

Such a warning should serve to remind us of the intensely spiritual quality ⅄
of symbolling activity at this time. The purpose of such narrative was not to
inform people more accurately about their world and neighbors, but to show
how the world mirrored God's immanence, and therefore the subordination of
the human to the divine. "The characteristics of the Romanesque period," M.-

M. Davy reminds us, "come down to two basic principles: unity and the sense of God's presence."[16]

The authority by which narrative discourse could connect the physical and the metaphysical in this way lay in certain Christian Neoplatonic tenets of the period. Not only did these tenets begin to inform historical narrative, but they did so self-consciously. Again, Davy recalls the eclecticism of the monastic movement of the period, which looked beyond Europe to the East, particularly to the doctrines of christianism, for much of its symbolic language.[17]

We need not go beyond the historians themselves, however, to see this monastic taste for theology manifested. Richer shows a lively interest in the theological debates of his time and devotes whole chapters to what purport to be verbatim accounts of such disputes. One of these was even held at the imperial court with the emperor Otto II acting as arbiter.

Richer came by this fascination for theological thinking naturally, for he was schooled by the most learned man of his time, Gerbert of Aurillac, the chief protagonist in many of the debates recorded by Richer, and the man to whom he dedicated the *Historiae*. Archbishop of Rheims from 991 to 998, then of Ravenna, Gerbert became Pope Sylvester II in 999. In choosing the name he did as pope, Gerbert himself was engaging in symbolic predication. His namesake, Sylvester I (314–35), together with Constantine the Great, had transformed the Roman Empire from an instrument of oppression of the Christian religion into the most powerful and extensive Christian *imperium* the world has ever known. This victory had confirmed the triumph of Christ over the Romans, from the medieval perspective, and symbolized the New Alliance of God with Christianity. It also established the concept of the empire as a form of divine monarchy. In 999, Gerbert clearly hoped to renew this germinal moment, building upon the legend of Charlemagne, as we shall see in chapter 3.

Gerbert's contemporaries perceived him as an extraordinary person, a manifestation of God's discourse with humanity. Richer did not hesitate to see in Gerbert both an emissary of God and a metaphor for divine light: "the Divinity himself sent Gerbert, a man of great intellect and marvelous speech, who later made all Gaul bright like a shining light."[18] A few lines later, he again stresses Otto II's discovery of Gerbert while still a young man as a proof of the divine intention to illuminate with a great light a Gaul shrouded in darkness.

We shall better understand the importance of the repeated references to intelligence as illumination, "the light of the Word," later on. For the moment, we need note only that more than any other man of his time—and by the testimony of his contemporaries, from simple clerks to emperors—Gerbert illustrated an ideal whereby the universe could be taken as a symbolic whole, a unified hierarchy with God as the beginning and ending of creation. In effect, the world could be read as a text, written in a literal or natural language by a creator who had encoded his generative presence within the creation. One had thus to "read" the world as a literal construct, but construe it symbolically to discover the immanent meaning.

Gerbert's own career consistently mingled the literal and the figurative, the material and the intellectual. While still an archdeacon at Rheims in the 980s, Gerbert's reputation as an eminent logician led him to be employed on diplo-

matic missions by both the king of France and the emperor Otto II. In the same period, he headed the cathedral school at Rheims, which he raised to a position of preeminence.[19] Richer devotes much of book 3 of the *Historiae* to the curriculum and pedagogy of Gerbert's school, so we have a good idea of the importance accorded to the Greek fathers by Gerbert and his circle. From letters exchanged between the archbishop and his pupil Emperor Otto III we know that the latter even aspired to personify Greek ideals in his person, as ruler and humanist.[20]

This esteem should not surprise us, for it was in the philosophy of such thinkers as Pseudo-Dionysius the Areopagite and Maximus the Confessor that the concept of symbolic forms so important to Romanesque expression was to be found in some of its purest examples.[21] Pseudo-Dionysius enjoyed a special prestige in France at this time, since he was still identified with Saint Denis, the first Christian martyr and patron saint of France. The writings of these men had been available in France, both in Greek manuscripts and in the Latin adaptation of the ninth-century monk John Scottus Eriugena, for over a century by the time Gerbert began teaching at Rheims.[22]

Pseudo-Dionysius taught that the symbolic reading of the world was the path of ascension by which humans might comprehend the way in which the lower, material world reflected the celestial world of true essences. What linked the two was not the materiality, the form, but the meaning; in effect, the significant content of the world represented divine language veiled:

> The sensible universe is, objectively speaking, that part of the universe which is accessible to the sense, and as such could be the concern of the senses only. But once it is impregnated with the *logoi* as a consequence of the Divine creative activity [*proodos*], it becomes a world of symbols. The *raison d'être* of a symbol does not reside in its sensible matter which confines it to a corner of space and time, but in its significant content.[23]

In seeing the world as the veiled language of the creative principle, this theology sought to penetrate the materiality in order to evoke the significance. And yet, in starting with the material, localized in space and time, the symbolic theology provided an excuse for history as an important point of departure, a defining of the space and time in which the particular form of symbolic speech occurred. For, if the content of divine language remained unvaried, its signification, eternal, the form nevertheless adapted itself to changing times and places. So in order to read the symbolic language, one had first to recognize the various forms it had been translated into.

To see how these ideas germinated and spread, we could perhaps find no clearer expression of this symbolic hermeneutics than the opening remarks of the *Historiae sui temporis* of Rodolphus Glaber, who wrote an even more ambitious history than Richer's some forty years later. Rodolphus's work shares many of the same concerns as Richer's, including an admiration for Gerbert of Aurillac/Sylvester II. Coming at a later date, more than a quarter of the way into the eleventh century, it shows how the ideas expressed by the earlier generation have transformed the discourse of history beyond Richer's conception.

Rodolphus was a monk at the immensely powerful Abbey of Cluny, in Burgundy. In the eleventh century, Cluny was at the center of an international

movement to restore prestige and influence to the monastic ideal, a fact which helps to explain the scope of Rodolphus's project as well as his pedagogical concerns.

> I respond to the just complaints of our studious brothers as to why no one exists in our day who will pass on to the people who come after us, some kind of account of the multiplicity of events, hardly inconsequential, which appear to be happening both in the Church and among the people, especially since the Savior says that until the final hour of the final day, working with the Holy Spirit, he will, together with the Father, continually bring about new things in the world.[24]

Yves Christe and M. F. Hearn, in two recent books dealing with the problem of symbolic form in Romanesque art, have pointed out Rodolphus's indebtedness to the thought of the Greek Christian Platonists as transmitted through the writings and translations of Eriugena, "dont Cluny détenait alors la majeure partie."[25] They did not concern themselves, however, with the consequences of this influence on the emerging concept of *historia* as a translation of the symbolic language of the Trinity working in the world.

There is nothing tentative in Rodolphus's assertion that *historia* constitutes a dialectic whereby the multiplicity of events at the microcosmic level of human action in place and time ("multiplicia haec . . . tam in Ecclesiis Dei, quam in plebibus") may be translated into the unity of divine creativity viewed from the universal perspective. Rodolphus's sense of assurance may well have come from the Eriugenian texts so assiduously studied at Cluny during this period. Given Rodolphus's purpose, Eriugena would have been the logical authority since, as John Marenbon recently pointed out, Eriugena's work stood at the center of the development and dissemination of ideas regarding essence and universals in the tenth and eleventh centuries.[26] And Eriugena certainly does help us to understand the importance of Rodolphus's conception of *historia* as symbolic form.

Scottus Eriugena employed a geographic metaphor to describe the relationship and functions of history and theology. *Historia* he compared to a deep valley in which events could take place without the participants being able to see beyond the immediate situation. *Theologia* (at that time the equivalent of philosophy) occupied the loftiest peak above the mountain valley. From this summit, it was possible to survey what was going on below and to connect it to the rest of the universe. Linking the two was the eagle, Scripture, particularly in the form of the Gospel according to John, considered the purest expression of the Logos.[27]

Besides the obvious point that *historia* provides an occasion for continuing interpretative dialogue between events in the world and their symbolic meaning—an assertion that only the universal view may correctly explain particular events—we find something else: the valorization of the particular. *Historia* assumes an important role as interlocutor with *theologia*, for without the events on the valley floor, the significance of the view from the summit cannot be demonstrated. It is not just the vertical dimension that matters here, the ascent from sensible matter to significant content as in Pseudo-Dionysius, but also the horizontal view, the scope of the action that occurs in the valley.

Historia now begins to emerge as a specific kind of writing, a literary genre,

reproducing the world as text to be read and interpreted in the here and now, the valley, as it were. Events could then be narrated in a referential discourse that did not take phenomenal reality as its object of imitation, but the texts of Scripture and theology. In other words, *historia* did not seek to describe events as they *were*, but to transform them into texts paralleling those of Scripture and theology in order to complete the dialectic of Revelation. For Scripture was veiled truth; it could only be understood, as we shall see, with effort, an effort to separate the imperfect reflections of the sensible world from the Truth.[28] *Historia* was now to become an ancillary to the hermeneutics of the Logos, helping people to understand it and how it related to their world.

With Rodolphus, the principle of starting with the here and now becomes central to this hermeneutics:

> First, it must be shown that although the recorded flow of years from the origin of the world according to the histories of the Hebrews differs from that of the septuagint, yet we can be certain that the year 1002 of the Incarnation of the Word is the first of the reign of Henry, king of the Saxons, and that the year 1000 of the Lord was the thirteenth of the reign of Robert, king of the Franks. These two princes were considered to be the most Christian and the most powerful in our world on this side of the sea. The first, that is Henry, subsequently acceded to the Roman Empire. Therefore we established the sequence of times from the remembrance of these men.[29]

We can already see in this statement the theoretical assumptions which made *historia* a rewriting, rather than an imitation of phenomenal reality.[30] Sacred history and *historia* combine to demonstrate the principle of continuity and change, of *translatio* by which the multiplicity of events in the world could be shown to be part of divine intentionality. The passage asserts the existence of two successive orders in the world since the beginning of time. The first was a mediated order represented on the one hand by the Hebrew *historiae* of the Jews, then by the Septuagint, an attempt by seventy or seventy-two scholars to establish an "authoritative" Greek text of the Hebrew Bible. This order, and its texts, fail to establish a precise temporal sequence. The implication, clearly, is that this mediated order is unreliable, in comparison with the new order established by the Incarnation of the Word.

Certitude in time and history began, Rodolphus asserts, with this unmediated act of divine discourse by which the Logos assumed human form. Despite the passage of a millennium—the very preciseness of the time lapse from one event to the other contrasts with the fuzziness of the chronology of the old order—the certitude continued to be reinforced by the existence of Christian kings and the continued existence of the Roman Empire. Rodolphus appeals thus to the present to confirm the continuing efficacy of the sacred past.

We can hardly miss the reference to the concept of *translatio imperii* (transference of the empire), the carrying forward from past to present of "the myth of ancient Rome and Christian Rome locked together," as M. D. Chenu so felicitously defines it.[31] *Translatio imperii* became a central element in the theology of history in the twelfth century, and we shall certainly have occasion to see its influence at work.

Still, the main emphasis in this passage does not fall upon the question of

the continuation of the empire, or even on the empire per se. The main emphasis falls upon Henry and Robert, what they become, how they are perceived, and what may be established from this. Rodolphus does not count the time from their birth as humans, but rather from their advent in history as kings and emperor. The elevation to the throne is an event that almost seems to constitute a "translation," an "incarnation" paralleling the advent of Christ in history. The latter is, in fact, the event compared to it. Their intervention in history as *reges et imperator* establishes a *terminus a quo* for Rodolphus's *historia* just as Christ's advent does for sacred history: and the two have here been placed in parallel.

Rodolphus seems to suggest that these men have been elevated to a position where they resemble or imitate Christ; that is, from which they can demonstrate in their situation, as Christ did in his, the principles of the Logos. In other words, a human gesture of ascent that reciprocates the divine descent. The idea of the Incarnation as a gesture intended to engender a human response had been advanced by Augustine, Maximus the Confessor, and Eriugena.

The phrase from John 1:14, "Et uerbum caro factum est" (and the Word was made flesh) was meant, Eriugena held, to encourage a dialectic that would result in a reciprocal gesture of ascent by humans acting through the grace of the Logos: "The Word descended into man in order that, through it, man could raise himself to God."[32] But he would have to do this by studying the world into which the Word descended and the Scripture.

Rodolphus espouses a complementary version of this hermeneutics of the world and word when he goes on, immediately after the passage quoted above, to offer a summary of the theory underlying his *historia*. This theory stresses the possibility for the individual to ascend to a knowledge of the unity of God, by finding how the multiplicity and diversity of material things really do constitute a coherent whole. God created such diversity of shapes and forms, Rodolphus maintains, "so that by means of what the eyes see and the soul understands, the learned man [homo eruditus] might be raised to a simple understanding of the divinity."[33] It was the Greek fathers, he says, who were particularly adept at this hermeneutics of the world.

He then outlines a theory of the world as a higher and a lower order, the higher being equated with the intelligible and the lower with the material or sensual. By a symbolic concordance of the elements constituting the material world—fire, air, water, earth—with the creative virtues forming the intelligible world—prudence (*prudentia*), courage (*fortitudo*), measure (*temperantia*), justice (*justitia*)—the two worlds can be made to reflect each other with perfect symmetry. Scripture provides the connection between the two worlds, allowing people to see the coherence of the Logos running through both. This occurs by a third metaphoric transformation which equates the elements of the material world and the virtues of the intelligible with the mystical sense of Scripture:

> The Gospel according to Matthew contains a mystical image (*figura*) of earth and justice, for it demonstrates more openly than the others the substance of the flesh of Christ as man. The one according to Mark gives an image (*species*) of measure and of water, since it shows how penitence flows measuredly from the baptism of

John; Luke's shows the similarity of air and courage, for it is diffuse in space and strengthened by many stories (*historiae*). The one according to John is linked to ether, source of fire and prudence, since it expresses manifestly the form (*forma*) [of fire and prudence], whence a simple knowledge and faith in God may be introduced.[34]

And so, by starting from the material world, with the events in the valley of *historia*, the individual gradually ascends to the summit of the intelligible world where he once again encounters John's Gospel, the "Voice of the Eagle" in Eriugena's phrase, which soars into the ether.

This ascent involves three movements of the soul in a vertical dialectic. Starting with the four senses that help to identify the elemental world, the individual then moves within himself by means of reason, in a step midway between the material and the intelligible world. Ultimately, he goes beyond the bounds of reason, to enter the world of intellect, the superessential world of Idea. At this point, the purpose of this movement of ascent, its reward, becomes manifest. For the individual has succeeded in reproducing, but in reverse order, the creative motion of the Trinity, descending from the superessential to the essential realms to manifest its activity in the world. By this strenuous re-creative hermeneutic, the individual returns toward the origin of all things, toward, as Rodolphus insists, God.

Eriugena's philosophical anthropology had a special term for this mystical conjunction of the ascending individual with the descending godhead: *theosis*. This manifestation of God in humans—the deification of the creature—was the logical result of the vertical dialectic Rodolphus outlines. It happened only to those privileged beings who engaged in the ascent toward divine condescension, and, for the purposes of *historia*, we shall see that such beings were either prelates—especially prelate saints—or the kind of kings and emperors, like Robert and Henry, whom Rodolphus took as the *terminus a quo* for his *historiae*. The choice of these men was not gratuitous. In the next chapter we shall witness the narrative of theosis of one of them, Robert the Pious. In subsequent chapters we shall see how the concept could be extended to legendary heroes fighting to preserve divine and royal order: heroes like Roland, Charlemagne's nephew, and William of Orange, the protector of Charlemagne's son, Louis the Pious. For the early part of the eleventh century, however, the narrative possibilities of theosis were confined to the beings of king and saint.

Sheldon-Williams summarized Eriugena's concept of theosis as a reciprocal dialectic in a manner that explains very nicely the demonstration Rodolphus provides:

> This process of conversion and the constitution of grace . . . is enacted not only in humanity in general but in every individual who reflects the Trinity in the three "motions" of the soul—intellect, reason, and sense. In the return, sense is absorbed into intellect which is both the first motion of the soul and her perfection, in which once unified she is caught up into the deity in theosis.[35]

At the close of his theoretical summary, Rodolphus provides a rather beautiful statement of the same concept when he describes how, as a result of this arduous hermeneutic, the individual participates in the divine procession and

return. He shows how the created reflects the creator through the motion of
the soul away from and back toward the primordial principle. He resorts to an
Eriugenian oxymoron, "immutable motion" (stabilis motus), to capture the
moment of conjunction when the soul in motion meets and reflects the mo-
tionless deity and theosis occurs.

> These most evident connections between things preach God clearly, beautifully,
> and silently; for with an immutable motion, each one in turn signifies the other in
> itself, and in proclaiming the primordial principle from which they proceed, they
> ask to come to rest there once more.[36]

In this passage, Rodolphus illustrates how the reader of the world-text may
discover the divinity through this hermeneutic, just as Eriugena had shown
how it might be done. Eriugena in fact says that this interpretive reading re-
covers at once the name of God and his activity in the world-as-text. Note
how Eriugena also insists on the oxymoron—here troped as a chiasmus—"mo-
tus stabilis et status mobilis."

> But when [Theos] is derived from the verb [theo] it is correctly interpreted "He who
> runs," for he runs *throughout all things* and never stays but by his running fills out
> all things, as it is written. "His word runneth swiftly." And yet he is not moved at
> all. For of God it is most truly said that *he is motion at rest and rest in motion*
> [uerissime dicitur motus stabilis et status mobilis]. For he is at rest unchangingly
> in himself, never departing from the stability of his nature; yet he sets himself in
> motion through all things in order that those things which essentially subsist by
> him may be. For by his motion all things are made.[37]

Rodolphus's confidence in the possibility of bridging the gap between his-
tory and Scripture, time and eternity, man and God, derives from the specular
confrontation in which humans become a microcosm of the universe: "For the
substance of his life is called by the Greek philosophers [microcosmos], that
is, 'little world.'"[38] Rodolphus thus bases his concept of narrative on a met-
onymic mechanism capable of equating the changing face of actuality—"the
diversity and multiplicity of things," as he puts it—into the unchanging, eter-
nal order, a mechanism capable of embracing both history and Scripture and
of showing how they must necessarily signify one another.

It is a containing image, a specular reflection of humanity situated, in per-
spective, within the larger order of the universe. As developed by classical
philosophers and adapted in Christian Neoplatonism, by Pseudo-Dionysius,
Maximus, Eriugena, among others, it expresses the concept of the phenomenal
world as microcosm, the *minor mundus*, whose features and principles corre-
spond to the macrocosm of universe created by God.

In a long article which still remains fundamental to the subject, Rudolph
Allers catalogued the different kinds of microcosmic theories that flourished
from ancient times to the sixteenth century.[39] According to his classification,
the theory that establishes a metonymic relationship between art and society,
indeed art and the universe, would be called a "holistic" microcosmic theory.
Such a holistic theory postulates a continuum from part to whole such that
any one manifestation of event-in-the-world may be taken as a relatum illus-
trative of the entire world order, and vice versa.

The argument runs as follows: humans create order around them. They do

so in a twofold manner: (a) by establishing a well-ordered society, and (b) by expressing their idea of order in art, in the widest sense of the term, incorporating all kinds of symbolling activity. The frame of reference being whole units, one speaks of a holistic microcosmic theory.[40]

Cosmos is here interpreted as "organized order," that is, the order of any organized entity, and "rests on the fundamental conviction that the order of any somewhat orderly ('organized') entity is always and everywhere essentially of the same kind."[41] In other words, all of the constructs on the continuum "correspond to one another not only in the general and formal sense that they are, all of them, ordered in some way, but in the strict sense that they are, each in its particular manner, representatives or, better, manifestations, concretizations of the one selfsame order. There is but one order, and whatever is ordered there is so according to one principle."[42]

We can see how eleventh-century *historia* could organize itself so that the most apparently disparate events might be made to reflect the creative Word because

> if the idea of an all-pervading and throughout identical order is consistently followed-up, every being appears as "mirroring" the structure of the whole, and accordingly, also of every constituent part. Every substantial whole then becomes a microcosmos, even though the universal order may be more perfectly and more completely realized in one being (or construct) than another.[43]

The roles of narrative and author assume an obvious importance here because it is through the author's construction of the narrative that the metonymic relationships described above will be made clear. The narrative will be required to demonstrate that objects or, more usually, events-in-the-world have three values: the literal, the symbolic, and the anagogic, and that the significance of any event will be incomplete until the multiple values have been demonstrated. Put in a slightly different way, the accidental appearance of events-in-the-world must be shown to have, in reality, an intentional deep structure which may then be related to the intentionality of the universe. In other words, *historia* as narrative would seek to represent divine utterance as Cause or Reason:

> The reasons of all things, as long as they are understood in the nature of the Word, which is superessential, I judge to be eternal. Whatever has substantial being in God the Word must be eternal, since it is simply the Word Itself. My inference, therefore, is that the Word Itself and the manifold and primal Reason of universal creation are one and the same. We can also express ourselves in this way: The simple and manifold primal Reason of all things is God the Word. By the Greeks, It is called *Logos*, that is, "Word, Reason, or Cause."[44]

This formulation postulates a closed narrative system in the image of the "holistic" microcosm it serves to record. Again, Rodolphus's theory and Eriugena's philosophy show that within the narrative system, Scripture holds the place of the higher world in the microcosmic system, while *historia* represents the equivalent of the lower world. Although the system presupposes a reciprocal exchange, the interlocutors do not hold positions of equality, any more than they do in the corresponding specular confrontation between humans and the divinity. Thus *historia*, like the individual human, represents the specific

application of Scripture to a particular place and time; it makes manifest the applicability of a general or universal truth or virtue expressed by Scripture but in a specific situation. Lying beyond the particular, Scripture lends authority and truth status to the *historia* that evokes it.

Precisely because *historia* renders explicit the scriptural basis for everyday reality, it must, as narrative, internalize Scripture and articulate the world view to which it gives rise, just as the individual must strive to internalize the same creative virtues in his ascent toward the enlightenment of theosis. As a narrative system, then, *historia* was a "directed vision" of the world: an image of the force of Scripture on everyday reality demonstrating how God's word shaped the universe, how, in the words of anthropologist Clifford Geertz, it synthesized "the audience's ethos—the tone, character, and quality of their life, its moral and aesthetic style and mood—and their world view—the picture they had of the way things in sheer actuality were, their most comprehensive ideas of order."[45]

In the next chapter we shall see how Rodolphus implemented his theory of *historia* in two important kinds of narrative. The first demonstrates how *translatio* and theosis combine to give us the story of the sacralization of a place, Orléans, showing why and how it became a sacred locus, linked by *translatio* to Jerusalem, the *umbilicus terrae,* and thus the seat of King Robert's monarchy—that same Robert cited by Rodolphus in his preface as one of the two special beings worthy enough, along with Christ, to help establish the succession of time in his *Historiae.*

The second of the two examples builds upon and extends the ideas developed in the first. The latter, more preoccupied with place than person, may be seen as static, while the second, which also takes place in Orléans, appears more dynamic. It constitutes a narrative of persons, showing the encroachment of the "hostile world"—think of Richer's *congressus gallorum*—not only on the Franks as a whole, but also its penetration to the very center of the Frankish society: the seat of the monarchy at Orléans, whose sacred value and resonance are carefully established in the first example.

The drama and horror of this second account will emerge from the way King Robert rises to the challenge to save France and the Church by an extraordinary act which inscribed him, and his adversaries, in the discourse of history. Together, these two accounts form a paradigm of *historia* as narrative discourse which will help us, in subsequent chapters, to understand more clearly the rhetorical basis and structure of Romanesque art and literature.

2

Historia and Theosis

The three Gospel accounts of Christ's Transfiguration on the mountain[1] emphasize the transformation of his garments, described as shining with unearthly whiteness: "And his clothes became shining, excessively white, like snow, whiter than any fuller on earth could make them" (Mark 9:2).

John Scottus Eriugena called the Transfiguration "the height of spiritual vision."[2] In the *Ambigua*, which Eriugena translated and commented,[3] Maximus the Confessor interpreted the white garments as a *translatio* into symbolic language of the dialectic of Transfiguration, revealing its status as a narrative of human understanding. The account did not just concern Christ, Maximus said; it also showed why and how the disciples, Peter, James, and John, were exemplary humans: why they merited the grace of participating in a dialogue with the deity.

As Maximus saw it, the revelation made manifest their comprehension of the coherence of the created world and Scripture as a single text, a conjoint discourse act focused on a single meaning: the manifold made one. Now if the scene represented in sensible symbol the descent of the Logos, it also illustrated the reciprocal of that descent: the ascent by Peter, James, and John to an understanding of this discourse. It was thus a narrative of their theosis:

> By means of the white garments they received a revelation of what they had learnt from the great works of creation and from the Scriptures as a single truth, and so in their contemplation [epignōsei] of God they beheld that which the Holy Spirit revealed in Scriptures and that which their science and wisdom had taught them about the created universe as one, and in that unified vision they saw Christ himself.[4]

The white garments turn out to be doubly significant as a trope. They represent the natural world invested or clothed first by the symbolic discourse of the Logos—the "ego sum lux mundi" of John 8 : 12—and secondly by the "science and wisdom" of human intellection. In each case, historiated narrative—the three accounts of the mountaintop theophany—provides the point of departure for the troping.

In what must be the best-known passage of his *Historiae*, certainly one of the most often quoted, Rodolphus Glaber appropriated the image of the white garments of the Transfiguration, including the extended meaning provided by Maximus and Eriugena. In Rodolphus's interpretation, the white garments became the "language" by which Christ clothes the world in the present age: that is, the Church. Since unmediated transfigurations could not occur in that

present temporal order, an indirect language had to be found to express the same things. So the metaphor of the "white garments" permitted Rodolphus to distinguish the varying degrees of openness or directness in the language of Scripture, as opposed to the more opaque language of *historia*. Both were veiled, but not equally so.

Rodolphus's white mantle of churches represents the indirect language of Christ, spoken through symbolic acts requiring a commentary appropriate for the present historical age of the Christian Imperium Romanorum. This is meant to be compared to the more direct revelation of the Logos, "Christ's shining white garments," in the scriptural age of unmediated Transfiguration.

> At the approach of the third year following the year 1000, it was possible to see almost everywhere in the world, but particularly in Italy and Gaul, the reconstruction of church buildings, even though the greater part of them, very well constructed, did not need rebuilding. A spirit of generous piety motivated each Christian community to have a more sumptuous one than that of its neighbors. One might have said that the world itself stirred to shake off its old garment in order to cover itself everywhere with a white cloak of churches. At that time, almost all the churches of the episcopal seats, those of the monasteries consecrated to all kinds of saints, and even small village chapels were built more beautifully by the faithful.[5]

The siting of this passage intensifies the significations of the subtended Transfiguration texts and commentaries. It occurs at the midpoint of the whole work, in book 3, chapter 4, which is also the midpoint of this third book, devoted in part to demonstrating how King Robert and the Emperor Henry at once range through their world, as "God's word runs through it," according to Eriugena, while yet remaining firm, stabilizing forces in the center of their kingdoms, or microcosms.

A related symmetry situates the beginning of the era of church building—a symbolic way of signifying the imposition of ecclesiastical order on the world—with the concordant monarchic and imperial order revealed by Rodolphus's *Historiae*. His preface, we saw, dates this event from the year 1002, the date of Henry II's accession to the imperial throne. Throne and Church conjointly signified the order of the created world and the sacred order of Scripture; narrating them as "a single text"—to use Maximus the Confessor's felicitous image—was the principal performative function of *historia*; the equivalent, as it were, to the "whiteness" of revelation in the story of the Transfiguration.

Accordingly, the accounts of the reconstruction of churches—especially those destroyed by the intervention of external manifestations, either natural or human, of the "hostile world"—will be linked, in Rodolphus's narrative symmetry, with accounts of the "reconstruction" of the faith. That is, the rescue and preservation of orthodox belief from internal menaces to its unity in the form of heresy.

As we shall see, heresy takes on a new dimension as a menace in this period. Because of the political ramifications of the deification of the monarch—which we shall follow closely in this and the following chapter—heresy seriously threatened the coherence of the political as well as the ecclesiastical order. It was not simply a matter for theologians. By destroying the basis on which the holistic microcosmic order had been erected, it could quite literally

destroy the image of the world. And so heresy became a matter for the king, or at least King Robert, to deal with.

The consequences of this change, both in what it tells us about the emergent concept of kingship and in the narrative possibilities it opens up for portraying the king and his tributaries as defenders of the faith, were not negligible; they led directly to a vigorous experimentation with historiated narrative form. But first the story of the "white cloak of churches."

History as Directed Vision

In book 1, chapter 5 of the *Historiae*, Rodolphus describes the destruction by fire of the churches of Orléans in the year 999 and their subsequent reconstruction, starting presumably in the year 1000. The significance of these dates scarcely requires comment. Orléans was the seat of the French monarchy at this time, so it provided an ideal setting for a *historia* that sought to narrate Church and Throne as "a single text."

Rodolphus begins in a somewhat curious fashion, at least from our perspective. Rather than recounting the details of the event itself, he sets up the occasion for a metacritical commentary by undertaking a contextual narrative that begins a year before the disaster.

> In the year of the incarnation of the Word, 998, there occurred in the Gallic city of Orléans a portent as memorable as it was terrifying. There is in that city a monastery founded in honor of the Chief Apostle, in which, originally, a community of virgins dedicated to the Omnipotent God served. This monastery is known as Saint-Peter-of-the-Virgins. In the middle of the monastery stood the venerable emblem of the Cross, displaying the image of the Savior Himself enduring the torments of death for the salvation of man. During the space of several successive days, a stream of tears, witnessed by many people, flowed from the eyes of this very image.
>
> So terrifying a spectacle naturally drew large crowds of people, many of whom, looking at it, saw in it a divine presage of a calamity to befall the city. Just as this same Savior, by his prescience aware of the imminent destruction of Jerusalem, wept for that city, so, clearly, the imminent disaster which would befall Orléans soon after was confirmed by the tears wrung from the representation [figura] of His image.
>
> Another event occurred in the same city a short time afterwards, an unheard of thing, also, upon reflection, a portentous event. One night, when the watchmen of the main church, that is the cathedral, came as usual to open the doors of the holy place for those coming to hear matins, a wolf suddenly appeared and went into the church, seized the bellrope in his mouth, and by shaking it, rang the bell. Those present were first terrified by amazement, then set up a great clamor, and, although unarmed, chased the wolf from the church. The next year, all the dwellings of the city as well as the church buildings were burned in a terrible fire. And no one doubted that so terrible a catastrophe had been prefigured by both of these portents.
>
> At this time, the bishop of the aforesaid city was the venerable Arnoul, a man as noble by his birth as by his great wisdom, and very rich thanks to the income from family holdings. In the face of the disaster which struck his episcopal see, and the desolation of the people committed to his care, he chose the wiser course: he amassed considerable resources and undertook to rebuild, from top to bottom, the edifice of the main church, which formerly had been consecrated in honor of the

Cross of Christ. While he and his people were hastening to complete the work in order to finish it as handsomely as possible, a sign of divine favor was accorded him.

For it came to pass one day, when the masons were testing the solidity of the ground to situate the foundation of the basilica, they discovered a great quantity of gold. They believed it to be sufficient to pay for all of the reconstruction of the basilica, however great the expense. They took this gold discovered by chance and brought it intact to the bishop. He gave thanks to Almighty God for the gift He had given him, took it and gave it to the construction foremen and ordered that it be faithfully expended in the building of this church. It was said that the gold was hidden thanks to the shrewdness of Saint Evurtius, the first prelate of the same see, who buried it for this very reconstruction. The idea came to this holy man because, when he was renovating the church for the first time, he too discovered a divine gift placed there for that purpose.

In this way, the edifice of the church, that is the Cathedral, was rebuilt more splendidly. And also, on the recommendation of the pontiff, the buildings of the other churches, dedicated to various saints, were rebuilt more beautifully than the former buildings, and the worship of God's works was better in that city than in any other. The city itself was rebuilt soon after with dwellings, and the people, purified of their corruption with the aid of divine forgiveness, recovered all the more quickly because of their wisdom in accepting the calamity as an exemplary punishment. This city was in ancient times, as it presently is, the principal seat for the court of the kings of France because of its beauty, of its large population, the fertility of its soil, and the purity of the river that nourishes it.[6]

In reading this account today, we cannot help but remark, perhaps even be distracted by, the interweaving of modes of direct and indirect narrative. The observation regarding the function and suitability of the city as the seat of the court of France does not seem, for example, to be related to the preceding narrative. And even in the account of the fire and its aftermath, we find a majority of elements related to a purpose other than that of straightforward reporting of an event-in-the-world.

And yet, given the principles outlined earlier, the account does possess a strict coherence, but one predicated upon stressing the alterity of Orléans, its nature as something special, a place resembling other special places known from Scripture; in short, the account seeks to relate place, event, and personae to a textual perspective of the world and the universe, the perspective of history and anagogy.

We perceive immediately that the account establishes a vertical dialectic demonstrating the descent of God in the world to manifest His purpose, and the reciprocal efforts of *certain kinds* of men to ascend toward the divinity in response to His condescension. Even a naive reader cannot miss the textual quality of Rodolphus's account. No observer, looking directly at the events themselves, would ever have seen what Rodolphus's narrative conveys. The locus of referentiality most emphatically does not lie in the phenomenal world, but on an intellectual horizon consisting of scriptural and philosophical knowledge.

In interpreting Rodolphus's account of Orléans at the turn of the millennium, then, we need not ask whether his image can be corroborated by historical facts, but rather what texts from the scriptural canon and patristic literature can help us to interpret his story. Why does Rodolphus seek to portray Orléans as a divinely graced place, an Edenic *locus amoenus* inhabited by a

favored people whose crops grow abundantly thanks to the fertile soil and lim-
pid, nurturing river? In representing Orléans according to the aesthetic of di-
rected vision whereby the world is "rewritten" to make it appear as a divine
work accomplished for the benefit of an obedient, God-fearing people, Rodol-
phus reveals a purpose for his work which parallels divine intention, or what
may be known of it. In other words, Rodolphus's work is the textual mimesis
of the dialectic of divine descent and human ascent it records.

This fact has a fundamental importance for establishing the authority of
Rodolphus as an interpreter of divine intentionality in the events whose sig-
nificance (as divine manifestation) he presents. To the extent that he may sug-
gest by and in his work that he is like those holy men Arnoul and Saint Evur-
tius, whose efforts to ascend toward the divine condescension keep the
dialectic of Salvation history alive for ordinary men, his vision may be ac-
credited. In a very real sense, the subtexts of Scripture function like the hoards
of gold hidden first by God, then by Saint Evurtius for the various reconstruc-
tions of the cathedral of Orléans. They are the God-given resource enabling
him to build a more splendid and worthier edifice, namely, the reconstructed
vision of Orléans as a christocentric locus, a spiritual Jerusalem, a place where
humans may more readily acquire those divine attributes which not only per-
mit them to manifest God's grace on earth, but also situate them within the
celestial hierarchy.

As we know, this manifestation of God in the creature was called theosis,
and we have heretofore discussed it primarily from the standpoint of person.
We saw roughly who tended to qualify for it, at least in narratives, and what
they must do to experience it. But there is another aspect, almost as important
as the anthropological one: the question of place.

Just as theosis happened only to privileged persons, it also happened only in
privileged places whose spiritual value could not be doubted. Since theosis
was essentially a displacement into human time and history of the christolog-
ical model—birth, death, Transfiguration, Resurrection, and Ascension, the
cardinal stages of Christ's earthly existence—person and place were closely
linked in the sacralizing process, as Christ and Jerusalem were linked in the
Passion story. Rodolphus's account made Orléans such a sacred place: a stage
setting for the drama of theosis.

Theosis was known in Rodolphus's time in the meaning given to it by Greg-
ory the Great and Eriugena:

"Theophany originates only from God, and is brought about by the condescension
of the Divine Word, that is, the only-begotten Son, the Wisdom of the Father, toward
the human nature created and purified by Him, and by the exaltation of human
nature toward this Word by divine love." By *condescension* I do not here refer to
that already brought about by the Incarnation, but to that resulting from *theosis*,
i.e., deification of the creature. Theophany comes about, then, from the condescen-
sion of God's Wisdom to human nature through grace, and from the exaltation of
the same nature to Wisdom Itself through love [*dilectionem*]. St. Augustine seems
to agree with this meaning in explaining the Apostle's words: "He has become our
Justice and Wisdom" (1 Cor. 1 : 30). His explanation states, "The Father's Wisdom
. . . is produced in our souls by an ineffable condescension of Its mercy, and joins
Itself to our intellect, so that in some ineffable manner there is a kind of com-
pounded wisdom made from Him as He descends to us and dwells within us, and

from our intelligence, which is drawn up by Him to Himself through love and is formed in Him." Similarly he explains about justice and the other virtues that they are produced simply "from a marvelous and ineffable conformation of Divine Wisdom and our intelligence." As Maximus states, "Divine Wisdom descends through mercy as far as the human intellect ascends through love [*caritatem*]." This is the cause and substance of all virtues. *Every theophany, therefore, that is, every virtue, both in this life in which it begins to be formed in the worthy, and in the future life of the man who will receive perfect divine bliss, is produced not outside a man himself but in himself, and arises both from God and from men themselves* (my italics).[7]

Four ideas emerge from this passage that help us to understand the role of theosis in the development of the aesthetic of directed vision: (1) theosis was a mentalist activity coordinating human perception and expression, thought and "language," with divine intentionality; (2) what was perceived determined what was expressed; and therefore (3) the object of the perception was reproduced in the language of the expression; (4) the object of perception (for example, divine intentionality) could thus be known through the expressive discourse; in other words, divine intentionality could be known and communicated via human creative activity.

Eriugena explained the collaboration of God in human expressivity by using the imagistic analogy of the mixture of air with sunlight, an analogy he found in Maximus the Confessor:

"When sunlight is mixed with air, it begins to be visible. So in itself it cannot be apprehended by the senses, but when mixed with air, it can." From this analogy you should understand that Divine Essence cannot be apprehended in Itself, but in a remarkable way becomes visible when joined to an intellectual creature, so that Divine Essence is the only thing visible in the intellectual creature. . . . God will be seen through bodies and in bodies, not in Himself. Similarly, the Divine Essence will appear not in Itself, but through intellect and in intellects.[8]

In other words, Eriugena argued that God literally participated in man's symbolling activity; He could not be experienced as an object of contemplation per se, at least not in this world, but He could be shown to exist by what happened when one looked at and wrote about the products of his creativity, that is, the world and its events. In this closed sign system—a circular one as we have seen—anything man contemplated or wrote about would reveal the latent presence of God, not least of all in the re-creative discourse itself. Directed vision simply made that coincidence of intentionality—the divine and the human—clearer by showing the extent of God's participation in the human, re-creative discourse.

What does all this tell us about Rodolphus's narrative? Among other things, it explains why the device known as *translatio* played so important a role in realizing the goals of directed vision in his story. *Translatio* was a metaphoric process whereby one construct assumed the symbolic signification of another considered greater than itself. For example, when Charlemagne sought to renew the Roman Empire, he built his capital at Aix-la-Chapelle as an acknowledged *translatio* of Rome and Jerusalem, calling it a "Second Rome, a New Jerusalem." This sounds very much like the four principles of theosis outlined above, as it should, for the two processes are similar, except that theosis des-

ignates a human cognitive activity, for example, "the intellect becomes what-
ever it can grasp,"[9] whereas *translatio* applies generally to ideas, things, places,
or holy relics. The two frequently function together, as part of the same story,
for *translatio* occurs at the behest of someone, and may constitute a signifi-
cant proof of his or her spiritual biography. That is what occurs in Rodolphus's
narrative.

The narrative mechanism for *translatio* may also be understood via the
analogy Eriugena made with the mixing of air and sunlight: the literal element
to be transformed by the symbolic one is like the air which provided the ve-
hicle for revealing the light, not perceptible in itself—according to the science
of the period—but only when mixed with air. But the air by itself, without the
light, has no meaning either, at least none so spectacular as that bestowed on
it as the vehicle of light. Thus the event-in-the-world or the object selected for
narration attains signification only when conjoined with another element to
which it may be analogized in order to interpret it. The meaning of the narra-
tive therefore can never be viewed in terms of the narrated event itself, but as
the two, literal and symbolic, taken together.

We thus come back to the earlier recognition of the ternary structure of
narrative: (1) to provide a "literal" account of events-in-the-world (the register
corresponding to the air in Eriugena's analogy); (2) to relate these events to
appropriate scriptural passages where Scripture provides the metonymic *relata*
corresponding to the sunlight in the analogy; and (3) to show how both con-
firm and justify divine order and its workings in the world; that is, the signifi-
cance of the *translatio* of the first register in terms of the second.

Since the function of narrative is determined by the third level, we know
that the first level, the so-called literal account will be cast in such a way as to
make it conform to the intentionality to be expressed, that is, "the object of
perception will be represented in the language of the expression." The narra-
tive will thus contain within it an icon or image of what it seeks to explain.

Narrative as Theosis

Returning to the account of the fire at Orléans, we recall that it adopts a sin-
gularly indirect approach to the main historical fact. The fire as event-in-itself
receives only the sparse, one-line description: "Sequenti vero anno tota illius
civitatis humana habitatio cum domibus ecclesiarum terribiliter igne cremata
est," with only the adverbs "vero" and "terribiliter" providing some measure
of rhetorical emphasis. And yet the facts of the catastrophe exposed in this
sentence evoke the desolation of human tragedy. Nevertheless, Rodolphus de-
votes much more space to the events preceding the fire, events whose neces-
sary connection to the catastrophe exists only in the context posited by his
own text.

The account begins by relating the audience to a prophetic perspective: the
event as verification of cosmic signs. Immediately, a context of symbolic al-
terity envelops the event-as-recounted. This perspective of indirection appears
first in the title given to the chapter: "De portento Aurelianae urbis mirabili"
(On the miraculous omen in the city of Orléans). Latin syntax permits the
noun, *portentum*, and its overdetermining adjective, *mirabilum* (*portentum*

was already semantically marked with the connotation "marvelous, miraculous"), to surround the genitive forms *Aurelianae urbis*.

From the beginning, then, the reader's perspective is colored by the idea that Orléans was set apart from other cities, (1) by being a place where something worthy of recording in the *Historiae* occurred, and (2) by possessing extraordinary spiritual status as a locus of the divine attention signified by "de portento . . . mirabili." The introduction to the *Historiae* warned that only events of a momentous nature which "took place in the holy churches of Christendom" would be recorded and that these events would demonstrate the historic and anagogic coherence of the concept and reality of the spiritual Roman Empire which had succeeded to the primitive, monovalent political entity. In other words, one of Rodolphus's concerns is the *translatio* of the old concept of *orbis imperium Romanum* under the New Alliance.[10]

We can begin to understand why this kind of historiography tends to be a retrospective reconstruction of contemporary events; less an account of the event itself than a *récit* of a series of details—which depended upon the literary context for their correlation—linked to demonstrate symbolic, rather than necessary, causality and intentionality. The events preceding the fire, and those subsequent to it—in short, the bulk of the narrative—inexorably relate historical fact to a context of other times and other histories. This analogical movement of indirection constitutes a narrative equivalent to Eriugena's principle of progression and return, imparting a circular form to the story. Contemporary events thus repeat past history both literally and symbolically, and the ultimate interpretation must assume the same circularity of progression and return. To demonstrate the continuing responsibility of divine providence for contemporary events, in the same way Scripture showed it to work in the past, *translatio* posits a dual dialectic in which contemporary historical "fact" displaces in the direction of myth and the mythic matrix moves to accommodate historical "fact."

The first motion, therefore, must be to establish a mythic resonance, what we might call a predisposition or readiness of the historical fact to receive the imprint of mythic marking. Hence the care taken by the text to detail the portentous events preceding the fire, even though these events, from our viewpoint, are neither logically connected to the fire nor particularly believable. The first anecdote is the most interesting in that it provides a specific example of the primacy of the Logos in interpreting phenomenal reality. We might note, incidentally, the consistency whereby the narrative of the first portent incorporates the four principles of theosis outlined above in a manner enabling it to establish the three hierarchical levels of directed vision.

Rodolphus carefully situates the prolegomenous omens in sacred precincts, thereby assuring a context of divine authority for them. His description of the crucifix carefully stresses its dual nature as image of the historical Christ ("In cujus denique monasterii medio defixum stabat crucis vexillam") and living, metaphysical meaning, that is, that aspect of the symbol which renders it potent as an icon of religious belief in the here and now ("a praeferans ipsius Salvatoris, pro salute humana mortem patientis"). The confrontation of past and present signals these dual aspects: (a) the past tense of the placing of the

image ("stabat"), and (b) the present tense of its sudden expressive activity ("praeferans").

The generic potency of the image becomes real when it behaves like a living person by weeping. The signified and signifier have been conflated so that the image becomes the object it represents, the living Christ, by means of supernatural intervention. This supernatural intervention would have appeared less miraculous to Rodolphus's contemporaries than it does to us because of the context of belief in Rodolphus's time, which permitted, indeed encouraged, such theophanic manifestations.

At this point, Rodolphus evokes scriptural precedent for the weeping, thereby establishing intertextual authority for the event. It also signals the subtext which provides the analogical basis from which will come the meaning of the whole passage: the incident of Christ's weeping for the imminent destruction of Jerusalem recounted in Luke 19 : 41–44, which occurred during his triumphal entry into Jerusalem at the beginning of Passion Week.

> As he drew near and came in sight of the city he shed tears over it and said, "if you in your turn had only understood on this day the message of peace! But, alas, it is hidden from your eyes! Yes, a time is coming when your enemies will raise fortifications all around you, when they will encircle you and hem you in on every side; They will dash you and your children inside your walls to the ground; they will leave not one stone standing on another within you—and all because you did not recognize your opportunity when God offered it!"

The events of Christ's Passion possessed an importance for the eleventh century which we can scarcely comprehend today. The Passion marked the moment, from which all human history was seen to depend, when Christ linked heaven and earth through his two bodies, the material and the spiritual, in a manifest demonstration of the interrelatedness of these two spheres of being.

Examples of Christ's prescience during the Holy Week were seen as underlining the essential irony of that event, so well illustrated by the passage from Luke: the irony stemming from the limitation of man's vision as compared to God's. This irony held that the literal meaning of an event (man's initial view) would always differ from its symbolic meaning (that is, that which most closely approximated what could be known of divine purpose). It also guaranteed a place for a mediator, an author or authority who would be required to represent the account of an event in the world in terms of the ironic opposition and its ultimate resolution in the direction of the symbolic meaning. This is, of course, the function of the Gospel writers, and Rodolphus structures himself into the account under analysis in precisely this way.

Both in Rodolphus's account and in the tenth-century vernacular *Passion* of Clermont-Ferrand, which also represents this scene, what seems to have fascinated authors and audiences was the example of Christ's dual vision, his ability to see the symbolic in the literal and to represent this vision; in other words, his ability to represent history in terms of divine intentionality. In our passage, the intervention of the Gospel incident imbues the impending destruction of Orléans with a mythic resonance not otherwise apparent. Orléans is homologized to the Jerusalem viewed by Christ, that is, the historical Jeru-

salem; historical event to mythic account, whereby both place and event achieve a meaning which renders the fact of the destruction of the city not only comprehensible, but, as the sequel demonstrates, even desirable as a manifestation of divine grace.

Just as the Gospel account of Christ's weeping for Jerusalem makes Christ not the author of the destruction of the historical Jerusalem but the interpreter of that act, so Rodolphus's account makes Christ's living image the interpreter of the destruction of Orléans. This fact cannot be overlooked, for it provides a key to the function of the whole account. It would be a mistake to see the reference to the destruction of Jerusalem as a simple historical analogy. Rodolphus's purpose in recounting the destruction and rebuilding of Orléans set out to explain why it was a privileged city, a sacred locus. Such an equation presupposed that it possess spiritual significance to valorize its historical role. To achieve this, in turn, required that Orléans be analogized to the historical Jerusalem so that it might possess the virtue of that spiritual city.[11]

For the Middle Ages, Jerusalem was two cities, a transcendental celestial one—Christ's city refounded in heaven after its destruction by Titus[12]—and the terrestrial Jerusalem marked by the splendor of the Holy Churches which Constantine had constructed over the sacred places associated with Christ's Passion. There were thus two "New Jerusalems," the heavenly city announced at the end of Revelation and the terrestrial *renovatio*—a refounding of the City of David and Christ—established by Constantine. It was Eusebius who first cast Constantine's building program in the perspective of *renovatio* by calling it "a New Jerusalem."[13] Pilgrim accounts throughout the early Middle Ages, however, call attention to the splendor of the buildings over the holy sites in Jerusalem, so there can be little doubt that at least part of the concept of *renovatio* was linked to the notion of creation of beautiful buildings commemorating sacred sites.[14]

Renovatio, because it was a spiritual renewal from above, did not necessarily need to be confined to the site of the original place or thing being renewed. Thanks to the concept of *translatio*, the spiritual values associated with one place could migrate to another, provided that the migration be associated with a significant creationist activity, like the building program of Constantine in Jerusalem.[15] Ernst Kantorowicz linked the distinction between "historical place" and "spiritual place" to the concept of Time and eternity, where the spiritual or sacred resonance was signaled by the process of "haloing": "the 'halo' always indicated in some way or another, a change in the nature of Time. It signified that the haloed individual, person or place, participated also in a category of 'Time' which was different from the one determining the natural life on earth. . . . [T]he halo removed its bearer . . . from *tempus* to *aevum*, from Time to sempiternity."[16]

Renovatio and *translatio* are concepts associated with artistic creation, as well as possessing spiritual connotation. They manifest themselves, in fact, in their spiritual sense in the presence of creative activity, as the anonymous hymn used at the consecration of churches, *Urbs beata Jerusalem*, reminds us. In this poem, "Jerusalem" represents the spiritual city, refounded and transformed by Christ's Passion. It is Christ; and, metaphorically, it is the new

church at whose dedication the hymn was sung and into which the faithful will enter, as later they will enter the heavenly Jerusalem.

> The blessed city, Jerusalem, called the vision of peace, which is built in heaven, out of living stones, and adorned by angels as a bride is adorned by her attendants.
>
> Like a bride coming from heaven, is ready for the nuptial bed, so that she may be united in marriage with the Lord. Her streets and her walls are made of purest gold.
>
> Her gates shine with pearls, her approaches lie always open; and in accordance with their merits all who in Christ's name are oppressed in this world are made to enter there.
>
> Her stones, shaped by crushing blows, are fitted into their places by the hand of the artificer and are disposed that they may remain for ever in the sacred building.
>
> Christ is placed as the corner-stone, which is bonded into the framework of both walls. Holy Sion receives him and, placing her faith in him, is fixed in him for ever. . . .[17]

The fourth stanza of this hymn makes the equation between the Passion and Resurrection of Christ and the destruction and rebuilding of holy places whose spiritual value derived precisely from the process of destruction and renewal. In fact, the *renovatio* depends upon the paradox of "creation by destruction": "Her stones, shaped by crushing blows, are fitted into their places by the hand of the artificer. . . ."

There is yet another important element in the equivalence of the destruction and rebuilding of Jerusalem to the Passion and Resurrection of Christ: that of divine intentionality. It was through the death and resurrection, as medieval texts did not tire of saying, that God reiterated the Genesis story but with a "textual commentary," this time in the form of the Logos who made explicit God's intention. We cannot miss, in this context, the underlying concept of circularity between heaven and earth, that is, procession and return, so vital to the concept of theosis.

Eusebius's accounts of the building of the "New Jerusalem" by Constantine repeatedly make the equation between building and revelation. They also equate revelation with aesthetic beauty, not because aesthetic beauty was somehow thought to be the same as divine revelation, but because divine revelation in and of itself was seen as a manifestation of God's existence, even if the nature of that existence was beyond man's comprehension. Thus the places which manifested His presence were to be rendered as beautiful physically as they were extraordinary spiritually. By creating in his own manner, that is, through the talents of aesthetic disciplines, man could imitate, however imperfectly, God's intentional creation, at least to the extent of calling attention to the splendor of those sites particularly imbued with His presence, and investing them with an atmosphere of awe calculated to dispose the faithful in the direction of pious contemplation. In effect, the sites were to be covered with a visual "rhetoric of revelation."[18]

The fifth stanza of *Urbs beata Jerusalem* explicitly evokes the intentionality of building as creation in terms of the insertion of Christ into the fabric of the edifice as literal and metaphoric cornerstone. The following stanza, omitted above, expresses the purpose of such religio-aesthetic creationism: to be a

new testimony to God's continuing presence by praising Him in its own form, and—most importantly for our purposes—by inviting others to perceive and praise God; which was, of course, the function of theosis.

> The whole of that city, sacred and beloved by God, full of melodies, praises and proclaims God, the one and the triune, with exultation.[19]

But, at the same time, human building activity served not only as a marker asserting a recognition and praise of God's existence, but also as an initiator of the dialectic of return, whose success would be marked by the descent of God into the building which will then be in spirit as well as intent a "New Jerusalem":

> Won by our prayers, come God most high, into this temple, receive the prayers of thy suppliants with clemency, and pour ever into it thy bountiful blessing.[20]

We can now understand the implicit irony in Rodolphus's account of the destruction of Orléans. From the initial terrestrial perspective, it was a disaster, but when seen from the divine perspective explicated by the omens, it becomes a necessary precondition of spiritual reconstruction, conferring on that community the status of "divinely preferred city," thereby making it eligible for the symbolic homologization with Jerusalem. The rebuilding of the city—the second stage in the account—thus assumes the function of a second stage in the dialectic of ironic reversal whereby God's Wisdom once again reveals itself to be greater than man's limited vision. This spiritual refounding of Orléans, under the sign of the *translatio Hierosylimitani* we have just witnessed, would make it clear that Orléans was indeed a sacred locus and therefore worthy to be the seat of a theosized being, the king of France. In such an equation, France, too, acquired a spiritual resonance as an integral part of that *renovatio* perceived by Rodolphus, the *renovatio* of the Roman Empire (*orbis imperium Romanum*).

The second half of Rodolphus's account demonstrates the dynamics of metaphoric transference in terms of person as well as place. There are two specific reasons for this: (1) a world view dominated by a creationist philosophical anthropology necessarily required a human authority to render apparent the coincidence between divine intention and human creative activity; and (2) the myth of a people elect of God required a visionary leader, the prophet, to point out the path of rectitude in order to lead his people back to it. In the Middle Ages, Christ was the logical culmination of the Old Testament prophet/leader. Therefore a *translatio Hierosylimitani* without a corresponding identification of a Christ figure, an *imitatio Christi*, would be impossible in the syntax of the mythic language at work here.

Creationism underpins the basic notion of the holistic microcosm theory. For man's re-creative activity to parallel, at the microcosmic level, the work of the Prime Mover at the universal level—the coincidence of human creativity and divine intentionality—must be maintained. This, in turn, might only be assured when it could be demonstrated, for the human sphere, that the re-creative effort had been the work of an authority, a "seer." *Seer* was one of the terms for God as interpreter of His work in Eriugena's symbolic etymology of

the word *God* from the Greek *theoro*.[21] Constantine appeared as a "seer" in Eusebius's account of his rebuilding of Jerusalem.

The penultimate sentence of Rodolphus's account also suggests another scriptural model at work in the narrative: the model of the prophet who brings the erring elect of God back to the paths of divine rectitude. Eriugena's *Homily on the Prologue to John* asserted that man had been guided back to the knowledge of God's commandments by a double movement: "through Scripture and through created things."[22] An authority figure must therefore be capable of revealing Christ-as-Word through Scripture and through created things, preferably the two taken together. The textual presentation of Arnoul's role in rebuilding Orléans makes him at once seer and leader, historic figure and scriptural prophet. It transposes Arnoul from human to divine context by making him the focus of a dual mythic structure: one scriptural, the other a historicization of scriptural authority.

Again, this section begins by indirection. This time the focus falls not on the event but on the person responsible for it, the bishop Arnoul. Like the city itself, Arnoul is represented as having a privileged status. Initially, this consists of his birth and wisdom. Wisdom is key here, for that quality will be valorized as corresponding to divine intention. The implication clearly conveys the uniqueness of the bishop's perception—his thought and "language," the latter analogized to the commands for rebuilding: he alone sees what must be done and how to do it, that is, God's intention. His perception of the *renovatio* of Orléans expressing via the splendor of buildings the concept of a renewed locus of spiritual life will determine the result: "the cathedral rebuilt more splendidly than before" and the refounded cult where "God's works are worshipped better than in any other city."

Furthermore, Rodolphus's narrative functions, at one level, to show that Arnoul's perception of God's intention has indeed been realized in the building program, conceived as the bishop's chosen form of expression, his "language." Rodolphus's narrative completes the building program by conjoining creative expression and human/divine intention in a context of interpretive language which reveals the perceptible world—the rebuilt city of Orléans—as a "microcontext" in which may be "read" the divine order—and ordering—of the universe.

All of this emerges with remarkable narrative economy in the three paragraphs devoted to the rebuilding of the city. Each paragraph represents a different level of concern, imparts an expanding focus to the account. The first treats the literal level of event, while incorporating markers which point to the symbolic deep structure of mythic subtexts to be activated in the unfolding of hierarchical concerns that occurs in the subsequent paragraphs. The markers, which remain virtual in this first paragraph, are the singling out of Arnoul—one of two named characters in the whole narrative (the other being Saint Evurtius, named in the second of the three paragraphs in this section)—and the authorial intervention at the end of the paragraph: "nimium evidenter praestitum est illi divinitus juvamen," which may be translated, with a weakening of the connotation of wonder conveyed by the Latin, as "a sign of divine favor was accorded him."

The second paragraph advances the literal narrative by explaining how the splendid buildings were financed. At the same time, the mythic resonance of this "historic" fact, the divine gold hoard, subverts the literality or univocity of the narrative, just as the lachrymose crucifix transformed the first part of the story. Together, the weeping crucifix and the gold hoard create the expectation, "portent = expression of divine intention," that supports the basis for the assertion of divine causality so important to the discourse.

The story of the miraculous gold also structures into the narrative the icon of another myth which tells the same story. The dialectic between these two stories operates in precisely the same way as the two sets of portents just described. The narrative of Saint Evurtius, probably derived from local legend, is preserved in a *Vita Sancti Evurtii*.[23] It demonstrates strikingly the circular principle of mutual definition—a kind of narrative semiotic chain—whereby one text provided the authority for a second text based upon a subsequent event whose credibility depended upon its being made as much like the account of the first event as possible.

The account of the original event incorporated into the new text serves as an icon of textual authority ratifying both stories and relaying into "modern" history the portentousness of the sacred past. This permits the double movement of displacement of myth toward modern historic event and vice versa, thus emphasizing a primary signification of historiography in this period: that the textualization of history was a "continually evolving process of creation, a process which strove to present the truth of the past from the perspective of the present."[24]

Rodolphus himself illustrates this principle by tracing the gold hoard not simply back to Saint Evurtius but to God Himself. Saint Evurtius's original cathedral would thus have been a human manifestation of divine intention; Arnoul's construction a reiteration of divine thought at one remove. We should note here the suspension of realistic time continua: the history of ecclesiastical construction in Orléans stands reduced to three primal movements: God's intention, Saint Evurtius's translation of thought to act, and Arnoul's replication of the two prior "moments." In this sequence, we can hardly miss the assertion by Rodolphus that Arnoul's act seeks to recapture all the splendor of the primal movement of condescension: God's original intuition.

Arnoul does not simply reiterate Saint Evurtius's action of building; he succeeds, we are told, in realizing a more splendid manifestation of the divine intention than had existed in the past by constructing a more magnificent cathedral and in refounding a more spectacular physical and spiritual setting. This exemplifies how deeply rooted was the concept of progress in human history, viewed, as we saw in the previous chapter, as a series of ascending stages from purification to illumination to perfection. Once again, we see that *translatio* was not a static concept, but one based on an ideal of history as a record of the return toward the One, which began, in the postlapsarian world, with the Incarnation of the Word, the *terminus a quo* of Rodolphus's chronology.

We now see why the second paragraph homologizes Arnoul to Saint Evurtius and both to Christ. They are *imitationes Christi* presiding in their different eras over a spiritualized Jerusalem. The specifically contemporary anchoring

"Holistic Microcosmic Theory" = Philosophical
Context evoked by Rodolphus's World-as-Word (text)

C

A B

Person: Arnoul	Christ/Apostle/St. Evurtius
Narrative	Scripture/Apocrypha
Place: Orléans	Jerusalem/sacred locus/ primitive Orléans

of the account in this second paragraph has not been denied so much as it has
been elevated to a timeless continuum of spiritual acts. The microcontext of
Orléans in the first quarter of the eleventh century has been interpreted in the
light of eternal texts—the *Vita Sancti Evurtii*—and, especially in the first part
of the account and the final paragraph, of the mythic subtext of the Old and
New Testaments. Obviously, this holistic view of place and person could only
be the product of Rodolphus's directed vision, of a narrative that textualized
space and time in such a way as to make it comparable to other spaces and
other times as represented in authoritative texts.

Unlike Arnoul's buildings, Rodolphus's narrative had at its disposal the self-
conscious capabilities of verbal language. An attempt to schematize the model
apparently used by the narrative of the events at Orléans would reveal some-
thing like the accompanying schema. It consists of a dynamic interchange
among three points of a triangle of signifying elements where the two base
points are narrative texts, while the apex represents the philosophical tradi-
tion informing the perception of these texts. In Rodolphus's *Historiae* that
philosophical tradition contains a strong admixture of the Neoplatonic doc-
trines espoused by Eriugena and the Greek Fathers whom Rodolphus cites
with such admiration.

The model has purposely been cast to resemble the metaphoric triangle pro-
posed by Pelc as modified by Alverson to incorporate the intentional proper-
ties of metaphoric language.[25] As in a metaphor, all the signifying elements of
the triangle are read simultaneously; it is only in the interpretive process that
the literal events (A) become consciously transformed by analogization with
signifying elements (B) and (C). That these elements may be seen as belonging
to the textual intentionality of the narrative may be demonstrated by the fact
that they are all internal to the *récit*, as the preceding discussion has made
clear.

Although the schema has been made text-specific to account for the narra-
tive under discussion, it clearly could be used to generate any number of nar-

rative accounts of events-in-the-world simply by varying the person/place specificity of (A) and by finding the applicable corresponding references to Scripture/Apocrypha for (B). There are dozens of places in the *Historiae* where the model has been used, and one could adduce without difficulty similar examples from other eleventh-century chroniclers like Adémar de Chabannes.

The model does more than simply offer a heuristic device for explaining the generative principles governing logocentric narrative. It enables us to understand why ancillary literature, that is, apocryphal literature or literature not specifically theological, could suddenly assume in the eleventh and twelfth centuries a role of considerable social prestige and privilege that it had not enjoyed previously. It also explains why it would be a natural complement to the more spectacular forms of religious expressive activity like the massive building programs undertaken at Orléans, Chartres, Rheims, and elsewhere. Rodolphus's *historia*, or any narrative constructed on the same principles, had the power of making divine creationist activity seem less distant from the world of everyday reality.

This coextensiveness of the spiritual and mundane worlds manifested itself intellectually as a circularity of intellectual exchange, a perpetual *va-et-vient* of objects and ideas from the terrestrial to the celestial realms. Only man enjoyed the privilege of participating in both spheres, according to the thought of the period, and this privilege required constant demonstration. In the philosophical horizon of the era, point (C) on the diagram, the concept of procession and return provided the most comprehensive intellectual framework by which to relate the coextensiveness of heaven and earth to daily existence. The diagram shows how the dialectic of procession and return could be internalized as narrative structure at levels (A) and (B) by being made a principle for intertextuality. The concept that all things flow from and ultimately rejoin their origin—becoming like it in the process—has been transposed to fit the literary situation: historical narrative must be shown to proceed from and return to its primordial source, the Word of God in Scripture, and in so doing construe the world as representation according to the same logocentric principles.

Narrative Theosis as Agon

The foregoing discussion demonstrated a static model of *translatio* and theosis in *historia*. It showed how fate and the perspicacity of privileged humans might function together to reveal the "white garments" of divine presence in a sacred place. Now we can see how *translatio* and theosis work dynamically to reveal God's hand in the drama of human affairs.

Above all, we may get an idea of how the holistic theory of microcosm imparts coherence to *historia* as a literary unit. While the fire and the rebuilding of churches at Orléans make perfect sense when read as a self-contained anecdote, they become even more meaningful when seen as a metonymic element in an overarching structure, beginning with the *Historiae* as a whole. Not only has Orléans been important in the far and recent past of France, but it will continue to manifest mythic resonance as a principle of differentiation, as we discover in a story told in book 3.

Book 2 of the *Historiae* ends with a chilling account of a new heresy discovered in Italy. Not surprisingly in so textually oriented a world, this heresy, Rodolphus asserts, arose from an evil but ingenious grammarian who placed the interpretation of pagan classical authors—for example, Virgil, Horace, Juvenal—above Scripture: "This man, corrupted by the tricks of the devils, began to teach things contrary to holy faith very bombastically, and he claimed that the sayings of the poets should be believed in all things."[26] In short, this Italian grammarian substituted a hermeneutics of a purely human, historic, and intercultural sort for the vertical, anagogic, and intertextual hermeneutics of ontology given in Scripture. A rival hermeneutics attacking the fundamental concept of a holistic microcosm threatened to undermine the most basic idea of order for the eleventh-century European; most particularly the idea of the monarchy. No wonder Rodolphus concludes both his introduction to the new heresy and book 2 with a reference to the most militant of New Testament texts, and the one which played so important a role in combating the dualist heresy in the early part of the Middle Ages: the book of Revelation.

As we shall see later on, Revelation had a privileged status as a subtext in the literature that was concerned with varieties of challenge to the orthodox Christian episteme: the *chanson de geste*. The reference made by Rodolphus at the end of book 2 suggests why heresy and its reciprocal, the affirmation of a coherent, scripturally based Christian community, were invested with such portentousness in the millennial century after the birth of Christ: "This presage agrees with the prophesy of John according to which Satan will be unleashed after a thousand years; we shall treat of this at greater length in the Third Book."[27]

Revelation had more to offer the world view of the eleventh century than an apparently topical reference to the Apocalypse. The basic theme of Revelation was that of celestial order and stability versus terrestrial disorder and mutability. The vision of John was one of a progressively disintegrating world upon which the Salvation symbol of the Lamb, finally surrounded by the eternally stable New Jerusalem, had been imposed. Standard illustrations of Revelation dating from the period show the toppling of earthly cities, the destruction of significant portions of humanity, the birth of the ideal manchild threatened by the serpent, and even the disintegration of the natural world in a vividly imaginative manner. In the midst of this evocation of disorder and chaotic movement stood the calm and stately symbols of order, notably the Lamb. In a quite literal manner, Revelation, as represented in the sumptuous illuminated manuscripts of this period, illustrated the divine forces in Apocalypse as *motus stabilis et status mobilis*.

The Eriugenian reference is not gratuitous, but had important corollaries in Romanesque art which show that the association of Apocalypse and heresy belonged to the intellectual horizon of the period. Meyer Schapiro demonstrated the survival of Carolingian motifs in eleventh-century illustrations in the Beatus Commentary on Apocalypse of Saint-Sever (c. 1060), in two drawings from Tours (late eleventh century), and in the great theophanic tympanum at Moissac, which we shall examine later in this chapter. These works, the drawings especially, "point," he argued, "to the continuity of Carolingian and Romanesque art in one of the great Carolingian centers—a continuity

which should have been suspected because of the corresponding relations of the Ottonian and Carolingian schools in Germany."[28]

Schapiro also showed that this continuity extended to Carolingian theological preoccupations which were incorporated in the iconography of these images of Apocalypse. In particular, he found the Carolingian conception of the sublimity of John the Evangelist to be echoed in these (and other) Romanesque works. "In a homily by the greatest Carolingian thinker, John the Scot [Eriugena], enthusiasm for the Evangelist reaches a climax of rapture. The author of the fourth Gospel is admired as more than human."[29] Saint John, in Eriugena's interpretation, wrote after experiencing a theophany, an intellectual transfiguration. This "voice of the mystical eagle that resounds in the ears of the Church . . . was lifted by the ineffable flight of his spirit beyond all things to the arcane of the unique Principle of all things, there to perceive the Principle and the Word, both incomprehensible, that is the Father and the Son."[30]

The mystical authority of John made him a particularly important witness in the struggle against heresies that sought to divide the universe by separating heaven and earth, rather than seeing them as a unitary creation by a divine principle. In his *Homily on John*, Eriugena expressly asserted that John had written "In mundo erat" (John 1 : 10, "He was in the world"), "lest one might think, sharing the Manichaean heresy, that the sensible world had been created by the Devil and not by the Creator of all things visible and invisible."[31]

When we recall that the author of the fourth Gospel and the author of Revelation were thought at this time to be the same John, we can understand the authority of these two works: one providing a theology, the other a vision of combat and ultimate victory, for the fight against "the hostile world" and, especially, heretics. Eriugena's precocious marshaling of John's Gospel in the fight against heresy must have been seen, in the eleventh century, as particularly prescient—and not least of all by Rodolphus, for whom the recrudescence of heresy cast the known world into apocalyptic disorder, making Revelation 20 : 3, to which he refers, the appropriate subtext for his *historia*.

Book 3 of Rodolphus's *Historiae* orchestrates the apocalyptic polarity between order and disorder with great assurance. In the first instance, it offers an apparently unmitigated catalogue of disasters, both natural and human in origin. It argues, for example, in the third chapter, that Robert the Pious's reign was distinguished by a divine portent of disaster: a comet which foretold catastrophes that befell churches and churchmen from one end of his kingdom to the other. It is this book that recounts the destruction of the Anastasis (Church of the Holy Sepulchre) in Jerusalem and the plague of heresy already noted.

Yet one feels no contradiction, reading the book, in remarking its essentially positive view. This optimism grounds itself in images of creative stasis, of integration, in the midst of gratuitous motion and disintegration. The countertheme of integrative stasis begins with the assertion, made at the beginning of the book, that since the year 1000, the world had been favored with great leaders, both churchmen and statesmen, "men whose life and work can furnish posterity with exempla worthy of being imitated":[32] such men as Pope Benedict VIII (1012–24) and Emperor Henry II of Germany (1002–24). But above all, King Robert the Pious of France (996–1031) serves as Rodolphus's

prime example of creative stability. The choice, from the standpoint of *historia* as narrative, must be linked directly to the focal point of the book, the chapter devoted to the suppression of heresy at Orléans. For the technique of this narrative, we find a new concept of the philosophy and aesthetics of theosis brought into play, the notion of agonistic hermeneutics.

The Agonistic Basis of *Historia*

As we turn to book 3, we might briefly focus on two correlative concepts that will help us to understand the narrative strategy. The first of these concerns the nature of will or action in the world as a struggle to intuit the path of ascent and to avoid the horizontal, worldly paths that lead away from reunion with the One. The second principle flows logically from the first and shows the world to be a place of chaos, resistant to order and requiring the effort of a strong, willingly enlightened leader to impose and maintain the order of the Logos. Together, these concepts account for many of the most characteristic aspects of Romanesque narrative and iconography.

Eriugena's concept of theosis, articulated by Rodolphus in the introduction to book 1, emphasized the notion of human *agon*, or struggle, toward the point where God's condescension met and filled the ascending human. But, as Rodolphus reminded us, it was not just any human who reached this point, although in theory, theosis could be available to anyone. Only the *homo eruditus*, moving from knowledge (*scientia*) to wisdom (*sapientia*), could achieve this end.[33] *Scientia* applied itself to active study of things in the world and was the first step in the difficult task of reading the world as a text in order to ascend toward the higher knowledge, or wisdom (*sapientia*), which contemplates the divine, eternal, and unchangeable nature of things: in other words, the Creative Principle (what could be known of God).

Eriugena conceived of this elevation of the spirit as a difficult struggle; although everyone might have the capacity for raising the soul to theosis, not everyone would choose to do so. Scripture, he said, provides an image of the two kinds of humans to be found in the world: those who seek God and those who turn away. The former provide the good *agon*, the dramatic struggle by which humans return to and affirm the creative principle. The latter cause the worldly *agon*, the dissension and chaos that threaten to undo the universal order.

Eriugena took his image of the two kinds of humans from a scriptural parable that became a great favorite in medieval drama and art: the parable of the Wise and Foolish Virgins in Matthew's account of the Sermon on the End (Matt. 25 : 1–13):

> In the Gospel the Lord Himself likened to ten virgins the whole of rational creation, which was created specially in man and which naturally has within it a desire for bliss and a capacity for knowledge of the Highest Good—that is, of the most sublime Trinity, from which flows all good. These virgins, taking up their lamps, that is, the capacity for knowing the eternal light, went out to meet the bridegroom and the bride, that is, Christ and the Church, which is now in heaven, consisting partly of the holy angels, partly of the purest souls of men. In them the first fruits of human nature, which still is in the captivity of mortal life and frail limbs, are added

to the citizens of the celestial country. But why to meet them? Because the Redeemer and the Bridegroom of rational nature, with the ineffable condescension and readiness of His clemency, moved by regard for our salvation, always has come to receive us spiritually, accompanied by celestial powers and holy spirits.[34]

Eriugena stressed the fact that the ten virgins represented all of humanity. Everyone had the capacity to know God; each person received a lamp, that is, the mind with its "capacity for the true light." But, as the parable taught, when the moment came to illumine and be illuminated by Christ, not everyone had oil for the lamp. The oil signified the effort of the human to ascend toward the understanding of the Logos: "a naturally implanted striving" and an "actual attempt to ascend to the sole natural goods of humanity, which subsist in Christ."[35] The five Foolish Virgins constituted that part of humanity unwilling to turn toward the Light of minds; those "unclean spirits" who "will not arrive at the supernatural grace and joy of deification in Him," that is, theosis.

Eriugena argued that by dividing humanity into two classes, the wise and the foolish, and by providing Christ as the archetype of the ideal man, the *homo eruditus*, God assured that man's free will would be most effectively employed in directed symbolling activity: "Scripture does not say 'Let us make man in Our image and likeness' but 'according to our image and likeness.' It is as though it were clearly saying: 'Let us make man to become Our image and likeness *if he guards Our precept.*' Man, then, was made not wise but receptive of wisdom if he should wish to be."[36]

Note that proper image-making here became the first and highest priority of ideal man: that part of humanity which followed God's precepts would demonstrate its receptivity by the kind of image produced. Theosis and its related concept, the *imitatio Christi*, became rhetorical models in a dual sense: a model for the author of *historia* to be encoded into the narrative and an exemplum for the readers to be imitated in their lives.

These reflections on the nature of agonistic hermeneutics as a principle of difference lead to the second thought to be borne in mind when considering the account of the theosis of King Robert. That is the correlative view promoted by agonistic hermeneutics of the world as a place of chaos, resistant to order and requiring a leader capable of interpreting and imposing on his realm the order of the Logos.

The concepts outlined above correlate closely with observable characteristics of Romanesque art: its dynamism, its contradictions, its ability to combine elements of a disparate nature. All of this belongs to the perspective of ordered disorder that has long been recognized as a feature of Romanesque narrative and iconography. It may be seen in monumental sculptures that intentionally thrust out beyond the confines of their frames, in the "contradiction of the implied order of planes,"[37] "in the contrast of abstraction and realism,"[38] and in the tightly packed visual spaces. It is a phenomenon which derives from a philosophical world view transposed into an aesthetic and structural principle of art. Meyer Schapiro has referred to it as "a conception of contrast as both a principle of arrangement and a quality of antagonistic or divided objects" and argued that it "promotes contrasts in the effort to realize the effects of movement and expression of excited energies."[39] In literature, it tends to promote a narrative characterized by an asymmetrical structure, at

least by classical standards. It also promotes a narrative that portrays the world and its institutions as perpetually afflicted by a radical kind of entropy, a world barely held together by the efforts and sacrifices of a few privileged humans.

The elements of the *agon* found in these works resolve into units dialectically distributed along axes which—thanks to the metaphoric/metonymic linking of Gospel texts and the physical universe proposed by philosophical anthropology—are simultaneously conceptual and spatial. These axes consist of the vertical dialectic created by theophany/theosis, and the horizontal axis constituted by the world where the initial struggle begins and is waged. This axis usually opposes the vertical not only actively—as in the case of heresy or paganism where, from the Christian perspective, there can be no transcendent referent (orthodoxy in any belief system reserved to itself exclusive access to transcendent reality)—but also by virtue of the different natures of the two axes.

The world is phenomenal, concrete, and immediate, whereas the path of transcendence is conceptual, a construct of the mind and spirit, an attempt to intellect the ineffable via the concrete. The agonistic element in the struggle to define the vertical path arose from the immediacy and apparent cogency of the worldly concerns as opposed to the uncertainty of determining divine intentionality when viewed from the perspective of man's limited vision. This posed a problem: how to tell the path for the return to God from among all the confusion and urgency of immediate worldly problems? A good part of the drama of Romanesque *historia* as represented in visual or literary form lay in its ability to represent this dilemma in terms of the real world and contemporary humanity.

This conception naturally gave rise to a viewpoint in which cognition or vision was a necessary precondition and corollary to action in the world. This explains in part the hierarchical conception of humanity, which placed so much emphasis on the exemplary human, the seer, or prophet, as leader. Logically, this theory privileged a hero-type as a person capable not only of acting, but above all of perceiving how to act in the face of great intellectual as well as physical odds and where the theater of action would be a world resistant to the ideals of order he would seek to impose. The historiated hero—saint, king, or warrior—was thus inevitably a type predicated on the paradigmatic man that Rodolphus called the *homo eruditus* and, as we saw, emblazoned on the beginning of his work.

The Agonistic Hermeneutics of *Historia*

Rodolphus's narrative of the heresy at Orléans incorporates the contrast of antagonistic principles identified by Schapiro as a structuring principle of Romanesque composition. The intrinsic interest of the story from the viewpoint of medieval narrative theory cannot fail to be heightened by its undoubted historical significance. From our perspective, it possesses not simply the kind of anecdotal fascination we found in the account of the rebuilding of Orléans, but an absolute importance as one of those authentic "firsts" of history which alter the way Western man subsequently behaved.

The conduct and resolution of the inquisition in Orléans in 1022 broke with a millennial tradition on two counts: (1) it was the first time that a trial for heresy had been conducted by a secular authority, and (2) so far as we know, the first time that heretics had been burned at the stake; indeed, the first time capital punishment had been exacted for heresy. Previously, heretics had been judged by ecclesiastical authorities and subject to canonical penalties.[40]

The account, then, contains two major historical anomalies: the perception of heresy as a major threat to the community at large and the intervention of the king in the place of ecclesiastical authorities. It was, indeed, says Rodolphus, Robert himself who convened the trial, conducted the inquisition of the heretics, and pronounced sentence on them. Other accounts agree in substance, but do not go to quite the lengths Rodolphus did to emphasize the king's role at the expense of other participants, a fact in itself suggestive of his commitment to *historia* as directed vision.[41]

The story resolves into two closely linked movements: a drama of event and person and a drama of opposing ideologies. Since Rodolphus intervenes as dialectician, arguing the case for orthodoxy, he assumes a textual persona, that of a visionary prophet working alongside the religio-political leader, King Robert, to articulate and thus maintain the order of the ideal society against those opponents who attempt to cut it off from the authoritative texts that support it.

Drama of Event and Person

The account of the heresy is too long to quote here, but the facts may be quickly resumed, even though, as we have come to expect with Rodolphus, it is less the facts that constitute the narrative than the context of intentionality in which he presents them. Much of the interest in the *récit* in fact stems from the fascinating alternation between such narrative modes as direct and indirect discourse and verb tenses, all of which figure in the rhetorical subordination of *récit* to *historia*.

The heresy described by Rodolphus at the end of book 2 penetrated to Gaul through the intermediary of an "Italian" woman, presumably a disciple of an evil grammarian, Vilgard.[42] A certain number of people were corrupted by the heresy, including a good many learned clerics. In particular, two noble and learned monks of Orléans, who had been on close terms of friendship with the king and court, became leading proponents of the heresy. In attempting to win over a priest of Rouen to their cause, as part of their plan to spread the movement throughout France, these monks, Herbert and Lisoius, revealed the full extent of their intentions, saying that the moment was approaching when all the people would rally to their cause. The priest, shocked by the revelation, notified Count Richard of Rouen, who immediately informed King Robert of what was happening.

Acting with equal celerity, the king went to Orléans, convened a council of bishops, abbots, clerks, and lay leaders, and began to conduct an inquisition to determine the nature and extent of the movement. Unrepentant, Herbert and Lisoius testified boldly to their beliefs. The essential tenets of their doctrine appear primarily in the text as indirect discourse, a technique that allowed the

narrator to construct a framework of phatic markers connotative of incredulity around the exposition.

At this point, Rodolphus interrupted the narrative in order to present a response to the heretical views just outlined. That exposition, which occupies the bulk of the chapter, grounds itself in unmistakably Eriugenian concepts, drawing upon the notions of procession and return and agonistic hermeneutics outlined above.

Declaring that the "errors" of the heretics—who numbered thirteen—have been countered by reasoned arguments, Rodolphus resumed the story to detail the final act. Despite all efforts to bring them back to the paths of orthodoxy, the heretics remained adamant in their antifaith. At that point, the king, treating the heretics as enemies of Church and State conjoined in his own person— this is at once an important historical as well as artistic concept—ordered them to be burned.

This second conflagration at Orléans, like the first, served a purifying purpose, and that made the dénouement the most lively part of the whole account. The condemned heretics boasted that they would pass unscathed through the fire. Even when led to the enormous pyre prepared by the king's orders, they proclaimed their willing acceptance of the test. When the thirteen—the number has obvious symbolic significance—had been cast into the flames, a miracle occurred. All thirteen declared themselves to have been led astray by Satan, and that everything they had maintained previously was false. The torments they now undergo in this world, they said, presage the eternal fires awaiting them in the next.

Rodolphus concluded by observing that the avenging flames entirely consumed the unfortunate souls, reducing them to ashes. Since then, he continued, "everywhere that these believers in perverse doctrines were discovered, they were subject to the same lawful vengeance. And the cult of the venerable catholic faith, the madness of these scoundrels extirpated, shone more brightly everywhere on earth."[43]

Even so brief a résumé makes clear that the narrative was cast in terms of dramatic confrontation between a limited number of characters, King Robert and Rodolphus on the one hand, and the two leaders of the heresy, Herbert and Lisoius, on the other. Rodolphus managed to include the multiple representatives of contemporary society in the account without actually according them a particular role in the action. Similarly, even though they do not speak, we have the distinct impression that large numbers of heretics are involved, although "only" thirteen are actually burned. Still, Herbert and Lisoius remain the only ones who take an active part in the account and who appear by name.

These observations underline the essentially dramatic and concrete nature of the account. Even the modern reader can feel the immediacy of the narrative. Rodolphus succeeded in making the abstract philosophical differences a matter of personal struggle. He translated doctrine into the immediate question: How can man know right and wrong? More cogent yet, How can individuals, a Herbert, a Lisoius, a Rodolphus, know these things?

Eriugena had already set the stage by casting the difficult, often abstruse doctrinal matters he dealt with in terms of a personal dialogue between the master and his disciple. After five books we know little if anything about the

two so far as the minutiae of everyday life may be concerned, but we do know what motivates them, how they think, and how they view the world. Yet Eriugena's characters remain aloof from the real, historical world. Rodolphus bridges the remaining gap between philosophy and history by interpreting real historical events in the light of Eriugenian philosophical premises. Particularly important from our viewpoint is the assumption that narrative art may be used to provide a blueprint for life, especially for the confusion and contradiction of life as lived in a fallen world.

To this end, Rodolphus presented a reverse version of the Hebrews in the Fiery Furnace or Christian martyrs tried by fire. For his work, the significant image of the pyre was the anguished cries of recantation emerging from the flames. It seems to have been less an event, important for its historical status as a departure from previous tradition, than a sign, a statement, a kind of contemporary version of the burning bush; in short, a theophany in which God has the final word in resolving the human dialectic.

No previous narrative attempted to convey so graphically the nature of heresy as a part of the agonistic struggle of man, with his limited vision, to perceive the Light. Rodolphus's prescience in conceiving the heresy less as a specific historical event circumscribed by time and place than as a perversion of the dialectic by which man knows God through his textualized understanding of the world has been ratified by modern church historians. At least one authoritative history of the Church, published in 1948, agrees with Rodolphus in linking the recrudescence of Manichaeism to an abuse of the dialectical methods practiced in the schools.[44]

Rodolphus had already suggested this in book 2, chapter 11, immediately preceding his account of the outbreak of heresy in Italy. The account merits at least a brief glance. In noting the first appearance in France, in the year 1000, of a populist heresy, he mentions two causes for the phenomenon, the one particular and circumstantial, the other more general. A heretical prophet, a peasant named Leutard, experienced a vision which led him to call into question the religio-political structure of society predicated upon Christian orthodoxy. Rodolphus describes Leutard's vision as a grotesque parody of the true theophanic visitation: it prompted the poor man to preach a simple version of faith disjoined from obedience to terrestrial manifestations of religion represented by Church and State.

Rodolphus's treatment of this event makes a double assertion: (1) that Leutard's views were predicated upon a selective hermeneutics according to which one might choose from among the prophetic sayings of Scripture those which merited belief and those which did not; and (2) that other heresies "in order to lead people astray more certainly, clothed themselves in a cloak of Holy Scripture of which, nonetheless, they were the negation."[45] They were thus the reverse image of the white mantle of revelation with which we began this chapter.

Leutard's selective hermeneutics, from Rodolphus's perspective, poses slight threat, for it is not based upon a dialectic with the body of Scripture and could not therefore lead to a convincing refutation of Scripture as a holistic representation of divine intention, thereby undermining the microcosmic view of society as a mirror of the celestial hierarchy. In short, no mentalist image of the

world-as-Word is involved. Accordingly, when Leutard was summoned before the "learned bishop" of his diocese, the churchman easily refuted Leutard's confused patchwork of beliefs, and quickly—Rodolphus asserted—brought those of his flock who had been seduced by Leutard back to the true belief. This incident tells us much about the process which had, for close to a millennium, constituted the Church's means of dealing with heresy as an internal matter, and by contrast underlines the striking departure from that tradition represented by the subsequent narrative of events at Orléans. No penalty is mentioned as having been exacted from Leutard, who is reported to have drowned himself in a well shortly afterward.

The second point made by Rodolphus—that the false mantle of Scripture is donned by some heresies—obviously contained a more serious challenge, for it raised the spectre of a rival hermeneutics. It is this threat that provides the drama at Orléans. For in this case it questioned the whole way by which man might know God, as outlined by Eriugena and other Fathers.

In essence, the problem posed resembles that evoked by Saint Augustine in his *Confessions*, the question of truth. How can man know that his re-creationist activity will, in fact, coincide with the "Spirit of Truth," that is, God's Word and intention of the world? Augustine's answer was to evoke the concept of theosis as a special kind of discourse or meaning production governed by virtue, that is, spiritual intentionality, not only on the part of the speaker, but also on the part of the listeners, the addressees.

The authenticity of the discourse could, from this perspective, be judged from three basic conditions of meaning predication, all three being given internally within the discourse and therefore made a constitutive part of the meaning recovered by the listener: (1) the discourse will express the speaker's struggle to intellectualize divinity, and this struggle will imprint on the discourse a substratum of paradigmatic expressive elements derived from the divine discourse the speaker has tried to understand; (2) consequently, the discourse will contain within itself an image of that struggle in some form or another, generally by revealing the circularity of the process inherent in the idea of procession and return; and (3) the condition of discourse is based upon a triad of participating subjects: the speaker, the primary addressee (God), and the secondary addressee (man).

The role of man-as-audience is not gratuitous. Just as God brings to the act of hearing the discourse the grace which may, if bestowed on the speaker, produce theosis, so man-the-audience must bring to the act of listening the human equivalent of grace, that is, charity. If the discourse is authentic, that is, "true," then there will be the same coincidence between the intention of human minds, the speaker's and the listener's, as between human mind and divine intention. Speech which realizes the spirit of truth will thus produce a coincidence of image in all three participants: man the subject of the agon, God, and man the listener, who will thus be able to reproduce for himself the vertical dialectic of the speaker.

What have I to do with men, that they should hear my confessions, as if they were to "heal all my diseases?" (1 Cor. 13 : 12). . . . When they hear me speak about myself, how do they know if I speak the truth, since none among men knows "what

goes on within a man but the spirit of man which is in him"? (Eph. 5 : 27). But if
they should hear about themselves from you, they cannot say, "The Lord lies!"
What else is it for them to hear from you about themselves except to know them-
selves? Who knows anything and yet says, "It is false," unless he is a liar? But
because "charity believes all things" (cf. Rom 12 : 12) among them whom it unites
by binding them to itself, I too, O Lord, will confess to you in such manner that
men may hear, although I cannot prove to them that I confess truly. But those men
whose ears charity opens to me believe me.[46]

Theology aside, Augustine's response suggests a narrative strategy already
familiar to us. It requires a personalized discourse as representation of an au-
thority whose credibility derives not from the worldly status of the speaker,
but from the image of his intention provided in the discourse. This image in
turn results less from what is asserted at any given moment than from the
totality: to be positive, and therefore true, the discourse must reveal a high
enough correlation with the underlying paradigms of scriptural language as to
make it appear less the *homo eruditus* who speaks on his own behalf than the
creator who speaks through him.

The dynamic elements represented in the agonistic narrative derive not
from the perception of events—the situation we found in the first narrative of
Orléans—but from the account of individuals' perception of the world and the
truth claims based thereon. They have to do with that ineffable realm, almost
as impenetrable as the divine mind, of "what goes on within a man." Roman-
esque narrative evolved as an exciting and still fascinating attempt to resolve
this question of human motivation when it learned to pose the question of
intentionality not as an abstract philosophical concept, but as a basic element
of the dynamic interpretation of historic reality. And that is what Rodolphus
attempts in the account of the heresy at Orléans.

Apocalypse as Misreading

Rodolphus casts the confrontation between orthodoxy and heresy in apocalyp-
tic terms as a conflict between blindness and insight, thereby naturally incor-
porating the dynamic of contrasting antagonisms identified by Schapiro as
characteristic of Romanesque narrative. We saw earlier that heresy, at this
time, evoked the book of Revelation. The narrative structure of Revelation
depends upon a vision of hidden supernatural events, certainly, but "it must
be understood first and foremost as a tract for the times, written to increase
the hope and determination of the Church on earth in a period of distur-
bance."[47]

The central drama of Revelation springs from a confrontation of true vision
and prophecy—represented, on the one hand, by John, the witness and author,
and the orthodox worldly institutions and, on the other, the false prophets
represented by the Beast and the Prostitute: Antichrist in league with rival
worldly powers. In one sense the story repeats that of the Transfiguration, with
which we began, but in a context of plurality. On the mountain, the white
garments could not be mistaken; in the world, the choice must be made be-
tween the authentic mantle and the counterfeit: the whiteness of true illumi-
nation and its inauthentic counterpart.

Rodolphus's drama highlights two opposing pairs of truth claimants: Robert and Rodolphus, on the one hand—Throne and Church—and Herbert and Lisoius, on the other: emissaries of the Beast and the Prostitute, as we shall see. A mythic resonance circumscribes their conflict, since the events at Orléans provide the focal point for a series of disasters in the larger world which show the Church on earth as besieged by hostile forces; at the same time, the successful countering of this menace at Orléans entails hope for the larger Christian world. Rodolphus's *Historia* thus becomes "a tract for the time," in the same manner as Revelation.

The metonymic exchange between Orléans and the larger world begins with a movement of epic scope, which one might imagine as the rhetorical equivalent of a cone, with Orléans at the apex and the world horizon at the other. The narrative moves centripetally from the wide end into the narrow focus on events at Orléans, and then, centrifugally, back out to the broader perspective. In the first movement, the general menace to Christianity and the unity of the Christian world, a general theme of book 3, becomes progressively focused on Orléans, where the apocalyptic confrontation occurs and the forces of entropy are defeated. The drama ended, the movement reverses with an expansion of focus projecting the peace and unity achieved at Orléans back onto the Christian world at large.

But the story of apocalyptic confrontation at Orléans does not occur in isolation; rather, it is the main act of a drama that begins, by way of prologue, in Jerusalem. Chapter 7 of book 3, immediately preceding the account of the heresy at Orléans, recounts the destruction and miraculous reconstruction of the Church of the Holy Sepulchre in Jerusalem. The destruction occurs at the hands of the pagan prince of Babylon, while his Christian mother, Mary, persuades her son to regret his act and to rebuild the central edifice of Christendom. The prince of Babylon did not act out of gratuitous hatred for Christianity, but was incited to his original deed of desecration by the urging of nonbelievers in Orléans, who sent messengers to Babylon urging the prince to destroy the Church of the Holy Sepulchre.[48]

In this new apocalyptic age, Babylon must still be feared, but as an agent of the emissaries of Satan, not as the place of greatest danger. The latter lay within the very centers of Christendom itself, Italy, France, and Orléans. Rodolphus's text structures the outbreak of heresy in terms of dialectical pairings predicated upon Revelation. For the heretics, we find the same coupling of perverse female and corrupt male, the Prostitute and the Antichrist, in the Italian woman and the evil grammarian, who subvert hitherto impeccable acolytes such as Herbert and Lisoius. For the Church and Throne, we see the same combination of witness/author and sacred soldier: Rodolphus and Robert the Pious, who correspond, *mutatis mutandis*, to John and Christ/Saint Michael. Rodolphus did not make this text a simple calque of Revelation, however, but rather a dialectical adaptation in terms of his own times that stressed both the difficulty of the struggle to interpret the truth and the need for a strong leader as guide.

Thus the Antichrist figure is a grammarian, and the chief sin of the fallen clerks lies in perverting their dialectical training—their capacity for reproducing the image of God in man. They turn from God as the primary addressee of

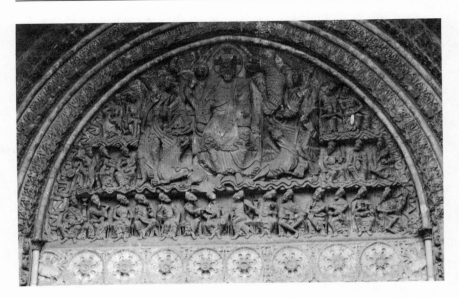

Figure 1. Saint-Pierre, Moissac. Tympanum showing Christ-in-Majesty, surrounded by animal representatives of the Evangelists and the twenty-four elders of the Apocalypse.

their discourse to a purely human interlocutor, thereby constructing a perspective of the world that would be purely horizontal in character, lacking its vertical, transcendent dimension. Gregory of Nazianzen had pointed out that a world predicated upon purely human discourse displaced the Divine Logos, that is, *theologia*, by the human logos, that is, reason uncontrolled by faith. The result, from the theological perspective, separated the individual from the Church, the agent and witness of the diffusion of enlightenment throughout the world. It divided heaven from earth, history from eternity.[49]

We have seen that the orthodox view imposed a vertical perspective according to which contemplation of created things in the lower world should lead to recognition of a hierarchy running from the world up to heaven and beyond to the Prime Mover. In denying this vertical continuum, the horizontal perspective of the heretics—as represented by Rodolphus—obviously negates the prevailing orthodoxy. Had Rodolphus elected simply to declare the heretics wrong and let it go at that, there would be no particular interest in his account from the viewpoint of the evolution of Romanesque narrative techniques. Happily, he chose instead to illustrate the nature of the heretics' failed hermeneutics in contrast to the correct dialectical framework adopted by the positive characters. In so doing, he offers the first example of a clearly conceived and executed biaxial narrative structure, the form that will play so important a role in later Romanesque art and literature.

In order to represent the opposing pairs of characters in terms of the image and meaning production that rendered them either positive (orthodox) or negative (heretical), Rodolphus utilized a narrative structure that distributes them along two axes, the one vertical and transcendent (anagogic), the other hori-

zontal, purely historic and linear. These axes are realized through the cumu-
lative effect of the actions and discourses of the different groups of characters
in relation to the dominant narrative frame. They function as a kind of narra-
tive determinacy helping to establish and maintain a readily tabulated distinc-
tion between the narrative groups. Naturally, the privileged characters are
those whose cumulative words and deeds correlate with the positive axis,
which in the agonistic narrative of directed vision can only be vertical.

The technique of biaxial narrative structure is somewhat akin to the distri-
bution of figures on a Romanesque tympanum, where the humans tend to be
set in horizontal registers, while the theophanic Christ figure—as at Moissac,
Vézelay, Autun, Beaulieu, Saint Denis, and others—cuts vertically across these
bands at the center of the image field to make a dominant vertical axis.[50] If we
look, for example, at the tympanum of Moissac (fig. 1), we see that the theo-
phanic figure of Christ—as we shall find to be the case for King Robert in our
narrative—represents a point of immobility in the center of the tympanum to
which the rest of the composition is both related and contrasted, the contrast
and relation being the same: the motion of the other figures versus the stasis
of the Christ image (fig. 2). His is the only figure not engaged in some motion.
All of the others are contorted so as to emphasize the movement of the heads
and eyes toward the frontally portrayed Christ (fig. 3).

Similarly, in Last Judgment scenes, such as Giselbertus's creation at Autun
(fig. 4), all of the human figures are engaged in movement toward or away from

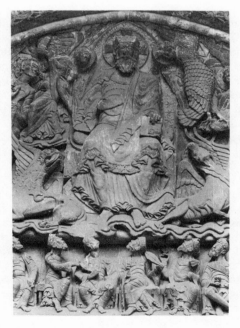

Figure 2. Saint-Pierre, Moissac. Tympanum
(detail): Christ-in-Majesty.

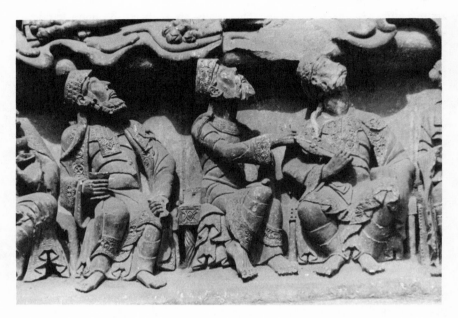

Figure 3. Saint-Pierre, Moissac. Tympanum (detail): elders of the Apocalypse.

Christ. The elect, on Christ's right hand, have vertically elongated bodies, some of them twice to three times the height of the bodies of the damned. These figures, as though to emphasize their association with the vertical axis made by Christ and the mandorla that contains him (fig. 5), seem to rupture the horizontality of their narrative space. Thanks to the split-level composition and the progressively greater height of the figures it contains, the register on Christ's right hand conveys the feeling of a gradually rising movement which becomes more sharply defined in its verticality as one's eye approaches the theophanic image at the center of the tympanum. This impression is conveyed by individual figures and by the cumulative effect of the repetition of postures from one figure to the next. The figures vary in height and importance, but all move in some way toward Christ.

The representation of the newly resurrected souls on the lintel marks even more strikingly the correlation between narrative axes and metaphysical signification. The image field of the lintel is a narrow horizontal band whose dimensions are further emphasized by the fact that the top of the lintel sharply divides the space of the lintel from the rest of the composition and serves as the support on which the bottom of the mandorla containing Christ rests. And yet, upon closer examination, the narrative of the figures contained in the lintel overcomes the horizontality which appears visually so dominant. The narrative space of the lintel is split into two halves by an angel with a sword immediately below Christ's feet. The figures on the angel's right hand are the souls who will be saved. They are shepherded along toward the center by another angel who points up toward the theophanic Christ above them. The final

figure in this procession stands directly below Christ, gazing upward with an expression of rapture, and so forms a continuation of the vertical axis while still remaining the last unit in the horizontal procession of the saved. His position at the conjunction of the vertical and horizontal axes receives still further emphasis from the unique position of his body: portrayed more frontally than his colleagues, he is nonetheless turned toward them with his back toward the other side of the lintel. From far right (Christ's right) to center, the procession moves horizontally, but always with eyes and heads turned upward, to the point of vertical ascension to Christ.

In contrast, the figures of the damned on the opposite side of the lintel move away from the center, propelled by the thrust of the angel with the sword, their heads downcast, their eyes, like their bodies, turned away from Christ. But this movement away from Christ is limited, for near the far end of this register the hands of a demon come down to scoop up the damned (fig. 6) to bring them to the scales of justice. There they are weighed and judged next to Christ, whose left hand points to that scene. Both the saved and the damned thus come back to Christ, as it were, but the means in each case are different. There is no mechanical contrivance to elevate the saved souls from lintel to paradise; their constant gaze toward the theophanic image constitutes the visual equivalent of the verbal dialectic described by Augustine and Eriugena. It is the damned, those who have avoided intellecting the Light, who find themselves forcibly reintegrated with the vertical axis.

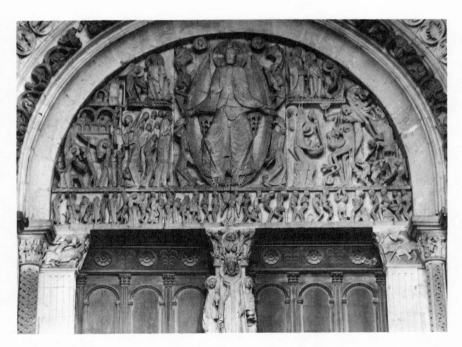

Figure 4. Saint-Lazare, Autun. Tympanum (west façade): Last Judgment, showing Christ as judge.

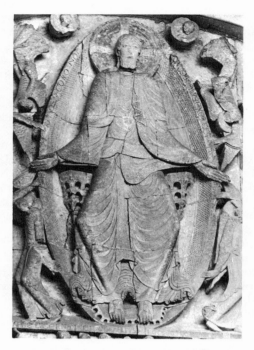

Figure 5. Saint-Lazare, Autun. Tympanum (detail): Christ-in-Majesty.

These examples correspond to the contrast made by Eriugena in book 5 of *De Divisione Naturae* between the constant motion of humans in the world and the immutable divinity, "which moves only immobilely in itself." There, Eriugena quotes Gregory of Nyssa, who "reasons that our rational nature as mutable is always in motion towards or away from God, the Good. If it moves toward Him, the motion will never terminate for the distance is infinite. If it moves away from Him, it reaches the limit of evil but cannot stop its motion and turns back in the direction of God."[51]

Translated into narrative terms, this means that while all humans experience the same horizontal space of the lower world initially, some will try to transcend it by the exercise of their rational natures, that is, through the agonistic discourse and actions suggested by the Augustinian and Eriugenian examples. The cumulative thrust of their discourse and actions—even if the protagonists may be temporarily mistaken at some point along the way, as happens in the more complex narratives found in the *chansons de geste*—will correlate with the vertical frame. The irrational characters, however, engage in action that denies the existence of the vertical axis or doubts its efficacy. They pursue a purely linear goal until the end, when they are disproved—as are the heretics in the Orléans narrative—and returned to God for judgment via execution.[52]

To say the same thing in a slightly different way, both groups of characters engage in image-making. The image of the world produced by the positive characters will coordinate with the orthodox world view espoused by the narrator and thus establish their progression from the horizontal to the vertical narrative axis. The negative characters, in contrast, will offer an image of the world that reverses and diminishes the one proposed by the narrator and positive characters.[53]

In the Orléans narrative, Rodolphus employs three means to represent the heretics as fixed in a linear, nontranscendent state-of-being: (1) the language by which they are depicted, both that of the narrator and their own; (2) the asymmetrical religio-political image of the world given by the heretics; (3) the negative mythic valence accorded to them by the scriptural subtext evoked by the narrative.

We have already seen two examples of these discoordinating narrative devices: the mythical correlation of Herbert and Lisoius with the servants of the beast in Revelation (the followers of the false prophet); and the narrator's pejorative distancing of himself and the reader from the clerics when they were introduced. Other examples abound in the text.

Of more dramatic interest, however, is the manner in which the narrative presents the asymmetrical world view produced by the "perverse" dialectic of the heretics. First of all, they are represented as discoordinate from the kind of

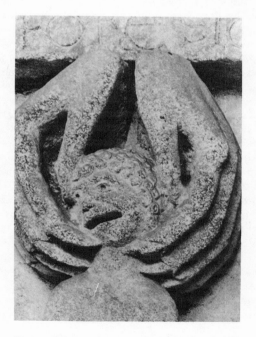

Figure 6. Saint-Lazare, Autun. Tympanum (detail): Damned soul being taken up for judgment.

temporal continuity that characterizes orthodox Christians. Their historical
origin, Rodolphus reminds us, comes not from positive scriptural authority
but from a negative apostolic presage: "We urge all the faithful to calm their
minds by this prophecy of the Apostle who, foreseeing this kind of treachery
in the future, proclaimed: 'It is proper that there be heresies in order to dem-
onstrate those who truly have faith.'"[54]

This asymmetry of their spiritual life corresponds to the equally irregular
image they project on the worldly level. The efforts of Herbert and Lisoius,
acting alone, to co-opt the priest of Rouen has the opposite effect from their
intention. At Orléans, the scene is even more striking. There, King Robert
convokes a synod composed of all the ecclesiastical orders and lay hierarchy.
The king himself sits at the head of this council, in the church whose con-
struction we witnessed in book 2.[55] In this setting, before the symbolically
ordered audience, in the cathedral so rich in connotation for Rodolphus's read-
ers, the heretics must expose their opposing view of the world. The asymmetry
of the scene could hardly be more telling: the heretics have no body politic to
support them; they have no religious orders or patristic tradition to support
their heterodox interpretation of Scripture; they have no sacred locus, no
church of their own. They do not even possess a "language" of their own, since
almost all of what they say appears as indirect discourse.

They do actually have *one* line of direct discourse, which simply serves to
underscore the strategy of representing the heretics as cut off from a truly
signifying language by their heresy. Nothing in the text lends credibility to
their one direct assertion; everything disconfirms it. They announce grandi-
osely to the assembled representatives of Church and State: "We have em-
braced this sect that you have been so slow to discover for a long time; but
now we expect you and all the others from every state and condition to join it
too; and we believe that this will yet come to pass."[56]

The disparity between word and world, as each appears in the text, could
hardly be greater. These heretical leaders cannot succeed in making good their
assertion because, lacking authoritative texts of their own, without a language
of their own, they cannot produce a narrative to rival that of the orthodox
faith. Without it, they cannot represent reality in such a way as to make their
views consonant for the rest of the community, with its perception of reality.

The final scene of the narrative may be read as the ironic reversal of this
main scene of confrontation. There, too, the heretics will speak, but in a way
that separates them from their earlier position and ironically reintegrates
them with the orthodox episteme. Just as the tympanum at Autun will later
make the same point, Rodolphus shows that the linear progression in evil has
finite limits; in the moment before coming face to face with Christ, the here-
tics see themselves, and are seen, as belonging to that all-too-common ortho-
dox category, the damned. With that ironic reversal, which we will discover to
be typical of Romanesque narrative, the one powerful statement the heretics
make in the whole narrative, and the one confirmed by contextual reality,
comes from the center of the flaming pyre.

The heretics are literally destroyed by the image they have made of them-
selves, an image of the Foolish Virgins rather than of the *homines eruditi* they
pretended to be. And like the Foolish Virgins, the heretics do not discover the

Light through their own efforts—by the lamp of the mind—but only by the light of the Abyss, the fiery lake into which the beast and the false prophet were cast in Revelation 19 : 20. It is a perfect ending, given the purpose of directed vision, for it brings the literal and symbolic levels of the narrative together in a reassertion of orthodoxy, while "proving" that the linear or horizontal narrative not only always ends with a reaffirmation of the primacy of the vertical axis, the axis of progression and return, but also with a recognition that it is only in reference to the vertical dialectic that the horizontal, historical level has any meaning at all. This explains, in good measure, why it will be impossible for historical or historically grounded narrative to exist in any capacity other than as exemplum of the transcendent fideist world view throughout the Middle Ages. Even Froissart, who comes perhaps closest to our idea of the historian interested in history for its own sake, subscribes to a vision of history as the deeds and influence of "Great Men" that Rodolphus Glaber would certainly recognize and approve. Indeed, Froissart's *Chronicles* are a not-so-distant mirror of Rodolphus's *Historiae*.

The Predication of Insight

We have seen enough of the narrative theory evolved by Rodolphus to know that the dynamic antagonism of contrasting elements on which it is based cannot be controlled or even predicated by the negative characters. The sense of discoordination consistently projected by Herbert and Lisoius derives from the strong narrative framework associated with the positive characters, King Robert and Rodolphus, that is, Rodolphus-as-protagonist participating directly in the dialectic against the heretics. In considering their role, however, we recognize a further division in the structure. Whereas Herbert and Lisoius appear equal—they speak and act together, representing one undifferentiated order of being—Robert and Rodolphus represent two complementary but hierarchically differentiated sources of meaning production.

Rodolphus-as-protagonist represents the kinesis of human motion described by Eriugena. He engages in the hermeneutic agon that illustrates and justifies the concept of the *homo eruditus* threatened by Herbert and Lisoius. To do so, he, too, must act on the same narrative axis as the heretics, but, like the portrayal of the saved souls on the lintel of Autun, his progression along the horizontal plane will be marked by a continual ratification of the vertical dimension, a verbal equivalent of the gaze fixed on Christ that characterized the represented souls at Autun. Robert, for reasons that will be apparent later, embodies the stasis of the divine order and so functions as the primary source of the microcosmic imagery in the narrative. Like the theophanic Christ figure on a Romanesque tympanum, Robert represents the static image of divinity unaffected by the motion of man; Rodolphus-as-protagonist, on the other hand, illustrates the language humans must use to recover that truth as a principle for living-in-the-world as a transcendent enterprise.

Like Christ's image on a tympanum, King Robert's presence dominates the narrative; all acts make sense only to the extent that they relate to his presence and function. Rodolphus-as-protagonist is a necessary adjuvant whose

role consists in performing the agonistic struggle which will disconfirm the heretics' claims and justify their dying judgment, but it also explains the king's real and symbolic status. Situated as it is in the midst of the narrative about the king's ritual cleansing of the city of Orléans and his kingdom, Rodolphus's intervention provides the epistemological justification for the status of the king at the summit of the human hierarchy at a moment of great importance for the history of the European kingship. In the face of a serious challenge to the fideist world order on which the principle of monarchy was predicated, it articulates the concept of celestial and human hierarchy, the concept on which rested the image of the monarch as a sacred being.

Rodolphus consciously, if modestly, declares his status as a *homo eruditus* at the beginning of the intervention, which resolves into two coordinated parts that move from refutation of the heretics' chief contention—that God is not the author of all created things—to an exposition of christology as the model for human existence. The reader does not get very far into the section without becoming aware that the whole intervention posits a subtext based upon Eriugena; it is literally a paraphrase of some basic tenets of philosophical anthropology articulated by him.

By a simple process of narrative indirection, Rodolphus sets up the transition from historical reconstruction to philosophy. He simply recast the principal beliefs of the heretics, introduced for purposes of refutation, in terms which make them the dialectical opposite of Eriugena's creationist tenets. It was then perfectly natural to introduce the Eriugenian paraphrase by way of refutation. In one stroke, as it were, Rodolphus not only assured that his words would appear true, that is, consonant with accepted belief, he also assumed the mantle of authority such that the heretics could not attempt to disconfirm his vision without undertaking to rebut the full weight of Patristic thought.

This intertextual coordination of Rodolphus with the Fathers naturally underlines the discrepant status of the heretics vis-à-vis the same tradition. They cannot be right because they do not properly utilize the dialectic of knowledge and wisdom ("scientia ac sapientia") which would allow them to know God's existence through his created world.[57] Above all, they cannot find God in man and therefore must deny the efficacy of the Trinity. Rodolphus invokes here Eriugena's concept of procession and return and the hierarchical chain of being, both material and spiritual, predicated upon it.[58]

He moves naturally from this concept to the freedom man receives from God to participate positively in this cycle of procession and return by using the gift of reason (for example, in the manner Rodolphus demonstrates in the intervention) to engage in the interpretive agon. Man himself determines his position on the chain of being, according to whether he chooses the agonistic way or not. If he does, his place will be with the higher, spiritual beings; if not, then with the lower, purely material creatures. Those who brashly deviate from the *documentum*, the Scripture given in Christ, serve as negative models.[59] God, Rodolphus says, knew that man would mostly choose the easier path and thus fall away from realizing his potential.[60] This is why—and here Rodolphus reaches the heart of the subject so far as its application to his own narrative is concerned—over the centuries God sent positive examples of the agonistic model of man into the world, and particularly why he sent the Ideal Man, that is, Christ.

The intervention goes on to develop the ways by which man, in taking Christ for his model—and the Scripture, which is also the image Christ took in the world—can learn to carry on the dialectic with Scripture and created being that will help him to realize the *imago Christi* in himself. Much is made of man's responsibility to be an image-maker, since, of all creatures, man alone was chosen to replicate God in himself, Christ being the model of that image.[61] Those who deny God are precisely the ones who refuse to accept the simultaneous burden of intellectual agon and the resultant image-making. Ultimately, these are the men at the origin of all heresy; for heresy, finally, is a refusal to make the image of God in oneself.[62]

It is not Rodolphus's derivative christology that interests us here, but the use he made of it to equate theological anthropology and narrative form. Even so brief a summary of the long intervention suggests that it provides a conceptual understanding of the narrative as a whole, not only in terms of idea, but also in terms of personae. Rodolphus offers his own version of the Augustinian concept of theosis as a special kind of confessional discourse whose purpose and authenticity derive from its ability to show the coincidence between human and divine intention. Indeed, the intervention meets the three basic conditions of meaning production demanded by the Augustinian model. As a result, Rodolphus-as-protagonist acquires the status of reliable narrator, of an authentic *homo eruditus* who demonstrates precisely why the heretics should be condemned. More importantly, however, we can see that the conditions for the meaning of the narrative as a whole are given in the intervention. It makes explicit the intention of the author in undertaking the historical reconstruction of reality that constitutes the surrounding narrative. In particular, the repeated insistence on Christ as model and man as *imago Christi*, an image of the model, sets up the expectation of and conditions for theosis that King Robert will be made to represent.

We must recognize that Rodolphus's narrative does not yet provide the full-fledged realization of the agonistic narrative that one finds, for example, in later vernacular texts of the period such as the *Vie de Saint Alexis* or the *Chanson de Roland*. In these texts, the agonistic hero will act, as well as speak, his struggle and be faced by difficult and conflicting choices in seeking the vertical path. Nevertheless, in demonstrating the difference between the agonistic hero and his opposite, the willfully unenlightened human, and above all in predicating that difference on their various capacities for image-making, particularly the ability of the heroes to replicate in themselves an *imago Christi*, Rodolphus discovered a principle of Romanesque narrative.

If we translate this discovery into modern terms, we would say that Rodolphus developed an artistic means for bringing the symbol structures of society into parallel with the representation of phenomenal reality as normative experience. In other words, he developed a means for representing contemporary life as narrative history, that is, as a controlled representation of events to bring them into consonance with the cultural norms underlying the social structure of the period. The basis for the agonistic element in this narrative is the representation of the conflict inherent in the attempt to integrate physical relationships with symbolic structure, the world as experienced with the world as defined by religion. In this case, however, the symbolic structure itself provided an agonistic model: Christ's own narrative history.

Recognition that historiated narrative might be used for such purposes played an important role in the official encouragement progressively given to public and monumental art in the eleventh century. In 1025, the council of Arras, convened to deal with a new outbreak of heresy, argued in favor of ecclesiastical art as a means for representing to the laity the efficacy of image-making as a constitutive part of individual worship, that is, internalization of the dominant symbol system in one's personal life. In other words, the council was urging that art be used to demonstrate the necessary parallelism of the cultural symbol and phenomenal reality, which is exactly what Rodolphus's work did.[63]

Drama of Theosis

The third and final aspect of the drama of heresy at Orléans is the theosis of King Robert in chapter 8 of book 3. Like the narrator, he, too, participates in an agon, but one of more cosmic significance than that of the *homo eruditus*. King Robert stands above and beyond the conflict between blindness and insight. That was a conflict of personal significance: the struggle of every Christian on his path toward God. In his capacity as an individual man, Robert had presumably to engage in that struggle as well, for he is described as "most learned and most Christian" (ut erat doctissimus ac christianissimus), but that aspect of the king's story lies outside the bounds of Rodolphus's account.

In this story, Robert is not simply an individual; he is a king, and as king he has two natures, "human and divine, or rather, in the language of that age, human by nature, divine by grace."[64] His struggle, then, consists of trying to make manifest the divinity of his office through the "truth" of his acts. He must realize in his human person the trinitarian ideal as a model for historical action. Since that ideal was already implicit in the symbolic value accorded to the king as "*christomimētēs*, the impersonator and actor of Christ,"[65] we might say that Robert's struggle, as represented by Rodolphus, consisted in predicating his literal, historical actions in terms of a symbolic model drawn, on the one hand, from the christology outlined by Rodolphus in his intervention, and, on the other, from a specific set of scriptural texts; in this case the subtexts for the *translatio gestorum* will be triumphant Psalms. To accomplish this end, the narrator utilizes the ternary structure we have witnessed in the previous narrative phases in a particularly interesting way, as we shall see shortly.

King Robert occupies a different position from the other characters in that the chapter forms part of an ongoing portrait of the king, one begun earlier in the *Historiae* and developed in the previous chapters of book 3. The heresy at Orléans is the last occurrence of Robert's reign that Rodolphus chooses to record, aside from his death. It thus constitutes the culmination of his struggle to realize, in his historical person, the ideality of kingship Rodolphus ascribed to him. Contextually, the situation of the chapter must be remarked: the eighth chapter of the third book (Robert's death occurs in the ninth and last chapter), it follows the account in chapter 7 of the restoration of the Church of the Holy Sepulchre and Jerusalem to the faithful. Similarly, Robert stands as the last survivor of the three great men of his time described by Rodolphus

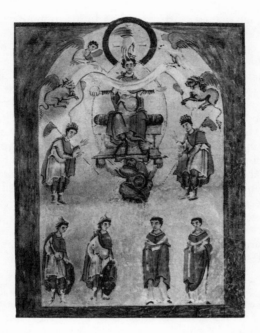

Figure 7. Reichenau evangelary. Apotheosis of
the emperor Otto II (c. 990). Aachen, Cathedral
Treasure.

at the beginning of book 3 as "men whose life and works furnished models
worthy of imitation": Emperor Henry II of Germany, King Robert, and Pope
Benedict. This final act of Robert's reign thus represents an epiphany of Ro-
dolphus's dramatic re-creation of the events of his time, a record designed to
show how God provides models in the fallen world for men to emulate in
order to overcome the entropy inherent in the world as distinct from the stasis
of the celestial order.

Drawing upon the theories of the dual status of king as man and sacred being
which were then current, Rodolphus portrayed King Robert as real and as sym-
bolic, and consequently as the only person in the account to function simul-
taneously on the two narrative axes, the historic and the agonistic. The inno-
vation of this portrait does not lie in the concept of the geminate person itself,
but in the successful realization of the narrative agon inherent in the concept.
Because we see the king realize his symbolic status through his historical ac-
tions, the narrative demonstrates the reciprocal exchange of signification be-
tween the historical figure, King Robert, and the symbolic ideal of king as
christomimētēs.

We may better understand Rodolphus's innovation if we look at an illumi-
nation, dating from the early part of the 990s, showing the apotheosis of the
emperor Otto II (fig. 7). Preserved in an evangelary prepared for Otto II by a

monk of Reichenau named Liutharius, the illumination now forms part of the treasure of Charlemagne's Palatine Chapel in Aachen.[66]

It shows the emperor seated in majesty, like the images of Christ on the Romanesque tympanums we looked at earlier, surrounded by a mandorla and holding the imperial insignia, a world orb surmounted by a cross, in his right hand. Parenthetically, we might note that this insignia figures in book 1 of the *Historiae*, where Rodolphus says that it was first devised by Pope Benedict VIII and bestowed on Henry II in 1014.

The painting shows Otto spanning the distance between heaven and earth: a personified figure of Terra supports the throne on which Otto sits, while the top of the mandorla containing his head intersects with the circle containing the Hand of God which touches the emperor's forehead. Behind God's hand, we see a cross whose base appears to rest on the top of Otto's head, so that his whole person seems to be surmounted by a cross and thus reproduces, in his person, the image of the world orb surmounted by a cross which he holds in his right hand.

The dual nature of the monarch may be discerned from the position of the veil that separates his bust from the rest of the body. This veil, as Kantorowicz showed,

> is actually *The Veil*, that is the curtain of the tabernacle which, according to the oldest Eastern tradition, symbolizes the sky separating earth from heaven . . . the interpretation of the veil of the tabernacle as "sky" was very common in the West as well. . . . Now the sky-curtain, according to Exodus (26 : 31f), was hung before four pillars. Those pillars were often identified with the four corners of the world. . . .[67]

The fact that in this illustration the four animal symbols of the Evangelists hold the veil reminds us of the strong identification that existed by the late tenth century between Scripture and the physical world, the two paths of access to the knowledge of God, as Eriugena held. He specifically analogized the world and Scripture: "Holy Scripture is an intelligible world constituted by four parts, just as the world is constituted by four elements."[68] Here, we find another connection between the world and Scripture, linked through the body of the emperor: Scripture contained the law governing the world; the divine provenience and force of that law appear from the fact that the Evangelists who signify it, the Hand of God who created it, and the crowned head of the emperor who must enforce it lie on the celestial side of the veil, while the agents who will assist the emperor to impose it stand below the veil, on the terrestrial side, and pay homage to Otto's person.

Kantorowicz observed that the striking illustration of the two natures of the monarch, underlined so graphically by the veil, constituted an essential part of the christological thematic of the work. Not only was the emperor portrayed "in the *maiestas* of Christ, on the throne of Christ, holding his open and empty left hand like Christ, with the mandorla of Christ and with the animal symbols of the four Gospels which are almost inseparable from the images of Christ in majesty,"[69] he was also shown to have the two natures of Christ. Saint Augustine had coined a term for this geminate characteristic which the painter obviously reproduces when he shows Otto, like Christ, with his feet on earth, but his head in heaven: "pedes in terra, caput in caelo."[70]

Figure 8. Reconstruction of triclinium mosaic
of Leo III formerly in Lateran palace, Rome.
Saint Peter bestowing the pallium on Pope
Leo III and the vexillum on the emperor Char-
lemagne (c. 800).

Kantorowicz did not, however, comment on the repetition of the earth sym-
bols in the painting nor upon the septiform and cruciform principles of com-
position. Although the vertical axis constituted by the divine aureola with the
Hand of God, the emperor and the mandorla containing him, and the personi-
fied figure of Terra cannot be missed, we must not ignore the horizontal axis
which contributes so much to the overall meaning of the composition. The
earth symbols help us to understand how biaxial narrative form produces theo-
sis. Two symbols signify the world: the personification, Terra, supporting the
emperor's throne, and the world orb held in his right hand. The latter appears
as a prominent part of the horizontal axis constituted by the arms outstretched
from Otto's body. The festoon of the veil, curved down over the emperor's
chest, requires that the arms be extended at somewhat unnatural angles from
the waist, the midpoint of his body, rather than from the shoulders, since the
arms, the means by which the emperor will carry out his terrestrial role, must
appear below the veil. The position of the arms imparts a cruciform posture to
the emperor, whose body thus reiterates the cross motif found both on top of
the world orb in his hand and above his head.

The displacement of the orb onto the horizontal axis shows how the artist
drew upon the two levels of meaning inherent in the metaphoric identification

of Otto as Christ and emperor. At the same time, it illustrates how he managed to signal the presence of an interpretive subtext to give increased connotation to the image. The orb sits in the emperor's right hand, the hand which, in the usual image of the Christ-in-Majesty, is raised to bestow Christ's pastoral blessing. The imperial right hand, however, assumes a different position and engages in a different kind of pastoral activity. Traditionally, it signifies the emperor's might, his function as "the strong right arm of God," as we see in the reproduction of a mosaic (fig. 8) which originally formed part of Pope Leo III's triconch triclinium in the Lateran palace, the official papal residence in Pope Leo's time (795–816).

The mosaic shows Saint Peter bestowing the pallium (a symbol of papal authority) on Pope Leo—who had crowned Charlemagne emperor on 25 December 800—while at the same time placing the vexillum, or battle-standard, in Charlemagne's right hand.[71] This banner later became the Oriflamme, the official standard of France. The *Chanson de Roland* describes how this banner, "which used to be Saint Peter's," flew at the head of Charlemagne's army when he took the field against the Saracens.[72]

The image of the world sitting in the right hand sent by God to defend His creation casts a triumphal aura over the composition, and rightly so, in Kantorowicz's view, since the miniature illustrates a triumphal Psalm.

> Commissioned, as apparently he was, to design a triumphal image of the emperor, [the Reichenau artist] naturally turned to Psalm 91 [Vulgate 90] and consulted Augustine's commentary. For Psalm 91 was the great Victory Psalm, the "imperial" Psalm *par excellence* according to oldest tradition, because it contains the famous versicle [v. 13]: "You will tread on lion and adder, trample on savage lions and dragons."[73]

The Psalm bears the title *Protectio Dei* (God's Protection) in the Vulgate, and the closing lines articulate very well the role of triumphant defender of the faith ascribed to the monarch, at least in theory, at this time:

> I rescue all who cling to me,
> I protect whoever knows my name,
> I answer everyone who invokes me,
> I am with them when they are in trouble;
> I bring them safety and honor. [Ps. 91 : 14–15]

Rodolphus Glaber certainly conceived the relationship between world orb and imperial office in terms of Psalm 91 when he said of the insignia which Pope Benedict conferred on Henry II: "The view of this globe was intended to remind the ruler of the earthly empire that he must govern, *and in which he must make war without other concerns than to merit being protected by the image of the life-giving cross*" (my italics).[74]

The figure of Terra provides another example of the emperor's christologically based world dominance. Whereas the world orb represented the world-as-Law, Terra symbolizes the natural or fallen world with all its entropic potential. Terra does indeed support the imperial throne, but it is also crushed into submission by the force of this emperor who, like Christ, spans the space between heaven and earth. Why, we might well ask, does the world orb figure

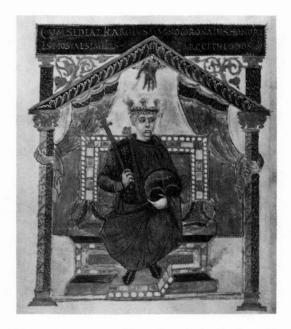

Figure 9. Saint Denis (?). *Psalter of Charles the Bald*:
Portrait of Charles (between A.D. 842 and 869). (Paris,
Bibliothèque Nationale, MS Lat. 1152, fol. 3v)

on the horizontal axis, while the fallen world constitutes part of the vertical?
Should it not be the other way around?

Terra's place on the vertical axis recapitulates the very story summarized in
the world orb symbol, for it was God-the-Father who created the Logos, or
Second Person of the Trinity, in order to subject the earth. In the Reichenau
miniature, Otto stands in place of the Christ figure, the Second Person of the
Trinity. It is he who subjects unruly Earth and offers to the viewer an ordered
image of the world in his right hand. Parenthetically, we might note how the
artistic structure reinforces the relationship between these three units: the
orb, Otto, and Earth. Terra's head, bowed by the weight of the throne, inclines
to the right, thus reiterating the bias of Otto's own head and eyes. A diagonal
axis projected from the bowed head and torso of Terra leads one's eye upward
to the world orb in the emperor's right hand, just as Otto's eyes seem cast
obliquely downward toward the orb.

Moving to the composition as a whole, we note that the repeated cruciform
images correspond to an obvious septiform structure. There are seven human
figures—excluding the personified Terra—in the part of the miniature that lies
below the veil. These figures are arranged in two registers: the bottom part
consisting of two warriors and two archbishops; the upper, of the two crowned
figures and Otto himself. This septiform pattern repeats in the upper part of

Figure 10. Saint Denis (?). Sacramentary. Allegorical representation of the coronation of Charles the Bald flanked by the archbishops of Trèves and Rheims (c. 870). (Paris, Bibliothèque Nationale, MS Lat. 1141, fol. 2v)

the miniature, where we find the four animal symbols of the Evangelists, the bust of the emperor, the Hand of God, and the cross. As we shall see in chapter 3, the symbolism of what Kantorowicz termed this "uncompromisingly christocentric period of Western civilization—roughly the monastic period from 900 to A.D. 1100"[75]—equated septiform and cruciform symbolism. This is but one more example of the metaphoric "language" of the painting whereby christological symbolism provides the setting on which Otto has been superimposed. If the equation of Otto with Christ did not work, the composition would have no meaning; it would be simply pretentious.

Fortunately, it does work, and we may now begin to understand why this should be so. The answer lies in the nature of theosis, an aspect of the painting that has never, to my knowledge, been fully explained. Let us begin by looking at the Hand of God. Kantorowicz described it as "reaching down from above, from heaven, either to impose or to touch and bless the diadem on the emperor's head."[76] Other scholars agree.[77] This seems a reasonable explanation in light of Carolingian illuminations, like that of the *Psalter of Charles the Bald*, which shows the emperor seated in majesty holding the orb and sceptre with the Hand of God bestowing a blessing on him from the peak of the tabernacle (fig. 9). Similarly, the allegorical representation of the crowning of Charles the

Bald, from a sacramentary completed around 870, shows the Hand of God actually holding or imposing a crown (fig. 10).

In the apotheosis of Otto II, however, the Hand of God neither holds the crown nor hovers above it. The crown readily appears through the open fingers, so there is no question but that it is actually behind them and not the object of whatever the hand is doing. In fact, the hand goes beyond the diadem and the fingers clearly rest on the forehead. Furthermore, the index and middle fingers seem to designate the emperor's eyes—they are slightly spread so that the middle finger points straight down to the right eye, while the index finger curves toward the left eye. The forehead and the eyes, then, are the object of the blessing bestowed by the right Hand of God. The blessing may well constitute a form of unction, but by this very gesture the Hand of God designates the *donum perfectum* of which the king is the recipient. This mixture of the human and the divine makes the king a special person, the object of divine grace. The graphic juxtaposition of the Hand of God on Otto's forehead provides an image of the commingling of the divine and human, the procession and return, which distinguished theosis.[78]

Now the mind and the eyes were precisely the means of perception that Eriugena designated as essential to the process of theosis—at least for the human participant. He showed that the trinitarian concept could become a constituent of the individual's movement toward theosis through a metaphoric conflation of the triune principles of the Godhead with the expressive activity of the mind.

He identified three stages in the evolution of thought, from intuition to expression, which he then equated with the three creative principles of the Trinity in order to demonstrate how human reason, and the activity predicated upon the rational process, could produce theophany.

> The Godhead as a whole creates the world, but it is possible to distinguish the role proper to each Person, or as Eriugena prefers, each Substance. All three are identical in essence, but the Father is the ultimate principle of all creation who begets the Son, His Word, in whom all things are made as unitary ideas; these ideas are then multiplied and distributed in descending logical order by the Holy Spirit.[79]

This trinitarian view of divine creative activity provides Eriugena with a model for the symbolling activity of humans. To establish and maintain the parallelism between the creative Substances of the Trinity and the human rational process, Eriugena conceives of the latter in trinitarian terms: (1) essence ("ousia"); (2) reason ("logos") or power ("dynamis"); and (3) sense ("dianoia") or operation ("energeia").[80] For Eriugena, these elements define the very essence of the soul and being of man.

> As God is One in Three, so each creature manifests in its ontological structure a triadic character reflecting Father, Son, and Holy Spirit. Although every substance or cause is an indivisible unit, within it can be distinguished its essence [ousia], its power [dynamis], and its operation [energeia]. A being is, it is capable of something, and it is effective in what it does. As God is both Beginning and End, or in Aristotelian terminology, both efficient and final cause of the universe, so each real being is both efficient and final cause, a center of creativity mirroring that of its Creator.[81]

Eriugena argues, in effect, that the exercise of the intellect in human crea-

tionist activity constitutes a theophany, "a showing forth of the multiplicity of God's power." As man ascends toward God by the exercise of intellect, God descends toward man, who is other than God but not outside of him because, as Eriugena never tires of repeating, God creates himself in his created objects.

In the christological climate of the time, this concept of the intellect as the essence of the soul had more to do with the evolution of the identity of kingship in general, and with the apotheosis of Otto II in particular, than it might seem at first blush. The conjunction of the intellect as theophany and the monarch as *christomimētēs*, but specifically as a principle of logos, or reason, bears witness to an important step in the evolution of monarchic theory. To the divine qualities invested in the king's person by the anointing with sacred oil and the imposition of the crown, the symbol of the Law,[82] we find conjoined yet another: the christological virtue of logos, or intellect. The monarch thus becomes a *translatio* of the Second Person of the Trinity, symbolizing not just the Law as a principle of rule but the rational process by which it is implemented with divine grace. This concept differs from the coronation in presupposing the monarch's active participation in the vertical dialectic with God; it conjoins the agonistic struggle outlined in Eriugena's system with the other duties imposed by the monarchical office.[83]

Fortunately, we can document in the Ottonian court this evolution of the concept of intellect as a royal quality. A monk of Reichenau painted the apotheosis of Otto in the decade of the 990s. In 997, Gerbert of Aurillac, soon to become Pope Sylvester II, visited Reichenau. As we saw in chapter 1, Gerbert exercised enormous political influence as well as intellectual ascendancy over the statesmen of his time. A protégé of the emperor Otto II, he served as tutor to his son, Otto III, known as the *mirabilia mundi*, who reigned as Holy Roman Emperor from 996 to 1002.[84]

Gerbert performed the same function for Robert the Pious, at the behest of Hugh Capet, his father. Rodolphus Glaber acknowledged Gerbert as his master, as did Richer, with whom we began. Otto III testified to the intellectual influence Gerbert exercised on him when he wrote to him: "We wish to attach to our person the excellence of your very loving self, so revered by all, and we seek to affiliate with ourself the perennial steadfastness of such a patron because the extent of your philosophical knowledge has always been for our simplicity an authority not to be scorned."[85]

Gerbert consistently advanced Eriugenian principles in his own work in science, ecclesiastical and royal governance, and in his vision of the imperial ideal. We should not, then, be surprised to find him writing to Otto III, from Reichenau in 997, to praise his pupil for his ability to conduct affairs of state according to the principles of reason. The wording of Gerbert's letter makes very clear that Otto's conduct of state amounts to a theophany, in the Eriugenian sense, revealing the divinity of the emperor's mind and his "divine prudence." Along with the letter, Gerbert sent to Otto a philosophical tract, *De rationali et ratione uti* (On the Use of Reason and Rationality), which, he says, he wrote to please the emperor's "sacred ears."

In Gerbert's formulation, Otto's exemplary being, the "spark of his divine mind," inspired the archbishop to "reveal to everyone qualities discussed in very difficult phrases by Aristotle and the greatest men. One such was the

wonderful ability of any mortal to have such depths of thoughts midst the strifes of war being prepared against the 'Slavs,' since from them flowed such noteworthy penetrating ideas like streams from the purest source."[86]

Gerbert leaves no doubt that the qualities which make Otto a *mirabilia mundi*, a ruler preeminent in history, are those of intellect and expression:

> Ours, ours is the Roman Empire. Italy, fertile in fruits, Lorraine and Germany, fertile in men, offer their resources, and even the strong kingdoms of the Slavs are not lacking to us. Our august emperor of the Romans are thou, Caesar, who, sprung from the noblest blood of the Greeks, surpass the Greeks in empire and govern the Romans by hereditary right, *but both you surpass in genius and eloquence* (my italics).[87]

We can now understand why the Hand of God in the Reichenau miniature rests on Otto's forehead, the seat of the intellect, and why "the divine aureola framing the Hand of God intersects with the imperial aureola, thus allowing the emperor's head to be placed in the spandrel which is formed by the intersecting haloes."[88] This identification provides a new insight into the nature of the apotheosis, and one that helps to explain the structure and color symbolism of the painting.

The emperor represents intellect, the essence of the soul "which presides over the whole [*universitas*] of human nature and revolves around God above all nature."[89] As the creative Godhead is One in Three, so the emperor, at the head of all human nature, contains within himself the other orders. He is essence (*ousia*), reason (*logos*) or power (*dynamis*), and also operation (*energeia*). Power and operation function as the adjuvants of essence: they hold the second and third places in this hierarchical conception. Thus in our miniature, the *reguli*, or feudatory dukes, inclined in obeisance toward the emperor, who rises above them, signify the second, middle level, that of *dynamis*, while the warriors and archbishops in the bottom register signify the third and lowest level, that of sense (*dianoia*) and operation (*energeia*).

Each of the six adjuvant figures wears a blue tunic covered by a scarlet cloak, in the case of the four secular figures, or a scarlet chasuble in the case of the two archbishops. Their dress thus mirrors that of the larger figure of the emperor, likewise garbed in a long blue tunic and scarlet cloak. But the resplendence of the human couture only underlines the creative domination of the divinity, for this color scheme originates with God and emphasizes the point that the *universitas* of human nature "revolves around God above all nature": the arm above the Hand of God appears clothed in a scarlet mantle, while the halo surrounding it is a darker blue.

The Reichenau miniature does indeed represent an apotheosis of Otto, but a theosis of the emperor as divine by intellect, of the social and political order as a product of reason, a theophany in which God's power displays itself as a multiplicity of powers invested in the sacred being of the monarch.

Returning now to Rodolphus's theosis of King Robert, we can better understand its innovative nature. Unlike the Reichenau master, Rodolphus does not portray the theosis as a fait accompli but as a narrative event. We actually participate in the telling of Robert's theosis, which Rodolphus structures according to the Eriugenian model. He does so by casting the narrative in three

stages corresponding to the movement of theosis: essence, power, and opera-
tion. In this account, essence equates with being; power with the capability of
action consonant with being; and operation with the efficacy of the realized
action. We can reformulate these concepts in terms of the questions each one
answers: "Who and what is the king?" "What is he capable of doing as king?"
"Is his action effective and if so, how?"

Like the figure of the emperor in the Reichenau miniature, the image that
dominates the whole scenario and that determines the measure of all other
characters is that of the king. In his being, he incarnates the essence of the
state as a political, social, and religious order. When the heretics challenge the
divine creation of the world, they strike a direct blow at the king's two bodies:
the body politic and his sacerdotal body. The king's person links the events in
the different parts of his kingdom: the priest and duke of Rouen turn to Robert
for help; he goes in person to Orléans. Rodolphus even describes the heresy as
a physical illness consuming the body politic: "a plague raging in Robert's
kingdom among the lambs of Christ."[90] The words obviously cast Robert as
the surrogate shepherd of Christ, the figure toward whom clergy and nobles
alike turn for help to protect the flock of Christ, and only when Robert person-
ally intervenes does the tide of heresy begin to turn. The inference that only
Robert possesses the capability and authority for effective action cannot be
denied.

Rodolphus's long intervention repeatedly stresses the theme of God's con-
cern for his people, manifested by the concern he shows in sending exemplary
beings into the world to bring humanity back to the path of rectitude. Simi-
larly, Robert figures as a compassionate ruler, saddened by the deviation of his
people. Rodolphus portrays him as fearful that the country would suffer and
souls be damned by the heresy; he grieves over the perverse revelations of
Herbert and Lisoius.[91] Because the king incarnates intellect and reason, he can-
not be subject to the temptations of his flock to heed the simulacrum of truth
propounded by the heretics. And because, like God, compassion motivates
him, he listens to the heretics in order to discover the errors inculcated in his
people so that his adjuvant, Rodolphus, may respond with the "spirit of truth."

We find three movements to the heresy account—the warning, the trial, and
the judgment—and each culminates with an example of effective action by
Robert that reinforces his image as a wise king, somewhat in the image of
Solomon: *ut erat doctissimus ac christianissimus.* Each movement, in fact,
offers a view of Robert as the head and moving force of the body politic and
the body ecclesiastical. In the first instance—the duke of Rouen's appeal—we
see that the king stands above his *reguli*, or adjuvants, just as Otto dominates
the *reguli* that flank him in the Reichenau miniature. But the narrator casts
the duke's appeal in metaphoric language that suggests another dimension of
Robert's superior status: the duke's reported message talks of the "lambs of
Christ" that Robert must protect. Thus, this first movement ends with Rob-
ert's dual being, as king and *christomimētēs,* firmly established through the
testimony of one of the high-ranking *reguli.* The duke of Rouen's appeal does
verbally for Rodolphus's narrative what the inclined posture of veneration by
the two *reguli* does for the Reichenau portrait, but with this difference: it in-
vites Robert to act in such a way that we shall see in "historical" fact what the
miniature only asserts *in potentio.*

In the second movement, Robert convenes the trial at Orléans, and then sits at the head of the assembled clergy, nobles, and people in the cathedral at Orléans, a *locus sanctus* whose symbolic valence as a place where Christ's presence has been "historically" manifested Rodolphus has already established. Rodolphus's intervention forms a part of this scene. If the intervention cannot be said to be Robert's voice, it certainly has been inspired by him—it is an act of one of his adjuvants—just as Gerbert says that "some hidden spark of [Otto's] divine mind secretly struck fire in us and refined the flux of our thoughts into words." And, like Gerbert's treatise, Rodolphus's intervention "revealed to everyone qualities discussed in very difficult phrases by . . . the greatest men."[92] We have already seen that the intervention propounds a christology for which the concept of the king as *christomimētēs* may be taken as a logical extension. When Rodolphus says, "all the beings who obey the laws of their Creator proclaim Him by their obedience,"[93] he might well be writing a caption for the Reichenau miniature. It certainly defines King Robert's essence.

The third movement culminates in a triumphal image of King Robert fulfilling his historical and anagogical destiny as a divine agent. He demonstrates how God answers Solomon's invocation: "Yahweh, God of Israel, not in heaven above nor on earth beneath is there such a God as you, true to your covenant and your kindness toward your servants when they walk wholeheartedly in your way. . . . Listen to the prayer and entreaty of your servant, Yahweh my God; listen to the cry and to the prayer your servant makes to you today. Day and night let your eyes watch over this house, over this place of which you have said, 'My name shall be there.'" (1 Kings 23, 28–29). But Robert fulfills this prayer by orchestrating a scene that realizes literally, in an historic event, the words of the *Exsurgat Deus*, Psalm 68 (Vulgate 67):

Let God arise, let his enemies be scattered,
let those who hate him flee before him!
As smoke disperses, they disperse;
as wax melts when near the fire,
so the wicked perish when God approaches. [vv. 1–2]

The psalm expressed the hope of God's people; Robert fulfilled that hope in the most dramatic—if, to us, horrible—way imaginable. As the smoke and flames rose from the pyre he commanded to be lighted, and as the heretics literally burned in this prefiguration of hellfire, their unbelief, we are told, melted like wax; they proclaimed the truth which Robert and Rodolphus steadfastly represented and then dispersed with the smoke. "So the wicked perish when God approaches."

We need not imagine that Rodolphus must have had the *Exsurgat Deus*, a psalm of theophany, in mind when re-creating this scene according to the principles of directed vision. The record of the Council of Arras, held two years later, in 1025, gives a vivid picture of the opening of the council that tried the heretics of that city. The heretics had been rounded up and incarcerated on a Friday, then brought to the cathedral for trial on the following Sunday. The account says: "Then, on the third day, which was a Sunday, the bishop, with his archdeacons, equipped with crosses and the texts of the Gospels, surrounded by all the clerks and a multitude of the people, held a synod in the

Church of the Blessed Mary; they marched [into the church] *and chanted the whole of the Psalm Exsurgat Deus"* (my italics).[94]

The *Exsurgat Deus* thus stands in relation to Rodolphus's narrative as the imperial victory Psalm 91 stands to the Reichenau miniature. Just as Otto personifies "God's Protection," so Robert shows how "he, the God of Israel, gives power and strength to his people" (Ps. 68 : 35). By his literal rendering of the opening verses of the psalm, he succeeded, Rodolphus assures us, in lighting a beacon that made "the venerable catholic faith shine more brightly everywhere in the world."[95]

Rodolphus's closing words provide yet another key to the nature of the theosis of King Robert we have just witnessed. They remind us that Robert personified reason, the triumph of intellect over the "madness of the insane scoundrels" (insanientium pessimorum vesania). His insight and rational action—speaking always from within the context of the time—restored his kingdom, and the "sheep of Christ" to the order intended by God. The message could hardly be clearer: although such an equilibrium could be described by an author like Rodolphus, only a sacralized leader, a king, and more specifically King Robert, could impose that vision on the historical world because he alone conflated these two models in his one person. The literal king presented by Rodolphus who performed historical actions reveals the *christomimētēs*, the impersonator and actor of Christ, who restored to his people the ability to see and know God once more by showing them how God worked to protect them.

Robert imitates in his person the christological image apostrophized in the sixth-century hymn "O lux beata Trinitas": "O Unity of princely might and Trinity of blessed light." History thus becomes revelation by translating a psalm into represented reality. The lesson, and the reality, now reads: "As smoke disperses, heresy disperses; as wax melts when near the fire, so heretics perish when Christ's agent approaches." Through Robert, Rodolphus demonstrates that the world is Word, and history a text subtending Scripture.

Rodolphus and his contemporaries provide important testimony to a trend equating history and Scripture that would have an enormous effect on the development of a public and monumental art later in the eleventh century. Whatever technical innovations they may have made, however, they drew their inspiration for the theosis of their hero kings and *reguli* from a longstanding artistic, political, and literary tradition: the legend of Charlemagne. No other historical figure gripped the medieval imagination for so long as did that of Charlemagne, and none had such profound consequences.

His coronation as Holy Roman Emperor by Pope Leo III on Christmas Day 800 inaugurated the idea of a *translatio* and a *renovatio* in the West of the Constantinian legacy. When he became pope in 999, Gerbert of Aurillac took the name Sylvester II as a reminder that Sylvester I had been Constantine's pope. Together with the new Constantine, Otto III, Sylvester sought to unify the West in a renewed spiritual community whose model derives straight from the legend of Charlemagne, a legend which Otto and Sylvester provided with a startling new impetus in Charlemagne's own capital, Aix-la-Chapelle, on the feast of Pentecost in the year 1000. At the end of the eleventh century, the Frankish conquest of the Holy Land reenacted a chapter of the Charlemagne

legend, and the first monarch of the Latin Kingdom of Jerusalem, Baldwin, had himself crowned on 25 December 1100, probably to place himself in the *mouvance* of the Charlemagne myth, recalling to mind that on the day of his imperial coronation in Saint Peter's basilica in Rome, Charlemagne had also received—so legend tells us—the keys to the Christian holy places in Jerusalem from the Saracen ruler, Harun al-Rashid. If the eleventh century concludes with so dramatic a realization of the Charlemagne legend, it begins with an equally dramatic chapter in the afterlife of the great Frankish emperor, and one that makes the theoses of Otto and Robert pale by comparison. In the following chapters, we shall explore this event and its consequences for the development of Romanesque art and literature.

3

Charlemagne Redivivus: From History to *Historia*

On the feast of Pentecost in the year 1000 the emperor Otto III discovered and entered the tomb of his predecessor, Charlemagne. Although one modern historian, at least, did not hesitate to term this event "the most spectacular of that year,"[1] our concern will be less to debate its historical characteristics than to demonstrate that its elaboration, indeed its very status as "event," conforms to the perspectives and models outlined in the previous chapter, a fact that may help us to explain the significance of Charlemagne's "resurrection" for the development of Latin and vernacular historiographic narrative.

In the account of the "invention" of Charlemagne's tomb by Otto III, just as Constantine's mother, Saint Helena, reportedly discovered the Holy Sepulchre and the True Cross,[2] we find a clear example of the way in which the art and literature of the period used "historical" characters and events to demonstrate a symbolic unity in the world, a unity which was based upon the primacy of Christ as sign and signifier, and which ordinary space and time tended to diffuse. Or, as one recent student of Eriugena put it, "all places and ages bear the symbols of Christ which each age formulates."[3] Let us now see how Charlemagne became one of those christological symbols in the eleventh century and the consequences of this development for narrative.

Although the earliest accounts do not speculate on Otto III's motivations for seeking to discover Charlemagne's tomb, they all agree that the location of the tomb in the Palatine Chapel at Aix-la-Chapelle was unknown. Otto alone seemed assured of the spot where the excavation should take place: he chose a spot within the church and ordered the dig to begin. The excavations were immediately successful, and we have three progressively more elaborate accounts of what Otto found, one of them by a putative eyewitness.

The first report, ascribed to Thietmar, bishop of Merseburg (975–1018), an exact contemporary of Otto, states that the emperor

> was in doubt as to the exact spot where the remains of the emperor Charles reposed. He ordered the stone floor to be secretly excavated at the place where he thought them to be; at last they were discovered in a royal throne.[4] Taking the golden cross which hung from Charlemagne's neck, as well as the unrotted parts of his clothing, Otto replaced the rest with great reverence.[5]

Although favored by historians because of its comforting lack of elaboration, this account scarcely conveys the historic drama that came to be associated with the event. We find the first suggestion of such an evolution in the putative eyewitness account of Otto of Lomello, who reports as follows:

We entered [the tomb] and went to Charles. He was not lying, as is the custom with the bodies of other deceased persons, but was sitting in a throne just like a living person. He was crowned with a gold crown; his hands were covered with gloves through which the fingernails had grown, and held a sceptre. There was, however, above him, a crypt, strongly built of marble. In order that we might reach him, we first had to have an opening broken through there. And when we came to him, we smelled a strong odor. Immediately, we worshipped him by kneeling, and then the emperor Otto covered him with white vestments, cut the nails, and repaired all that was in need of it around him. None of his members had decayed, but a small portion of the tip of his nose was missing, which the Emperor restored with gold. He removed one of the teeth from the mouth, rebuilt the crypt, and then departed.[6]

Count Otto's description vividly conveys the immediacy of the experience, while refraining from elaboration. Rather appropriately, perhaps, a contemporary and compatriot of Rodolphus Glaber takes the last step in the progressive development of the event. Adémar de Chabannes (ca. 988–1034) offers a version much criticized by modern historians. Our task not being to pass upon the historicity of the event, we can appreciate Adémar's account on its own terms. Even so, whatever one's opinion regarding its historical value, there can be no doubt as to its distinction as the first contemporary report of the exhumation outside of Otto's domains. Moreover, since Adémar was a monk at the abbey of Saint-Martial in Limoges—a main stop on the pilgrimage route south to Saint James of Compostela and right on the border of "Charlemagne and Roland country"—it testifies to the diffusion of and interest in the event over a wide area. Adémar writes:

In those days, the Emperor Otto was advised in a dream to raise the body of the Emperor Charlemagne, who had been buried at Aix. But having been obliterated by time, the exact place where he lay was not known. At the end of three days' fast [by the emperor Otto], [Charlemagne] was found in the place which the Emperor had perceived in his dream. He was found sitting in a golden throne, within an arched crypt, under the basilica of Saint Mary, crowned with a crown of gold and gems, holding a sceptre and a sword of purest gold, the body itself uncorrupted. After being raised, the body was shown to the people.

A canon of that church, Adalbert, who was enormous and tall of stature, put the crown on his head as if to take its measure, but found the top of his head too small for it, the size of the crown being bigger than the circumference of his own head. He also compared his leg to that of the king, and his was found to be smaller. Immediately afterward, by a divine miracle, his leg was fractured, and although he lived another forty years, he remained a cripple.

Charles's body was buried in the right transept of that basilica behind the altar of Saint John the Baptist and a magnificent golden crypt constructed over it, and it began to be known by means of many signs and miracles. There was no thought of a solemn feast day for him, aside from the common rites of the anniversary of the dead.[7]

Invention as *Historia*

Adémar's narrative suddenly confronts us with the invention-as-*historia*. No longer a simple anecdote raising more questions than it answers—for example, how did Otto know where to dig?—it has become a coherent unit, but not by

attempting to "stick to the facts," as it were. The people represented no longer function as mere agents of the discourse. They have—particularly the hapless Adalbert—become "persons." As Frank Kermode recently suggested, "of an agent, there is nothing to be said except that he performs a function . . . [but] when the agent becomes a kind of person, all is changed."[8]

Two of the things that have changed in Adémar's version suggest why this narrative, and not the other two accounts, inspired the rather astonishing evolution of the legend. In the first place, this text, like those in the first chapter, rhetorically situates the audience within its discourse. Not simply does it convey information to an audience, it also demonstrates that to go beyond the immediate sense of the discourse to a profounder meaning—and, unlike the previous two accounts, it asserts that there is a hidden meaning—one must interpret the story with information alluded to but not provided explicitly by the narrative.

To the modern reader, Adalbert's maiming appears as a mildly amusing anecdote, although the medieval audience would certainly have been expected to see in the story an example of the miraculous power of the sacred past and its symbols over the here and now. This potency, in turn, would justify the superiority, the ascendancy of the sacred past over the present. But, beyond that, the Adalbert incident would seem, on the surface, to add little to the meaning of the main event.

We learned in chapter 2, however, that such apparent asides may in fact be of crucial importance, alerting the reader to a dimension of analogical symbolism whence derived the real signification of stories in this period. So it is here. In a manner reminiscent of Uzzah's sudden death for touching the Ark of Yahweh (2 Samuel 6 : 6–7), the maiming of Adalbert demonstrates the potency of Charlemagne as relic, as well as the mediating role of the story in presenting both the scene and its signification, image and assertion of a meaning to be sought, in the manner of Scripture. Beyond that, the deeper context calls up the situation in Second Samuel where David brings the Ark of the Covenant to Jerusalem, thereby establishing the relationship between the Sacred City, the Temple, and the monarchy; in short, the symbolic setting of the Old Alliance. It became a commonplace of Carolingian political philosophy and iconography—as may be seen, for example, in the mosaic of the Ark of the Covenant as a symbol of the New Alliance in Theodolphus's late eighth-century oratory at Germigny-des-prés[9]—that the Carolingians were successors to David and that, by *translatio*, the Franks had become successors to the Hebrew Royal nation as the Elect of God,[10] and even though the authority for it went back to Clovis and Pepin, it was really Charlemagne who symbolized the historico-sacred personage who had successfully manifested this *translatio*.

But if Charlemagne effected the *translatio* of this symbolic code to the West, it was Constantine who manifested the *renovatio* of the New Alliance in the Holy Land by discovering and embellishing the most sacred sites of Christian Jerusalem. The Constantinian example was consciously nourished, as we saw in chapter 2, by Otto III and his pope, Gerbert of Aurillac, whose papal name, Sylvester II, commemorated Constantine's pope, Sylvester I.[11] Not surprisingly, then, the accounts of Otto's invention of Charlemagne's tomb share a

certain structural similarity to the legendary accounts of Saint Helena's invention of the Holy Sepulchre and the True Cross. We shall return to this later.

For the moment, let us observe that the other remarkable feature of Adémar's narrative, and, to a lesser extent, that of Otto of Lomello, is the strongly imagistic or graphic quality of the story—the same characteristic we found in Rodolphus Glaber's *historiae*. The rhetorical imagery readily translates into a pictorial rendition of the scene. And with good reason, as we shall see, for the legend of Charlemagne, from the ninth century to the nineteenth, developed as readily in art as in literature, making it imperative to consider the two together. This is especially true in the case of the *Chanson de Roland*, for example, when we would appear to be dealing with a self-contained literary work. We can see better how this works in the accounts of the discovery of Charlemagne's tomb by looking briefly at the three accounts as a whole.

Invention-as-Story: The Poetics of Place

Isolating the elements common to the accounts, or at least to any two of the three, we find nine principal components. They function either to give structure to the ceremony or, equally important, to attach the action firmly to a given time—the feast of Pentecost—and to a given place—the basilica at Aix-la-Chapelle—built by Charles himself. These elements are as follows:

1. TIME: The feast of Pentecost of the year 1000, during a visit Otto III paid to Aix-la-Chapelle.
2. PLACE: The basilica of Our Lady, Aix-la-Chapelle, the former capital of Charlemagne's empire (an empire Otto III was then in the throes of extending spiritually by the conversion of Hungary).[12] Tomb known to be within the precincts of the basilica.
3. DISCOVERY: Although the exact location of the tomb was unknown, Otto, the *homo eruditus* ("qui philosophia intentus, et lucra Christi cogitans"),[13] discovered it by divine guidance.
4. CAST: A restricted number of notables (four) make the visitation.
5. SPECTACLE: Charlemagne was discovered, enthroned in majesty, in a vaulted crypt.
6. ARTIFACTS: Charlemagne's body was found to be adorned with precious objects connoting sacerdotal and political authority.
7. RITUAL: Veneration of the site and Charlemagne by visitors; sacred nature of the occasion stressed.
8. TRANSLATION: Body and objects associated with it treated as relics. Remains replaced in tomb or re-sited in another, more accessible one.
9. REVELATION: Authoritative and progressively more significant narrative of visitation conveyed the image and detail of the event to an audience.

The foregoing should make clear the ceremonial nature of the occasion, or rather, the progressive importance accorded to it as such by the narratives. Especially in the last two versions, the visit to the tomb appears as a ritual of solemn religious import, such that Robert Folz called it a prefiguration of the

canonization of Charlemagne in 1165.[14] We might recall some of the solemnity surrounding the time and place of the ritual.

Pentecost, the fiftieth day after Easter, traditionally marked the end of the Easter season; it was also the feast which celebrated the coming of the Holy Spirit, the completion of the movement of procession and return in the "life cycle" of Christ which revealed to man the Trinity. Thus, it was the feast which confirmed the full import, the ultimate truth of the Resurrection.

The Resurrection itself, as O. B. Hardison observed, "is the moment when humanity, represented by the holy women visiting the tomb of Christ, first recognizes the full significance of the Incarnation."[15] We have thus a series of ongoing moments—Incarnation, Nativity, Crucifixion, Resurrection, Ascension, Pentecost—each confirming the truth and heightening the significance of the preceding. Each is a narrative event, and reference to one implies the others; but each is also a temporal event standing within historic time, but also outside of it, in eternity. The concept of time and narrative sequence here illustrated must be seen as a dual one, then, in which the historical implies the anagogic and vice versa.

The same is also true for Christian space, and, in fact, the place in which our drama unfolds really constitutes one sacred space within another: a tomb within a place for worshiping the tomb. More boldly still, we may view it as a sacred space sequence (church—tomb/tomb—church) in one place and time, that is, Aix-la-Chapelle in the year 1000, which represents other sacred space sequences in other places and times, that is, Jerusalem, Constantinople, Rome. Let us see how this works, looking first at Charlemagne's church, the Palatine Chapel.

The main part of the basilica "is an eight-sided domed center room surrounded by an ambulatory on its lower floor, by a gallery on its upper floor and surmounted by an eight-sided dome."[16] The church was dedicated both to Christ and to the Virgin. Below this main part, as we saw, lay Charlemagne's crypt, called by Otto of Lomello a *turgurium* and then a *turguriolum*, or "little hut," a fact whose importance will become apparent.

In this spatial arrangement of a sacred tomb below-ground enclosed above by a basilica we have the typical arrangement of the early medieval martyrium, but especially of that archetypal martyrium, the Anastasis (Church of the Holy Sepulchre) in Jerusalem. We will return to the prototypes of the Palatine Chapel in a moment; for the present, it is less the architecture that concerns us than the semiosis of the ensemble.

The Anastasis, constructed by Constantine over the cave-tomb of Christ—although in the eleventh century Saint Helena received credit for the initiative[17]—became the cherished goal of medieval pilgrims from the fourth century onward. The tomb, a cave at the outset, had been enclosed by a colonnaded monument under Constantine's direction. This structure came to be called an edicule, or little house, and all representations of the holy sepulchre per se may be so called. Eusebius reports that the cave was adorned by the emperor with "choice columns and much ornament," and that he spared "no art to make it beautiful."[18] Even so, as evidenced by early testimony and modern reconstruction, the edicule was but a small part of the original Anastasis; the magnificence of the latter was intended by Constantine to impress upon the faithful the importance of the former. In Eusebius's words, the Anastasis

should "make conspicuous and an object of veneration to all" the Holy Sepulchre.[19]

The two structures, inner tomb and outer basilica, relate figuratively to one another by means of synecdoche, although, like Scripture itself, spiritual meaning rather than physical or material properties determines the order of relation. The smaller structure within, namely, the tomb, has the greater spiritual value and therefore controls the meaning production for the ensemble, but the larger object, the basilica, interprets the smaller—presents it to the world in a specific way that enhances and authenticates the predetermined meaning. Each implies the other in a reciprocal relationship, _even though it was not that way at the beginning._

Thus, although the tomb of Christ was the historical location of spiritual value to the believer, from the fourth century on it became the Church of the Holy Sepulchre that represented the tomb to the believer; symbolically, the splendid edifice of the church functioned to guarantee the authenticity of the tomb. In effect, the tomb had entered into the _mouvance_ of the basilica, to borrow a term from the vocabulary of feudalism. Confirmation of the interdependence of basilica and tomb in signifying this holiest of Christian holy places may be readily found in eleventh-century chronicles such as Rodolphus Glaber and Adémar which describe the destruction of Constantine and Helena's basilica by Saracens c. 1010. Although the edicule could not be destroyed by the Saracens, the fact that the basilica suffered—even though rebuilt rather quickly by divine intervention—was enough to engender great lamentation, _as though_ the basic component of the site itself, the cave of the Holy Sepulchre, had been destroyed.[20]

These same sources show us that just as the tomb had entered into the _mouvance_ of the basilica, so also the author of the basilica, Constantine, and later his mother, Saint Helena, had acquired a spiritual as well as a political suzerainty over those sites, thanks to his plan to adorn the holy places with "the splendor of buildings." That suzerainty ultimately transferred to Charlemagne, or at least a good part of it.

Between the year 800 and the year 1000, and particularly in the half-century preceding Otto III's discovery of Charlemagne's tomb, a considerable documentation had developed stressing the relationship between the Holy Land and Charlemagne. After 1000, the literature became even more insistent, ultimately transforming Charlemagne into the archetypal crusader king, the scourge of the infidel, protector of the Holy Land, and, in the ultimate versions, its conqueror. Prior to the mid-eleventh century, however, the picture of Charlemagne's relationship to the Holy Land appeared more restrained and more nearly parallel to the role traditionally accorded to Constantine.

In other words, Charlemagne was portrayed as an endower of monuments in Palestine, such as the hostel and church for Latin-speaking pilgrims in Jerusalem, Saint-Mary-the-Latin. The legends of this earlier period depict Charlemagne as having enjoyed good relations with the Saracen caliphate, whose incumbents invest Charlemagne with custody of the Christian holy places. More interestingly, the documents also show the emperors in Constantinople as quite willing to concede to Charlemagne _their_ nominal rights as custodians of the Holy Land.

Besides the better-known early accounts in which Harun al-Rashid, the Sar-

acen caliph, purportedly sent the keys of the Holy Sepulchre to Charlemagne on Christmas Day in 800—the same day as his imperial coronation—along with a promise to place himself and his land under Charlemagne's protection,[21] several new legendary texts provide further evidence that the Holy Land was entering the *mouvance* of the Carolingian empire. These texts show that the meaning of the concept "Carolingian Empire" had undergone a profound evolution to the point where it stood as a metonymy of the Christian world, with Jerusalem and particularly the Holy Sepulchre, as its metaphoric center.

When we recall that Jerusalem and especially the Holy Sepulchre passed, during the Middle Ages, as the physical as well as spiritual center of the earth, we can better understand the desire to perfect the spiritual connotation of Charlemagne's empire by ascribing to it this polysemous site.

> The Sepulchre of the Lord . . . has been constructed in the middle of a temple, and the temple is in the city centre towards the north, not far from David's Gate. Behind the Resurrection is a garden in which holy Mary spoke with the Lord. Behind the church and outside it is the Centre of the World, the place of which David said, "Thou hast worked salvation in the midst of the earth." Also another prophet says, "This is Jerusalem: I have set her in the midst of the nations."[22]

The legendary texts themselves corroborate this incessant association of Charlemagne with relics of Christ's Passion. The *Translatio Sanguinis*, composed at Reichenau around the year 950,[23] tells the story of the abbey's most precious relic, a cross containing several drops of the blood of Christ, supposedly obtained and donated by Charlemagne. The *Translatio* tells how this cross was given to the Frankish emperor, along with many other relics of the Passion, by the prefect of Jerusalem, who had traveled to Corsica to meet the emperor. From Ravenna, Charlemagne went barefoot, we are told, all the way to Sicily, with a large number of pilgrims, to take possession of the relics. He then brought them back to Aix, where he distributed them to various churches, keeping some for his own Palatine Chapel.

As Folz pointed out, the *Translatio* tells us two important things:

> It attests to the persistence of the memory of the friendly relations that Charlemagne maintained with Near Eastern rulers. It also demonstrates that some churches kept alive the memory of the arrival in the West, around the year 800, of particularly illustrious relics, specifically those of Christ's Passion, which they owned thanks to Charlemagne's generosity.[24]

Less than a quarter of a century after the *Translatio*, we find a narrative that actually predicates a voyage to the Holy Land by Charlemagne. Around the year 968, the monk Benedict of Mount Soracte wrote a chronicle in which Charlemagne purportedly mounted an expedition to Jerusalem.[25] According to Benedict, Harun al-Rashid quickly concluded a treaty of peace and friendship with Charlemagne. In a dramatic exchange, the Saracen confers upon Charlemagne the dignity of protector of the Holy Sepulchre at the moment when the emperor visits Christ's tomb to pay homage. Having concluded an alliance, Harun and Charlemagne journey to another center of Christian heritage, Alexandria, where they preside over a joyous demonstration of peaceful coexistence between the Saracen and Christian inhabitants. Departing Alexandria, Charles then proceeds to Constantinople, where the reigning powers acknowl-

edge him as an ally and, most importantly, do not challenge his suzerainty over the Holy Land. Finally, Charlemagne returns to Rome, the object of a triumphal welcome by the pope and the people, who proclaim him Augustus.

Benedict's chronicle represents a significant step in the legendary substitution of Charlemagne for Constantine as the religio-secular suzerain of the Holy Land. For the first time, Charles actually "takes possession" of the Holy Sepulchre *in person*: physical presence at the sacred site played an important part in the transference of symbolic powers. By the late tenth century, then, we have evidence for a legendary homologization of Charlemagne to the Holy Sepulchre where the figure of Constantine serves at once as the mediating principle and source of the authority now claimed for Charles.

The homology runs

<div style="text-align:center">Holy Sepulchre : Constantine : : Holy Sepulchre : Charlemagne</div>

in which the common element establishing the authority of both Constantine and Charlemagne is the all-important title "emperor," particularly Christian emperor, extended to include the Holy Land. The term *emperor* figures as a clear sign of religious authority—protector of the sacred places of Christendom—as well as temporal dominance. Thus the choice of Christmas Day for Charlemagne's imperial coronation and the early legend that Harun al-Rashid sent the keys to the Holy Sepulchre to Charlemagne on the same day.

By the later tenth century, then, to mention the Holy Sepulchre no longer automatically called up the sole image of Constantine, but also, and perhaps even rather, Charlemagne. Nevertheless, the authority of Charlemagne derived from his implicational relationship with Constantine. Constantine and Charlemagne stood at this time in synecdochic relationship.[26] Thanks to the special nature of Christian time, Charlemagne could be seen less as a successor to Constantine than as a *renovatio* of him, a re-presentation of what he was perceived to have stood for. It makes no difference that it was not so at the beginning; once the new view imposed itself, it became canonical. Often characterized as naive, this anachronistic perspective whereby the authority of the past might be "revised" to include facts and perceptions from the present constitutes a rich mythopoeic resource that explains why periods of this sort tend to produce so vital an epic and historiographic heritage.

Before moving on, we might remark the symmetry of Benedict of Mount Soracte's narrative. Charlemagne, in his work, went first to Jerusalem and the Holy Sepulchre, then to all of the other principal cities over which Constantine once exercised control: Alexandria, Constantinople, Rome. In essence, Benedict asserts the same claims for Charlemagne regarding empire that existed for Constantine, the significant difference being that no *historical* basis existed for the claims to an Eastern empire that now spring up for Charlemagne. True, Charlemagne and his advisors consciously emulated the Constantinian model from 800 onward, but that kind of behavioral patterning was quite a different matter from Benedict's rewriting of history. We can only conclude from his boldness the strength of the symbolic authority accruing to Charlemagne in the second half of the tenth century, on the one hand, and, on the other, the authoritative role of narrative-as-history. We may also begin to understand some of the assumptions about the Frankish emperor that would

have been part of the consciousness of the actors in the drama of the exhumation when they descended to Charlemagne's tomb in that millennial year of 1000, and most certainly of the historians, like Adémar, who recorded the event.

Renovatio often occurs in company with *translatio,* and if there were a tendency to view Charlemagne progressively as a *renovatio* of Constantine, so, too, did the *translatio* of potency from the Holy Sepulchre begin to assume greater signification in the late tenth century and early eleventh. Here again the authority of Charlemagne assumed legendary proportions, and, yet again, the legend might be seen in one sense as an outgrowth of historical fact, but historical fact with mythopoeic elements strongly encoded.

The setting in which Otto III's invention of his forebear's tomb occurred has been programed, as it were, by Charlemagne for just such an event. In a still valuable study, "The Carolingian Revival of Early Christian Architecture," Richard Krautheimer argued persuasively that symbolic value and liturgical function were stressed more than the technical aspects of ecclesiastical architecture in the Middle Ages.[27] "The 'content' of architecture," he says, "seems to have been among the more important problems of medieval architectural theory: perhaps it was indeed its most important problem."[28] In comparing different edifices which medieval sources saw as having a strong relationship, the modern student must look less for exact physical resemblances than for symbolic and functional *points de repère.*

On this basis, Charlemagne's Palatine Chapel at Aix may be seen as an edifice whose meaning, like that of Charlemagne himself, by this time, derived from a ternary relationship of sign and referent. It combined within itself two models whose prototypes might be found in Jerusalem and Rome. The description of the basilica given earlier places it in a group of "round" churches associated at once with the Anastasis and also with martyria dedicated to the Virgin. Strictly speaking, the Palatine Chapel does not fall into the group of conscious "copies" of the Anastasis that were built in Europe beginning in the first half of the eleventh century, soon after the events we are discussing.[29] Based loosely on its use of the two-story rotunda with galleries and its dedication to Christ, the Palatine Chapel may be said to conform to the typology of the copies of the Holy Sepulchre, especially since Krautheimer points out that even the "approved" copies resembled their prototype in little more than the use of the rotunda and gallery motif and their dedication to Christ.[30] Given Charlemagne's close association with the Holy Sepulchre, it hardly seems radical to assume that, as the archetype of the Anastasis became more prevalent in Europe, the Rotunda at Aix, itself a martyrium dedicated to Christ, would assume a typological association with the Holy Sepulchre.

Another prototype for the Palatine Chapel lies in the Valley of Josaphat, outside of Jerusalem. This is the church over the Tomb of the Virgin, described by Arculfus, a Frankish pilgrim of the seventh century, as follows: "The church of Saint Mary is double-storied; its lower part is found with a wonderful stone ceiling; in the eastern part is an altar and to its right the empty tomb of the Virgin hewn in rock. The upper story is likewise round; it contains four altars. . . ."[31] This church seems to have exercised almost as important an influence on ecclesiastical architecture in the East and West as the Anastasis.[32]

Its immediate derivative in the Eastern Empire was the Hagia Soros in Constantinople; both the Church of the Tomb of the Virgin and Hagia Soros have been proposed as models for the Palatine Chapel. The latter, in its turn, was "greatly admired by contemporaries and by later generations; and the structure was reflected in derivatives all over Charles' Empire from the ninth through the eleventh centuries."[33]

Once again, we find the filiation Jerusalem, Constantinople, Aix: Christ/Mary, Constantine, Charlemagne. But what about Rome? In Rome the Pantheon had been rededicated as Sancta Maria Rotunda on 10 May 609 or 610, by Pope Boniface IV.[34] Krautheimer cogently asks why the Pantheon, a domed rotunda with niches, should have suddenly been considered appropriate as a martyrium dedicated to the Virgin in the early seventh century. The answer seems to lie yet again in the axis of signification, Jerusalem, Constantinople, Rome.

In the mid–sixth century, a church was either built or rebuilt over the Tomb of the Virgin in the Valley of Josaphat by the emperor Maurikos (582–602). "In commemoration of this structure," Krautheimer argues, "the chapel of _Hagia Soros_ may have been set up in Constantinople."[35] At any rate, from the early seventh century the chapel of Hagia Soros is cited as one of the "great sanctuaries of the capital, for at that time it sheltered the kerchief of the Virgin, or else her belt, her dress or her shroud."[36]

In dedicating the Pantheon to the Virgin, Pope Boniface IV simply extended this process of symbolic transference of shrines from the Holy Land to significant spiritual centers—which also happened to be political centers—in the West. The Pantheon resembled the archetypal Tomb of the Virgin; Constantinople had such a church; therefore, Rome, too, should rededicate a major architectural monument to the Virgin. In so doing, Pope Boniface additionally demonstrated the power of the New Alliance to redefine the monuments and sacred precincts of the old order. Within a short time of Boniface's rededication, Sancta Maria Rotunda had become "the fountainhead for a whole group of early medieval round churches with niches all dedicated to the Virgin,"[37] and legend held that it had been that way from the beginning.[38]

Charlemagne inscribed this monumental symbolism into his complex of public buildings in Aix. The model for his palace—which was attached to the chapel by a kind of long arcade—was the Lateran palace in Rome. Tradition, as evidenced by the Donation of Constantine, claimed the Lateran to have been Constantine's own palace. Given the obvious connection between Charlemagne's palace and the Lateran, we should have no difficulty postulating a similar connection between the chapel connected to the palace and Sancta Maria Rotunda.

After all, it was a commonplace of Carolingian documents that Aix should be seen as the Nova Roma, a claim due in no small part to the "splendor of buildings" by which Charlemagne distinguished it, a Constantinian lesson that had not been lost on his Frankish emulator. We can argue, then, that the Palatine Chapel is trinitarian: representing the Church of the Tomb of the Virgin, Hagia Soros, and Sancta Maria Rotunda—Jerusalem, Constantinople, Rome—all within the _mouvance_ of Aix-la-Chapelle.

The symmetry between Constantine and himself, the old empire and the

new, seems to have been the height of Charlemagne's own ambition, and no
mean one at that. By the year 1000, however, Charlemagne's successors enter-
tained even greater ambitions for him. In art, literature, and history, we find a
tendency to refer to Charlemagne in terms of an expressive system usually
reserved for Christ. By the thirteenth century, that transference had become a
commonplace, as the following gloss, taken from the *Chronique Sainton-
geaise*, makes clear:

> Karles si est lumeire de char, car il sormonta toz les rois de terre charnaus apres
> Jesu Crist, per la lumeire de totes vertuz e de science e de proece.[39]

> [Truly, Charles is the light of the flesh, for he surpasses all fleshly kings of the earth
> after Jesus Christ by the light of all his virtues, and his knowledge and prowess.]

This view already informs the image of Charlemagne in the Oxford *Roland*.
Charlemagne has attained patriarchal age: "dous cenz anz ad passet" (v. 524);
biblical miracles like the staying of the sun in its path are reproduced by God
at his request; and he maintains mediated communication with God via the
archangel Gabriel, from whom we learn that Charlemagne's titles possess
celestial validity: "*Reis magnes*, que fais tu?" (v. 3611). The last *laisse* of the
Roland makes even more explicit Charlemagne's role as divine agent.

Now that we have a clearer picture of the symbolic valorization of Charle-
magne around the year 1000, let us consider the structure of Otto III's descent
to the tomb of his illustrious predecessor as conveyed by our three accounts.

Invention-as-Story: The Poetics of Person

First of all, let there be no doubt as to the significance of Pentecost in the
representation of the event. Pentecost was to Easter what the Nativity was to
the Annunciation. In the ongoing narrative of Christ, it was the moment of
extreme creative potency when the Trinity became a fully realized sign. As
the feast of the coming of the Holy Spirit, the revelation of the Third Person
of the Trinity, Pentecost signaled the commutativity of the Verbum, the Sec-
ond Person, with human speech. It was Pentecost which gave man "the gift of
speech," that is, the ability of humans to represent in *their* speech the "speech
of the Lord" (Acts 2 : 17).

The ninth-century Latin hymn sometimes ascribed to Hrabanus Maurus,
"Veni, creator spiritus," expresses very cogently the concept of Pentecost as
the origin of man's ability to become an *imitatio Christi*:

> Veni, creator spiritus
> Mentes tuorum visita,
> Imple superna gratia
> Quae tu creasti péctora
>
> ..
>
> Tu septiformis munere,
> Dextrae Dei tu digitus,
> Tu rite promisso Patris
> Sermone ditans guttura. [1–4, 9–12]

[Come, Creator Spirit, visit the souls of thy people, and fill with grace from them
on high the hearts which thou hast created. . . . Thou art seven-fold in the gifts, the

finger of the Father's right hand, and duly by the Father's promise thou endowest human lips with speech.][40]

Pentecost provided a resounding answer to the question posed by Easter as interpreted by the three Marys who went to the Holy Sepulchre on Easter morning to anoint the body of Christ, only to find the tomb empty. That moment, with its explicit question—so often interpreted visually in miniature ivory carvings and paintings in the tenth and eleventh centuries—was given dramatic form by the most famous dialogue in medieval literature, the *Quem Queritis*.

In its simplest form, the *Quem Queritis* dialogue consisted of a question, an answer, and a reply:

Quem queritis in sepulchro, O christicole?
Ihesum Nazarenum crucifixum, O celicole.
Non est hic, surrexit sicut ipse dixit; ite nunciate quia surrexit.

[Whom do you seek in the tomb, O followers of Christ?
Jesus of Nazareth who was crucified, O Heaven Dwellers. He is not here, he has arisen as he said; go announce that he has arisen.][41]

Hardison reminds us that the *Quem Queritis* "became quite literally the bridge whereby medieval culture made the transition from ritual to representational drama. . . . It is not a tentative and blurred effort to express a felt experience in representational form, but a decisive realization of experience in terms of the history that the Middle Ages regarded as its basis."[42]

By the beginning of the eleventh century, the *Quem Queritis* had attained widespread popularity and had already begun to undergo elaborations which would eventually culminate in a full-blown play of the Passiontide. A masterpiece of functional symbolic representation in which persons, site, gesture, music, and words combine to make the revelation of the Resurrection a stunning recognition scene, the *Quem Queritis* could not help but provide a ceremonial archetype and intertext for a tomb visitation, especially one so clearly predicated upon christological symbolism as this.

The setting alone, as we saw, represented a rotunda martyrium of the type associated with the Church of the Holy Sepulchre. Otto of Lomello provided two details in his account which make the parallel between the representation of the tomb visitation in the *Quem Queritis* and the invention of Charlemagne's tomb the more striking.

Following its biblical source, the *Quem Queritis* represents five people present in the tomb: the three Marys and two angels. We find the same number in Otto of Lomello's version, where four notables proceed to find a Charlemagne erect in his throne "ceu vivus residebat." Note that Charlemagne appears very much as a presence in the tomb visitations. His majesty dominates the scene and highlights the procession toward the throne. Note also that the reverences made to the enthroned emperor do not differ from those that would have been accorded him by courtiers at a royal audience. Indeed, he appears with all the imperial regalia, symbols of authority—both secular and religious—that he would have displayed on state occasions.

His posture, attitude, and appurtenances receive dramatic treatment from the chroniclers, and, as with the three Marys in the *Quem Queritis*, the atti-

tude of the visitors toward the state which they find in the tomb reminds us
that we are witnesses to a revelation, a revelation of a truth which could take
place only in the tomb. Let us note, too, that just as the Marys found the
plenitude or fulfillment of the Word in the emptiness of the tomb—"surrexit
sicut ipse dixit; ite nunciate quia surrexit"—and just as the *Quem Queritis*
gave dramatic representation to the fullness of that absence, so the visitors to
Charlemagne's tomb found, in a way that will become even more apparent
later, the accomplishment of the Word: manifest evidence that Christ's
triumph over death, as the *Historia Karoli Magni et Rotholandi* took pains to
remind its audience, was not *sui generis*, not for himself alone, but to be
shared by all men.[43]

The second detail of Otto's account which deserves comment concerns the
estate of the four tomb visitors. These are not witnesses chosen at random,
but highly placed representatives of the ruling estates: the monarchy, the
church, and the nobility. And, like the Marys, they are at once in the story and
the instruments of its communication. Indeed, the second Otto here, Otto of
Lomello, responds quite literally to the injunction of the angel in the *Quem
Queritis*: "ite nunciate quia surrexit."

Just as in the *Quem Queritis*, then, a small number of authoritative wit-
nesses experience the event and then tell about it. And just as in that sequence,
the existence of the concrete artifacts—the tomb, the relics taken, etc.—at-
tests the authenticity of the experience. Even more important, in both cases
it is the representation of the event *in verbal accounts* that anchors and me-
diates all of the other elements. Without these accounts, there would be noth-
ing else. The articulation of the event in narrative form makes it available to
the culture at large by transforming it into *mythos*, socially acceptable histor-
ical "fact." As such it is then free to inspire subsequent developments of an
artistic, literary, and political nature. We shall have occasion to study some of
these shortly.

The narrative structure depends upon the same process of metaphor and
metonymy that we witnessed in the Holy Land, except that now the transfer-
ence from sacred site to sacred person and vice versa occurs in the Western
terminus of the Jerusalem-Rome-Constantinople-Aachen axis. And once
again, even though the discovery of Charlemagne's tomb occurred almost two
hundred years after his interment, we find a retrospective reconstruction of
the mythos which assumes that the situation represented as existing in the
tomb in the year 1000 *must have been that way from the beginning.*

This retrospective reconstruction may best be seen by comparing the ac-
counts of Charlemagne's interment given by Einhard in his ninth-century *Vita
Karoli* with the report that Adémar de Chabannes includes in his eleventh-
century chronicle. While scholars have not failed to note the obvious differ-
ences between the accounts, they have largely ascribed them to the imagina-
tive fantasizing of Adémar. In fact, we must be aware that these accounts
represent not simply two versions of the same event—the one reliable, the
other not—but two radically different conceptions of the ceremony depicted
and of the nature of narrative.

Einhard's version tells us that Charlemagne's

body was washed and cared for in the usual manner, and was then carried to the church and interred amid the greatest lamentations of all the people. . . . He was buried there the same day that he died, and a gilded arch was erected above his tomb with his image and an inscription. The words of the inscription were as follows: "Under this tomb is interred the body of Charles, the Great and Orthodox Emperor, who gloriously extended the kingdom of the Franks and reigned prosperously for forty-seven years. He died at the age of seventy, in the year of our Lord 814, the seventh Indiction, on the 28th day of January."[44]

This description accords with the conception of Charlemagne as a continuator of Constantine, a primarily secular ruler, pious, but whose principal concerns lay with the territorial imperatives of his kingdom; there is no suggestion that imperial and spiritual geography have as yet acquired the synonymy accorded them in later versions of the Charlemagne mythos. The person buried in this description may be exceptional, but nothing suggests extraordinary spiritual, let alone supernatural, powers.

Now consider Adémar's report:

> Charles was interred at Aix in the basilica of Our Lady which he had built. His body, having been anointed with spices, was placed sitting in a golden throne in a vaulted crypt. The body was girt with a golden sword and was holding a golden book of the gospels [evangelium] in its hands and [resting] on the knee. The shoulders were leaning back against the throne and the head was held boldly erect, linked by a golden chain to the diadem. In the diadem was fixed a piece of the True Cross. They filled the crypt with aromatic spices, balsam, musk, and treasures. The body was dressed in imperial robes and a handkerchief [sudarium] placed on the face under the diadem. The gold scepter and the golden shield which Pope Leo had blessed were placed before him and his sepulchre was sealed. [One manuscript adds:] The hair shirt which he secretly always wore was placed next to his flesh, and over the imperial robes was placed the gold pilgrim wallet which he used to wear to Rome.[45]

As we can readily recognize from what we learned in the last chapter, the intentionality of theosis informs Adémar's description. Indeed, the whole rhetorical stance of this passage contravenes the traditionally elegiac function of the *tumulus* or *tombeau*, that is, the memorial description of an illustrious deceased. On the other hand, Einhard's account, in keeping with this convention, features a retrospective epitaph, telling who Charlemagne was, how and why he might be revered as great, but above all, reminding the viewer that he was no more and would not be again until the final days. The tomb itself conveyed the same message.

In Adémar's case, however, a confident prolepsis dominates the description. We find no epitaph, almost no hint of the anteriority of accomplishment, aside from the first sentence, where Adémar gives the years of Charlemagne's reign and tells us that Charles had built the church in which he was interred. Even that fact possesses a certain futurity, since, by the eleventh century, it was the presence of Charlemagne's tomb that rendered the church noteworthy, just as the presence of Christ's tomb distinguished the Anastasis.

As it happens, we possess a sketch of the Palatine Chapel and the tomb of Charlemagne in Adémar's own hand (fig. 11). The autographed sketch accom-

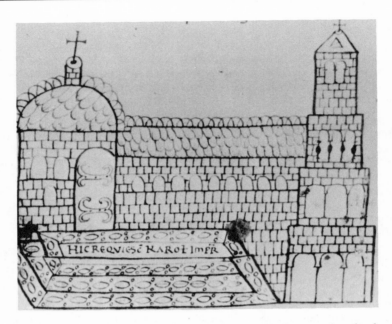

Figure 11. The Palatine Chapel of Aix-la-Chapelle, showing the edicule containing the tomb of Charlemagne. Inscription reads, "Here lies the emperor Charles." Sketch by Adémar de Chabannes (c. 1020–34). (Vatican Library, MS Lat. 263, fol. 235r)

panies the description of the interment in an early eleventh-century manuscript preserved in the Vatican library (MS Latin 263, fol. 235r). It provides a striking confirmation of the intentionality of the burial account discussed above.

Note how Adémar sketched the edicule containing the tomb—identified by the inscription, "Here lies the emperor Charles." Realistically speaking, it stands out in total disproportion to the edifice surrounding it. Figuratively speaking, however, the edicule demonstrates very well the symbolic proportion existing between tomb and church in the perception of the period—as seen in the relationship of edicule and Anastasis in Jerusalem. Exactly as with the ivory carvings of the Anastasis from this period, the outsize tomb identifies the church, rather than vice versa. More significantly still, Adémar's account and sketch show that Charlemagne's tomb causes the Palatine Chapel to signify in precisely the manner that Christ's tomb provided meaning for the Anastasis.[46]

The church, in fact, has become, in Adémar's sketch, the setting for the tomb-as-reliquary. This squares with his description, which might well be said to emphasize much less the disposition of the body than the placing of a relic within a reliquary. Certainly the preparations described by Adémar—but *not* by Einhard—do not envisage the disappearance from view of a body, as

Einhard's version suggests, but rather the opposite. So much so, in fact, that when Adémar states that the sepulchre was sealed, we see this not as the closure of the narrative but rather as a kind of punctuation, a transition from the account of the interment to that of the invention.

Consider also the dialectical relationship between sketch and narrative. The latter purports to give a retrospective account of an event that took place more than two hundred years prior to Adémar's writing. It closes with the sealing of the sepulchre. The sketch, on the other hand, represents the edicule/tomb in the present, as it could have been seen in Adémar's own time. Furthermore, it projects a symbolic valence on the scene that we know to have been that of the early eleventh century rather than of the early ninth.

The sketch, then, illustrates the *result* of the action described in the narrative. Consequently, when we compare the sketch and the narrative, we understand why the latter has a proleptic quality in sharp contrast to the retrospective tenor of Einhard's account. In other words, Adémar's sketch serves both literally and figuratively as an icon of the intentionality of the account; it is a *mise-en-abyme* of the description, revealing that its purpose was to re-present the *mise-au-tombeau* of Charlemagne as a necessary corollary to the invention of the tomb.

We know that the invention must follow because not only did Adémar write the interment as a prelude to the invention, he even, in a sense, wrote the invention *into* the interment.

He did so by incorporating into the account a graphic detail that might also be said to serve as an icon of the story by which the significance of the invention-to-come would be interpreted. Adémar's narrative of the interment, remember, reported that a piece of the True Cross had been fixed in the diadem placed on the enthroned emperor's head. By prominently featuring this graphic detail, Adémar inscribed within his narrative the intertextual stories, both biblical and apocryphal, by which Otto's invention of Charlemagne's tomb attained its full christological signification.

All this may be quickly verified by noting how each of the two accounts of the interment deals with concrete artifacts. Again, we find only the retrospective and funerary in Einhard—a gilded arch and an image—while Adémar provides a movable feast, a positive treasury of items, each one of which might be detached from the tomb-setting to serve as a relic or a symbolic instrument of religio-political power.

The stone throne of the Palatine Chapel in which Otto I was consecrated in 936, and in which other German kings subsequently received their consecration, became known as the Throne of Charlemagne.[47] The sceptre, sword, and crown, after having been translated to Saint Denis, where they were preserved as principal relics of the royal abbey, became essential features of the ceremonial regalia used by French kings for their *sacre* at Rheims.[48] As a matter of fact, the sceptre was last used by Napoleon I at his imperial coronation.[49]

We should not be surprised at the strong religio-political valence attained by these items when we consider them in terms of Adémar's description. One of the most striking aspects of this, as it was of the account of the invention, concerns the strong visual image of Charlemagne sitting in enthroned majesty. With Adémar, we undoubtedly begin a long and fruitful development in the

iconography of Charlemagne, especially as concerns the parallels with Christ. From this period on, the Charlemagne mythos developed two branches, verbal and visual, with the two often intermingled. Adémar's description constitutes, in essence, a verbal portrait that is also self-authenticating, that is, it calls attention to the very objects in the composition which may later be used to establish the "authority" of the portrait. This is slightly different from a graphic representation where all the same objects may be present but cannot "explain themselves" without a legend. In the case of Adémar's portrait, we have an explicit identification not only of the content of the immediate picture, but also a well-defined framework for the two portraits of Charlemagne interred and Charlemagne redivivus.

The Poetics of Image: Charlemagne-in-Majesty

This context, in turn, not only draws upon the historical association of the Charlemagne legend in word, image, and architecture with christological symbolism as we traced it in the early part of the chapter, but also upon the associations of the immediate context portrayed: the scenario engineered by Otto III. Otto III sought to make Charlemagne the fountainhead of the "Universal Roman Empire" as Christ was the fountainhead of the Universal Roman Church. In effect, the mythos of Charlemagne was thereby placed squarely and without the mediation of the Constantinian reference into the *mouvance* of the Christ mythos with all the reciprocal implication connoted by that feudal term. We saw that trend developing in the chronicles; Adémar's description marked the beginning of a corresponding iconographical tradition of a frontally portrayed "Charlemagne-in-Majesty," bearing a striking resemblance to the iconography of the "Christ-in-Majesty," a Romanesque theme par excellence particularly favored in the eleventh century.

Without attempting to trace the development of the Christ-in-Majesty, let us simply examine quickly some significant examples. The first represents, appropriately, work done by the Palace School at Aix-la-Chapelle and may be found in an *evangelium* attributed to Godescalc, the pupil of Hrabanus Maurus, and dating from the last part of the eighth century (fig. 12).

Contemporaneous with Charlemagne's own period, it portrays Christ frontally, with a decorated Gospel in his left hand; his right makes the gesture of benediction. Seated on an ornate cushion, placed on a handsomely carved throne on a raised dais, Christ's complex being as created and creator, as Word, Book, and Flesh—and the authority vested in him because of this complexity—stands out dramatically.

A ninth-century illuminated Christ-in-Majesty from the Lothair Gospels shows Christ enclosed in a mandorla, his body spanning the distance between heaven and earth—the convention seen in the last chapter (fig. 13). The tetramorphic representations of the Evangelists surround the mandorla, while within it, Christ holds two symbols of the Word: the host in his right hand and the book in his left. Note that the Gospel here appears not clutched to his breast as in Godescalc's illustration, but held in Christ's hand *and* on his knee, precisely in the manner Adémar ascribes to Charlemagne.

A very interesting combination of these two types of *Maiestas Domini* may

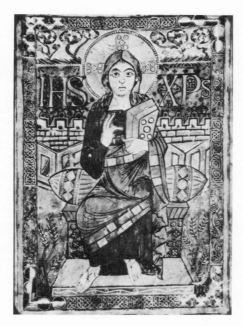

Figure 12. Christ-in-Majesty. Godescalc's evangelary. Aix-la-Chapelle, Palace School (781–83). (Paris, Bibliothèque Nationale, MS Lat. nouv. acq. 1203, fol. 34)

be seen in one of the earliest sculptural representations of this theme; it is ascribed to the workshop of Bernardus Gelduinus, who worked at Saint-Sernin of Toulouse in the late eleventh century (fig. 14).[50] This beautiful sculpture, now found at the head of the ambulatory, behind the main altar, combines the throne, cushion, and benediction of the Godescalc representation with the mandorla, tetramorphic representations of the Evangelists, and position of the Book of the Lothair Gospels. Emphasizing this posture, as in the Lothair Gospels, the sculptor has accorded greater prominence to the left knee and to the drapery over the left leg. The same emphasis may be seen in the gathering of the drapery over the left side of the torso and left arm, immediately beside and over the left hand.

By its restrained size and execution, the Saint-Sernin Christ conveys its relationship to the miniature ivory carvings and goldsmith work that inspired it. On a larger scale, however, we find the same type of *Maiestas Domini* in different places throughout France in the early twelfth century. In passing, we might mention the Christ of the tympanum of Cervon (Nièvre), which retains the iconographical details of the Saint-Sernin Christ, although the artistic execution is more reminiscent of Giselbertus's elongated forms at Autun. Two obviously related examples may be found in the Saône-et-Loire at Anzy-le-

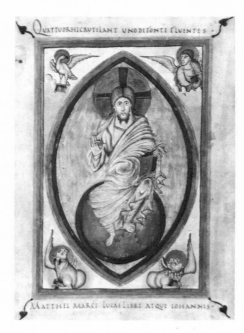

Figure 13. Christ-in-Majesty. St. Martin of
Tours, or Marmoutier, Gospel Book of Lo-
thair (c. 849–51). (Paris, Bibliothèque Na-
tionale, MS Lat. 266, fol. 2v)

Duc and Perrecy-les-Forges. The interest in these examples lies in the dispro-
portionately large books held between the hand and the knee of the enthroned
Christ.

For our purposes, the most significant development in the iconography of
the sculptural representations of the Christ-in-Majesty, after Saint-Sernin,
may be found, appropriately enough, at Moissac, artistically related to Saint-
Sernin. We have already had occasion, in the last chapter, to look at the Christ
which dominates the tympanum at Moissac (figs. 1 and 2).

This figure resembles to a greater extent a venerable secular ruler than do
the ethereal Christs of the Godescalc Psalter, the Lothair Gospels, and the
ambulatory relief at Saint-Sernin. The full beard imparts a patriarchal air to
the figure not found in the clean-shaven earlier images or even in the more
lightly bearded Christ of the Lothair Gospels. More significant still, the Christ
of Moissac not only has the requisite nimbus with cross behind his head, but
he also wears a prominent crown. This Christ, in fact, is the Pantokrator,
Christ-king of the universe. No wonder local peasants took the statue to rep-
resent an earthly king, Clovis, until recently.[51]

The Christ of Moissac has only one iconographical counterpart among elev-
enth- and twelfth-century representations of secular rulers that I have been

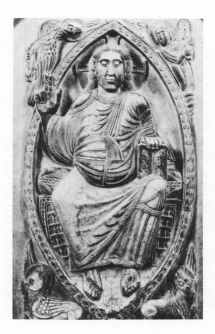

Figure 14. Christ-in-Majesty. Toulouse,
Saint-Sernin, ambulatory relief (late
eleventh century).

able to find, and that counterpart is Charlemagne. Before we look at these
examples of *"Maiestas Karoli Magni,"* however, one obvious question must be
answered. In the last chapter, we saw several examples of secular rulers en-
throned, including one, the Reichenau apotheosis, which appeared to illustrate
very well the *majestas* theme. While it might appear as though the Charle-
magne portraits simply continue this tradition, at least two things differen-
tiate the Carolingian and Ottonian illustrations of enthroned rulers from the
Charlemagne-in-Majesty representations we shall now examine.

In the first place, the portraits of the enthroned rulers illustrate the *theosis*
of these princes. Consequently, the illustrations show rulers who were alive
when the paintings were executed. Secondly, the qualities stressed in the por-
trayal of the theosized monarch are those associated with the Old Testament
models of kingship, David and Solomon, which the portraits also illustrate. It
was a commonplace of Charlemagne's court that the Frankish monarchy
should be viewed as a *renovatio* of the Hebrew monarchy founded by Saul,
David, and Solomon under the aegis of the New Alliance.[52]

We can see this double reference to the Old Testament monarchical model
and to Charlemagne in the illustration of Charles the Bald as Solomon in the
so-called Bible of San Paolo fuori le Mura, painted around 869 at Saint Denis
(fig. 15). The portrait complements an illustration of Solomon (not shown)

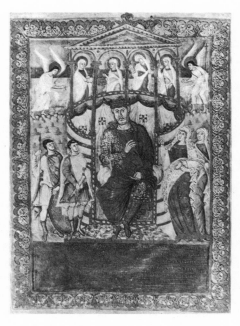

Figure 15. Charles the Bald on his throne.
School of Rheims (c. 870–75). (San Callisto
Bible, Rome, San Paolo fuori le Mura, fol. 1r)

sitting in judgment in his temple. The features of Solomon and those of
Charles the Bald, the details of the crowns, and so on, bear a very close resem-
blance to each other. However, Charles the Bald holds a symbol of power im-
possible to ascribe to a king under the Old Alliance. This symbol, the orb,
resembles on the one hand an enlarged host, like that held by Christ in the
Lothair Gospels, but inscribed on it we see a threefold symbol of Charlemagne.
We recognize first the monogram or emblem of Charlemagne, which makes
the sign of the cross with the letters *"Karolus"*; next, the name itself, and
finally the state or title. Charles the Bald, then, must first emulate the models
of Solomon and Charlemagne, and then Christ.

 One last document provides convincing testimony to the intentionality of
the Carolingian and Ottonian tradition of the enthroned ruler; it also helps to
explain the transition from theosis to theophany, as it were, when we reach
the Charlemagne-in-Majesty portraits. *Aulae Sidereae*, a little-known but
highly significant poem to Charles the Bald by John Scottus Eriugena sheds
much-needed light on this problem. The poem was written for the dedication
of a palace church that Charles the Bald had constructed for his use at Com-
piègne; not only did he seek to imitate his forebear Charlemagne in building
the church, he had it built as a rather faithful copy of the chapel at Aix.[53]
Besides serving to document the intentional association of the Carolingian

ruler with his church as an extension of or setting for his throne, the poem also provides a good commentary on the symbolic value ascribed to Charlemagne's church at this time.

Eriugena's poem equates the structural details of the church with the symbolic structure of the world at the moment of Christ's birth, thereby establishing the fact that "reading" the symbolic structure of the church permits one to "read" Christ in the universe; put another way, Christ, the church, and the world constitute a set of equivalences related in a metaphoric/metonymic pattern.

In a brilliantly modulated metaphoric run, Eriugena plays upon the church as the Light itself, that is, Christ, and the setting for the Light which dissipated the darkness of the Fall. In the process, the church comes to symbolize the places or spaces where the Light resided in its oral trajectory from spoken Word of God to the Spirit of human speech at Pentecost. In this way, the church—like Charlemagne's dedicated to the Virgin as well as to the Savior—is also womb, tomb, and throne. Throne thus becomes an equivalence of theosis, a setting for the Light of the Word and a *renovatio* of the throne of the Old Testament intentionally revalorized by the Word-God enthroned in his temple, and here equated to a principle of life itself.

> Uerbum nanque deus processit uirginis aluo
> Lucis in augmento quam noctis uicerat umbra,
> Nos homines miseros paradisi luce remotos,
> Olim commissae septos umbramine culpae,
> Sponte relinquentes praeclara sedilia uitae
> Mortis perpetuae deuinctos iure catenis,
> Quo mortale genus lueret sua debita soluens,
> Sentiret meritas inflata superbia poenas,
> Restaurare uolens priscasque reducere sedes. [22–30][54]

[For the Word-God proceeded from the womb of the Virgin / To the growing of the Light which had conquered the shade of night, / (For) us, miserable men, removed from the light of paradise, / Enclosed in the shade of the anciently committed sin, / Abandoning of our own accord the resplendent thrones of life, / Bound by right in the chains of eternal death, / By which the mortal race expiates by suffering its debt, / And feels what punishment its haughty pride merited, / (For us the Verbum proceeded) wishing to restore and return to us the ancient thrones.]

Contemplation of the church alone invites the mystic leap of the intellect into the spiritual realms "above the substance even of the soul."[55] In a complex but inspiring manner, Eriugena demonstrates how, as Foussard points out, "La chapelle de Charles le Chauve symbolise pleinement cette procession et ce retour—cette descente et cette montée des peuples autour des autels (v. 94): autour du Christ. Théophanie de la Sagesse, elle conduit le fidèle jusqu'à la manne des déifiés, jusqu'au repas que Dieu lui-même sert à ceux qui l'aiment."[56]

But if the chapel functions as a "text" for displaying Christ as the restorer of ancient thrones, the unifying principle of coherence of the world as text, it also functions to display its builder, or "secondary mover," on his throne. Enthroned in this monument-text, Charles the Bald shines forth as a sacred, theo-

sized being, as a living servant of Christ (ll. 78–79, 84–85). Eriugena leaves no doubt as to the reciprocal meaning exchange between the church/temple/throne and Charles; each signifies the other, because both signify and are signified by Christ, the Word and ruler of the universe:

> Ipse throno celso fultus rex prospicit omnes
> Uertice sublimi gestans diadema paternum,
> Plena manus sciptris enchiridon aurea bactra:
> Heros magnanimus longaeuus uiuat in annos. [98–101]
>
> [Himself raised on the lofty throne the king sees all / Wearing the diadem of his fathers on his sublime head, / His hand filled with sceptres bearing the golden staffs; / May this magnanimous hero live long years.]

"Uiuat in annos": the phrase sums up perfectly the difference between the representation of the enthroned ruler in Carolingian and Ottonian times and the representation of Charlemagne after the year 1000. These rulers sit enthroned during their lifetime; only Charlemagne thrones after death. The *Maiestas Domini* portrays a Christ who has been through life and death and now, on the other side of history, sits enthroned in heaven. So Adémar's verbal portrait represents Charlemagne as surviving the interment to sit in majesty after the test of death. Again like the *Maiestas Domini*, the *Maiestas Karoli Magni* appears in sacred settings.

To go no further than the end of the twelfth century, we can find two striking representations of the theme worthy of comment. One is a *vitrail*, executed around the year 1200, the original of which used to be in the Romanesque cathedral of Strasbourg; the other is an ornate reliquary containing Charlemagne's mortal remains, preserved today in the Palatine Chapel. Aix-la-Chapelle and Strasbourg were the first two cities to celebrate the cult of Charlemagne after his controversial canonization in 1165.[57]

The Charlemagne-in-Majesty of Strasbourg (fig. 16) sits on a square-backed throne, like the Christ at Moissac, with a prominent crown and halo. The ornate cushion associated with the thrones of the Christ-in-Majesty appears here, too. The iconography of the Strasbourg *vitrail* differs from that of Adémar's description and of the *Maiestas Domini* in that Charlemagne does not hold an *evangelium* in his left hand and on his knee, but rather holds the imperial globe. In this respect, the *vitrail* evokes the tradition of the Christ-with-host, found in the Vivian Bible frontispiece and in the Cambrai Gospels, and also used for the San Paolo fuori le Mura portrait of Charles the Bald (fig. 15).

Like the Christ-in-Majesty, Charlemagne is surrounded by symbolic figures associated with his mythos. In this case, it is not the Evangelists or their symbols but representatives of Charlemagne's twelve disciples, the twelve peers, here figured by Roland and Oliver. These associates play an analogous role to the Gospel authors surrounding the Christ-in-Majesty by pointing to the verbal incarnation of Charlemagne's mythos.

The iconography of a recently discovered reference to another Charlemagne window in Alsace provides even more striking a rapprochement of Charlemagne and Christ.[58] The window, now destroyed, was in the church at Lièpvre, near Ribeauvillé.

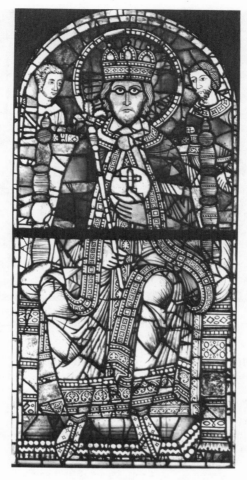

Figure 16. Charlemagne-in-Majesty, flanked
by Roland and Oliver (twelfth century). Stras-
bourg, Musée de l'Oeuvre Notre Dame.

It portrayed—under a crucifixion scene—the Virgin and patron saints of the church
distributed in three lanceolated rows. In the lower register one saw, from left to
right: kneeling, the abbot Fulrad of Saint-Denis, founder of the monastery; the em-
peror Charlemagne, seated on a throne, holding a sceptre in his hand; then Roland
and Oliver, completely armed.[59]

This configuration of sacral beings reproduces almost precisely, including the
reference to the Paschal events, the situation described by Adémar and Otto
of Lomello at Aix.

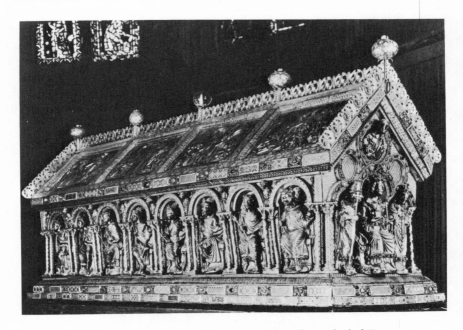

Figure 17. Charlemagne reliquary (c. 1215). Aix-la-Chapelle, Cathedral Treasury.

We come finally to the Aachen reliquary (fig. 17), dating from the first decade of the thirteenth century. This work of extraordinary beauty, more than two meters in length, must be one of the most resplendent reliquaries fabricated during the Middle Ages. Worked all in gold with precious gems embedded in the goldwork at intervals, the shrine may be seen as a figural rendering of the Light troped so richly in Eriugena's poem *Aulae Sidereae*. The shrine also was made in the image of a basilica.

Like its monumental counterparts, this basilica was constructed to illuminate man's darkness by means of relief scenes and sculptures representing all the facets of the life and history of Charlemagne. Since it was intended to review for the onlooker the salient features of Charlemagne's hagiography, it depicts four hundred years of historical tradition, both verbal and iconographic.

The reliquary would prove an inexhaustible subject if one attempted to examine the whole work. Accordingly, we must forbear to comment on more than the "façade," that part of the reliquary that would constitute the entrance to the basilica of which the shrine is a model (fig. 18).

This portal, if one may so call it, first impresses the viewer by its symmetry, the physical balance of its parts. The symbolic symmetry could hardly be less remarkable, since the two correlate precisely. Let us note at once that the presence of Archbishop Turpin on Charlemagne's left, as one of the accompanying attributes, reveals that Charlemagne, like Christ, will be celebrated as logos, as *Historia*, since Turpin plays the same role vis-à-vis Charlemagne that John

does to Christ: he was at once witness and author of Charlemagne's exploits, as we shall see in the next chapter.

The figure of Charlemagne enthroned in the center is the largest statuette on the shrine (fig. 19). In his left hand Charlemagne holds the sceptre, and in his right hand a model of the church—the same church in which the shrine stands—which he may be seen elsewhere on the shrine donating to the Virgin and Child (fig. 20). We know from John Scottus Eriugena's _Aulae Sidereae_ the significance of the church to its builder, especially when the builder also happens to be emperor.

The symbols in Charlemagne's hands represent the conjoining of the secular and spiritual realms, the _regnum et sacerdotum,_ in the king's person and authority. The symbols clearly enunciate the balance of authority, emphasizing the position of Church and Throne in the terrestrial world and the monarch's responsibility for them.

In the twelfth century this idea served as a basis for an innovation by Abbot Suger in his reconstruction of the royal abbey at Saint Denis. It led him to flank the three portals of the main façade with column statues of Old Testament kings and queens, thought to be royal ancestors of Christ. "The presence of royalty, prominently displayed on the entrance portals, was certainly appropriate to the royal abbey, and the emphasis upon secular and spiritual au-

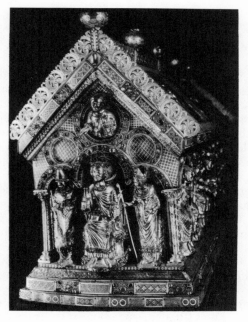

Figure 18. Charlemagne-in-Majesty. Charlemagne reliquary (detail). Aix-la-Chapelle, Cathedral Treasury.

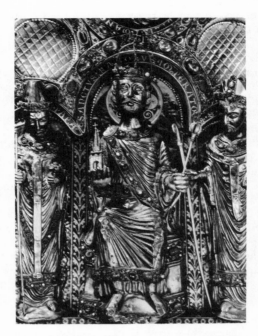

Figure 19. Charlemagne-in-Majesty. Charle-
magne reliquary (detail). Aix-la-Chapelle, Ca-
thedral Treasury.

thority was a basic premise in Suger's philosophy."[60] This innovation formed
the basis for some brilliant Gothic iconographic programs in portals at
Chartres, Rheims, and elsewhere. In other words, the extension of the *regnum
et sacerdotum* theme on Gothic portals occurred during the period when the
Charlemagne reliquary was conceived and executed.

The symbol in Charlemagne's left hand reinforces the claims of the Church
in his right. It is the symbol of authority over the secular realm, indicating
that the emperor will undertake to enforce with equity and justice the prin-
ciples of the Church in the world, just as he undertook to protect the Church
from the world. The sceptre symbolized "the mark of royal power, termed the
sceptre of rectitude and the rule of virtue, for the proper guidance of the king
himself, the Holy Church, and the Christian people. . . ."[61]

The emperor thus undertook to rule by the principles associated with Solo-
mon: wisdom and justice of divine rather than human origin; in short, the
ideals upheld, as we saw in the last chapter, by the Reichenau apotheosis of
Otto. A ninth- or tenth-century manuscript drawing now in the Bibliothèque
Nationale in Paris shows Charlemagne in this role, seated on a square-backed,
elevated throne, under a festooned portico (representing the temple), holding
the *virga*, or rod of justice.[62]

The special religious authority vested in Charlemagne may also be judged

by looking at the horizontal register of statues, whose relative proportions have been accentuated by the three niches in which they reside. It is not Roland and Oliver this time who represent Charlemagne's adjuvants, but Archbishop Turpin and Pope Leo III, both labeled as saints.

Looking at the symmetry of the horizontal register, we find that the three niches containing the statues form a triangle with Charlemagne as its center and apex. This triangle thrusts upward to form a vertical axis at whose summit we see a medallion containing a bust of the Pantokrator. Christ holds the Gospel in his left hand, while, with his right, he blesses Charlemagne. To emphasize the reciprocal nature of the vertical axis, the artist fashioned Christ's hand so that it points down toward Charlemagne, rather than having it upraised in the more usual gesture of benediction. The gesture appears the more marked by the hand's extending out beyond the border of the medallion.

The three medallions in the upper register repeat the triangular theme of the niches in the lower. But the active emptiness of the two smaller medallions—emphasized by the bright gold background and crosshatched design—above the statues of Leo and Turpin contradicts the triangular schema to some extent by emphasizing the binary, vertical axis of Charlemagne/Christ. Like the niche containing the emperor, the medallion containing Christ is not only higher but larger than the two empty ones—one more visual delineation of the Christ/Charlemagne rapport.

Charlemagne stands out here as, in the words of the *Chronique Saintongeaise,* "the light of the flesh who surpasses all earthly kings after Jesus

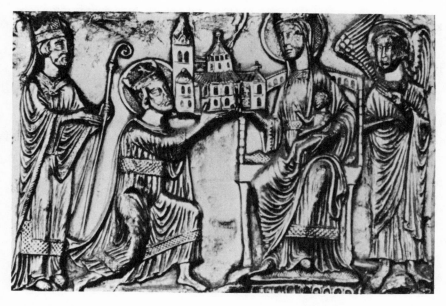

Figure 20. Charlemagne and Archbishop Turpin donating the Palatine Chapel to the Virgin. Charlemagne reliquary (detail). Aix-la-Chapelle, Cathedral Treasury.

Christ." He has thus become a principle of logos in his own right. In his being, he hypostasizes the potential of Christ to be both Word and act, that is, to generate story which transforms the disparate events of the world into a coherent text. The reliquary literally illustrates this power of Charlemagne in the relief scenes drawn from Turpin's *Historia Karoli Magni et Rotholandi* placed on the top of the shrine and in the succession of kings and emperors that encircle it. The principle of logos that gives meaning to all of these stories is, of course, Charlemagne, and then, through him, Christ.

Like Eriugena's reading of Charles the Bald's church at Compiègne, the reliquary demonstrates how Charlemagne as a generative principle of historical coherence can help the viewer to penetrate the spectacle of the intelligible world, to go beyond the fleeting events of history to recover the unity of the world as Word which time and space disperse. In effect, the *Maiestas Karoli Magni* demonstrates the Eriugenian principle that "All places and times bear equally the symbols of Christ that each age formulates."[63]

The reliquary, containing Charlemagne's bones, was solemnly sealed and consecrated in the Palatine Chapel by the emperor Frederick II on 27 July 1215. No chronicler was needed to recount, à la Adémar, the significance of this new resting place, for the reliquary itself told the story. The word and image of Charlemagne had indeed become a sign of royal beauty bright leading westward, as the nineteenth-century hymn says, to the perfect light of Christ in the world. And more explicitly, to the illumination of the Franks as the elect of God.

Charlemagne thus ceased to be the subject of narrative *tout court*. Like Christ, he became a rhetorical force in his own right, a means of generating story and meaning: specific kinds of story and specific kinds of meaning. The kind of story Charlemagne's mythos promoted was marked by the rhetorical process we have traced in this chapter. As we saw, Charlemagne could become a symbol of Christ because of the organic coherence of the synecdoche underlying the figural process, the synecdoche of the Incarnation.

The great advantage for historiographic narrative of the *Maiestas Karoli Magni* symbol lay in the ease with which history could be narrated in terms of the biaxial Christian epistemology, the historic and the anagogic, by association with the Charlemagne mythos. Although the story would be grounded in the phenomenal world, the symbolic system of the Charlemagne mythos guaranteed the possibility of a rhetoric of Salvation history. This rhetoric has not been fully appreciated, particularly in the interpretation of individual works of the Charlemagne canon. In the next chapter, we shall see the implications of the figural use of the Incarnation on the narratives which developed from the new mythos of Charlemagne.

4

Historia and the Poetics of the Passion

As one moves down the main aisle of the Cathedral of Notre Dame de Chartres, past the north transept with its handsome rose window donated by Blanche of Castile, the mother of Saint Louis, and into the ambulatory, where it begins to circle behind the high altar, one comes upon the most famous of the cathedral's history windows: the Charlemagne window. In a cathedral noted for its spectacular stained glass, this window, a perennial favorite, arrests one with the beauty of its colors, of course, but even more with the boldness of its pageantry.[1]

Its subject matter evokes the most venerable chapters of the early glory of the French monarchy and heroic age: Charlemagne's conquest of Palestine and Spain, and the exploits of his nephew, Roland, and the Twelve Peers of France.

Boldly, the iconographic program of the window conjoins elements from a number of literary sources so that the early-thirteenth-century viewer could read in pictures the full grandeur of the enterprise ascribed to Charlemagne: the conquest of a Christian *imperium* stretching from Palestine to the pillars of Hercules (figs. 21–23).

If the historical assertions convey a sense of grandeur, the anagogic elements of the iconographic program go even farther. They link Charlemagne directly to the most sacred places of Christendom and accord him a rank in the celestial hierarchy on a level with the apostles and their successors. This status derives, in the assertion of the window and its literary counterparts, from Charlemagne's role as the liberator and protector of the sacred tomb-sites of Christ in Palestine and Saint James the Great in Santiago de Compostela.

In the first narrative section of the window—the six panels devoted to the Jerusalem crusade cycle (figs. 21 and 22: the schema, fig. 21, provides the key for reading figs. 22–24)—Charlemagne appears twice in company with the Byzantine emperor Constantine, whose role in discovering and embellishing the holy sites in Palestine was considered, in the Middle Ages, second in importance only to his establishment of Christianity as the official religion of the Roman Empire. He first appears with Constantine in panel 3, but let's recall that panel 1, the "signature" panel, shows a furrier—whose guild donated the window—displaying a fur pelt to a client. Panel 2 shows Charlemagne, enthroned and nimbused, receiving a delegation of two bishops, one of whom bears a letter from Constantine recounting the dream shown in the next panel.

In panel 3, then, we see a re-creation of the divinely inspired vision in which Charlemagne, completely armed and mounted for battle, appears before Con-

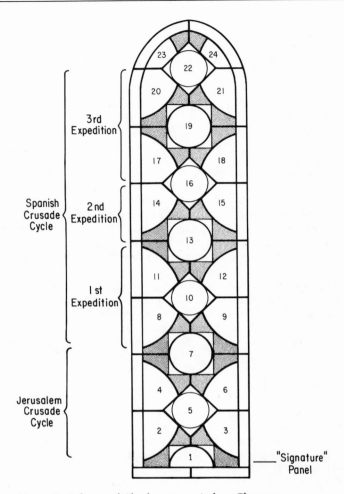

Figure 21. Schema of Charlemagne window, Chartres.

stantine in answer to the Eastern emperor's prayer that God send him a champion to liberate the sacred sites of Palestine. Then we see him, after completing this mission (panel 4), back in Constantinople (panels 5 and 6), where a grateful Constantine confers upon him precious relics of Christ's Passion, which he solemnly translates to his cathedral at Aix-la-Chapelle (panel 7).

This whole narrative sequence illustrates the "re-writing" of the Charlemagne mythos which we witnessed in the last chapter through such tenth-century texts as the *Translatio Sanguinis*. Now, however, the valorization of Charlemagne moves him entirely to the foreground. Constantine remains in Constantinople, where he confers upon his successor the symbols of his custodial role as keeper of the holy sites: the symbols of the Passion (remember that Adémar portrayed Charlemagne as having been interred with a piece of the True Cross in his crown).

The second narrative campaign of the window, the Spanish crusade cycle (figs. 23–24), also begins with a vision. This time Charlemagne lies sleeping while Saint James the Great appears before him (panel 9) to exhort the Frankish emperor to liberate the land where his corporeal remains lie "unknown and without memorial." We will have to comment on the rhetorical process underlying the genesis of these stories later. Suffice it to say for the moment that we have seen this metaleptic chain of transpositions at work before.

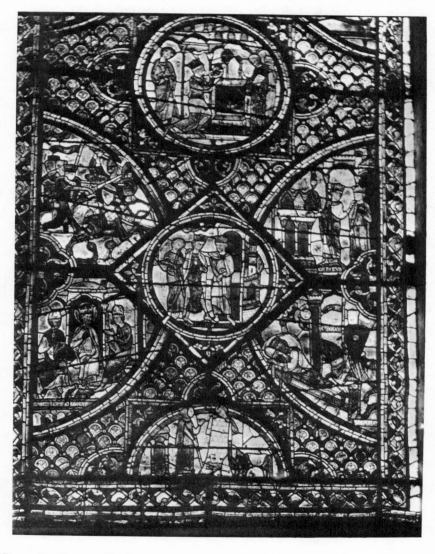

Figure 22. Chartres. Charlemagne window, panels 1–7.

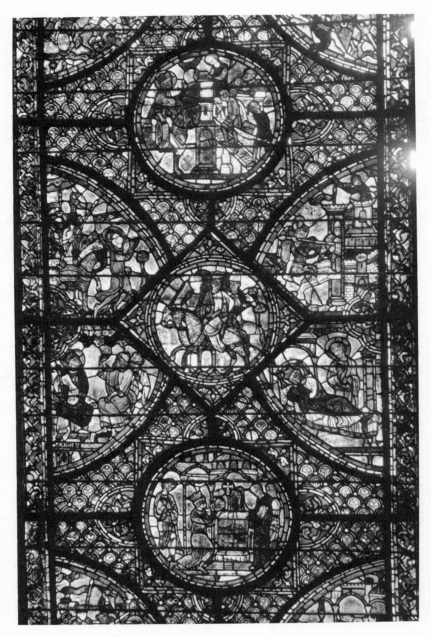

Figure 23. Chartres. Charlemagne window, panels 7–13.

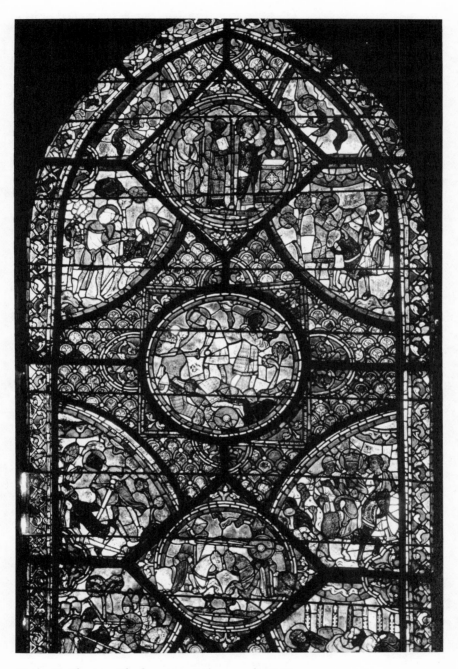

Figure 24. Chartres. Charlemagne window, panels 14–24.

Christ's tomb lay "unknown and without memorial" when Saint Helena and Constantine, according to Sulpicius Severus and other chroniclers (re)founded it; the same held true when Charlemagne, according to still later legends, restored it. Charlemagne's tomb lay "unknown and without memorial" when Otto III, Otto of Lomello, and Adémar de Chabannes collaborated on its (re)invention. The Chartrain window illustrates how the literary *historiae* which it elaborates, following the lead of its earlier model—the Charlemagne window at Saint Denis (c. 1150)[2]—realize Charlemagne's status as logos, as word and act capable of generating story, above all story which deploys the disparate events of the world in a coherent text. As foreseen in the previous chapter, Charlemagne has passed from the status of a subject of texts about tombs to the constituter of such texts.

Subsequent panels of the window depict Charlemagne accomplishing the task set for him by God and Saint James, and building, like Constantine in Palestine, resplendent cathedrals to commemorate the resting places of the Christian martyrs in Spain. The most famous of these was the monument erected over the tomb of Saint James in Compostela, which became, like the Church of the Holy Sepulchre in Jerusalem, the goal of one of the most sacred pilgrimages in Christendom.

One last panel devoted to what Abbot Suger of Saint Denis, describing his own stained glass windows, called "urging us onward from the material to the immaterial,"[3] deserves comment. The uppermost of the central register of panels as the window now appears (number 22 in our schema), the panel depicts the Mass of Saint Gilles, a less well known aspect of the Charlemagne legend, at least to modern readers of the legends consecrated to the Frankish emperor. It shows Saint Gilles saying mass before an enthroned Charlemagne. A figure holding an open book stands between the emperor and the saint, while the bust of an angel holding a scroll emerges from the frame of the medallion immediately above the altar.

According to the *Vita Sancti Aegidii*, the scroll contained God's announcement of a sin committed by Charlemagne: the incestuous union of the emperor with his sister by which the "nephew" Roland was conceived. At the same time it reveals the sin, however, the scroll announces a divine pardon for it.[4] This signal act of clemency enhanced Charlemagne's saintly status to a considerable degree. In fact, throughout the window, Charlemagne wears the nimbus, while Roland, too, acquires it at the moment of his Passion at Roncevaux (panels 17, 19, 20).

Clearly, the iconographic program of this so-called secular history window involves a great deal more than the simple account of the triumphs of heroes over their enemies.[5] The secular accounts of imperial expansion and hegemony cannot be separated from religious concerns to the point where the interpenetration of the two dimensions constitutes a basic characteristic of the narrative. And yet the anagogic component of heroic legend has often been treated as either a superficial, derivative, or secondary element of these narratives, or else an ornament applied to a fundamentally secular tale in order to help it pass muster with ecclesiastical censors. In fact, we shall find that anagogic structures of meaning are not simply one element of the narrative language among many, but, along with the historical or human structures, a fun-

damental paradigm for narrative meaning. The most solemn moments of the epic hero's existence were cast, rhetorically and semiologically, as a metaphor of a corresponding moment in the life of Christ or an important apostle, although the Christ analogy generally prevailed.

Form as Meaning: Iconic Structure

If we look at the schematic organization of the Charlemagne window, its iconological structure, we can see how strikingly it brings out and reinforces the historic/anagogic pairing which we found in the story. Scholars have long recognized that the patterns within stained glass windows, constituted by the supporting armature and leading which held the glass in place, were regarded, in the Middle Ages, as an expressive form in their own right. The patterns traced by the leading and armature within windows in a vast edifice like Chartres astound the viewer by their complexity and variety. For just as the stories told by the painted glass differ from window to window, so, too, do the patterns.

As Henri Focillon observed, the techniques for this symbolic expression had been borrowed from the art of the goldsmiths, with lead replacing the gold filigree. "Le plomb," said Focillon, "n'est pas monture seulement, il est dessin, il est valeur. Il écrit puissamment la forme et il fait chanter le ton."[6] Recent observations linking the stained glass programs, as well as the sculptural programs of twelfth-century churches with the symbolic systems of Pseudo-Dionysius and Eriugena suggest that the iconic signification of the windows should help our understanding of the way in which symbolic structure constituted a separate but related kind of meaning production to narrative discourse itself, whether iconographic or verbal.[7] At any rate, although the narrative panels of the Charlemagne window at Chartres, and what remains of its precursor at Saint-Denis, have been much-studied, I have not found a close reading of the iconic signification of the Chartrain window. And yet such a reading tells us a good deal about structures of meaning in Romanesque art.

If we ignore the actual scenes depicted in the window and concentrate instead on the interplay of forms which frame the images—and which provide the armature and leading of the window—we note that the shapes resolve into a varied, but purposed repetition of lozenges, spheres, hemispheres, and squares (see fig. 21). By their distribution over the space of the window, these geometric shapes create a coherent pattern which generates a polysemous meaning of its own.

The shapes may be taken as a whole pattern; they may be grasped in several different kinds of small-group patterns; they may be construed as three vertical columns; and finally, they may be considered as they are "read" when one follows the narrative content of the panels: horizontally from left to right in a vertical progression.

If we consider the window as a whole, the vertical central column dominates by the dual fact of its centrality and its visual variety: it consists of alternate spheres and lozenges as opposed to the unvaried hemispheres which characterize the vertical register on either side. In addition, the shapes of the central vertical column retain their integrity—complete and undivided—

Figure 25. Charlemagne window, lozenge/circle unit.

whereas the flanking shapes are hemispheres further divided into an upper and lower "chamber."

The shapes themselves mean. As Georges Duby recently reminded us, the linking of squares and circles was a common symbolic device for expressing the interrelationship of heaven and earth: the circle symbolizing heaven, the square, earth.[8] In the central column of the window (fig. 21), the circles—enclosed by much less boldly delineated squares—alternate with diamonds, or lozenges, which initially strike one simply as a variation on the square motif. Upon closer examination, we see that the rhombus-shaped configuration of the lozenge makes it the crucial link between the circle and the square. In other words, the three geometric patterns constitute a tripartite grouping in which the middle, or linking, element, the diamond, brings the other two together to make a unit of signification which may be "read" tropologically.

With its axes pointing both vertically and horizontally, the diamond shape literally represents the horizontal and vertical progression by which one reads the narrative images. Notice also how the lozenges frame circles, just as the squares do, but in this case we do not find a difference in emphasis. The squares, remember, are fainter than the boldly inscribed circles they contain. The lozenges, on the contrary, stand out just as boldly as their contained circles. Another detail underlines this reciprocity between the circle and the diamond enclosing it: fleur-de-lys filler designs occupy the interstices between the edge of the circle and the apices of the diamond (fig. 25).

Figure 26. Charlemagne window, septiform cluster.

The diagram makes it plain that the only space for a picture lies within the circle. At the same time, the circle and its picture lie within the lozenge that frames and contains. The full import of this should be apparent in a moment.

Look first at the presentation of the circles in the central column as compared to the lozenges; the former stand alone, whereas the latter form the center of a cluster of panels. In addition, the circles connect to one another, in the central column, through the intermediary of the vertical axis of the lozenge. Note, too, how the other axis, the horizontal one, also connects with a circular form: it penetrates into the upper and lower registers of the laterally placed hemispheres on either side of the central column. In this way, the lozenge must be seen as the center of an image cluster extending horizontally and vertically from the circle it contains (fig. 26).

But if we look at the window as a whole, we see clearly that the lozenge does not simply constitute an image cluster per se; it permits the possibility of a certain kind of image cluster, a paradigmatic one capable of repetition. And, as we know, the image clusters with the diamond-and-circle at their center do recur regularly in a pattern whose significance will become clearer shortly.

Now what is the lozenge and why? The circle and the square possess clearly established symbolic meanings; no less so the diamond. Its symbolic valence may be divined initially from its function in the geometric symbolism of the window: to connect and relay the squares and circles, to establish a vertical and horizontal narrative space; in short, to contain and mediate the symbols

of heaven and earth. Projected back on the plane of symbolic equivalences, that is precisely the function of Christ's Passion in Salvation history, and the symbolic value of the lozenge.

As a shape, the diamond connects the perimeter of a Greek cross; that is, by connecting the ends of a cross whose horizontal and vertical pieces are of equal length, one forms a diamond. Now, if instead of filling in the cross whose outline has been inscribed, one were to substitute a circle in the same space, an even stronger meaning for the image emerges. For the circle is the sign of the Trinity, the whole central drama of the Passion, from Crucifixion to Pentecost. Both circle and cross represented Christ, which is why the iconographic sign for Christ was the nimbus with the Greek cross overlaid on it.

What we see in this interplay of signs and symbols is not the application of symbolic equivalences in a literal manner, but something richer, more complex. When we think about the interplay of shapes, it is clear that we have been witnessing a whole series of transpositions or substitutions involving rhetorical or figurative processes: metaphor, synecdoche, metonymy, and metalepsis. These figurative processes imbue the syntax of the geometric structure of the window with their affective and intentional power. They enable virtual shapes to signify by making conspicuous the symbolic or indirect nature of meaning.[9]

The circle, symbol of the Trinity, occurs in consequence of the cross, symbol of the Passion, but after the Resurrection; that is, after the Revelation of Christ as Logos. But, as we saw in the previous chapter, the Trinity completes the Resurrection by permitting man to be logos, to take the paradigm of divine speech for his own. Thus it conveys the commutative property of the Passion, its power to be repeated by man; in other words, the guarantee that man, too, can participate in the procession from and return to the One.

Narrative sought to make conspicuous this commutativity of the Passion by showing how exemplary humans could repeat, in their own history, the trajectory of the Logos. Figural language played an important role in this project, since, according to influential thinkers of the period, it was through the symbolling activity of humans that divinity manifested itself: "The Divine Essence will appear not in itself, but through the intellect and in intellects."[10] Together with the notion that "God is both the maker of all things and made in all things,"[11] we can understand how in such an expressive system the signified—or a symbol of it—could be contained in the signifier; intention in expression. In short, we see why this language needed to internalize symbols constitutive of its purpose.

We noted the cross-shaped fleur-de-lys in the apices of the lozenge, and how the diamond shape evoked the cross. If we look at the whole image cluster formed by the lozenge or, indeed, at the pattern of geometric shapes over the window, we find that their coherence derives from the septiform principles by which they have been distributed. These septiform elements may be found in the vertical central column—divided into three spheres and four lozenges— and in the organization of the smaller groupings of spheres, diamonds, and hemispheres. These smaller units, the septiform clusters (fig. 26), comprise the basic structural unit for the organization of forms in the window.

As figure 26 illustrates, the septiform cluster consists of three vertical units

(a diamond and two spheres), and four horizontal units (the two halves of each hemisphere flanking the lozenge). At a glance, we can see that the septiform cluster organizes the three basic shapes found in the window into a unified form: that of a schematized cross; in fact, the cross suppressed in the lozenge. As one progresses from the bottom of the window to the top, the septiform cluster repeats three and a half times. Accordingly, the viewer who "reads" the window will find the narrative inscribed in a context of compelling cruciform imagery.

This visual symbolism cannot but have an effect on the way in which we construe the story, particularly as regards the interrelationship of the historic and anagogic elements. The sign of the cross, repeated so manifestly by the septiform clusters and evoked immanently by the other septiform elements, not to mention the references to the Passion sequence made by the lozenge, must have been seen by the artist as relating significantly to the story depicted in the historiated images. Something in the structures of meaning of the literary sources on which the artist drew, and their subtexts, must have suggested the appropriateness of so insistent a reference to the Passion.

Space will not permit discussing all three texts on which the window bases its synthesis of the Charlemagne legend,[12] but even a quick reading of the source for the Spanish crusade, the *Historia Karoli Magni et Rotholandi*, reveals that the nimbused Roland and Charlemagne who triumph over original sin and Saracens in the Chartrain window are the products of a semiotic process whereby the historic and anagogic are carefully correlated in a system of oppositions based upon a model derived from Christ's Passion.

Before taking up the question of the *Historia*, however, it will be useful to go back even further than the end of the eleventh century, or the early twelfth—the dating of the *Historia* remains moot[13]—to examine manifestations of cruciform symbolism in the religious art and literature of the early eleventh century.

The Augmentative Aesthetic

The Charlemagne window at Chartres demonstrated the conscious and *parallel* elaboration of form and content in an artistic setting where form possessed an independent meaning correlative to, but still separate from the historiated images of the iconographic program. Historiated images, on the one hand, and the framing context of spheres, lozenges, and hemispheres organized into cruciform clusters, on the other: both must be taken together, but they function oppositionally. Each has its own syntagmatic elaboration which relates to the other by reciprocal implication. The proof that each may be read as an independent signification may be seen in the fact that each may be referred to a referent outside of and independent of the other.

Henri Focillon called attention to this characteristic of Romanesque aesthetics in discussing ecclesiastical architecture: "Another feature which should be emphasized is the legibility of the parts. Each one was designed not only to fulfill a function, but also to proclaim it both inside and outside the church."[14]

The term *augmentative* (French "additif") has been used by some art histo-

rians to describe the paradox in Romanesque architecture of a form in which each part may be viewed at once as an independent statement and as a subordinate element contributing to the constitution of a coherent whole. Speaking of the façade of the cathedral of Trèves, Louis Grodecki describes this tendency as follows:

> It would be hard to imagine a better illustration of the thesis which defines the structure of space in Romanesque art as "augmentative" ["additif"], composed as it is of juxtaposed parts each of which may be perceived independently; a complex that unites, as distinct elements, towers, turrets, apse, portals, this façade gives rise to a maximum potential for forms where no liturgical function is sacrificed, no novelty refused.[15]

Whatever term one uses to identify the phenomenon, however, the essential point to bear in mind is the paradox that coherence derives from compositeness, unity from diversity. Perhaps a more accurate term than *augmentative*— which denotes the aesthetic process very well, but not the symbolic inspiration for it—would be *triune*, for it is the analogy of the trinity which clearly underlies the structural principle of coherent compositeness.

Triune aesthetic also reminds us that the expressive processes at work here belong to the domain of artistic or poetic language. To make a coherent statement from diverse elements, where the base elements remain visible—thereby rendering the statement richer and more complex by permitting an association of ideas that would not otherwise be apparent—constitutes a fundamental property of metaphoric expression: its comparative aspect. As Nietzsche pointed out, "Metaphor is a brief comparison, just as, in return, comparison may be designated as 'amplified metaphor.'"[16] The triune aesthetic permits context, form, and structure to provide an intentional setting for historiated content, a setting which signifies in its own right. This signification constitutes the element of directed vision identified in the first chapter—a kind of prereading of the story by the author or artist inscribed in the form or structure of the work.

Recent studies on the relationship of liturgy and architecture show how this principle could link architecture and ritual, text and context in the eleventh century. The triune aesthetic established a correlation between ritual space and architectural space so compelling as to bring about the modification of ecclesiastical architecture to accommodate symbolically structured liturgical rites.[17] The church edifice, under this impulse, gradually changed from a series of parts each more or less detached and set off from the others[18] into a complex but unified whole with open, flowing spaces, a condition that facilitated the elaborate, symbolic liturgical processions that had become so significant a part of religious expression by the eleventh century. According to the principle of the augmentative aesthetic, architectural space had come to be viewed also as liturgical space, space that could be used to enhance the liturgy, and the two functioned conjointly to interpret in exciting ways the principal symbol of Christianity: the cross as representation of the historic and anagogic characteristics of Christ.[19]

The French art historian Carol Heitz recently studied the conjunction of cruciform symbolism and liturgical offices in the pre-Romanesque period in a

fascinating article entitled, "Architecture et liturgie processionnelle à l'époque préromane."[20] Heitz points out, among other things, that we can scarcely comprehend the pervasiveness of cruciform symbolism in early medieval thought today, although it is possible to get some idea of its extent from the fact that it underlay rites as basic as the fraction of the host into seven parts disposed on the paten in the form of a cross during the mass. This simple act could be seen and comprehended by an individual observer.

But cruciform principles informed much more extensive and complex rituals whose effect could not be perceived by a single observer, let alone by the participants as a whole. Records exist, for example, of intricate liturgical processions during which hundreds of participants, simultaneously following different itineraries, each one coordinated with the others, visited the different chapels and altars in the church. These processions were "regularly performed by the monks according to a precisely codified processional choreography."[21]

The description of the processions comes from the late-eleventh-century chronicle of the old Norman abbey of *Centula*/Saint-Riquier by one of its monks, Hariulf.[22] These processions, according to Hariulf, quite literally sought to inscribe the figure of the cross by their complex movements. They expressed this purpose at least twice: symbolically by the septiform principles of the choreography, and literally by the cross-shape traced by the itinerary:

> Transposing these itineraries into diagrammatic form reveals a harmonious and powerful orchestration. The second itinerary is especially revealing. While the monks progress in *four* movements from one liturgical pole to the other: from the Holy Savior (on the west) to Saint-Riquier (on the east), they recess to the Altar of Saint-Maurice in *three*. The sum of the combined movements gives the number seven. The "septiform" order also appears in the division of the itineraries: four movements are performed together, . . . three, separately. . . . The liturgical choreography allowed them to give thanks to God in a beautiful "pilgrimage" interspersed with prayers . . . at altars arranged in the form of a cross.[23]

Heitz feels that the ultimate expression of this symbolic conjunction of setting and ritual may be found in the description given by Hariulf of the great Easter procession at *Centula*/Saint-Riquier. To appreciate it, we must remember that the monastery of *Centula*, founded by Angilbert, a nephew of Charlemagne, had a tower church dedicated to the Savior. This is the left tower in a seventeenth-century engraving of the monastery (fig. 27).

Like the martyria discussed in chapter 3, the huge edifice of the tower church, Saint-Sauveur, at *Centula* served to set off the crypt, or tomb space, which contained the most precious treasure of the abbey: twenty-five relics of Christ. Not only the relics of Christ had been brought back from the Holy Land; the design of the church itself, like Charlemagne's Palatine Chapel at Aix, was intentionally linked to the Church of the Holy Sepulchre in Jerusalem.[24]

It was not sufficient that the church and its sacred contents provide the sole commemoration of the Holy Sepulchre, however. At the mass of Easter Sunday, some fifteen hundred celebrants and participants distributed themselves in the Turris Sancti Salvatoris in a manner which made the tower church a huge cruciform with people, ritual objects, and relics filling in the symbolic

Figure 27. The abbey of *Centula*/Saint-Riquier, 1673.
(Paris, Bibliothèque Nationale)

outline of the cross framed by the edifice. This ritual gesture briefly transposed
the church from a symbol of the tomb space where the Resurrection occurred
into a metaphor of the Passion place and sign. In the ritual, the human partic-
ipants became figurations of the "lignum vitae" of the cross, as well as of the
human/historic aspects of Christ transposed, in a paradigm of grace that would
have import for all humans in the belief of the time, by the miracle of the
Cross. The participants, in Hariulf's words, thus "demonstrated the septiform
grace of the Holy Spirit."[25]

In this cruciform tableau (fig. 28), the celebrants and participants occupied
positions consonant with their real-life relationship to the sacred and secular.
Thus, the lay participants, belonging to the temporal domain of space and
human history, took positions in the tower church in such a way as to form
the arms of the cross, the men being separated from the women, as was the
custom of the period. The women occupied the south arm, the side corre-
sponding in Last Judgment scenes to the sinister, or hell-side, of Christ. The

men assembled in the north *augmentum*, to form the right arm of the cross, the side reserved for the elect in Last Judgment scenes.

The monks who celebrated the mass and who by vocation were the *sacerdotes* representing the anagogic realm occupied the center of the tower, on the vertical axis of the Church/Cross, directly over the *capsula major*—the reliquary of the Savior—and immediately under the high church and spire, that part of the edifice which sweeps up and points to heaven. Metaphorically figurations of Christ and the apostles, the monks stood at the nexus of the horizontal and vertical members of this living cross. On the transverse register, they stood between the two lay groups, signifying at once the connection between sacerdotal and secular humanity symbolized by Christ, the teacher, but at the same time marking the difference achieved by separating themselves from the world. Their simultaneous position on the vertical register marked this difference.

Occupying that part of the cross which in a crucifix would correspond to the torso of Christ, the monks comprised the sole living elements of the vertical register, thus emphasizing their literal and figurative status as *homines eruditi* already embarked upon the ascent toward the One. Their example mediated this halfway state for the laity, who—like the figures on the lintel at Autun—

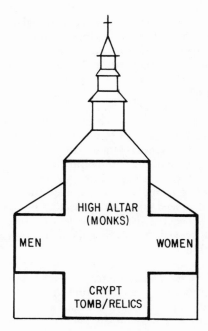

Figure 28. Diagrammatic representation of the Turris Sancti Salvatoris at *Centula*/Saint-Riquier during the Paschal Mass.

had to complete their trajectory on the horizontal path before beginning the
ascent toward the divine essence. In this tableau, the monks played the same
role, connecting the two registers through their own meaning and position, as
the lozenges in the septiform clusters of the Charlemagne window at Chartres.

In studying the diagram (fig. 28) of the Paschal ritual at *Centula*, we should
bear in mind that Hariulf, who described the office in his *Chronicon Centu-
lense*, firmly believed that the Turris Sancti Salvatoris had been built as it was
precisely to accommodate such ritual enactment of cruciform symbolism.
Like the Chartrain window, Hariulf's *Centula* and its rites demonstrate the
aesthetic of coherent compositeness, the triune concept in which the figura-
tive and literal use of cruciform symbolism logically ties together elements
from a number of different media, not excluding human ritual gesture. Above
all, we should note Hariulf's assumption that the historic and human natu-
rally serve to denote their opposites, the anagogic and eternal: the living tab-
leau in the Church of the Holy Savior on Easter Sunday quite literally obliged
the celebrants to mime their trajectory in Salvation history.

The Passion in Art and Literature

We can scarcely understand such an intensely emotional involvement with
the cross cult in the eleventh century unless we also comprehend the value of
the Passion at that time. This evocation of the crucifixion of Christ with its
human witnesses, Mary and John, provided seemingly inexhaustible inspira-
tion for artists of the period. In their carvings, manuscript paintings, and writ-
ings, the Passion became a metonymic evocation of the whole process
whereby ordinary humanity might triumph over the physical and social limi-
tations of worldly history. What fascinated people at that time was the paradox
of the Passion. A historical event, taking place at a precise moment in human
time—more significantly still, at a specific moment of the linear time seen to
circumscribe world history, that is, the middle of the temporal span whose
beginning was the Creation and Fall told in Genesis and whose end would be
the Apocalypse and Last Judgment—the Passion nonetheless contradicted his-
torical determinacy. Instead of the ending intended by its human perpetrators,
the Passion turned out to be a beginning; a guarantee that the second and
greater life—for those condemned to experience the dismal everyday life of
medieval Europe—did indeed come after "death." By putting death in quota-
tion marks, by showing that it was but a necessary passage, the Passion, as it
was then interpreted, proved that God spoke a language not governed by the
rules of human speech or thought.

Fulbert of Chartres, who died in 1027, the most learned man of his time and
to whom we are indebted for constructing the crypt of the present Cathedral
of Chartres, provides a key to understanding the affective attachment of the
people at this time to the Cross and Passion as liberating forces in human
history. Fulbert treats the Cross and the Passion less as subjects for didactic
exposition than as the generative elements of language. In a Latin poem, "De
Sancta Cruce," he tropes the cross as a living symbol. Through an intense
apostrophe, Fulbert's text conveys to us the rhetorical potential of this symbol
to convey meaning in those emotional and subjective terms which penetrate

so deeply into the individual consciousness in exactly the way Nietzsche described.[26]

Fulbert tropes the cross as a personified synecdoche for Christ, a Christ who metaphorized in his own *historia* the *historia* of humanity; he did so, Fulbert shows us, by revitalizing a dead metaphor. Death was a consequence of the Fall; a continual expulsion from meaning to nothingness. Fulbert, drawing upon a prominent Eriugenian concept, shows how Christ made death a metaphor for a new genesis, but a genesis beyond irremedial lapse; a genesis in which humanity can participate because a genesis in which the language of God can be approximated by the language of man.[27] Salvation history constitutes a series of dual references, of double meanings: Christ, Fulbert shows, achieved the ultimate in paradoxical expression not simply by dying in order to live, but by expressing a double story in this act, the story of the Fall and the Passion.

A commonplace in the typology of the period, this duality creates the expectation of biaxial signification. We can see how natural a basis for rhetorical structure it was by observing the facility with which Fulbert interweaves double meanings in the language of his poem so that almost each phrase, indeed many individual lexical items, expresses the dual referentiality whereby the language of the Passion also evokes the language of the Fall. In this way the Passion rhetoric literally deconstructs the lapsarian imagery which thereby assumes a new figurative reference as a trope on the Passion.

> August Standard of the all-ruling King,
> O Holy Cross, outshining all heaven's stars,
> You alone restore to those who fell through the taste of death,
> The remedy of life, bearing an eternal fruit.
> You I worship, you I confess, and, prostrate on my knees, I revere and adore you.
> Christ the beginning, end, resurrection and life,
> Reward, light, rest, glory of the saints and crown,
> The Lord who offered to redeem his servants,
> By hanging from you with a tree's help took away the poison that came from a tree,
> And opened again the closed doors to life.[28]

"And opened again the closed doors to life . . . ": Fulbert could hardly have found a more striking example of the rhetorical force of the Passion as mediator between the universal and the intensely subjective. The remainder of the poem illustrates this point by troping Fulbert's own life as an example of the transposition brought about in the potential meaning of "ordinary" human and historical existence by the Passion as genesis. Fulbert himself thus becomes the object—one of the servants liberated by the Lord (line 9)—of Christ's gestural discourse: "The Lord who offered to redeem his servants / By hanging from you with a tree's help took away the poison that came from a tree."

The vertical/horizontal axes evoked by the imagery acquire syntagmatic reinforcement by Fulbert's assertion of equivalence between himself and his flock and the scriptural servants. We find, then, two constant levels of spatial and temporal reference—the *in illo tempore* and the *hic et nunc*, the *in loco sancto* and the *in loco isto*—corresponding to the equation of Scripture and Fulbert's own text, that is, of Logos and logos. The interplay of referentiality

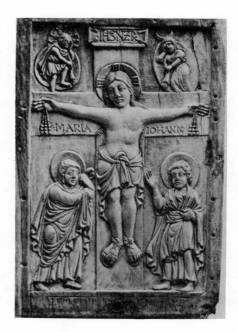

Figure 29. Crucifixion, German (ninth century).

shows how meaning can be generated between the two axes of signification: Fulbert simply makes his own example follow the biaxial pattern established for the story of Christ. The two stories, paradigm and exemplum, thereby reflect one another while at the same time authenticating each other. That is, the model serves as an "authority" for the exemplum, while the exemplum guarantees the "truth" of the model by realizing it in the here and now.

All of this illustrates very well how the augmentative aesthetic generates incremental signification, that is, signification surpassing that which could possibly be attributed to the parts taken separately. It also suggests the extent to which the cross as sign tended to reproduce itself, to encourage replication within the texts of stories which took the Passion as a model and in their form. Early manuscripts of Hrabanus Maurus's poem, "De Laudibus Sanctae Crucis," tend to have figural images of the subject overlaid on the text or else to have the text laid out on the manuscript in cruciform.[29] We may better understand this penchant for cruciform imagery and narrative if we now look briefly at some examples in art.

The Rhetoric of the Image: "Reading" the Passion in Ivory Sculpture

One of the richest sources for our understanding of the augmentative aesthetic of cruciform symbolism in the early Middle Ages may be found in the ivory sculpture and manuscript illuminations of the period. The corpus of ivory

carvings was collected and published by the German art historian Adolph Goldschmidt in the early years of this century.[30]

Representations of the Passion in this corpus are frequent and of two basic kinds: those giving the minimum number of iconographic details required to constitute the signifying unit which we call a "Passion," as distinct from a simple crucifix, and those representations which have been expanded to include details of the eschatological events preceding and following it. The latter sometimes include everything from the Fall to the Last Judgment.

Let us look at two examples of the first kind of Passion, that reduced to the essentials. During the period that concerns us, three pairs of elements proved sufficient to signify "Passion": Christ affixed to the cross; Mary and John the Evangelist (with a book or scroll); the sun and the moon. The placard giving the abbreviation for "Iesus Nazarenus, Rex Iudaeorum" sometimes appears affixed to the head of the cross; at other times, the Hand of God replaces it.

Figure 29 shows a relatively simple ninth-century German example of such

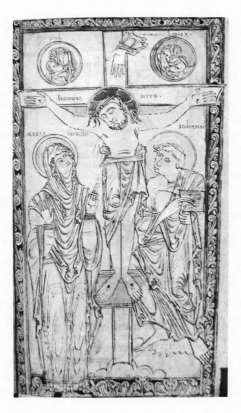

Figure 30. Crucifixion, Winchcomb Psalter, British (eleventh century). (Cambridge University Library, MS Ff. 1.23. 88r)

a Passion. Looking at it, we immediately discern two levels of visual signifi-
cation: a prominent foreground consisting of the large figure of Christ and the
very wide cross in contrast to the smaller figures of Mary and John and the
personified sun and moon. Because of the disposition of the cross, its emphatic
division of the image field, we have to regard the background figures in two
horizontal registers corresponding to the transverse member of the cross that
divides the image field in half. The Crucifixion being the event which placed
Christ at the nexus conjoining the secular and the anagogic, the historic and
the eternal, it is natural that Christ and the cross be the dominant figures in
the carving.

 This Christ, as opposed to the Christ in the tenth-century Winchcomb Psal-
ter illumination (fig. 30), is not a dead or dying figure, but a living Christ—
even down to the sandals on his feet, indicating his readiness to walk the road
to Emmaus with his disciples—who bears on his body the dramatically height-
ened stigmata of real death.

 The main thrust of Christ's figure in the carving, aided by the wide cross, is
vertical, although the arms of the cross, and Christ's own carefully modeled
arms and hands, with the streams of "living" blood flowing from them, do
throw the horizontal register into secondary prominence. Since the basic mes-
sage of the Passion concerns the simultaneity of Christ's participation in the
historic and anagogic, the composition must establish the biaxiality of the
narrative. Our "reading" of the scene will necessarily relate all the other ele-
ments to the two axes posited by the dual central image: Christ and the cross.
As in Charlemagne's window at Chartres, the formal structural elements di-
rect our interpretive reading, or at least seek to do so.

 Fulbert's poem to the cross stressed the elements of logical contradiction
inherent in Christ's Passion through the use of such rhetorical figures as irony,
oxymoron, syllepsis, and synecdoche. Interestingly enough, we find the visual
equivalent of these tropes expressed in the carving.

 The conflict of opposing tensions—life-death, history-anagogy, human-di-
vine, light-darkness, darkness overcome by death-as-life—inscribes itself in
the image by what we can only see as a contradiction in its mode of self-pre-
sentation. We find it impossible to read the secondary elements of the image
field other than horizontally. Yet, we shall also find that the horizontal regis-
ters are meaningless without reference to the single vertical register, which
itself cannot mean without the participation of the horizontal registers. The
three horizontal registers superimposed one upon the other form an ascending
unit of signification; they must each be read horizontally, but taken together
they form a whole story which can be understood only by reading "up," that
is, from bottom to top.

 The horizontal registers, then, imitate the vertical axis and, in so doing,
contradict themselves. This sense of contradiction turns out to contribute an
important part of the meaning conveyed by the image, which sought not to
resolve the conflict of opposing axes but to state it; to assert flatly that this
asymmetrical symmetry disclosed a central existential truth of Christ's Pas-
sion: that once and for all the vertical connection of heaven and earth, through
the Word, proved dominant over any worldly meanings. In short, the conflict
re-presents—in the sense of making immediate—the vertical thrust of the
Word-God across the varied forms of human discourse to prove that time, not

space, is the issue because theophany rather than history finally constitutes the signification of such reiterations of the Passion. The rhetoric of the image, in other words, sought to prove the primacy of the temporal—the passage from time to eternity—rather than the spatial in all representations of *historiae*: "In principio erat uerbum." The point may seem obvious here, but we must understand it in an obvious context before passing to texts where its presence has not been perceived.[31]

This asymmetrical symmetry, a kind of oxymoronic structure, governs the reading of the whole image. First of all, the four secondary figures present themselves in semiprofile, as opposed to the frontally portrayed Christ. Since the lateral figures turn toward Christ, the eye naturally moves from them horizontally back to the central, primarily vertical figure. The gestures made by the lateral figures also direct the viewer's gaze back toward the center, where the attributes of Christ, the cross, cruciform nimbus, the *écriteau*, and Christ's body itself command attention.

But if the lateral figures look and gesture toward the center, they also indicate one another: each pair of lateral figures forms a symmetrical unit constituting a horizontal register in that part of the picture. That horizontal unit— below the arms of the cross and Christ for Mary and John, above, in the case of the sun and moon—also determines how we experience these figures as signification, how we "read" them. Syntactically, each secondary element forms a pair with its opposite number; each requires the other to signify, and that signification can occur only horizontally. At the same time, the symmetry of each of these horizontal units fails of completion because of the vertical thrust in its center of the Christ mass, which reminds us that, taken singly, the horizontal units have no meaning.

Mary and John, taken in conjunction with Christ, constitute narrative units of signification within the larger story of the Passion. They are secondary elements in that larger *historia* because without the dominant, central Christ which separates and yet connects them, their story possesses little historical import and no anagogic significance.

Similarly, in the upper register, the personified sun and moon shown in postures expressive of mourning—the inverted torches signifying the darkness during the hours when Christ agonized—derived their significance from the Christ figure toward whom their heads bend and their inverted torches point. Their grief-stricken attitudes, as well as the symbols of personification, would be meaningless in themselves. Taken in conjunction with the central Christ figure, they become discrete units of meaning and complete the concept of universal mourning introduced in the lower register where Mary and John figure human grief.

One other set of elements in the carving reinforces the subordination of the horizontal register to the vertical while at the same time providing a concrete image of the textual foundation for the whole scene: the words in the carving. They stand out because of their difference from the other visual components, because of their dual function as visual element and textual element pointing to the larger text underlying the whole scene.

As text in their own right, the words provide a commentary on the images, reproducing the groupings by threes which we saw in the lower and upper registers of the carving. The words do not simply overdetermine the signifi-

cation of the images, however; they realize the irony, or, more properly, the ironic reversal by which the Passion attains its principal meaning.

Besides functioning as labels for the figures within the carving, "Maria" and "Iohann" disclose the full significance of the title IHSNZRX at the top of the vertical column. For the Romans an ironic, even scornful, epithet, this title assumes literal and figurative value for the medieval Christian precisely because of the divinity of Christ revealed by the Passion, as attested particularly by the roles of Mary, the Virgin Mother, and John, the witness and author. These functions remain tacit in this carving, but in the next illustration (fig. 30) they surface as a specific part of the verbal text within the illumination. There the term "Uirgo" completes the label "Maria," while "Iohann" carries an open book or square piece of parchment on which is written "et ego vidi et testimonium."

The visual disposition of the words in the carving also realizes the symbolic message. The human names "Maria" and "Iohann," distributed on the horizontal arms of the cross, form the base of a triangle whose apex is the label IHSNZRX at the head of the cross. Whether one reads from apex to foot or foot to apex makes little difference. Either way, we find the circular progression from divine to human, human to divine; in short, the story of Christ, whose critical moment of transition from human to divine—a passage revealing his original divinity—occurs in the Passion here depicted. The virginal conception figured by Mary, and John's "In principio erat uerbum et uerbum fuit Deum" attest to this progression. The ease with which these disparate elements combine into one structure of meaning, while retaining their potential for independent signification, illustrates yet again the principle of the augmentative aesthetic.

Our reading of the carving discloses how the minimal units of signification work to confirm our identification of the scene as a "Passion." But it is more than the simple accretion of minimal elements of visual meaning that makes this image a coherent unit identifiable as a "Passion." That would require our taking the image in isolation, our ignoring a whole set of references which it makes; in short, ignoring the underlying text, whose indicators figure so prominently in the image field itself. The interest of the scene, hinted at in the title "Passion," arises from the interplay between textual reference and visual image, on the one hand, and the oppositional tension rendered by the shifting emphasis between vertical and horizontal axes on the other. Indeed, the dynamics inherent in the asymmetrical symmetry we have analyzed derives from the knowledge of the original text(s) continuously evoked by the carving.

To begin with, the scene elaborates these texts, one of whose authors appears holding a representation of his gospel. These original texts give rise to commentaries which point to the specific importance of this moment and scene as crucial to the meaning of the whole story. They also stress, as we saw in Eriugena, the concept of procession and return, the dominance of the vertical and anagogic over the human and historic. They privilege John over the other Gospel writers,[32] point out the multivalences of Mary, the cross, and so on.

We cannot take the carving as a simple representation of the original Gospel

text, then, since it illustrates not only the *historia*, or Bible text, but also the *theoria*, as Eriugena calls the theological elaboration of biblical texts.[33] This point helps to explain why structures of meaning in Romanesque art forms tend to incorporate interpretive symbols as well as the basic narrative; or, to put it slightly differently, why Romanesque art privileged forms that include story and commentary; in short, why they affect the augmentative aesthetic. The point, Eriugena says, is not simply to present the two in their different spheres, but above all to show that they do not conflict, that, on the contrary, their apparent differences finally cohere to constitute the basic harmony of the Christian world view.

Accordingly, in our ivory carving and Psalter illumination, we find this biaxial meaning production with incremental enlightenment as we move from the literal, historic axis to the figurative plane inscribed on the image field. Thus the triangle of historiated figures distributed in the lower register—Mary, John, and Christ—is simultaneously replicated *and* transformed rhetorically to another register of meaning potential—the verbal or textual realm of *theoria*—by the triangularly disposed words in the upper register: MARIA, IOHANN, IHSNZRX.

Cruciform Semiosis in *La Passion du Christ*

The interplay we have just witnessed between literal meaning and figurative interpretation suggests some of the ways by which cruciform symbolism, or, more properly speaking, cruciform semiosis, imparts a more complex dimension to biaxial narrative.[34] We may confirm these tendencies, as well as understand the essentially rhetorical basis of the meaning structures generated by cruciform semiosis, in one of the earliest extant vernacular literary works, the Franco-Provençal *Passion du Christ*.

This largely unexplored work, also known as the Clermont-Ferrand *Passion*,[35] probably dates from the late tenth century, judging from its language, an interesting mixture of Occitan and Old French. In 129 quatrains of assonanced, octosyllabic verse, the poem recounts in detail the events of Christ's Passion from Palm Sunday to the Ascension. As a result, it explicitly inscribes in its text the ironic reversal between the meanings of triumph and tragedy invested in these events by the Gospels. Whereas the latter leave the reversal of meaning virtual—part of the veiled predictions Christ makes to his disciples prior to the events (for example, John 15, 16)—the Clermont-Ferrand text emphasizes the Passion as rhetorical transformation on two levels—triumph-tragedy/tragedy-triumph—occasioned by the cross.

This fascinating work merits study in its own right. Unfortunately, we can examine only that aspect of it dealing with the reciprocal significations projected by the Christ/Mary equivalence.

The Clermont-Ferrand poem sought to direct attention to Mary's role in rendering explicit the biaxial nature of Christ's story in several ways that play upon figural parallels between Christ's birth and death. Not only does Mary play an articulated role in the Passion that goes beyond a passive presence at the Crucifixion, but her presence allows the poet to trope the new tomb in

which the deposed Christ was laid as a second virgin womb; the burial then
becomes a three-day gestation leading to a postmortem parturition:

dunc lo pausen el monument
o corps non jag anc a cel temps.
La so madre virge fu, 89
et sen peched si portet lui;
sos monument fure toz nous,
anz lui no i jag unque nulz om. [351–56]

[Then they laid him in the tomb where no body had lain before that time. / His own
mother was a virgin and bore him without sin; his tomb was new, before him no
man had ever lain there.]

A few lines previously, the *Passion* had described the role played by Mary at
the Crucifixion in a manner that renders explicit the oxymoronic nature of the
event demonstrated by the ninth-century German carving, where the valences
of grief and joy, death and life figure prominently:

De laz la croz estet Marie 83
de cui Jhesus vera carn presdre:
cum cela carn vidre murir,
qual agre dol no l'sab om vius.
Ela molt ben sab remembrar 84
de soa carn cum Deus fu naz;
ja l'vedes ela si morir,
el resurdra, cho sab per ver. [329–36]

[Beside the cross stood Mary, from whom Jesus received true flesh. Now she will
see that flesh die; what bitter grief (she feels) no living man may know. / She re-
members all too well how God was born from her flesh, now she might be seeing
him die, (but) he will arise, that she knows for truth.]

As the second, third, fifth, and sixth lines of this extract show us, Mary first
of all conveys the concept of "humanness" in contrast to the idea of "divinity"
conveyed by the names "Christ" and "God," as well as by the last two lines.
Formulaically, we have a basic equation, Mary : humanity :: God : divinity,
which will continue to signify even as the connotations of the scene necessar-
ily assume greater complexity.

Mary does not simply signify "humanness" in a passive sense; her womb,
as the text tells us, plays a special role in the history of humanity. Like the
tomb, it was an agent of rhetorical metamorphosis: the place where God be-
came man, where Jesus, the Verbum, assumed "true flesh" (vera carn), the sign
of humanity. In a very real sense, then, Mary functions here as a text which
allows us to read Christ as having the dual value—human and divine, history
and anagogy—necessary to the signification "Christ."

In the *historia* of Christ, "Mary" forms the link enabling him to be the
nexus of the anagogic and historic and therefore a synecdoche for redeemed
humanity. Mary appeared at every major stage of Christ's human passage in
the art of the period—birth, Crucifixion, Resurrection, Ascension. But it is her
appearance at the Crucifixion that conveys most strikingly Mary's place in the
human/divine continuum. These scenes show Mary beside Christ and God
above him; in other words, she signifies the human, on the horizontal plane,

God, the divine, on the vertical, and Christ lies between at the point of juncture of the two planes and conditions.

Mary also interprets Christ's dual sign value for the audience, showing how the scene should be read as both ironic and literal, as constitutive of "presence" as well as of "absence." The text chooses this moment to remind us that the poles of Jesus' earthly trajectory were Mary's womb and Joseph's tomb. They may be equated thanks to Christ's contradiction of the old concept of "death," which makes the tomb, like the womb, a place of formation and a point of departure.

The Crucifixion thus assumes the role of an Annunciation: it presages the filling of the virgin tomb not with a permanent signifier of death as a constant, but with a permanent signifier of emptiness, of the transience of death, of the rebirth that contradicts death just as the empty womb signifies gestation as a transient state between nonbeing and being. The Crucifixion thus signals the "death of an ending" and paves the way for the metonymic subordination of "tomb" to "womb."

As the trope for womb, Mary conveys the alternate condition of presence and absence associated with that term: the womb is either full or empty, although its potential as a generator of being remains at all times. We then see how "womb" and consequently Mary—becomes also a metonym for mind, or heart, those medieval seats of understanding in humans where Christ—as we saw in Eriugena's commentary on the parable of the Wise and Foolish Virgins and in the Conversation with Nicodemus—could either be present or absent, although the potential for presence remained possible at all times. These and other passages repeat the lesson that each person, like Mary, could be a womb giving birth to the "belief in the name of God's only Son" (John 3 : 18) and thus to the certitude that through belief, death would prove not rupture but repetition.[36]

The substitution of womb for tomb suggests that the ultimate contradiction wrought by the Crucifixion upon the concept of death lay in its substitution of repetition, or rebirth, for the connotations of rupture, closure, and finality that mark it at the worldly level. Through repetition, death ceased to be a rupture with life and instead became a crucial link in a chain of being for which womb and tomb simply serve as transitional markers.

Mary shows the audience how human expression may mediate the duality of absence and presence. Her mourning for Christ conveys the reality of his death (absence) and consequently her belief in the purpose of his presence and the certitude of his re-presentation: "and the Son of Man must be lifted up as Moses lifted up the serpent in the desert, so that everyone who believes may have eternal life in him."

Present at the main events of Christ's earthly life, Mary fulfills a very human function, that of the mother participating in the joys and sorrows of her child ("qual agre dol no l'sab om vius"). Not only does she link the divine and human in and through Christ, by the mediation of her body and sign value as *genetrix*, she also links Christ and the audience through her emotion. Grief-stricken at the death of Christ, she also knows the joy of his impending triumph, his regeneration, which will complement and extend to the audience her own original role and function ("el resurdra, cho sab per ver"). Like the

Mary in the carving, this one participates in a dual register: a historical present and an eternal future; even as she mourns, she knows that the re-presentation will occur, and the audience knows that the text itself constitutes a re-presentation, a repetition, or ritual reenactment of the original scene.

Emotion, the movement of the psyche in response to perception of events, serves a primary purpose in religious ritual participation. Affective response "proves" the "reality" of the divinity by demonstrating its power to dwell within the participant and thus to exist at a basic level of human response. Both in the image texts of the Passion and in the Clermont-Ferrand poem, the emotional valence of Mary constitutes an important part of the meaning conveyed by the text.

We should note also how the affective response provides an image within the text of the correct interpretation of the Scripture which subtends these Passion scenes. Mary performs the responses which the audience is meant to have. Again, the human/divine continuum figures. Emotional response, "mourning," equates with the connotation "humanness" conveyed by Mary, with whom the audience identifies. This emotion, an effort to understand the event, and thus a form of spiritual ascension as described by Eriugena, elicits a reciprocal response from the divine end of the continuum in the form of *com-passion*, a constituent of grace. Com-passion, emotion attendant on a passion, signified the divine reaction that humanity had been told it would gain from the ritual sacrifice, or rather from its belief therein. Compassion clearly signifies more for the audience than for Christ (in these re-presentations), for it guarantees that individual humans would indeed be able to "put themselves" in Christ's place and so repeat his contradiction of death as rupture.

Mary also functions as the mediator for this very desire on the part of the audience: through her may be attained that access to the vertical ascension which the Passion taught was the central metaphor of Christian life. Just as her mourning aroused divine compassion for Christ, so it could do the same for the *imitatio Christi*, or human, who imitated him.

Mary shows us the importance of the human mediating figure in these re-presentations of the Passion. Standing between Christ and the audience, linked to each, she enables the text to generate emotional correlates. These in turn permit the audience to comprehend the immanence of the divine in the world by watching and identifying with a human figure, other than Christ's, who accomplishes a progression through the world culminating in a reintegration with the divine. In sum, the progression and return portrayed on the theophanic tympanums like that of Autun.

From this perspective, the human/historical plane becomes a natural constituent of the anagogic/eternal; the qualities associated with purely sacred beings found in the celestial spaces—the angels, saints, and so on—may be seen to have their origins, in the case of saints, for example, in transformations of being that began in the world. The texts that deal with these themes thus undertake to transform the purely spatial conception of the historic and anagogic planes into an existential conception. Not place, but being—the dual nature and quality of life in a given place—determines progress toward theosis.

To make this point, the Clermont text specifically develops the return to his

disciples after the Passion. It has Christ, in a much more insistent manner than in the Gospel, repeat the Passion-as-lesson. Before the astonished eyes of the disciples—and, one imagines, the equally astonished ears of the tenth- and eleventh-century audience—Christ repeats the Passion as a catechism, showing how his own biography unites the historical and the divine in a new kind of existential experience. He returns, in short, to offer himself as a rhetorical figure, *Anakephalaiosis*, or Recapitulation—to use Saint Paul's term for Christ as recapitulation of human and divine history.[37] He will thus demonstrate how the seemingly unique and unrepeatable sacrifice of the Crucifixion could be transformed into a language of sacrifice capable of infinite repetition by humans who, by assuming this language, could transform their own experience of the world into the same multidimensional phenomenon as Christ's.

In essence, Christ teaches the language of the Passion to his disciples at the end of this work—written during the tenth century, when the cross cult began to emerge as a powerful intellectual and artistic force. But Christ's instruction served less as a mimesis of an actual event than as a lesson, for the people of the period, of the means by which the central drama, so specific to his cult, could be transposed into other settings and assumed by other heroes, such as Roland, whose case we shall examine shortly.

Christ as Recapitulation

The ending of the Clermont-Ferrand *Passion* occurs in three stages in which Christ demonstrates the concept of symbolic language-as-being three times: first, in his own case, then for the disciples, and finally for the audience. Recognizing that the predictions of the Passion prior to the event—as in the Conversation with Nicodemus—had figured the act in language, but not in the flesh, as it were, Christ now returns to his disciples to recapitulate the event in his own person, to show them that the tomb has indeed been a womb and death a rebirth.

More importantly, he instructs them in the art of reading his risen being as both human and spiritual, *historia* and *theoria*. This theophany really constitutes a reading lesson which stresses the dual valence of the body of Christ as a being who has been reborn in the flesh and the spirit, just as the Conversation with Nicodemus had urged.

The language of the Clermont-Ferrand text seems surprisingly sophisticated. Christ specifically presents himself as a "textualized" being, a figure in which the story of his having been "stretched out" (pandere) on the cross may be read. He literally reveals himself in the flesh, but also points to the flesh where the markers of his ordeal remain clearly imprinted. He tells the disciples *that* he is, but at the same time he tells them that he is what he was, a crucified being who has survived death. Prior to the Crucifixion, in the Conversation with Nicodemus, or the Sermon on Ends, he had spoken metaphorically to describe what would come to pass; now he has *become* metaphor, but, like the earlier metaphors he used, this fleshly metaphor, too, requires instruction to decipher. As before, Christ serves as docent:

"Pax vobis sit," dis a trestoz; 109
"eu soi Jhesus qui *passus* soi:

vedez mas mans, vedez mos peds,
vedez mo laz, qu'i fui plagaz."

["Peace be with you," he said to all, "I am Jesus who suffered: look at my hands,
look at my feet, look at my side which was wounded."]

By pointing to the signs which allow the disciples to read the story of the
Crucifixion written in his skin or flesh, Christ invokes the textual metaphor
("qui *passus* soi") which can never be far from one presented, like Christ, as
both Word and Sign. He invites the disciples to read the story of the Crucifix-
ion written in his flesh repeatedly: "vedez . . . vedez . . . vedez."

But what precisely is the nature of the act he invites them to undertake
here? Not simply to read the story of his Passion in his flesh, but rather to
comprehend the full import of acquiescing to the suffering of exposure, to the
opening up of being to meaning. This first lesson in the post-Crucifixion
drama will lead inexorably to the last: Christ's self-reading will show the au-
dience how it can and must recapitulate, in its own life, the teacher's lesson:

contra nos eps pugnar devem, 126
fraindre devem noz voluntaz

[we must struggle against ourselves; we must break our will]

The battle, then, was interior and existential; to assume the Passion in one-
self meant undertaking the same kind of suffering as Christ, not literally by an
actual, historical Crucifixion, but figuratively, as a recapitulation of the *theo-
ria* of the act—although the verbs "pugnar" and "fraindre" suggest that the
effort and suffering were still formidable. The post-Crucifixion drama in the
Clermont-Ferrand text underscores the point that the real meaning of the Pas-
sion for Christ lay in its simultaneous duality as literal and figurative gesture.
We may see this in the chiasmus by which Christ casts himself as biaxial
narrative: "eu soi Jhesus qui passus soi"; both human *and* anagogic, he is *Jesus*
and *passus*; the one because the other, the other because the one.

Passus supplies the key to understanding the concept of cruciform language
as text production. From *patior*, "to suffer, endure," *passus* also bears the con-
notation of "consent" or "acquiescence" or "to be in a state of mind." In short,
passus connotes intentionality in the act of suffering, voluntary commitment
to this state. That, as we saw in the first chapter, constitutes a primary moti-
vation in the path of ascent.

But *passus* was also an adjective formed from the past participle of *pando*,
pandere, with the sense "stretch out, reveal, lay open," and having the com-
plementary meaning, "spread out to dry." For a culture in which writing was
done on skin that had been stretched out to dry, to which marks would then
be added to reveal truth, the aptness of Christ's metaphor would have been
immediately apparent. The text has him say, in effect, that he acquiesced in
the suffering which caused his skin to be stretched out on the cross to reveal
him as the Messiah—just as he had predicted in the Conversation with Nico-
demus—thereby signing himself as a text written in the flesh in which the
Passion could be read and reread.

The next act in this drama of return and revelation recapitulates the Last
Supper. But whereas the food at the Last Supper symbolized the body and

blood of Christ, that is, the sacrificial aspect of the Passion, here the food consumed stresses its redemptive power. Christ and his disciples eat grilled fish and honey, glossed respectively as signs of the Passion as grace and Christ's divinity revealed by the Passion. Again we find the chiastic dualism where *historia* and *anagogia* figure simultaneously as narrative: the fish equates with *historia* ("sa passion peisons tostaz") and the honey with *theoria* ("lo mels signa deitat").

Christ eats to prove that he is flesh and not spirit—as the disciples first thought; but in eating, he also recapitulates the sacrifice of the Passion by taking into himself the symbols of this event, thereby proving its veracity ("veritad") and potency as a recurrent, repeatable act:

> Mel e peisons equi menget, 111
> en veritad los confirmet:
> sa passion peisons tostaz
> et lo mels signa deitat.
>
> [Honey and fish he eats now; he confirms them as truth: grilled fish signifies his passion, and the honey his divinity.]

Several important things occur here. Christ extends the symbolic vocabulary by which his Passion may be signified from literal symbols taken directly from the Passion story, for example, the cross and the lance, to include figurative symbols, the fish and the honey, of the *theoria*. Just as he assumed the *historia* symbols in his flesh as wounds, so here he consumes the *theoria* symbols—incorporates them into his body—to confirm them as truth, that is, to show that he and his symbols are one: both flesh and spirit, literal and figurative.

The text represents Christ as assuming the significance of his act, thereby making it part of the physical sense of the Passion. This second level of meaning demonstrates how the redemptive potency of the Passion might be extended to humanity at large via a ritualized recapitulation of the Passion as a communal, repeatable physical act which transforms the original individual and nonrepeatable physical act of the Crucifixion. In the formulation of Clifford Geertz, which we used in chapter 1, the text has Christ demonstrate how the Passion passes from a unique "model of reality," historically localized in space and time, to a virtual "model for reality," capable of infinite repetition, like a linguistic formula.[38]

The third and final act of this recapitulation shows the disciples themselves speaking the language of the Passion; we might also say applying the "model for the Passion" in a variety of ways which all, ultimately, reiterate Christ's paradigm. As they spread out through the world speaking the language of the Cross:

> Per toz lenguatges van parlan, 121
> las virtuz Crist van annuncian
>
> [By means of all languages they go speaking; they go announcing the power of Christ]

they also acquiesce in the suffering occasioned by the worldly opposition aroused by their language.

They begin to experience a variety of tortures; to assume in their own flesh the meaning of their words; and, as in Christ's case, the manner of their passion becomes the sign of their state as successor to and martyr for Christ. Their intention to speak the language of revelation to the world transforms their historical function into a cruciform one, characterized by the biaxial narrative mode Christ used in his chiastic formula of revelation: "eu soi Jhesus qui *passus* soi."

They literally recapitulate Christ's lesson. In their case, too, speaking the word actualizes a corresponding spiritual valence or potency ("podestad") whose efficacy may be judged by the response it elicits in the world, where widespread conversions to Christianity occur, and in the cosmic continuum of heaven–hell, where the widespread dissemination of the language of Christ occasions great pain for Satan, stirring him to harass the newly won converts and to devise tortures for the disciples (stanzas 121–24).

Satan's actions, cast as oppositional attempts to rupture the trajectory of the apostles' language from speech to meaning, turn out to be reciprocal responses which ironically confirm the proposition he seeks to contradict. As in the case of Christ, the physical destruction of the word confirms its veracity and completes the meaning it strives to prevent. Within this closed referential world, opposition provides a necessary component transforming historical, monovalent speech into a fully developed biaxial, polysemous language.

In other words, Satan provides the necessary closure, in the form of martyrdom, to complete the cruciform configuration of apostolic discourse. The text confidently, even complacently, asserts that Satan's efforts avail him not at all: far from vanquishing the faithful, his persecution only increases their number.

The stanza which makes this claim, quatrain 125, then breaks into a metaphoric discourse which shows how the apostles' language, like a living vine, spreads and flourishes the more it is pruned. This vine, "which is worshipped [adhorad] throughout all the world," is at once the language of the cross, the tree-cross ("arbor crucis"), Christ, and, finally, the Church.

Specific Gospel texts subtend all Passion metaphors. Here the subtext is John 15, "The True Vine," where Christ says:

"I am the true vine,
And my Father is the vinedresser.
Every branch in me that bears no fruit
he cuts away.
And every branch that does bear fruit he prunes
to make it bear even more. [15 : 1–2]
...
I am the vine,
you are the branches.
Whoever remains in me, with me in him,
bears fruit in plenty;
for cut off from me you can do nothing." [15 : 5]

Here again the language demonstrates the metaphoric intercalation whereby the historical and material may be simultaneously spoken as the spiritual and anagogic. To say that he is the vine, and Christians the branches of that vine,

also posits an intentionality of acceptance, of resignation, which we saw to be essential in Christ's earlier discourses: the acceptance of being "pruned away" or sacrificed to assure the greater productivity of the vine.

Obviously, in undertaking to persecute the apostles, Satan does not engage in an independently willed act. He does not speak his own language, but rather inadvertently speaks the language of God. He acts for "the vinedresser who is the Father." So when the Clermont-Ferrand text comments: "What good does it do him [Satan]? He will not conquer," the assertion cannot be disconfirmed because Satan has been brought into the Christian "linguistic community" as an agent of the very language he seeks to destroy.

But the metaphor of the vine reveals more than Satan's inadvertent discourse. As the "third act" of Christ's post-Passion Revelation, it demonstrates how and why the Passion can be, indeed had to be, a language capable of recognition; an archetypal act characterized by recurrence, the foundation of narrative; in short, why cruciform semiosis is so prevalent in the Middle Ages.

The second part of John 15 advances the concept of "The Hostile World," the world which refuses to listen to and understand Christ's words and act (John 15 : 22–24). It posits yet again the biaxial model of a world divided into the nontranscendent, or essentialist, world of specificity opposed to the fideist world of Being, of striving to become (John 15 : 5, 10), the world of completed meaning. This opposition asserts itself whenever a passion occurs and an apostle or other *christomimētēs* sacrifices himself.

This and other similar Gospel texts all stress a particular condition of biaxial discourse as a precondition for the Passion. On the one hand, there is a nontranscendent rhetoric of negativity directed at the Christ figure, particularly at his words or acts.

Satan and his followers, the agents of the "hostile world," distinguish themselves by their imperfect competence in understanding "the language of truth" and by an equal incompetence in using their own negative rhetoric. They cannot understand metaphoric speech; for them "a vine is a vine," and a human, mortal. Similarly, a word is a word; it does not necessarily imply a whole *langue*, a transcendent discourse (John 15 : 19–20). Not understanding the *parole/langue* relationship of spirituality figured by Christ, they set out to destroy the individual and his *parole* without seeing that they thereby strengthen the *langue* of the whole spiritual community by contributing to the vocabulary of martyrdom on which reposes the language of spirituality.

The rhetoric of affirmation—the language of the spiritual community—requires the presence of the hostile world and its would-be negating rhetoric in order to function. For the transcendent language of the Passion was based upon a double negative: it required accepting—as Christ does in John 15—the negative predication of the hostile world; it then negated that negation, thereby transforming the predication of the adversary into the positive affirmation of the believer: the cross became the tree of life; tomb, womb; death, rebirth.

The concept of the Paraclete or advocate—an affirmative speaker—advanced by Christ in John 15 guaranteed in advance the idea of multiple levels of meaning in which Christian life would be a totality of acts, a kind of text, interpreted by the temporal, or existential, consciousness. By definition, then,

those who engaged in the rhetoric of affirmation would learn to acquire the competence to read the signs of a passion narrative: to learn that what comes after repeats and confirms what went before. Thus, just as stanza 125 of the Clermont-Ferrand text postulates a prior knowledge of the Gospel (John 15), so the passions of the apostles—recounted in the preceding stanzas—constitute a "recollecting forward," a recapitulation of a past event, Christ's Passion.

This polysemous perspective was encoded in the metaphoric language of stanza 125. The vine, which "per tot es mund es adhorad" (throughout this world is adored), represents the tree-cross; in fact, it is certainly one of the earliest vernacular manifestations of this symbolic language. "Tendrils, leaves and bunches of grapes grow from this Cross. The vine in the Old Testament symbolizes the blessings of the promised Messianic age (Micah 4 : 4; Zechariah 3 : 10; Psalm 80 : 9ff.); from John 15, it was looked upon as a metaphor for the Church."[39] The vine-tendril and bunches of grapes also represented eternal life, and the tree-cross "expressed the relationship between Christ's sacrificial Death and sacrament."[40]

The task of the Clermont-Ferrand *Passion*, then, was not to retell the biblical story but to recast it as narrative, or, more specifically, to create a narrative Passion genre capable of illustrating how the biaxial rhetoric of the Gospel could be transposed into the present to teach Christians to read in the world the signs of transcendent meaning just as the Gospels had taught.

The Clermont-Ferrand poem carries out the dictates of the Council of Tours (813), later restated in the Council of Arras (1025), to the effect that the message of the Bible should be announced in the vernacular and not just in Latin so that ordinary people might understand it. In doing this, the *Passion* incorporates two ideas of paramount importance to later developments in the transformation of the Passion genre from a literal representation of Gospel accounts to a metaphorical model capable of transposition to secular historical legend.

First, the Clermont-Ferrand text stressed the idea that Christ's Passion really did constitute a worldly event, a historical happening which disconfirmed the negativity of history. This lesson made possible the incorporation of historical and secular material as part of the rewriting of the world, one consequence of which we saw in chapter 1, and whose sequel we shall examine shortly.

Second, it demonstrated the concept of Christ as *Anakephalaiosis*, Recapitulation. Just as Christ recapitulated sacred and worldly events in himself, so he could teach, as we saw, how those events might be recapitulated in the lives of his imitators. But we also saw that the *Passion* cast Christ as a textualized being, with the consequent implication that texts, like the Clermont-Ferrand poem, could be, if not *imitationes Christi* themselves, then certainly, like Christ, the textualized setting in which the lives of "historical" beings could be revealed as recapitulations of christological events in the same way that the Gospels revealed Christ.

In sum, the Clermont-Ferrand *Passion* announces the movement that flourished and grew in the eleventh and twelfth centuries, the movement of vernacular history-telling. Let us now turn to the first and most powerful of these historical legends, the legend of Charlemagne, to see how it incorporated this model into one of its earliest and most enduring forms.

The *Historia Karoli Magni et Rotholandi*

We saw at the beginning of this chapter the compelling iconographic program of cruciform semiosis coupled with the augmentative aesthetic by which the designers of the Charlemagne window at Chartres, and its predecessor at Saint Denis, treated the material of the Charlemagne legend. Within the precincts of Saint Denis or of Notre Dame de Chartres, one can understand that the Charlemagne window might well serve such an aesthetic.

But how to explain the obvious ease with which the iconographic program of the window, based upon late-eleventh-century and early-twelfth-century texts dealing with the legend of Charlemagne, lent itself to such treatment? Clearly, the artists responsible must have perceived something in the original texts that authorized their interpretation.

The work on which the majority of the Chartrain Charlemagne window's panels are based—the *Historia Karoli Magni et Rotholandi*—enjoyed enormous popularity in the Middle Ages. It exists today in a far greater number of manuscripts than the (to us) better-known *Chanson de Roland*: more than a hundred manuscripts of the *Historia* have been inventoried as opposed to a half-dozen for the *Roland*. It was widely translated into other languages, including Old French, and became the basis for a part of the official history of France, *Les Grandes Chroniques de France*.[41]

The last fact especially would lead us to believe that the *Historia* might have been perceived primarily as an epic of national conquest and aggrandizement in which the principal roles would have been played by secular heroes fighting for the glory of God, to be sure, but even more for personal and national honor. Earlier critics often perceived the *Chanson de Roland* from this perspective.[42]

The *Historia* certainly cannot be characterized as modest in its claims for the territorial imperative of the Christian *imperium* entrusted to Charlemagne. And yet, too little attention has been paid to the fact that Christian conquest, both in this text and in the *chansons de geste* in general, emphasizes not the physical and historical details of imperial aggrandizement, so much as a hermeneutics of the world-as-word, a recovery of the meaning invested in the land by divine creation, but lost to Christianity by the confusion of meaning occasioned by the postlapsarian state symbolized by the Tower of Babel.

Very often the beginnings of *chansons de geste* stress the loss or threatened loss of real or putative Christian territory to the "Saracens," portrayed as forces of chaos, that is, as the original condition of the world which God's word, in Genesis, overcame by order, which is to say, by the imposition of divine language. The beginning of the *Historia Karoli Magni* could not be more instructive from this point of view. We find, in fact, two beginnings: one referring to the purpose of the work itself, the other to the matter. Each outlines a particular hermeneutics of the world-as-word.

The prologue casts the *Historia* as an epistolary account written by an eyewitness, the same Turpin whom we saw elevated to the status of a saint alongside Charlemagne and placed in a complementary position to Pope Leo III on the Charlemagne reliquary of Frederick II, dedicated in 1215. "Turpin's" letter claims to be directed to Leobrand, dean of Aix-la-Chapelle, shortly after the

events depicted, and thus intended for the "imperial archives" at Aix. Claiming to be an eyewitness to the fourteen-year campaign of Charlemagne in Spain, "Turpin" says that he is responding to the request of Leobrand and thus will write about the "crowning glory of the miraculous deeds" accomplished by "our most renowned Emperor Charlemagne" when he liberated "Galicia and Spain from the power of the Saracens." He seeks to reveal the good news of Charles's deeds, for "the mighty works which the king accomplished in Spain have never been sufficiently revealed, in their full meaning, by any chronicle."[43]

This fictionalized epistolary frame for the *Historia*, often denounced as another example of crude medieval forgery, provides an important clue to the intentionality of the work. The vocabulary used by "Turpin" in the prologue, and particularly in the passage just quoted, suggests an important conflation of word and deed, text and subtext. In ecclesiastical Latin, *magnalia* means both "mighty works" and "mighty words." And it is the *magnalia*, never fully elucidated, that "Turpin's" text claims to "invent" or reveal to the world.

The epistolary form was not neutral in the medieval Christian context. From the prologue to Paul's first letter, the epistle acquired the status of teaching Christians to read the transcendent signs of God in the world, that is, to show them how the meaning of the Gospel functioned in the world to change their lives. The epistle was, in Paul's words, the *Evangelium Dei*, "the Good News of God"; *Evangelium* also denoted the Gospel. It sought, just as the Clermont-Ferrand poem portrayed Christ as doing, to show how one could read the *Evangelium Dei* in the events of the world.

The author of the epistle acquired the status of the *homo eruditus* by virtue of the fact that he strove to read and reveal ("invenio") *theoria* in *historia*. The formulation of the first sentence of Paul's exordium in the Epistle to the Romans recasts the chiasmus used by Christ to represent himself as biaxial narrative in the Clermont-Ferrand poem—"eu soi Jhesus qui *passus* soi"—to apply the same integration of historic and anagogic duality to the act of rewriting human history. The historical person becomes an apostle and servant of Christ by virtue of having been selected to write the word/world: "Paulus, servus Iesu Christi, vocatus Apostolus, segregatus in Evangelium Dei (Rom. 1 : 1). The *Evangelium Dei* confers authority on its author and confirms his status as apostle. Again, the authority derives from the text's ability to recapitulate, like Christ, *historia* and *theoria* so that event may be understood through and in the Word.

The exordium of the *Historia Karoli Magni* accomplishes the same task by literally inventing "Turpin" as a perfectly symmetrical being whose person contains the biaxial valence of *historia* and *theoria* to be repeated in the work introduced by the exordium. In short, the prologue seeks to establish a coextensiveness of text and being in the person and work of Turpin similar to that found in the Gospels or the epistles of the apostles.

Just as Paul's titles, "servus" and "Apostolus," seem credible because he has been "segregatus in Evangelium Dei" (specially chosen to preach the Good News), so Turpin's being, the identity announced to the world by the prologue, includes his special relationship to the *evangelium* of Charlemagne's *magnalia*. Thus he is styled—or putatively styles himself, in the manner of the

epistles—"Tulpinus Dei gratia Remensis archiepiscopus *ac sedulus triumphalis Karoli Magni in expeditione Hispanie socius* Leobrando Aquisgranensi decano salutem in Christo" (Turpin, by the grace of God Archbishop of Rheims and zealous companion in the triumph of Charlemagne in the Spanish expedition, to Leobrand, Dean of Aix-la-Chapelle, greetings in Christ).

Turpin thus bases the authority of the *Historia* in his own person, inscribing the events first of all in himself, then in the text. In this sense, he is the recapitulation of the events to be described and hence doubly the author/authority.[44] The first symmetrical relationship in "Turpin" connects the *Historia* which he has written to that which he lived and witnessed ("que propriis oculis intuitus sum XIII annis Hispaniam perambulans . . .)."

The exordium also asserts an anagogic equivalence between Turpin's life and his text. Just as he repeats in his authorial persona the events which he experienced as "sedulus triumphalis Karoli Magni in expeditione Hispanie socius," so his persona as interpreter or overseer of the *theoria*—the doctrinal elaboration of the historical events—reiterates his condition as "Remensis archiepiscopus" and correspondent of the dean of Charlemagne's own cathedral at Aix. *Episcopus*, we recall, meant "overseer," and *archiepiscopus*, a still higher form of overseer. But these associations do not simply assert a generalized ecclesiastical authority. They also formulate an important intentional valence of the work.

The see over which "Turpin" presides, Rheims, was an originary site for the divine conjunction of Church and monarchy in Frankish history. Like Golgotha, it conjoined human history and divine revelation. For it was at Rheims, according to a Carolingian legend most probably invented by another archbishop of Rheims, Hincmar, a ninth-century contemporary of Eriugena, that God revealed the divine mission of the Franks by sending a dove bearing a phial of holy oil from heaven to anoint the brow of Clovis when he was simultaneously baptized and sacralized as the first Christian king of the Franks. That oil continued to be used for Clovis's successors and established Rheims as the place where Frankish monarchs were anointed and crowned. The archbishop of Rheims naturally became the principal officiant at the *sacre*.[45]

Similarly, "Turpin" associates himself with the dean of Aix-la-Chapelle. We know, from the previous chapter, the resonance of Aix for the legend of Charlemagne. Aix and Rheims, then, were the loci whence emanated the *historia* of Charlemagne as a sacred legend. By inscribing both places in his person, the exordium establishes "Turpin" as an authority for the *theoria* of "his" text. In effect, the exordium establishes an author who recapitulates in his own person the biaxial symmetry of the work to come. It provides, at the outset, an icon of the reading we must give to the text that follows, a dual reading similar to the one given by Christ in interpreting the events of his *historia* in the last part of the Clermont-Ferrand *Passion*.

The second beginning of the *Historia Karoli Magni* illustrates how the biaxial narrative project inscribes itself in the rhetorical strategies of the work. This time Charlemagne himself engages in a hermeneutics of the world-and-Word as the first step in the story, which begins with a cosmic confrontation between the emperor and Saint James the Great, the agents both of *historia* and *theoria*. The opening scene casts the subsequent events of the story in a

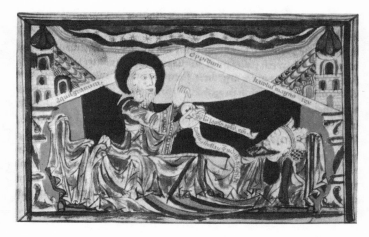

Figure 31. Charlemagne's vision of Saint James. Codex Calixtinus
(fourteenth century). (Vatican Library, Arch. S. Pietro, MS C 128,
fol. 133v)

framework of natural order, or rather a natural order to be realized by Charle-
magne, who literally reads his destiny in the heavens and in the divine com-
mand carried to him by Saint James, acting as a celestial messenger.

The first scene portrays a kind of postlapsarian genesis; it commands a re-
making of the world to conform to the original intentionality of the Creator,
but on which chaos and disorder have encroached, concealing the signs—in
this case the tomb of Saint James—placed by God to enlighten man. In a post-
lapsarian world, God no longer acts directly but through divine agents; or,
rather, through a hierarchical pairing of divine agents, in this case Saint James
and Charlemagne.

We grasp the nature of this pairing, as well as the biaxial nature of the nar-
rative, by observing a medieval transposition of the narrative into visual
terms. Although the illumination here reproduced (fig. 31) dates from the four-
teenth century Vatican copy of the Codex Calixtinus, it *is* a faithful rendering
of the eleventh-century text, with the exception—resulting from the conven-
tion for portraying visions in medieval art—that Charlemagne appears sleep-
ing in the illumination, whereas the text specifies that he was awake, studying
the miraculous portents that illuminated the heavens, at the moment when
Saint James appeared to him.

The illumination renders the hermeneutic imperative of the scene quite dra-
matically. Vertically dominant slightly to stage right of center (that is, Christ's
right, the space occupied by the celestial elect on a tympanum), Saint James
presents the dual texts that the recumbent Charlemagne must read and inter-
pret. His right hand points to the Milky Way, which encompasses, as the text
says, all of Europe from the Frisian Sea in the north down to Galicia, "where
the body of the blessed James at that time lay unknown and hidden." This
celestial banner crowns Charlemagne's terrestrial authority with a supernatu-
ral portent of divine manifest destiny. The lands between the extremities of
the stellar portent form a catalogue of the countries that made up Charle-

magne's empire; in the context, it seems natural that Galicia, where Saint James's tomb lay, and, by extension, all of Spain, be added to the list. At the same time, this catalogue of Charlemagne's conquests served as a reminder to the audience of the power exercised by the Frankish emperor in what they believed to be real, historical terms.

In his left hand, Saint James holds a banderole inscribed with the text of God's command to Charlemagne. Once again we have a kind of *mise-en-abyme*, a perspectival rendering of icons of the text within the text. In essence, the verbal command spells out what the visual scene has just shown, namely, that Charlemagne extend God's dominion over Spain in order to recover the tomb of Saint James:

> so that all the people who live between one sea and the other, and in other regions, will be able to go on Pilgrimages, after you, to entreat Our Lord's pardon for their sins, and then, from your time to the end of the world, be able to recount the miracles that Our Lord accomplishes for his friends.[46]

We pick up the story in medias res, as it were, although the *res* is not the finite one of our story, but the soteriological *res* of Salvation history. Charlemagne must read the signs, carry out the instructions, and create a pilgrimage route so that others after him may continue to perpetuate the Christian *historia*.

Saint James commands Charlemagne to leave at once for Spain and to be assured that he, James, would aid Charlemagne in all peril and see to it that Christ reserve for the emperor a lasting crown in Paradise. This apparition occurred three times to "Charlemagne, the soldier of Christ."

By the terms "beatus Karolus Magnus" and "Christi Miles, Karolus Magnus," the double valence of Charlemagne as a figure operating on the historic and anagogic plane—the situation of Mary, the apostles, and Jesus in the *Passion*—becomes clearly established. Similarly, by the end of the introduction, the historic/anagogic pairing of Charlemagne and Saint James naturally correlates the simultaneous narrative levels of *historia* and *theoria* that will continue to function within the story proper, even at less literal moments of celestial and historical conjunction. Still, the text does not leave things to chance. This pairing receives regular reinforcement throughout the work, notably after the conquest of Galicia when the biaxial trinity—Christ, Saint James, and Charlemagne—receives special emphasis: "And so Galicia, having been delivered from the Saracens by the power of Christ and Saint James, and with the help of Charlemagne, stands firm in the true faith to this very day."[47]

The pairing of Saint James and Charlemagne, coupled with the theme of tomb discovery, functions in yet another way at the beginning of the work. We have already seen the transference between Charlemagne and his legend and the Christ mythos, particularly as regards the Holy Sepulchre. Now the reiterated emphasis placed upon the dishonor suffered by Saint James's tomb, in the first chapter of the *Historia*, particularly upon its unknown whereabouts, repeats the medieval legend of the condition of Christ's tomb in the early fourth century, and, to a lesser extent, at diverse other moments when the tomb seemed to have been "lost" to the West, particularly in the early eleventh century when the "Saracens" destroyed the church/monument that protected it.

The Romans had destroyed the sacred places of Jerusalem, and particularly

Christ's sepulchre, according to early Christian legends. Constantine, acting upon the instructions of his mother, to whom the whereabouts of the tomb had been revealed in a divine vision, discovered the site and constructed the Church of the Holy Sepulchre over it. In the second decade of the eleventh century, a new wave of pagan oppressors, led by the caliph Hakin, according to the accounts of various contemporary chronicles, destroyed the church that Constantine had built. Then, thanks to the miraculous intercession of the caliph's mother—a closet Christian—the sepulchre was again made available to Christian pilgrims, and a new church constructed over it, replacing Constantine's original edifice.[48]

Rodolphus Glaber reported that when the Saracens had tried to destroy the edicule surrounding and protecting Christ's sepulchre, they had not been able to damage it, let alone destroy it. An analogous myth existed regarding Saint James's tomb. A firm article of faith surrounding the shrine of Saint James at Compostela held that the entire body of the saint lay there, and that claims by other churches to possess Jacoban relics had to be false because no human ever succeeded in displacing the body from the tomb, where it lies miraculously fixed.[49]

These and other details suggest that the *Historia* sought, as one of its raisons d'être, to establish Saint James in the *mouvance* of the Christ mythos so that his shrine would authoritatively represent the Galician equivalent of the Holy Sepulchre in Jerusalem: an object of veneration and the goal of a major pilgrimage. Similarly, Charlemagne, "the strong arm of God," received the same role vis-à-vis Spain that Constantine played in Palestine, or, more accurately speaking—since we have seen that Constantine's role in the Holy Land gradually blended into the Charlemagne legend during the tenth and eleventh centuries—Charlemagne's mythos as liberator/protector of the Holy Sepulchre and other sites in Palestine here underwent extension to cover the cult of Saint James of Compostela.

Note the coincidence of narrative isotopies in the two cases. In both instances it is a question of tombs of important sacred figures which serve as important theophanic sites revealing divine intentionality and thus perpetuating the cult in the world. The tombs suffered oblivion—*not* obliteration—but are reinvented by a *miles Christi*—Charlemagne or Constantine—with the help of divine revelation. The invention of the tombs coincides with the liberation of the land where they lie by the same *miles Christi*, who is also an emperor and thus has the temporal power to govern the land. The invention of the tombs and the liberation of the land give way to embellishment of the sites with "the splendor of buildings" and the opening of the sites to worship by pilgrims. By the eleventh century, the emperor in each case is the same: Charlemagne. The *Historia*, however, adds another dimension of sacred drama to the narrative by investing the recovery of the sacred site with a reiteration of the *Passion* in the here and now of the narrative: Roland's story will contribute a special dimension of contemporary sacred history to the Galician pilgrimage that Charlemagne's intervention opened up to Western Christians, as we shall see shortly.

One final aspect of the anagogic formulation in the *Historia* concerns the valence of Compostela as a mythic site. We have seen the reciprocal semiotic

exchange between a legendary figure such as Charlemagne and the site asso-
ciated with him. Aix-la-Chapelle signified for the Ottonians and their subjects
because of the prestige it had acquired as Charlemagne's capital and tomb site.
But Charlemagne's legendary stature, in its turn, grew to ever greater propor-
tions because of the reputation of Aix as a city whose splendid buildings and
treasures consciously evoked Rome and Jerusalem.[50]

Compostela did not have the same universal resonance, initially. The *His-
toria* utilized transference of a rather blatant sort to establish the identity of
the Galician city as a European religious center on the same order, for instance,
as Rome and Aix-la-Chapelle. Thanks to this exigency, we have a marvelous
insight into the ritual power of cruciform semiosis.

At the end of chapter 19, situated after the general conquest of Spain but
before the events at Roncevaux, the *Historia* recounts the steps taken by Char-
lemagne to fulfill the divine charge given him at the beginning of the work: to
recover the tomb of Saint James and affirm the Christian faith in Spain and
Galicia. Charlemagne exceeds the letter of the command, however, for he
makes Compostela and the church of Saint James the religious center of the
whole territory. Convening a council at Compostela, Charles bids the ecclesi-
astical and secular hierarchy to attend—archbishops and bishops, the king and
princes of Spain—so that they might swear allegiance to the archbishop of
Compostela. They also swear to recognize Compostela as an apostolic see and
that, in consequence, all high office, both secular and ecclesiastical, would be
confirmed and invested in the Church of Saint James. "Turpin" intervenes to
assert that he personally dedicated the newly constructed church and main
altar to Saint James at the request of Charlemagne.

At this point the text delivers an interesting lesson on the sacred valence of
apostolic tomb sites. It argues that Compostela is one of the three principal
sees of the Christian church, the other two being Ephesus and Rome. These
three cities can claim primacy because their Christian community was
founded by and their main church contains the body of one of the three
apostles supposedly most intimate with Christ: Saint Peter, Saint John, and
Saint James the Great. Those places where the apostles closest to Christ la-
bored to preach the Word and where they were martyred or entombed must,
we are told, be of greater religious importance than sites where these things
did not happen.

We obviously have to do here with the whole principle of *translatio*, but
even more with the notion of recapitulation. Those disciples closest to Christ
would naturally recapitulate more perfectly in their beings His Being since
they enjoyed the special privilege of direct and intimate revelation. They
would also, by virtue of the same literal and figurative proximity to the Logos,
recapitulate Christ's own pastorate more accurately in their own apostolate.

We have seen, however, that the power of Christ as *Anakephalaiosis* derived
from the fact that the Passion resumes and reverses the Fall, thereby trans-
forming the rhetoric of negativity to which the Fall had condemned human
history into the affirmative rhetoric of Salvation history. On this logic, the
works accomplished by the three key apostles in their sees would figure less
prominently in explaining the transference of christological virtue to these
sites than their deaths, seen as recapitulations of Christ's own. But the influ-

ence is not one-sided. These apostolic passions increase the significance of the primordial events they reiterate by demonstrating their continued power to make meaning; in short, by expanding their historic, anagogic, and semiotic connotations:

> In all the world, there are three principal Sees and Churches honored above all others: namely, Rome, Galicia [Compostela], and Ephesus. This is not without reason, for just as [Christ] chose, above all the others, the principal Apostles, Saint Peter, Saint James, and Saint John, to whom he revealed fully his innermost secrets, as the Gospels show, so did he wish to assure that their Sees would be honored above all others, and for that reason they are called the principal Sees; for just as these three Apostles had more grace and worth than the others, so should the places where they preached and where their bodies repose.
>
> The Church of Rome is called the first; for Saint Peter, the Prince of Apostles, *dedicated it by his preaching and sacralized it by the blood of his Passion and tomb.* Compostela is rightly called the second See because the Blessed James, who stood out greater among the other Apostles, preeminent in dignity, honor, and rank after Saint Peter, and who was the first crowned in heaven by martyrdom, fortified it by his predication, then consecrated it with his most sacred sepulchre, and hallows it by miracles and does not cease to enrich it by incessant favors.
>
> The third is that of Ephesus, where Saint John the Evangelist wrote his gospel: *In principio erat uerbum*, and the Apocalypse in which he reveals the secrets of heaven; Saint John who had so much grace with Christ that he enjoyed the privilege of his love above all the others. These three churches should receive so much honor and dignity that judgments, whether divine or human, should not be made in the other churches throughout the world, but rather be made and defended in these three churches alone.[51]

The main anagogic thrust of the *Historia*, then, develops from the passion of Saint James. But—and this is of crucial importance—the *Historia* is *not* hagiography; it is *not* the story of Saint James's passion. It is rather *historia*, commemoration of an event which could not exist without this passion, but which constitutes an extension of its consequences rather than the passion itself.

Roland and the *Mise-en-Abyme* of the Passion

In essence, the *Historia* reveals to the world the advent in "contemporary" human history of the tomb of Saint James and the consequences of this revelation for the extension of Christian governance into a land newly restored to "*the* Law." This sounds, perhaps, like a relatively simple matter. But we should not overlook the real problems the author faced in undertaking such a task. To accomplish it in a spectacular manner required finding a historical dimension to the story that could rival the interest and significance of the anagogic myth of Saint James. In fact, we discover that in seeking to create a new historical myth, the author did not necessarily discard or ignore the sacred material at his disposal, that is, choose *not* to tell the story of Saint James's passion—for that, as we have seen, subtends the work from the beginning. Rather, he follows the lead of the councils and the example of the Clermont-Ferrand *Passion* by telling a new, historically based story through the Passion metaphor.

By his choice of the reconquest of Spain as the historical framework for this story, the author hit upon a project grandiose enough to assure that the historical dimension would not be eclipsed by the anagogic. Furthermore, the historical material provided an undeniably oppositional setting—"the Hostile World" element—which we saw to be requisite for a passion. What remained to be developed, however, was a group of human actors who could rival in significance the apostles who originally recapitulated the Passion.

More to the point, a manner had to be found to permit these protagonists to take upon themselves the narrative project in the same manner that Christ and the apostles assumed their historical roles. In other words, the hermeneutics of the word/world had to be adapted to the historical setting. We have seen that Turpin and Charlemagne so present themselves in this manner from the beginning of the work. In the exordium, Turpin assumes the role of participant, witness, and author that Saint John played in Christ's passion. Like Saint John in the Gospel and in Revelation—which the *Historia*, in accord with contemporary belief, ascribes to him—Turpin "sees and bears witness." Charlemagne, too, intuits and assumes into his being the project ordained by God.

Roland, however, did not possess a clearly defined sacred valence prior to the late eleventh century, just as Compostela did not enjoy the authoritative prominence in the hierarchy of apostolic sees ascribed to it by the *Historia* prior to that period. And just as the valence of Compostela received reinforcement from its prominent associations with Ephesus and Rome in the text, so the matrix of Roland's spiritual role derives from his prominent textual association with Charlemagne, Turpin, and, by extension, Saint James, for whom he will ultimately stand as recapitulation.

Although this Roland, like Saint James's tomb, must be invented and revealed to the world, the *Historia* does not simply rely on association to realize the goal. Roland willingly predicates his own valence as *miles Christi* and then fulfills it by word and deed. Like Turpin and Charlemagne, he defines himself as exemplary being in a manner that transforms *historia* by means of a *theoria* predicated on the passion model, which he voluntarily articulates and assumes. By looking briefly at the principal passages in which he figures, we may understand the sacralization of Roland that occurs at Roncevaux and which has proved too difficult to explain from the sole perspective of the Oxford *Roland*. The *Historia* details the Frankish hero's spiritual progress toward theosis and the rank of "Blessed" which it and the *Guide du Pèlerin* confer upon him.[52]

To understand how Roland figures as a recapitulation of Christ, or more immediately, Saint James, we must recognize the basically syllogistic structure of the work. The prologue and introduction present the theme and part of the rhetorical strategy for its realization. The intervention at the end of chapter 19, discussed above, further develops the concept of the passion metaphor as central to the claims made for Compostela and Saint James. However, this elaboration occurs *after* the ostensible goal of the work has been realized. Through Saint James, God has asked Charlemagne to free the apostolic tomb and establish Compostela as a pilgrimage site. At the end of chapter 19 all of this has been achieved; and yet the intervention introduces a *new* dimension

to the argument by specifically positing the idea that sacralization of being and site correlates with exemplary sacrifice.

By introducing such a concept at this stage, the intervention—like the beginning of the work—sets up premises whose conclusion has not yet been reached. A passion model has been evoked but not yet fully realized. Compostela has been liberated, but as a dead metaphor; the archetypal passion that made it sacred to begin with has not been repeated, and therefore its power to continue to make meaning—in short, its potency as a sacred site in the here and now—has not been demonstrated. To prove that it was both a model of and a model for reality, it had to be resacralized by a repetition, in the historical present, of the hallowing by predication and martyred blood which the intervention stresses so prominently, not once, but three times. And this exemplary sacrifice had to be elective, consciously assumed by a *homo eruditus*.

As a matter of fact, the text lays the groundwork for the emergence of Roland as self-elected martyr-designate during the account of the conquest of Spain prior to the end of chapter 19. It does so in two ways. First, by a contextual evocation of miraculous prefigurations of a passion to come; and second, by the emergence of Roland as a hero who differentiates himself from the collectivity by an agonistic assertion of individuality. Instead of simply defending the Word, he intellects and preaches it, thereby inscribing it in his persona. His, then, is the active *fate* of the predicator as opposed to the collective *faith* of the multitude. His being is literally his story, or history; theirs, hearsay.

During Charlemagne's first two campaigns, the heroes who die in battle first receive miraculous tokens of impending immortality when, during the night before the battles, their lances take root in the earth and burst into flower in the morning. This happens not once, but three times. The reiterated miracle invokes an Old Testament event, the flowering of Aaron's rod (Numbers 17 : 16–26), understood in medieval tropology as a figural tree-cross and thus a prefiguration of the Incarnation and Passion.[53]

The text underlines the Passion context of the miracle of the flowering lances by stressing that the plain where Charlemagne met the Saracen king Aigoland was the site of the martyrdom and burial of Saints Facundus and Primitivus and that later on Charlemagne built a spacious and beautiful church ("basilica ingens et optima fabricatur") in their honor where their bodies repose. As a further, if not overly subtle, indication that the martyrdom of the Frankish soldiers prefigures the more significant passion of Roland still to come, the text cites by name only one of the forty thousand Christians whose death in the first battle was signified by the flowering lances: "dux Milo, Rotolandi genitor" (Duke Milo, Roland's father).[54]

Even though the major battles of the initial campaigns possess an undeniable importance, they do not stand out as particularly memorable, with the exception of the miracles they occasion. Nor, more importantly, do they in themselves bring about the conquest of Spain, either in the first or final instance. Only Roland's intervention enables Charlemagne to accomplish that goal.

The final phase of the conquest turns much more emphatically upon two major narrative sequences, the first occurring prior to the intervention at the end of chapter 19, and the second taking up chapters 21–26.

The first of these sequences depicts the confrontation between the Saracen giant Ferracutus and Roland. It is the single event securing the liberation of the tomb of Saint James and the establishment of Compostela—at least within the context of the work—as the third principal apostolic see of Christendom. Roland achieves this victory single-handedly, thereby acquiring a sacred aura no other hero except Charlemagne can claim. As we shall see in a moment, he achieves this victory more by predication than by martial feats, or at least his predication occupies a more prominent role in the narrative than does the fighting. It constitutes the first act of his recapitulative drama: the stage of speaking the language of Christ that differentiates the sacral victim, showing his ability and willingness to implement the affirmative rhetoric of the Cross in his own sacrifice.

The second sequence, consisting of the Betrayal of Ganelon and the Battle of Roncevaux, completes the sacred drama by enlarging the concept of "the Hostile World" to include not only those natural enemies by birth, the unbelievers, but also the unnatural enemies—which medieval typology emphasized as a central part of Christ's Passion—the apostates among one's own people who reject the power of the Word and actively seek its undoing.

The combat with Ferracutus is the most detailed single combat of the whole *Historia*, but the narrative devotes much more space to a curious catechism between Roland and the Saracen than to their martial exchange, which, incidentally, Roland wins only after and as a result of their dialogue. The significance of the sequence for the story as a whole may be adduced not only from the text of the *Historia*, where it takes up more space than any other single narrative incident except its sequel, the Battle of Roncevaux itself, but also from the iconographic program of the Charlemagne window at Chartres, which devotes two panels to it (fig. 23, panels 16–17).

Roland enters this combat electively after Ferracutus has defeated and imprisoned some of the other peers of France. Seeing that no other heroes come forward to continue so unequal a combat, Roland, like David, willingly seeks this combat, thereby taking upon himself the project ordained by God. Although the fate of the other heroes does not befall Roland, he experiences such great difficulty in the combat that after a day and a half nothing decisive has occurred. Clearly, victory on either side cannot be gained simply by material means.

At this point, the narrative shifts from a direct descriptive approach to a discourse of indirection. It introduces typological language evoking the rhetoric of affirmation by means of references to biblical prefigurations of the Passion. This shift in mode reveals yet another facet of cruciform rhetoric: its language of indirection appears more real and immediate than that of direct, historical description because it is far more interesting.

Alleging great fatigue, Ferracutus requests a truce in order to take a nap. In an apparent gesture of compassion, Roland brings him one of the stones—to which the text has made several cryptic references—littering the battlefield for him to use as a pillow. The stone-as-pillow motif derives from Genesis 28, where Jacob, sleeping with his head on a stone, experiences a theophanic vision in which Yahweh reveals his and his family's destiny as the chosen of God and says that the place where Jacob lies sleeping is "Bethel, the house of God

and the Gate of heaven" (Genesis 28 : 17). Upon awakening from his dream, Jacob consecrates the stone as an altar: he "took the stone he had used for his pillow, and set it up as a monument, pouring oil over the top of it" (Genesis 28 : 18).

In medieval typology "God's appearance to Jacob . . . was related to Christ's Ascension,"[55] and the subsequent nocturnal struggle with the angel—which Genesis 35 suggests also occurred at Bethel—prefigured Christ's "wrestling with death and defeating it on the cross."[56] By the same typological association, the David and Goliath motif implicit in the confrontation between Roland and Ferracutus was also interpreted as prefiguring "Christ's victory on the Cross over the enemy, that is, death and Satan."[57] Unlike Jacob, Ferracutus has his vision of the celestial order and Salvation history after he awakens, and it will be Roland who fulfills the pastoral role of predication; and, finally, although Ferracutus will be sacrificed on the altar stone Roland fetched for his pillow, that initial sacrifice only serves to prepare for Roland's own immolation.

The actual dialogue between Roland and Ferracutus, which occurs when the giant awakens, places us literally and figuratively within the Passion context. Ferracutus begins to question Roland about his country and the religious beliefs that would lead him to elect so unequal a combat. In response, Roland takes Ferracutus step-by-step over the principal mysteries (cf. the Christian *credo*). The giant shows repeated astonishment over each new revelation. But the progressive amazement by which the giant responds to Roland's catalogue of wonders reaches an absolute crescendo of disbelief over the matter of the Passion and Resurrection:

> "Roland! Roland! Why do you tell me such crazy things? It cannot be that a man, once dead, can come back to life."—"Ferracutus, I tell you that the Son of God did not come back to life alone, but that all men who have been born since the beginning of the world and will be until the end of the world, will be resuscitated on the day of judgment before the throne of majesty of Jesus Christ . . . and he himself who resuscitated several dead men before his Passion, could in no way be considered as dead; for death flees before him, and at the sound of his voice and at his commandment the dead will revive in great crowds."[58]

Resurrection, the Passion and its consequences, this ultimate mystery captures Ferracutus's imagination, illustrating graphically for the Christian audience the whole transcendent dimension of spirituality which the "enemy" lacked. The triumph over death cannot even be conceived, apparently, outside the context of the Christian faith. Since the debate was written by a Christian author for a Christian audience, this was the message which they, like the Saracen giant, must hear again as though for the first time to recapture the full awe of its mystery. Cruciform semiosis functions here to render the fact of the Passion an uncommon lesson for everyday life: "Ferracutus, I tell you that the Son of God did not come back to life alone . . . " (non solum, inquit Rotolandus, Dei filius a mortuis resurrexit, verum etiam omnes homines qui fuere ab inicio usque ad finem sunt resurgendi ante eius tribunal . . .).

These questions do not simply suggest humorous incredulity by a nonbeliever in the face of the basic tenets of Christianity. They perform an impor-

tant narrative function and evoke an impeccable scriptural subtext, as we shall
see in a moment. Irrupting at this crucial moment so that they cannot be
overlooked, they demonstrate how the biaxial narrative attests the contradic-
tory impulse of *historia*, its dimension of story-as-parable, reminding the au-
dience that Scripture concealed as well as revealed meaning.

The agonistic narrative model propounded by Christ in the Gospels pur-
posed an order of understanding based on faith and effort. As Eriugena's inter-
pretation of the Wise and Foolish Virgins made clear—or Matthew 6 : 22–23—
only by struggling with an oblique text could the believer work out a meaning
that would be enlightening, and one that would reveal his/her status *within*
the religio-political microcosm. Not just explanation—of the naive, Ferracu-
tus variety—but faith and understanding were required to join with labor in
order for the "reader" to discover meaning. The paradox of the historiated
Scripture had been profoundly stated in the quotation of Psalm 78 : 2 in Mat-
thew 13 : 35: "I will speak to you in parables and expound things hidden since
the foundation of the world."

The naive interlocutor like Ferracutus underlines the oblique status of *his-
toria* as text; its quality as parable requiring the light of *theoria* to clarify it.
Scripture provided a model for the naive interlocutor. In John 3, we find a
report of a long conversation between Jesus and a man named Nicodemus.
Among other things in this exchange, we find that it permits Christ himself
to provide the interpretive link between *historia* and *theoria* when he points
out the necessity for what comes later to explain and confirm what went be-
fore. It is a theory of narrative based upon repetition, recurrence, and return; a
theory which valorizes the biaxial mode as basic for representing the Christian
Platonic notion that material existence can be understood only in terms of
spiritual origin and end.

Nicodemus poses questions which reflect the human perspective, grounded
in the logic of the material and literal. "How can a grown man be born? Can
he go back into his mother's womb and be born again?"

Christ responds in a way that stresses another, higher perspective beyond
the realm of materiality. "I tell you most solemnly unless a man is born from
above, he cannot see the kingdom of God." Christ's assertions and Nicode-
mus's questions stress repetition; they are in fact repetitious: "I tell you most
solemnly, unless a man is born through water and the Spirit; he cannot enter
the kingdom of God . . . " "How can that be possible?" asked Nicodemus.

The formal repetition simply underlines the main business of the conversa-
tion: predicating repetition as an existential category. In John 3 : 13–15, Christ
predicts his own Passion in metaphoric terms as simultaneously a reiteration
and revelation of the bronze serpent in Numbers 21 : 9.[59] Repetition thus be-
came a central characteristic of the Passion, or rather of its interpretive po-
tency, and thus a major factor in the Christian view of world-as-word. The
Passion as repetition, as well as repetitions of the Passion, required interpre-
tation since the repeated action was a figurative rather than a literal iteration
of the primordial action:

and the Son of man must be lifted up
as Moses lifted up the serpent in the desert,
so that everyone who believes may have eternal life in him. [John 3 : 13–15]

It was the poet or witness/narrator who predicated the interpretation of an act as a Passion, just as Christ, in his discourse, equated the bronze serpent and his own Passion. In this passage and in 3 : 17–21, John made Christ the authority for the biaxial narrative model, while at the same time demonstrating how the two levels work to establish an ironic vision; a view of the mundane overturned and extended by the power of the spiritual and ineffable.

The narrative thereby represents the interiorization of knowledge, its transformation into existential experience, that movement from matter to spirit traced by Eriugena which postulated a reversal of the purely worldly meanings. What appeared to be enlightenment from the viewpoint of the historical narrative axis turned out to have been darkness, failure of illumination, as one penetrated the previously murky reaches of the second level, leading upward toward theosis.

The Conversation with Nicodemus ends with Christ's reference to works as a grammar of intention: "Everybody who does wrong / hates the light and avoids it, / for fear his actions shall be exposed; but the man who lives by the truth / comes out into the light, / so that it may be plainly seen that what he does is done in God" (John 3 : 20–21). Narrated acts, then, must have two levels: the first establishing them as acts-in-the-world, and a second, figurative level confirming their intentionality as meaningful acts which illumine and reveal the transition from the historical plane to the anagogic: "Qui autem facit veritatem, venit ad lucem, ut manifestentur opera eius, quia in Deo sunt facta." All narrative of such acts must contain, within the structure of meaning, this intentional standpoint.

In the conversation between Roland and Ferracutus, we find all these elements. Ferracutus questions Roland, just as Nicodemus questioned Christ; the same naive literality that characterized Nicodemus's questions may be seen in those of the Saracen giant, including the awed incredulity in the face of the Christian mysteries. More to the point, the dialogue with Ferracutus permits Roland, like Christ in the Conversation with Nicodemus, to provide the interpretive link between *historia* and *theoria*; as in the first instance, we find the expected stress on repetition and recurrence, and once again with specific reference to the story in progress.

We must remember that Roland speaks at two levels: ostensibly to Ferracutus, to whom he repeats the whole concept of Salvation history in a way that proves him to be a *homo eruditus*, that is, someone who has engaged in the spiritual path of ascent to intellect, as principles of being, the Christian doctrine; at the same time, he addresses the audience of the era, showing how the Passion story can inform familiar, historical situations.

In other words, Roland does not simply explain Christianity to Ferracutus in a manner that the audience might find amusing; he literally repeats the lesson of Christ in the Conversation with Nicodemus: that material existence can be understood only in terms of spiritual origin and end. The text of the dialogue specifically makes the Passion the *theoria* of the *Historia*, and especially of the *Historia Rotholandi*. Looking closely at the emphasis of the dialogue, we find that Roland's discourse predicates the repetition of Christ's death and resurrection as an existential category for all men ("non solum . . . Dei filius a mortuis resurrexit, verum etiam omnes homines . . . "), and, proleptically, for Roland himself.

The conversation takes place in the midst of a mortal combat; it began when Ferracutus asked the first series of questions which, like the whole dialogue, appear naive on one level but ultimately touch the most profound issues. The questions, and ultimately the conversation as a whole, operate in a metaphoric/metonymic mode in which Roland and the French serve as the historic/human correlates for Christ and Christians in the larger spiritual dimension.

This metaphoric/metonymic structure, relating purpose and being so naturally, emerges with impressive narrative economy from the three stichomythic questions and answers that begin the dialogue:

"Tu autem quomodo vocaris?"
—"Rotolandus," inquit, "vocor."
—"Cujus generis," inquit gigas, "es, que tam fortiter me expugnas?"
—"Francorum genere oriundus," inquit Rotolandus, "sum."
At Ferracutus ait:
"Cujus legis sunt Franci?"
Et Rotolandus:
"Christianae legis, Dei gratia sumus. Et Christi imperiis subiacemus,
Et pro ejus fide, in quantum possumus, decertamus."[60]

["What is your name?"—"I am called Roland."—"To what race," says the giant, "do you belong that you fight me so bravely?"—"I am of the race of the Franks," he says. And Ferracutus: "What law do the Franks recognize?" And Roland: "We are of the Christian law, by the grace of God. And we subject ourselves to the commands of Christ, and for his faith we struggle and fight as much as we are able."]

Now when Roland continues the dialogue by explaining the essentials of Christianity, he simultaneously performs for the audience the same task that Christ performed for Nicodemus. In that instance, Christ made the Old Testament episode of the bronze serpent a proleptic icon of his own Passion to come; here, we see how Roland's own passion will be a figurative iteration of the story of Christ which he retells for Ferracutus. Like Christ, Roland functions as both narrator and interpreter.

The conversation closes in a manner that integrates the spiritual dimension inextricably with the action: the resumed combat will be a test of spiritual truths. The winner will have his world view ratified by a judgment of God. By interpreting Christ's story for Ferracutus, Roland interpolates his own story into the primordial myth of soteriology, just as Christ inscribed his impending Passion into the Conversation with Nicodemus. Henceforth, the *Historia Rotholandi* will unfold on two levels: that of historical specificity and that of anagogic signification that invests the first level with significance by repeating it in a context of universal meaning.

We can now understand why, in the Charlemagne window at Chartres, Roland acquires the attribute of the nimbus (panel 17) at the moment when, after calling upon "the Son of the Virgin," he thrusts his sword through the giant's navel, Ferracutus's only vulnerable spot. The symbolic significance of that detail can hardly escape us. It is the umbilicus through which Ferracutus was nurtured in his mother's womb. Conceived and nurtured by a false mother, the Saracen faith, the umbilicus would naturally be his vulnerable spot in this context.

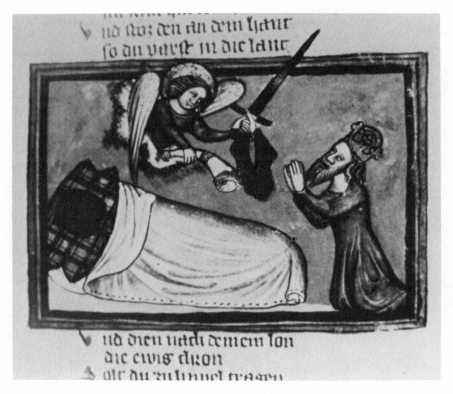

Figure 32. Angel bringing the olifant and Durendal to Charlemagne from God. Anonymous imitator of Rudolf von Ems, *Christ-Herre Chronik* (fourteenth century). (New York, Pierpont Morgan Library, MS 769, fol. 338v)

The text specifically ascribes Roland's success to Christ's aid. The sword, Durendal, was also sent by God, according to one legend (fig. 32). The message could scarcely be clearer: Roland, the historic agent, works with the help and instruments of the divine order to discredit paganism and make manifest the truth of the Word in the here and now. And he does so, like Christ, by being both the interpreter and, if not the incarnation in Roland's case, at least the translator of the Word into action.

The conversation with Ferracutus is Roland's first real appearance in the work. He does not yet occupy the place accorded to Saint James and Charlemagne from the beginning. Like the monks and celebrants at *Centula*, Roland must still perform, in his own life, the cruciform ritual to demonstrate that he has assumed into his own person that basic article of the faith which he expressed so forcefully to Ferracutus: "I tell you that the Son of God did not come back to life alone, for truly all men who have been from the beginning to the end of time will be reborn. . . ."

At this point in the *Historia*, although we take Roland's presence for

granted, we should note that he provides the kind of emotional identification for the work that Mary contributes to the Passion. He is the human agent through whom we understand divine purpose. Young, charismatic, eloquent, and courageous, Roland enables us to understand the existential category of the hero: the motivation of a youth of the time fighting for Christ; in short, an affective identification hardly available to the audience through the authoritative figure of Charlemagne.

The final drama of Roland's life, his passion, actualizes this potential in a series of actions, speeches, and visions which place Roland squarely in the *mouvance* of Christ and, more particularly, of his Passion. Through this final act, Roland provides for the *Historia* what Christ does for Scripture: an affective identification of the human and the divine.

The episode not only activates the model of the Passion in representing Roland's death, it also demonstrates very nicely the commemorative mechanics of the model. We find precisely those kinds of historic and spiritual details that had come to constitute, in the course of the eleventh century, a means for verifying and experiencing Christ's Passion: tomb sites, relics, concrete artifacts associated with the event, witnesses, and testimonials.

Accordingly, we find at least two levels of signification in all of the actions performed by Roland at Roncevaux: the narrative sense, which pushes the story to its conclusion, and the commemorative sense, which posits an act or artifact that would have been verifiable in the real-life experience of the eleventh- or twelfth-century audience.

The augmentative aesthetic functions here, as we might expect, to constitute a story *ending* which, like the Passion, will also be a beginning. That is, the reader will have to reinterpret all of Roland's actions from the beginning, and notably the conversation with Ferracutus, in light of the anagogic dimension he acquires via the passion. Thus, the anecdote of the stone that Roland slices in two by attempting to destroy Durendal on it (fig. 33) and the story of the "Valley of Charlemagne,"[61] where the emperor first hears the echoing strains of Roland's horn, cease to be purely narrative records of monovalent historical events. The stone and the valley become sites attesting to the rhetorical transformation of history by revelation; concrete reminders that human history can recapitulate Scripture, once again proving that meaning in the world derives from divine intention perceived in sacred writ.

More to the point, these events, unlike the biblical ones, occurred in the "near" past and in sites accessible to the European pilgrim. Roland's passion thus imprints the distant events of Christ's Passion on a real but hitherto neutral geography, proximate both temporally and spatially. The medieval audience could visit these sites in order to commemorate, to experience for themselves an anagogic event in the immediacy of everyday life.[62] The *Historia* thus not only rewrites the past world, but also infuses the present with the rhetoric of Revelation.

To take but a few of the more salient details of the episode, we note that Roland, like Christ, is betrayed by one of his own kind, Ganelon, who by his betrayal hopes to undermine the work of Saint James and Charlemagne, as Judas sought to destroy Christ's work. As in the Gospel, the plan ironically assures what it intended to prevent and ultimately guarantees the complete and successful—if legendary—conquest of Spain.

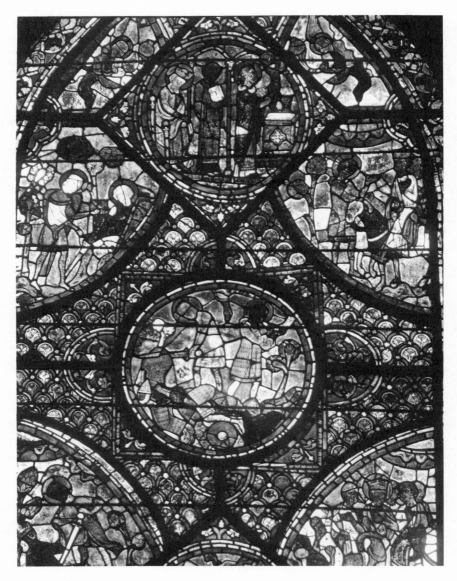

Figure 33. Roland sounding the olifant and slicing the rock in two with Durendal. Chartres. Charlemagne window, panel 19.

Lest the reader miss the point, the text explicitly makes the Ganelon/Judas correlation at the moment when Ganelon tries to persuade Charlemagne not to turn back: "O subdola controversia! O Ganaloni pravum consilium, Iudae proditoris tradicioni comparatum!" (O cunning contention! O vicious counsel

of Ganelon, worthy to be compared to the treason of the traitor Judas! [chap. 23, p. 195]).

Just as the Passion itself signifies ironically—death becomes life—so do the instruments of a passion. The cross, we saw, was a torture instrument of death transformed into "lignum vitae," the tree that "took away the poison that came from a tree / And opened again the closed doors of life," in the formulation of the poem by Fulbert of Chartres, "De Sancta Cruce," which we discussed earlier. The cross was also a human instrument that acquired, via the Passion, divine status by means of the synecdoche wherein it came to signify the crucified Christ.

The instruments of Roland's passion, the sword Durendal and the olifant, acquire similar characteristics. Like the cross in whose shape it was fashioned, Durendal is an instrument of death that becomes, in the hands of the beatified Roland, a life-affirming instrument, a spiritual object.

Like Roland himself, ultimately, Durendal figures Christ's name and meaning, which are inscribed on the blade: *magno nomine Dei Alpho et ω insculpte*. Durendal becomes a relic; it also leaves its mark on the place of Roland's martyrdom when he slices the stone in two while trying to destroy the sword so it will not fall into the hands of the Saracens after his death. Like the cross, Durendal appears as an object of incomparable beauty and religious power in the apostrophe which Roland addresses to the sword, not prior to an important battle, significantly, but just prior to his own death and apotheosis.

In this apostrophe, Roland stresses the perfect proportions of the sword, proportions of length and breadth in which, like the cross, the breadth is congruent to the length. He underlines the correlation between the physical proportions of the sword and its spiritual purpose: to exalt the Christian faith and extend the praise of God. Once again we witness the augmentative aesthetic, in which form and purpose relate symbolically, even though each part may signify independently. Clearly, Roland's apostrophe to his sword and description of its purpose function metaphorically to describe his own role.[63]

The other artifact of Roland's passion, the olifant, brings Charlemagne back to Roncevaux and to the battle, while simultaneously causing Roland's death, thereby permitting him, literally, to take his death upon himself. This act of self-sacrifice does not have the same cosmic significance as Christ's, but the correlation supplies the meaning to the incident and to the denouement of the work as a whole. It is during the actual agony Roland undergoes, from the moment of the sounding of the horn, that the christological symbolism becomes most evident.

Panel 20 (fig. 23) of the Charlemagne window shows Baudoin, Roland's brother in the *Historia* version of the legend, holding a helmet before Roland. The text of the *Historia* specifies that Roland suffered from an overwhelming thirst. Baudoin, sent to seek water, finds none. Both the window and the text thus stress the parallel between the thirst of Christ dying on the cross and that of Roland dying at Roncevaux, and the inability of either to find even that physical comfort in their last moments.[64]

Finally, Roland himself, in his moving confession, recalls the Passion in terms which make the audience recognize his worthiness to be enrolled in the ranks of the martyrs. The confession specifically evokes the same sequence of

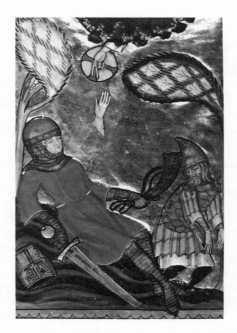

Figure 34. Roland killing Saracen and render-
ing homage to God. *Karl der Grosse*, Stricker
(fourteenth century). (Deutsche Staatsbib.,
MS Germ. fol. 623, f° 22v)

events in Christ's life—Nativity, Passion, Resurrection, Ascension—which
constituted the catechism used earlier in the conversation with Ferracutus.
This time, however, Roland relates them to his own situation, incorporating
them in his plea for inclusion among the saved: "Sicut pro me Virgine nasci
dignatus es et pati et mori et resurgere, sic animam meam liberare digneris ab
eterna morte" (Just as you deigned to be born of the Virgin for me, and suffer
and die and be resurrected, so please be willing to free my soul from eternal
death).

The long confession terminates only when Roland has translated his beliefs,
his life, into a rhetoric of volition and faith marked by serene expectancy. With
his entrails and torn skin in one hand, he turns his eyes toward heaven, where
he "sees the place God has readied for those who love him." Finally, he raises
both hands toward heaven to pray for the souls of the dead warriors around
him. As he says "amen," "the soul of the blessed martyr Roland leaves the
body and is taken by angels into the eternal glory of the company of holy
martyrs who live and reign without end."[65]

The ascension of Roland's soul into heaven appears in greater detail in a
mediated vision granted to Archbishop Turpin, the author of the *Historia*. Like
that of Saint John in Revelation or Dante in the *Divine Comedy*, Turpin's

vision confirms the sacralization of Roland by casting his apotheosis as a revelation given by God to a saintly witness.

If one had to choose one image to show how cruciform semiosis operates to render the anagogic and historic aspects of Roland's life, that image would almost certainly have to be a fourteenth-century illumination from a German version of the *Historia, Karl der Grosse* (fig. 34). This splendid example of the augmentative aesthetic shows the moribund Roland performing simultaneously his last act on the horizontal plane of *historia* and his ultimate gesture toward the divine powers; in other words, his own statement of the *theoria* informing his historical acts.

The recumbent Roland uses the olifant to bludgeon the Saracen who tried to steal Durendal. As Roland wields these God-given weapons for the last time, immediately above him a nimbused hand descends from heaven to take the glove proffered by the warrior in a final gesture of fealty to God. Here the glove, like the hero's faith, raises itself in the air, alone, a miracle which conveys strikingly that Roland's prowess derives from a faith ever turned toward God, even while he is engaged in martial effort.

The image thus stands as a synecdoche for the battle as a whole, for Roland's life as a whole. Roland, like Christ, dedicates his humanity to the service of the divine. And so it may be said of Roland, as Saint Clement of Alexandria said of Christ, that:

> Here in o'erwhelming final strife
> The Lord of life hath victory;
> And sin is slain, and death brings life,
> And sons of earth hold heaven in fee.

5

Roncevaux and the Poetics of Place/Person in the *Song of Roland*

However satisfying the *Historia Karoli Magni et Rotholandi* may be from a programmatic viewpoint, the fact remains that since the discovery of the Oxford version of the *Song of Roland* in 1830 and its publication in 1836, the latter progressively and inexorably eclipsed the former as the preferred literary form of the legend for modern times.

The reasons for this may be traced to the fundamentally different kinds of enunciation or discourse they represent. These differences would have been well understood as functional variations of narrative in the Middle Ages, but they have become "existential" differences in the modern period because the *historia* form has no modern counterpart. Whereas the mixed poetic form that we identify as epic continues to be a viable genre of literary expression within the normal experience and expectation of the average educated person, neither the concept nor much less the practice of the *historia* survived the Middle Ages. It was replaced in the Renaissance by a purer form of the classical model of historiography from which modern historiographic literature descends. For the modern reader to read and appreciate the *historia* form he must engage in what amounts to an archaeology of the genre.

One of the major constraints of the *historia* as narrative—especially when we possess a poetic version of the same legendary material—stems from our impatience with what constituted the major virtue of the genre for the medieval audience: its precisely controlled, programmatic discourse. A character like Roland, for example, remains purely an agent of the discourse in the *Pseudo-Turpin*; the text allows him no autonomy to develop a language of his own, to become "a person," "a character," in the sense we are accustomed to use these terms. So much so, in fact, that although we witness and understand Roland's theosis in the *Pseudo-Turpin*, we cannot fully appreciate it because we have not participated, as an audience, in the agonistic struggle that preceded it. Roland simply begins, in medias res, as the *homo eruditus* capable of recapitulating the language of Christ at the appropriate moment.

In the Oxford *Roland*, on the other hand, the monumental, historical scope demanded by the *historia* yielded to a more restricted form of discourse with an unambiguous literarity. We find the same impulse toward directed vision as in the *historia*, the same effort to rewrite the world as history, but the focus is definitely narrower, more specifically trained on the problematics of the heroic, that is, on the agonistic struggle of the hero to discern and follow the path of ascent. Not the making of the martyr-saint as object, but rather his

gradual emergence into the light and his self-predication (and self-doubt) are what the poetic enunciation of the legend undertakes.

The success of the heroic self-predication can never be in doubt, but the fact that it is postulated at all marks a major step forward in the dialectic of Romanesque narrative from our viewpoint. This development follows Eriugenian principles in shifting the narrative balance from result to process. In consequence, it opened poetic discourse to a much greater degree of audience participation: to the extent that all narrative values are not didactically spelled out, the audience plays a greater role in interpreting meaning. In short, the poetic form takes greater risks by permitting misinterpretations, by even encouraging, some might argue, misprision as part of the poetic experience. This, too, corresponds to the Eriugenian concept of reader participation as seen in our first chapter.

We can really comprehend the extent of the innovation in Romanesque narrative wrought by the Oxford _Roland_ if we compare the poetics of person and place studied in the preceding chapters with those of the Oxford text. Person and place were indissolubly linked in the sacralization process as we have seen it emerge in different kinds of verbal and visual narrative in the eleventh century. Taking only the _Pseudo-Turpin_, we find Roland linked to Roncevaux from the moment he appears in the text, just as Charlemagne was to Aix, Saint James to Compostela, Saint Peter to Rome, Saint John to Ephesus, and Christ to Jerusalem.

All of that stemmed naturally from the authoritative discourse of the _historia_ form. It represents that control which guaranteed the equivalence author/authority that we saw in chapter 1. But when the enunciation becomes truly mixed, that is, when the author permits the personae to play a greater role in the discourse, then uncertainty, doubt, error, in short, all the natural conditions with which humans generally relate to the wor(l)d must be inscribed in the text.

Now the uniqueness of the Oxford _Roland_, and its excitement, stems precisely from the fact that it forces the characters to discover and predicate for themselves the valence of the action they undertake; and it permits them to question and make mistakes. By the same token, it encourages the audience to participate in the same dialectic, to take sides with and against the characters and their positions.

Unlike his alter ego in the _Pseudo-Turpin_, for example, Roland does not initially understand the valence of Roncevaux. Much of the drama of the poem stems from his initial misreading of the site and from his subsequent efforts to correct that misreading. The medieval audience, on the other hand, as we shall see in a moment, knew the valence of the site, and while it could still participate in the dialectics between the heroes, it possessed sufficient knowledge to recognize Roland's misreading and to realize the extent of the correction he would have to make before attaining the sacred valence which the audience also knew from tradition.

Obviously, then, one of the fundamental differences between narrative in the _historia_ and in the _chansons de geste_ lies in the use made by the latter of ironic distance. Not inconsequentially, the Clermont-Ferrand _Passion_, also an early _poetic_ narrative, as we saw, makes very effective use of dramatic irony in

the disparity of knowledge between the audience (and Christ)—the privileged
participants—and the other characters, who did not possess foreknowledge.
For obvious reasons, the ironic distancing in the text can involve only the
disciples and secondary characters. The principal figure, Christ, possesses fore-
knowledge from the first and relies on it in predicating Jerusalem as the site of
his humiliation and Golgotha as the site of his Passion.

In the Oxford *Roland*, however, the scope for a hermeneutics of the word/
world becomes much greater, since Roland, unlike Christ, does not possess
foreknowledge. As a phenomenon of being-as-language, he must discover and
then predicate humiliation. Accordingly, the potential for doubly and triply
ironic interplay between site and understanding, world and word assumes rich
proportions.

Let us turn, then, to consider the poetics of person and place, and the ex-
tended use of ironic discourse, the language of humiliation, in three crucial
moments of the Oxford *Roland*: the beginning of the battle, the second horn
episode, and Roland's death scene. But first, it will be helpful to examine
briefly the poetics of the site, Roncevaux, in the context of eleventh- and
twelfth-century descriptions.

Roncevaux and the Poetics of Place

Roncevaux has for so long been associated with Roland and Charlemagne,
with epic din and tragic death, that we tend to forget the two-hundred-year
interval between the first mention of the Pyrenean battle in the *Royal Frank-
ish Annals* (c. 816) and its first specific siting at Roncevaux by the *Nota Emil-
ienense* (c. 1050). But even though the textual tradition of Roncevaux does not
begin until the eleventh century, the battle there was viewed, already at that
time, as a historic event of the first importance, and the early manifestations
of the tradition show signs of wanting to explain that significance.

In addition to, or perhaps because of, its diachronic instability, Roncevaux
is curious in another way: for the strikingly ambivalent nature of its monu-
ments and relics from a military point of view. Most battlefields tend to be
commemorated in terms of specific military maneuvers or events associated
with the progress and outcome of the battle.[1] Such is not the case for Ronce-
vaux.

The Oxford *Roland*, the *Historia Karoli Magni et Rotholandi*, the *Ronsas-
vals*, the historical texts dealing with Roncevaux, none of them provides a
description of the site that would permit military historians to reconstruct the
battle strategies of the combatants. Over fifty years ago, Bédier drew attention
to this fact without, perhaps, fully realizing its significance: "certainly the
scholars who have had the pleasure of reading the *Chanson de Roland* at Ron-
cevaux have all quite rightly deplored the fact that the work contains practi-
cally no detail specific to the depiction of that valley."[2] He does point out that
the poet—"wishing to locate the action of his drama in two sites, to depict
two highly contrasted settings like those that nature offered him"—did give
an accurate topographical description of the site. In particular, the text juxta-
poses the dramatic height of the mountain, the Port de Cize, over which Char-
lemagne passed, and the valley plain below, Roncevaux itself, the latter more
suited for mounted combat between two feudal armies.

But a reading of the Oxford text shows that the contrast is not evoked in terms of the military feasibility Bédier stressed: valley versus mountain. The *whole* décor, mountains and valley, is Roncevaux. And yet this contrasting décor, especially the sweeping heights of the Port de Cize, is hardly conducive to military action, as the earliest descriptions of the battle make clear. Nonetheless, in all the descriptions of Roncevaux, be they in historical texts or poetic versions, the contrasting décor, "Halt sunt li pui e tenebrus e grant, / Li val parfunt e les ewes curant" (1830–31),[3] so nightmarish for a pitched battle of the proportion assumed by this one, not only remains a basic feature of the landscape description, it becomes central to the narrative action itself at crucial points.

In other words, both historical records and poetic versions of Roncevaux insist upon a specific kind of topographical configuration for the site which is not only unfavorable for military engagement but downright dangerous for it. This was perfectly understandable for the first descriptions of the engagement in the ninth-century accounts of the *unsited* ambush in the Pyrenees. In both the *Royal Frankish Annals* and Einhard's *Vita Karoli*, to take the earliest accounts, the repeated references to the unsuitability of the terrain clearly serve to rationalize an embarrassing defeat.[4]

But the later texts do not make this claim. Far from decrying the setting, they seem to valorize it. For Bédier, a late romantic, as for Vigny, an early one, the answer to this apparent turnabout lay in the majesty which the natural setting lent to the epic action. But that setting, as we shall see, cannot be construed simply in terms of a romantic backdrop to the event, any more than it may be comprehended in terms of military strategy. The sign value of Roncevaux has more to do with Revelation than Romanticism, with Apocalypse than Clausewitz.

We may begin to come to an understanding of Roncevaux as a complex sign system if we recall that in the Middle Ages the term *Roncevaux* stood for two distinct, if related, systems of referentiality. On the one hand, Roncevaux was a prominent pilgrim site, belonging to an important network of sites which together formed the pilgrimage to Saint James of Compostela. That pilgrimage was, as Bédier has long since demonstrated, a social, economic, and cultural phenomenon, as well as a religious one. It also served as a stimulus for artistic works of various kinds and facilitated their circulation. The primary text which we possess today describing the pilgrimage to Compostela as a semiotic system, as a network of expressive forms—texts, monuments, sites—is the *Guide de Pèlerin de Saint-Jacques de Compostelle* (c. 1130–40).[5]

On the other hand, *Roncevaux* was the term used during the Middle Ages to designate the poetic versions of what we today collectively call *The Song of Roland*. While this fact is well known, the significance of the metonymic conflation of place and texts in the medieval signifier does not seem to have been fully appreciated or explored. What does this mean?

The same term was used to signify the site of a historical event and the texts recounting the event. The latter do so in a way quite different from the early accounts of the same event before it was attached to the specific site, Roncevaux. In other words, the mythos of *the* battle of Roncevaux given in the poetic versions differs from the mythos of *a* battle fought and lost by Charlemagne's troops as recounted in ninth- and tenth-century texts, which say only

that the engagement occurred in the Pyrenees. This suggests that the significance of the historical event—its value as sign and interpretant—was transformed in some way when it was identified with a specific site.

We may get some idea of the semiotic significance of Roncevaux during the late eleventh and early twelfth centuries by looking briefly at a few descriptions of the site in documents roughly contemporaneous with the earliest literary versions. Our purpose will not be to suggest influence between the different sets of texts, but simply to ascertain what the audiences' expectations might have been regarding the value of the site, Roncevaux, based upon a variety of references. Is there general agreement among available texts that Roncevaux be viewed as other than a military site? What do these historical texts tell us about the alterity of Roncevaux? Its difference, its specialness? And finally, will we be able to find a correlation between the "historical" valence of Roncevaux as sign system in such texts and the role it plays in the discourse of the poetic versions, the "Roncevaux," or at least in the Oxford text?

Roncevaux: Generative Locus

Before looking at the *Guide du Pèlerin de Saint-Jacques de Compostelle*, let us recall briefly that the *Nota Emilienense* (c. 1050) provides the first extant precise siting for the battle when, in its last line, it names "Rozaballes" at the "portum de Sicera."[6] This brief text singles out one hero, of the twelve mentioned and six listed by name, whose death is significant enough to stand as a synecdoche for all the rest:

> Deinde placuit ad regem pro salutem hominum exercituum ut Rodlane belligerator fortis cum suis posterum ueniret. At ubi exercitum portum de Sicera transiret in Rozaballes a gentibus sarrazenorum fuit Rodlane occiso.

> [Then it seemed right to the king that, for the safety of the main army, Roland, the powerful warrior, should come behind with his men. But when the army crossed the Port de Cize at Roncevaux, Roland was killed by the Saracens.]

Taking only the most salient details of the whole text, we find that it juxtaposes the death of an exemplary hero—who is associated with Charlemagne and esteemed by him over all the other warriors—with a locus, "Rozaballes," dominated by the highest peak in the vicinity; it places a warrior-prelate, Archbishop Turpin, among the slain; and finally, it ascribes the significant death of the exemplary hero to an alien *and pagan* race: "a gentibus sarrazenorum."

The *Nota* suggests that the site and the death of Roland signify together, but nothing more. By the end of the eleventh century, however, we find that the whole site of Roncevaux has become the object of a donation to a religious order. In the cartulary of Conques, an entry dating between 1097 and 1104 records the donation to the Abbey of Sainte-Foy of the church and almonry of Roncevaux, along with a communal oven and mill. Indeed, the entire bourg of Roncevaux was, according to the charter, to have passed to the monks of Conques upon the death of the donor, Sancho, count of Erro.[7]

In 1132, the hospital at Roncevaux was founded by the bishop of Pamplona, Sancho de la Rose, with the help of the king of Navarre and Aragon, Alphonso

the Warlike. This fact is attested by an early thirteenth-century poem pre-
served in the archives of Roncevaux. The poem stresses the mountain setting,
characterizing Roncevaux and the hospital as "ad radicem maximi montis Pi-
renei." The purpose of this foundation was to assist the pilgrims who passed
through Roncevaux en route to Compostela.[8] Underlining the importance of
this charitable undertaking by the bishop of Pamplona and king of Navarre,
two papal bulls of Innocent II, the first dated 5 May 1137, confirm the enter-
prise. In addition, they place under the pope's special protection "the church
of Saint Mary of the hospital of Roncevaux as well as the hospice of the poor
in the same place."[9]

Other documents, perhaps forgeries, suggest that there may have been a
Chapel of Charlemagne above Roncevaux. Although it is unlikely that this
church actually did exist in the early twelfth century, its anteriority was con-
sidered so firmly established by the thirteenth century, and so important, that
documents were forged to show that it had been founded in 1106.[10]

These scattered but insistent documents attesting the association of Ron-
cevaux with religious foundations may be better understood if we turn now to
the most extensive early-twelfth-century historical document describing the
site of Roncevaux, the fifth and last book of the *Liber Sancti Jacobi, Le Guide
du Pèlerin de Saint-Jacques de Compostelle*. The *Guide* refers to Roncevaux
and the Port de Cize in five of the eight chapters devoted to aspects of the
pilgrimage outside of Compostela itself. In fact, the *Guide* devotes more space
and provides greater detail for the setting of Roncevaux than for any other
shrine mentioned except Compostela.

Chapter 3, which names and comments on the towns and cities on the road
to Santiago, says that "at the foot of the mountain of Cize, on the Gascon side,
there is the town of Saint Michael; then, after having crossed the summit of
the mountain, one finds the hospice of Roland, then the city of Roncevaux."[11]
Saint-Michel, a royal possession, also possessed an important religious estab-
lishment, including a church and hospital for the use of pilgrims.[12] As such, it
would naturally form a complement to the similar foundations at Roncevaux,
on the other side of the mountain. We shall soon see that for the pilgrims who
passed that way, the religious shrines imparted a special aura to the whole
mountain—its bases as well as its summit.

The three principal sites on the mountain were under the protection of Saint
Michael, Charlemagne, and Roland; Saint Michael, we recall, is the warrior
archangel known from Revelation—and from the Oxford *Rôland*, where he is
cited five times and appears once, to help Gabriel transport Roland's soul to
heaven. In the *Guide*, Roland and Saint Michael are the patrons of religious
foundations linked to and by the impressive height of Cize, described by con-
temporary texts as the highest mountain in the Pyrenees, an impression given
also by the *Guide*.[13]

Our own familiarity with the sky as a normal place of travel makes us forget
the awe with which earlier ages viewed it and the consequent sign value at-
tached to impressive eminences in the Middle Ages. In chapter 7, the *Guide*
refers to the Cize as that "excellentissimus mons quod dicitur Portus Cisere,"
and then justifies the superlative by giving its height: "cujus ascensus octo
miliariis et descensus similiter octo habetur".[14] Now this sentence rather

adroitly conjoins what appears to be realistic description with obvious affective projection. The "ascensus" and "descensus" of the description refer to the paths, one leading up and the other down, an ostensibly realistic detail. But the fact that these paths were so long, eight miles up and another eight down, imparts a suggestion of great height to the mountain. This affective reaction emerges clearly in the commentary: "Sublimitas namque ejus tanta est quod visa est usque ad celum tangere, cujus ascensori visum est propria manu celum posse palpitari . . . " (the height of this mountain is such that it seems to touch the sky; to whoever climbs it, it seems to be possible to feel the sky with his own hand).

The text credits the creation of this skyline route—a terrestrial parallel to the Milky Way (see fig. 31) running from the Frisian Sea to Santiago de Compostela described in the *Historia Karoli Magni et Rotholandi*—to Charlemagne. According to the *Guide*, he built the road on the journey to Spain with his army and raised a cross on the summit, the "Cross of Charlemagne," and then knelt to pray to God and Saint James. This cross became a prominent boundary landmark, demarcating the southernmost marches of France from Spain, as we know from a bull of Pope Paschal II in 1106 and from the *Chronicle of Vézelay* (c. 1160).[15]

Eleventh-century pilgrims, in their turn, ritually reiterated Charlemagne's original cruciform gesture upon reaching this sacred locus: "Wherefore," says the *Guide*, "pilgrims customarily bend their knee and pray in that place, turned toward the country of Saint James, and each thrusts his cross of the Lord into the ground as his own standard. A thousand crosses may be seen there; wherefore this place is said to be the first station of prayers of Saint James."[16]

Descending from the summit toward Roncevaux, pilgrims found yet another relic linking the site with a numinous past; a relic over which not a military, but an ecclesiastical, monument had been erected. This was the stone split by Roland with a treble blow of his divinely created sword, Durendal. As in the *Nota Emilienense*, Roland alone, of all the heroes, is singled out and glorified as "Rotolandus heros potentissimus."[17] The church and the rock constitute tangible monuments to his presence on the site.

It is not accidental that the moment commemorated by the rock split in two is that just prior to his death. Poetic versions and historic texts alike differentiate the battle proper from the narrative of Roland's death and the actions, such as the splitting of the rock with Durendal, that accompanied it.

In the *Guide*, the battle, mentioned after the description of the church and the rock, is spatially and commemoratively separate from the locus, the site occupied by the physical monuments to Roland's death: "Next may be found Roncevaux, that is, the place where formerly a great battle took place in which King Marsile and Roland and Oliver and other warriors with forty thousand Christian and Saracen soldiers were killed."[18]

No monuments, only the textual memory, marks the site of the military action, a site which is oriented in relation to the sacred locus of church and rock. In this account, the memory of the battle clearly functions to provide an anchoring context for the event associated with the relic—the split rock—marked by the church. The battle is thus somehow ancillary to the commemorated event, the death of Roland and the deeds of Charlemagne, both of

which made possible—the text implies—the pilgrim's presence "in media via
sancti Jacobi."

Finally, we should note that the reciprocal sign relationship between the
relic and the church containing it corresponds to and completes, on the Span-
ish side of the Cize—that is, the side closest to the enemy territory—the set-
ting apart, or sacralization, of the mountain begun at the *bourg Saint-Michel*
on the French side. The whole natural setting of the Cize, affectively assumed
to be the highest in the Pyrenees, has been phatically marked, in the descrip-
tive language of the *Guide*, with anagogic connotation.

Furthermore, this anagogic connotation stems from the composite actions
of Charlemagne's army both going to and returning from Spain. The implica-
tion could not be clearer: the campaign was a religious one whose intention
was to create the pilgrimage route whose itinerary the *Guide* describes. Note
that the pilgrim, however, is supposed by the *Guide* to be going from France
to Compostela. It is his progress toward the spiritual experience of that locus,
not his return to everyday life, that the *Guide* seems to be concerned with. We
must bear this fact in mind, for it corresponds in more than one respect to the
textual intentionality of the poetic versions.

On the French side of the mountain, the pilgrim passes through the shrine
commemorating Saint Michael. Like Saint James, Saint Michael had the *co-
quille* as an iconographic attribute; he is considered as the guardian par excel-
lence of sanctuaries; the defender of the Church ("custos Ecclesiae romanae");
and, finally, he is the Lord of Souls, who bears them to heaven, as the Oxford
Roland depicts him and Gabriel taking Roland's soul there.[19]

The cruciform symmetry appears full-blown on the summit of the Cize
where the Cross of Charlemagne serves as a monument sacralizing the em-
peror's struggle against nature and pagans in creating the pilgrim road, and
commemorates his pious gesture upon its completion. In climbing the moun-
tain, planting their own cross, and kneeling to pray to Saint James and God,
the pilgrims reiterate Charlemagne's actions (and presumably those of his
host).

The whole site, then, ceased to be a natural or a historic one. It received its
meaning from a sacred rewriting: in conjunction with the *Guide*, the site be-
came a textualized itinerary directing the pilgrim's vision and telling him that
his progress through this place was a symbolic one; a projection of himself
back onto the sacred time of *in illo tempore*, when real heroes and martyrs,
his Christian predecessors, waged a literal battle against nature and nonbeliev-
ers to win the prize of eternal life and the heavenly crown.

Roncevaux, Bordeaux, and Blaye

The *Guide* does not evoke the terrible scene of Roland's suffering and martyr-
dom for the pilgrim at Roncevaux itself. It does provide an emotionally
charged description of his martyrdom in chapter 8, when describing the tomb
of Roland at Blaye. Here, we find a brief recapitulation of the battle details
given in chapter 7 in the description of the site, but recast in the context of a
text-event encompassing the life and death of the martyr-hero. Like the de-
scriptions in chapter 7, this one too is constituted around relics: the horn pre-
served in Saint-Seurin at Bordeaux and the tomb containing Roland's body in

the church at Blaye, just across the Gironde from Bordeaux. Each of the relics is an object with a dual nature as (1) relic in the present time, but functioning as (2) a constituent of the sacred past as *historia.*

In other words, the instruments/relics signify at the level of both *historia* and *theoria,* as we came to understand these terms in chapter 4. Here, they help to stress the link between the dual loci of signification, that is, the locus of the *historia,* Roncevaux, and the locus of *theoria,* the relic sites of Bordeaux and Blaye. Thus, if the poetic versions recount the original events in great detail, including the translation of Roland's body from Roncevaux to Blaye and the deposition of the olifant at Bordeaux, it is the *Guide* that reveals the purpose of those acts by demonstrating the semiotic exchange between battle site and relic site, between poetic texts and pilgrim text.

The title of the chapter is instructive: "De corporibus sanctorum que in ytinere sancti Jacobi requiescunt, que peregrinis ejus sunt visitanda" (Regarding the saintly remains which lie on the route of Saint James that pilgrims should visit). At Bordeaux and Blaye the principal objects of veneration, so far as the *Guide* is concerned, are the "corpus beati Rotolandi martiris" and the ivory horn. The enumeration of these objects, the recapitulation of the original event at Roncevaux, and the story of their translation to the present locations take up a whole page in the text. A mere two-sentence reference to the body of Saint Seurin, whom we might expect to receive rather more attention, alerts us to the fact that the principal objects of pilgrim interest here are Roncevaux-related.

In the recapitulation of the Roncevaux material, we find Roland again distinguished from the rest of the army; he is credited with what appears to be the single-handed expulsion of the Saracens from Spain. The rest of the passage concerns the two feats of what the Oxford text will develop as Roland's passion. Asserting Roland's great strength, the text, by way of corroboration, repeats the story of the rock split in two by Roland with his sword. This time the story is extended by reference to the horn, also split in two by the force of Roland's blowing it, an anecdote that had not been recounted in the description of Roncevaux. "The horn of ivory," continues the *Guide,* "precisely the one that was split, is in the city of Bordeaux, at the church of the Blessed Seurin, and over the rock in Roncevaux, a church has been built."[20]

Constructed by means of chiastic order, these two periods place the rock of the event and the rock as relic, the Roncevaux of the event and the Roncevaux as sacred site in first and last position, surrounding the horn-event at Roncevaux and the horn-relic preserved at Bordeaux. The resultant homology demonstrates clearly the semiotic exchange between original event/commemorative event, battle site/relic site, and the different texts they constitute:

a	b		b		a
(rock)	(horn)		(horn)		(rock)
text-event	text-event	::	relic-text	:	relic-text
Roncevaux	Roncevaux		Bordeaux monument		Roncevaux monument

All this is but a necessary prolegomenon; there remains the task of valorizing Roland's tomb, the main object of the pilgrim's veneration at Bordeaux and Blaye. For this purpose, the text again uses comparison, this time with Scrip-

ture. A reading of the passage reveals that it is, in fact, constructed on two levels. There is the mimetic register of historical denotation, which provides the armature for the description. This minimal narrative offers the basic details of Roland's mythos—his death at Roncevaux and burial at Blaye—but does not explain them: for example, what was the manner of his death? How did he come to be buried at Blaye?

A second level interprets the literal meaning of the minimal narrative. This level answers the questions raised by the purely factual account and directs the pilgrim's understanding of the tomb as an object of veneration. The second-level narrative functions by semantic indirection. Rather than denoting the historical givens of the Roncevaux–Roland matter, the elements of this register are semantically marked with meaning from another, analogous sign-system of known value: that of Christ's Passion and the martyr passions based on it. This connotative register actuates a system of referentiality which might not ordinarily be associated with the history of Roncevaux. It comes in here as a gloss or trope—a metatext—to show that what happened to Roland at Roncevaux and Blaye was like what happened to Christ and the apostolic martyrs as told in the accounts of their deaths.

Thus the putatively "historical" account of Roland's death and burial is really a metaphoric transformation of soldier to *martyr Christi*, of event-site to passion-site, and of tomb-site to relic-site.

> After having conquered kings and people in many wars, Roland, worn out by hunger, cold and excessive heat, beaten by violent blows, ceaselessly whipped for the love of God, pierced by arrows and lances, this precious martyr of Christ died, it is said, of thirst in the aforementioned valley. His companions buried his most sacred body in Saint Roman's basilica at Blaye with fitting veneration.[21]

Such representations could hardly be justified by the authority of the *Guide* alone. The dual referential system of historical denotation and anagogic connotation was concordant with contemporary versions of the legend, as we saw in the last chapter.

This raises the question of intertextual references in the *Guide* to the contemporary accounts of the legend upon which the *Guide* bases its résumés. That the *Guide* assumes a knowledge of the poetic versions, the *Roncevaux*, cannot be doubted, for there are details in the *Guide* whose importance is asserted, but not explained: the significance of the horn, for example. The *Guide* tells us that Roland split it with the force of his blast, but not why he blew it.

The primary difference between the poetic versions and the *Guide* is that the former set out to reiterate the *historia in illo tempore*, to cast it in a framework of anagogic (metaphysical and teleological) signification for an audience that will not necessarily be on the site, whereas the *Guide* postulates an audience that will actually visit Roncevaux, Bordeaux, and Blaye and will want to understand the relationship of venerated objects and site to the sacred past which it is reexperiencing by its physical pilgrimage.

This difference constitutes a crucial distinction for the role of place in the narrativity of the two kinds of texts. Each articulates place as presence differently. The *Guide* treats place as experienced space in a dual time frame, where

the emphasis falls upon the here and now, the commemorative activity of site visitation. In the *Guide*, we see that place—responding to the augmentative aesthetic, which we studied in the last chapter—has acquired a coordinated but independent meaning as the setting or frame for a new set of significations of the original material.

The poetic versions, on the other hand, treat place, Roncevaux, as formal space, a setting for the narrative which is a reiteration of a sacred past. In the latter case, Roncevaux is not actually assumed to be a physical presence to the audience; it is the site of action of the *historia*, and therefore a function of the story.

Nevertheless, to the extent that the two spatial connotations were coeval, and to the extent that the audience for both kinds of texts was homogeneous, the Roncevaux of the *Guide* and other historical documents has a role to play in our determination and interpretation of the function of Roncevaux in the poetic tradition.

In any event, we can see that both kinds of texts, the poetic versions and the *Guide*, predicate meaning of person and place as sacred according to the triangular model of signification discussed in chapter 1 apropos of the text production in Rodolphus Glaber's account of the conflagration at Orléans. We can restate that schema for the case in hand as follows:

"Microcosmic World View" = *Historia/Theoria* (World-as-Word Context)

Person: Roland
Narrative: *Roncevaux, Guide*
Place: Roncevaux, Blaye

Christ/*martyr Christi*
Scripture/Apocrypha/Hagiography
Jerusalem/Passion Site/Relic Site
(Sacred Locus)

Iconography of Roncevaux: Pilgrimage Site as Text

We should now look at the role played by Roncevaux as site in the Oxford *Roland*. Before doing so, however, it might be useful to summarize the iconography of Roncevaux as site.

The early texts, including the *Royal Frankish Annals* and Einhard's *Vita*

Karoli, which we did not have time to examine, situated the event on a high mountain in the Pyrenees, a site ill-suited to military exploits but not to sacred associations. Subsequent elaboration set off the mountain with sacred shrines: a site dedicated to Saint Michael on the French side, a shrine commemorating Charlemagne and Saint James on the summit, and a church dedicated to the principal martyr-hero of Roncevaux, Roland, built over a relic of his passion, the stone split in two, on the Spanish side of the mountain. The name of the site, first given as *Rozaballes,* a descriptive toponym meaning something like "flat plain," becomes *Runciavallis* or *Rencesvals,* meaning "Vale of Thorns."[22]

Later texts recount the foundation of edifices devoted to the Virgin Mary and the Holy Savior in proximity to Roland's church; the existence of white hawthorn bushes and black thorn trees as marking the places where Christian warriors fell as opposed to Saracens; and the regular appearance on the site of "troops of angels who frequently visit the Chapel of the Holy Savior [where the remains of the Christian warriors who died in the battle were said to lie], as is attested by witnesses who have heard them."[23]

While this review does not exhaust the iconic element of Roncevaux, it is sufficient to establish a clear schema, and one that helps to show that the text-event in narratives of the site was completed by another level, that of site as anagogic index. It was this latter factor that underwent a rich development, overlaying the original text-event, the battle, with a progressive accretion of sacred symbolism, primarily christological in nature. This accreted symbolism inexorably displaced the meaning and function of the site from military denotation to religious connotation.

The purpose of this displacement is well known. As the *Guide,* the *Historia Karoli Magni et Rotholandi,* and the Oxford *Roland* attest, it aimed at incorporating Roncevaux into a network of pilgrimage sites closely interlinked by the thread of iconographic and intertextual coherence provided by the *camino francés,* the route of Saint James of Compostela.

The dual function of Roncevaux may be better understood if we leave it momentarily to go to Le Puy, which the *Guide* cites as the starting point for one of the four principal pilgrimage routes to the Galician shrine. Marcel Durliat recently studied the nature of medieval shrines in southwest France, particularly those associated with the route of Saint James. Speaking of the importance of naturally dramatic sites, Durliat says,

> It must be remembered that the veneration of pilgrims could be directed either toward a naturally sacred site or toward an object containing a fragment of the sacred. This distinction seems fundamental to us . . . for consecrated sites commended themselves generally by their spectacular appearance: *be it elevated summits,* deep caves, or vast rock shelters [my italics].[24]

He goes on to point out that such "naturally consecrated sites were most frequently placed by the Church under the protection of exceptionally venerated saints but for whom there were no relics, that is, essentially the Virgin Mary and the archangel Saint Michael."[25] Le Puy is dominated by three peaks. "As early as the sixth century, the Virgin Mary took possession of the most massive of these rocky masses. . . . [T]he precise location of the shrine was

determined by supernatural intervention, for angels assisted at the consecration of the church. Originally, there were no relics and the pilgrims venerated with exceptional fervor a huge rock which had perhaps been part of an ancient dolmen."[26]

Durliat's description emphasizes points already familiar to us from Roncevaux: the association of the shrine with a dramatically high place, a sacred rock, and an angelic visitation marking the site of the church dedicated to the Virgin. This description provides the basics of the narrative function of the site, as it were, with a minimum of elaboration as regards its connotative significance. That aspect developed later, during the tenth century, when the site underwent a dramatic transformation from an isolated shrine commemorating the Virgin to a richly connotative site connected to a sacred textual tradition, on the one hand, and to the network of pilgrim shrines, on the other.

In the mid–tenth century, a neighboring peak, higher than that consecrated to the Virgin, was dedicated to Saint Michael. Ever since his appearance at Mount Gargano in Italy in the 490s, Saint Michael had a tendency to establish his authority in high places, but in this instance, Durliat sees another reason for the dedication of the peak that rose above that of the Virgin to Saint Michael. It was to create a dialectical pairing of the two sites. Saint Michael and the Virgin: the reference is unmistakably an evocation of that apocalyptic confrontation in Revelation 12 : 1–8, when Saint Michael rushes to protect the mother and child against the menace of the dragon.

> At Le Puy, nature itself celebrates the Christian mystery. From the summit of his rock, the awesome Saint Michael rises up to protect the Virgin. And so an apocalyptic combat perpetuates itself in the sky: the struggle of the angel against the dragon who threatens the woman adorned with the sun and the male child to which she has given birth.[27]

Tenth-century contemporaries, says Durliat, had a clear understanding of the significance of this *mise-en-scène*. It is one we find repeated, for example, in the plan of the different parts of the abbey of Saint-Michel-de-Cuxa, for which we possess a contemporary text elucidating the symbolism.[28]

We also have evidence attesting that the purpose of this transformation of site at Le Puy was indeed to establish a dual system of referentiality for the shrine. The author of the scenario at Le Puy was Bishop Godescalc, who dedicated the shrine of Saint Michael in 961.[29] The date is significant for it comes precisely a decade after Godescalc made the first pilgrimage, by a non-Spaniard, to Santiago de Compostela, a pilgrimage he is generally credited with founding.

Durliat sees a definite connection between the creation of the pilgrimage route by Godescalc and the dialectical expansion of the sacred site at Le Puy. Godescalc's pilgrimage undoubtedly made him conscious of the potential of a dramatic setting for bolstering the religious fervor of the pilgrim, and of the consequent economic benefit to a shrine to be derived from nurturing that fervor. It certainly made him aware of the value of a sacred site which figured a text of sacred or apocryphal writ, as did the shrine at Compostela.

The significance of all this for us lies in the second-stage expansion of the sacred site. In enlarging the context of the original shrine, Godescalc estab-

lished an index level for the site based upon reference to a specific text of the Logos: the book of Revelation.[30] The new shrine, dialectically paired with the older one, gave a textual coherence to both, since they now, together, signify the eternal apocalyptic struggle of the chiliastic forces of good over evil.

Thus, just as in the case of Roncevaux/Bordeaux/Blaye, Le Puy underwent a metaphoric glossing whereby the site might be "read," or interpreted, according to a system of referentiality, the Book of Revelation, not originally linked to it. This glossing provides an expanded connotation for the site, permitting it to be linked with a whole network of other sites and texts.

Godescalc created this monumental scenario after his visit to Compostela, which established the pilgrim route between Le Puy, the starting point, and Compostela, the goal. The linkage of Le Puy and Compostela established by Godescalc was not merely spatial, the beginning and the end of a pilgrimage; by choosing Revelation as the paradigmatic work for his shrine, Godescalc created another level of signification through its author, John, then believed to be John the Evangelist, the son of Zebedee and brother of James, the patron of Compostela, as we saw in the last chapter. James and John, after Andrew and Peter, the first to be called by Christ, were distinguished among the apostles for Christ's prediction of their martyrdom.

Their mother had asked of Christ: "Promise that these two sons of mine may sit one at your right hand and the other on your left in your kingdom" (Matthew 20 : 21). Christ answered with a prophecy generally regarded as casting their death in terms of a recapitulation of his own: " 'You do not know what you are asking,' Jesus answered. 'Can you drink the cup that I am going to drink?' They replied, 'We can.' 'Very well,' he said, 'you shall drink my cup' " (Matthew 20 : 22–23).

Saint James was the first apostle to be martyred; his martyrdom reiterated that of Christ's precursor, John the Baptist: James having been beheaded by Herod Agrippa as John was by Herod Antipas. Since James's role as the first apostle to preach in the West definitely made him, like John, a "vox clamantis in deserto," the homologization of his life and death to that of John the Baptist seemed inevitable. His brother John also preached a vision in the wilderness: he wrote Revelation while in exile on the island of Patmos, as the *Historia Karoli Magni et Rotholandi* reminded its audience.

Godescalc thus made sure that this branch of the pilgrim route would begin and end with evocations of martyrdom and apocalypse, highly appropriate imagery for a region where the confrontation of the forces of God and Mahomet would remain a fact of life for several centuries to come. In effect, Godescalc's scenario proclaimed the lesson of the martyrs, who, as the *Passion* of Clermont-Ferrand puts it, make their lives a living text announcing the arrival of the "regnum Dei." In them, the coherence of language was the coherence of reality.

That shrines were conceived of in this way as manifestations of the Logos, physical figurations of the text as sacred writ, appears clearly, as we saw in the last chapter, in such works as the *Historia Karoli Magni et Rotholandi.* Rome, Ephesus, and Compostela, we recall, were seen as the principal seats of Christianity because they had been consecrated by the teaching and death of the three disciples, Peter, James, and John, "those who were closest to Christ and

to whom he revealed his secrets." They are revelation sites placed in the *mouvance* of the Logos by the words and deeds of the apostles associated with them; their authority could be "proved" by the fact that their tombs could be found there, just as Christ's tomb could be found in Jerusalem.

Physical space may thus be differentiated according to a hierarchy of proximity to the Logos, a kind of textual apostolic succession:

> for just as Our Lord elected Saint Peter, Saint James and Saint John over all the others, to whom he revealed his secrets, as the Gospel shows, thus did he wish to show that their seats [Rome, Compostela, and Ephesus] be honored above all the others; and they deserve to be called the foremost, for just as these three Apostles had more grace and dignity than the others, so should those sacrosanct places in which they preached, and where they are buried, take precedence over all the other seats in the world.[31]

It follows, therefore, that for a place to be sacralized it had also to be "textualized," that is, shown to express some aspect of Scripture. We can now begin to answer, perhaps, one of our original questions: how *Roncevaux* could be used interchangeably to signify *texts* and *place.*

That the lesson of Le Puy and Compostela does indeed figure in our understanding of the sacralization of Roncevaux and Roland may be further supported by the fact that Archbishop Turpin is the textual narrator and putative author of the lines quoted above. Like Godescalc at Le Puy, he equates locus and text, for—immediately preceding the above quotations—he has placed Compostela in the *mouvance* of Charlemagne and of his own text with the claim,

> And I, Turpin, Archbishop of Rheims . . . dedicated the church and altar of Saint James [at Compostela], at the request of Charlemagne in the month of June. To this Church, Charlemagne subjugated all of Spain and Galicia . . . and established that henceforth this church be called an Apostolic Seat because the body of Saint James lay there. . . .[32]

Whether one chooses to link the iconography of Roncevaux to that of Le Puy, the similarities adduced remain, as does the evidence for a dialectical rapport between Roncevaux and the sites along the route from Le Puy to Compostela. Fern Farnham and Charles Altman have discussed the rapport between the tympanum of Sainte Foy de Conques and the composition of the *Roland.*[33] We also saw a direct connection between Roncevaux and Conques in the donation of Count Sancho of Erro mentioned earlier.

The Chronicle of Moissac speaks of Roncevaux, and, high on a crenellation of the porch of Saint-Pierre de Moissac, there is a single stone figure, a warrior turned toward the Pyrenees, holding an olifant to his lips (fig. 35). This sculpture dates from the early twelfth century.[34]

These rapports are far less dependent upon local legends, as Bédier thought, than upon the major textual tradition of Christianity: the Book of Revelation at Le Puy; hagiography and the Passion Gospels at Conques; the Acts of the Apostles at Moissac; the Passion at Roncevaux; the Acts of the Apostles and Apocrypha at Compostela. Always a dialectical tension between site and Scripture, legend and Logos, and always, the site placed under the protecting *vocable* of a martyred saint or apostle, or else, of the Virgin and Saint Michael, patron of those who fought the Saracens.

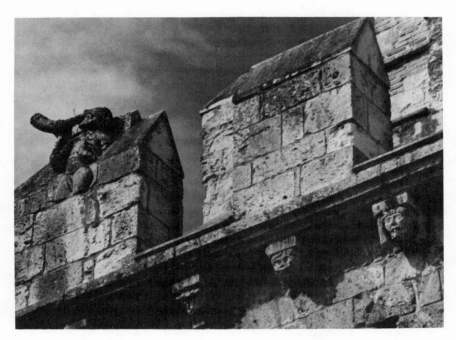

Figure 35. Saint-Pierre, Moissac. Crenellation of porch (twelfth century): Warrior (Roland?) sounding his olifant.

Bédier's formula possessed the right elements, but in the wrong order. Instead of "Au commencement était la route, la route jalonnée de sanctuaires," the motto should read, "Au commencement étaient les textes, les textes représentés par sanctuaires."

Roncevaux and the Oxford Version

The preceding pages have given us some understanding of the semiotic value of Roncevaux in the historical documents associated with it, and of the site itself. We must now turn our attention to the poetic versions, particularly the Oxford *Roland*, to ascertain the means by which they predicate Roncevaux as other than or more than a battle site. The tension implicit in the concept of the battle as other is precisely what makes the poetic versions so interesting. All of the documents examined attest to the importance of the "historical" event, the battle, as the basis for Roncevaux's and Roland's fame, even while emphasizing other aspects of the material. Only the poetic versions have the dual task of telling the story of the battle while simultaneously signifying its expanded connotation.

The problem is not dissimilar to the two-stage expansion of site that we saw at Le Puy. In the poetic texts, however, the two stages occur simultaneously as a function of the narrative in the text, rather than in historical sequence. Still,

the principle is quite similar, especially when one remembers that the mythos of the battle antedates the poetic versions which provide the elevation of connotation by several centuries, precisely as the shrine of the Virgin antedates the shrine of Saint Michael at Le Puy. The addition of the latter did not change the meaning of the first shrine, in and of itself, but it did give a new connotation, a more universal significance to the context of the shrine, by activating a complex of textual and intertextual referentiality.

In the poetic versions, the two stages correspond to two kinds of narrative strategy: (1) predication of the story (narrative as sign), *historia*, and (2) expansion of context to "explain" the story (narrative as interpretant), *theoria*. These two narrative levels constitute the dual referential system of historical denotation and anagogic connotation which permitted the metaphoric transformation of Roland from soldier to *martyr Christi* in the *Guide du Pèlerin* and in the *Pseudo-Turpin*.

The linking of person and place here should not surprise us. The preceding chapters have repeatedly shown how Romanesque narrative linked person and place in a process of mutual significance. In the Oxford text, the narrative expansion of battle site that we recognize as a poetics of place involves a reciprocal transformation of the principal persons signified by the place, Roncevaux, particularly Roland.

The Oxford text establishes a discourse which permits the battle to become a setting for a spiritual struggle and illumination for its principal hero. In itself, that would not distinguish the Oxford version from the *Pseudo-Turpin* or from the other materials studied in this book. The poetic innovation of the Oxford text lies in the risks it takes, in the reticence shown by the text in developing this theme. Unlike the *Pseudo-Turpin*, the Oxford version does not immediately concern itself with the theosis of Roland nor even postulate it as an inevitable conclusion. The interest of this work, its freshness, lies in its refusal to reveal its ultimate purpose immediately. It accepts the risks of misreading—a risk the *Pseudo-Turpin* would never run—in favor of a gradual revelation of purpose, one that comes primarily through the intuitional progress of Roland.

This poetics of person requires that the principal characters play a more active role in the narrative exposition than is the case for the *Pseudo-Turpin*, for example, where authorial discourse predominates. The Oxford *Roland*, on the contrary, has a much higher percentage of the "mixed" or alternating discourse (authorial intervention and character dialogue) traditionally associated with epic poetry. More importantly, we find that the whole episode of the Battle of Roncevaux develops dramatically through the perceptions of the principal persons, especially the Franks: Roland, Turpin, and Oliver. The dialectic of perception appears primarily, but not exclusively, in the confrontations between characters where the "naming" of the battle, identifying what, in fact, Roncevaux really means, becomes a central device for rendering it present and immediate to the audience.

By means of the dialectic of perception, the text manages to overcome the foreknowledge of the audience—for whom Roncevaux and Roland were known values—and to present the situation in terms of the problem of knowing, or recognition, it posed for the characters.

The dialectical approach causes the two parts of the battle—the initial phase, from *laisse* 69 to 110, and the second phase, from *laisse* 111 to the death of Roland in *laisse* 176—to be perceived differently by the characters and the audience. The progression from one part to the other involves a movement from "historical" to sacred time and space, and a gradual convergence of authorial and audience perspective with that of the principal persons, particularly Roland.

In the first part of the battle, the narrative representation of a probable historical space and time appears to be scrupulously postulated by the discourse; in the second part, this mode gives way to a mythic predication in which "real" time is suspended and space already appears as locus, or sacred site, treated in much the same way that the *Guide* treats the Cize and Roncevaux. Supernatural beings and events—conspicuously absent in the first part of the battle—dominate the scene progressively through the second part, reaching a crescendo at the moment of Roland's death and in the events that follow it.

As might be expected, the language of the battle undergoes a transformation from one part to the other, so that the manner of predication of the two sections is quite different. The two parts of the battle, which appear initially to form a sequence, in fact constitute two ways of perceiving the events, the second requiring a reinterpretation of the first; it is, to borrow Charles Altman's useful term, an intratextual rewriting of the first.[35] As at Le Puy, the mediation of a text from Scripture signals the transformation from narrative as *historia* to narrative as *theoria*.

Viewed in this way, the battle may be cast in terms of a praxis of revelation. At the beginning, Frankish and Saracen characters alike speak of the battle in terms of a purely military engagement, familiar to them from past experience. They not only state the event in these terms, they act accordingly. Gradually, as their initial predications undergo deliberate ironic reversal—the text is structured on an axis of predication and reversal, as we shall see—another order of reality appears, but one whose perception constitutes a spiritual act that will function to create a hierarchy of characters based upon their stated proximity to the Logos. Access to the truth will distinguish the privileged characters just as in the *Historia Karoli Magni et Rotholandi* the principal triad of apostles was distinguished from the others by its proximity to Christ, the Word.

This narrative transformation, corresponding to a change in the function of the two sections, may be measured by the role of the Saracens in the battle. At the beginning, they figure prominently, and the fighting occurs very much as we might expect in a more or less realistic account. Gradually, this mimetic narrative gives way, until, in the last engagement, three Franks rout fifty thousand Ethiopians. Roland announces to Turpin, the archbishop: "Cist camp est vostre, mercit Deu, vostre e mien" (l. 2183; This battlefield is yours, thanks to God, yours and mine). The Saracens have been effaced from the site and are absent altogether during the next thirteen *laisses* culminating in Roland's death and the appearance of the archangels Saint Michael and Gabriel and the Cherubim.

These heavenly messengers descend not only to bear the soul of the ultimately, and ironically, victorious Roland to paradise, but also to provide an

illumination for the audience, the only "living" presence remaining on the battlefield at the moment of Roland's death. This illumination has been prepared not by the "voice like a trumpet" which spoke to Saint John in Revelation 4 : 1, but quite literally by the voice *of* the trumpet, the horn episodes that mark the final stages of Roland's battle.[36] This revelation is not "of what is to come in the future" (Revelation 4 : 1), but of the circularity of Christian time in which man's history signified only to the extent that it could be shown to be an exemplary rewriting of soteriology.

A Dialectics of Predication: (Mis)Naming Roncevaux

Most readers tend to overlook the fact that the Battle of Roncevaux begins as a rhetorical predication by the combatants. The Saracen warriors are the first to name the place where the battle will occur, and they do so in a series of speeches which not only project a scenario for the impending battle, but also interpret the purpose and meaning of the fight.

Laisses 69–78 recount the choosing of the twelve Saracen peers to oppose the twelve peers of France. The *laisses* contain a number of speeches by the Saracen protagonists, and it is in these discourses that the name of the battle site, Rencesvals, occurs for the first time, always in the context of a discourse predication by a Saracen hero of the exploits he will perform "en Rencesvals." In a series of parallel *laisses*, almost all of the twelve Saracen peers predicate their role in the impending battle and predict its outcome: Roland will be killed, the Franks defeated, and Charlemagne disgraced.

Immediately following this scene, in *laisse* 78, the focus shifts to the Frankish camp at Roncevaux, and specifically to the well-known debate between Roland and Oliver as to whether or not Roland should sound the olifant. Although this scene has received much attention, it has not been taken in its full context as a sequel to the series of hypothetical predications by the Saracen warriors. But what are Roland and Oliver engaged in, if not a similar kind of projection of meaning onto the battlefield before them? While Roland and Oliver, as Christians, may claim to be closer to the Spirit of Truth than their pagan counterparts, each of them, too, sees through a glass darkly and commits the same basic error of interpretation as the Saracen heroes, using the same kind of literal vision. Their identification of Roncevaux as site is as much of a misnomer as the Saracens'.

The full meaning of the ironic perspective which undercuts the predication of Saracen and Christian alike would be attenuated if the locus of their projection, Roncevaux, were not, like Golgotha, already a known valence to their audience. Thanks to this discrepancy, the audience could perceive the irony inherent in the erroneous belief of the combatants that God's purpose manifested itself in the appearance of an event, instead of in the meaning.

But a distinction must be made between the misreading of the event by the Saracens and that by Roland and Oliver. The Saracens could not possibly perceive truth, let alone express it, because they neither believe in nor know its language. They could see only the literal, empirical world, speaking always within the epistemological framework of the period.

Each of the Saracens sees Roland primarily as a historical agent with no

symbolic or spiritual valence. By effacing the defender of the "lei franceise," they believe that the law itself will be destroyed. They make the same mistake, in other words, as the Foolish Virgins and the heretics we discussed in chapter 1 when they relegate the material and the spiritual to two separate and unconnected spheres. In doing do, they lay the foundation for the ironic reversal of their predication in the same way and for the same reasons as the chief priests in the Gospel accounts of the Passion. By crying, "Crucify him!" or, in this case, "Kill him!" they announce not the end but the beginning of the story.

> "Jo cunduirai mun cors en *Rencesvals,*
> Se truis Rollant, ne lerrai que nel mat!" [892–93]

["I'm off for Roncevaux, / If I find Roland, I shall not fail to bring him low."]

> "En Rencesvals guierai ma cumpaigne,
> .XX milie ad escuz e a lances.
> Se trois Rollant, de mort li duins fiance,
> Jamais n'ert jor que Carles ne se pleignet." AOI [912–15]

["I'll lead my troops to Roncevaux, / Twenty thousand with shields and lances. / If I find Roland, I give my oath that he shall die, / Never again will there be a day that Charles does not lament."]

> "En.Rencesvals irai mun cors juër;
> Se truis Rollant, de mort serat finet
> E Oliver e tuz les .XII. pers.
> Franceis murrunt a doel et a viltiet.
> Carles li magnes velz est et redotez,
> Recreanz ert de sa guerre mener,
> Si nus remeindrat Espaigne en quitedat." [901–07]

["I'll risk my life at Roncevaux; / If I find Roland, he shall be put to death / With Oliver and all the Twelve Peers. / The French shall suffer an agonizing and shameful death. / Charlemagne is old and decrepit. / He will forsake the war he is waging, / He will abandon Spain to us and leave us in peace."]

The measure of error in these discourses and others like them is easily taken, but the manner in which error is conveyed alerts the audience to the deductive fallacy at work, an awareness that will help it understand the more subtle fallaciousness in the predications of the Christian heroes. Each discourse advances a fact known by the audience—through its cultural exposure to the Charlemagne mythos, as well as to the work itself—to be true, for example, "Charlemagne is old," but then draws from this fact a conclusion known to be false, for example, "Charlemagne is . . . [also] decrepit." Thus, the French may be going to die painfully, but they certainly will not die shamefully, as the last-quoted discourse claims; Roland will indeed die at Roncevaux, but not because he has been found and killed by these Saracens.

The iconic value of the site has yet to be established by the narrative, but already there are certain potentialities of the story that would be untenable for an audience whose social enculturation had taught it that Roncevaux, Charlemagne, Roland, and Turpin signified positive virtues. These values might be refined, extended, and otherwise glossed; they could not be controverted.

Recognizing this, the narrative marks the divergence between Saracen discourse and known mythic valence according to an axis of truth or falsehood. Each Saracen forcefully projects his presence onto the battlefield by means of verbs cast in the future of the indicative: "En Rencesvals irai mun cors juër" (l. 901); "En Rencesvals guierai ma cumpaigne" (l. 912); but the predication of the deeds to be done there is prefaced by the "se" ("if") of hypothetical discourse.

The divergence between what the audience knows to be true, drawing upon its collective view of the past, and what the characters hypothesize as future truth can never be greater than in these discourses. They serve to alert the audience, however, to the possibility of ironic distancing of character and audience, a technique to be exploited with ever greater subtlety in the subsequent sections.

We do not have to wait long to see this technique used with greater complexity. Roland and Oliver both fall victim to the same kind of misprision as the Saracens, but with graver consequences. They, too, mistake material manifestation for spiritual meaning, the historic for the anagogic, as Oliver looks out over the plain at Roncevaux to see "Tanz blancs osbercs, tanz elmes flambius!" (l. 1022; So many gleaming hauberks, so many blazing helmets!).

Theirs is not the conscious error of the unbeliever, the detester of truth, but the error of those Christians too enmeshed in material things, and who, consequently, cannot fully apprehend divine purpose, as Saint Augustine pointed out, because they do not "look and question"; or who, having looked and questioned, do not understand because they have not compared what "they have taken in from outside with the truth within them."[37]

For Augustine, as for Eriugena, knowledge derived from an inner, agonistic processing of external data, not from remaining at the simple level of empirical observation. The first horn episode between Roland and Oliver constitutes a kind of parody of the empirical looking and questioning without understanding described by Augustine in the above quotation.

Both Roland and Oliver look and question, but at different things and on different levels. Oliver stands atop the hill looking out at the Saracens. We "see" the Saracen hordes as a presence through his direct and indirect discourse in *laisses* 80–83. In contrast, Roland refuses to mount the hill to look at the Saracens; instead, he contemplates the Franks and their meaning.

Seeing and questioning provide the basic structure for the scene, thus placing it in sharp contrast to the previous one where blind assertion prevailed. The discourse of the two French heroes differentiates itself from that of the Saracens by the rhetorical model it illustrates. Whereas the latter took the *gab*, a vain, boasting discourse, for its model, Roland and Oliver's speeches utilize *disputatio*, a technique of rational dialectic.[38] *Disputatio* as found, for example, in Abelard's *Sic et Non* may aid in creating the conditions for finding truth, but it is no guarantee. So here, although the givens of the problem are clearly exposed, each disputant errs in looking but not "seeing," although it is Roland, as we know from the meaning of the site, who will ultimately be vindicated, but through God's mercy and only after he has undergone a more profound search for the meaning of the battle.

Ocular evidence of the site and of the Saracen host is one of the important

products of this scene. Although we find nowhere near so detailed a description of the terrain as in the *Guide,* we do find the familiar evocation of mountains and valleys, here used to stress the overwhelming numbers of the Saracen host. This serves not only as a realistic matter for the debate, but also to emphasize the sheer superiority of numbers that will eventually overwhelm the majority of the rear guard, but which, in a miraculous reversal akin to the suspension of the sun's course when Charlemagne returns, Roland's and Turpin's faith will put to flight at the climax of the third horn episode.

We have seen that the theme of numerical superiority of the enemy has been a given of the Roncevaux mythos from the time of the Royal Frankish Annalist. Its evocation in the Roland–Oliver debate, therefore, constitutes a fact whose truth value is known to the audience and has only to be activated and confirmed by the narrative.

> "Jo al veüt les sarrazins d'Espaigne,
> Cuverz en sunt li val e les muntaignes
> E li lariz e tretutes les plaignes.
> Granz sunt les oz de cele gent estrange,
> Nus i avum mult petite cumpaigne." [1083–87]

["I have seen the Saracens from Spain, / The valleys and mountains are covered with them, / The hillsides, too, and all the plains. / The armies of that foreign people are huge, / We have a mighty small company."]

Oliver's speech demonstrates the same opposition between reality and unreality that marked the Saracen discourse, but in this case the reason is false logic, at least within the context of the Christian episteme. "They are many, but we are few" is a concrete fact, a textual corroboration of the mythos. But Oliver casts it in such a way that it could also be construed as a psychological fact, and therefore a factor in the reasoning which leads him to argue for the recall of Charlemagne. More importantly, in terms of the dialectic between this scene and the previous one, it appears to be an extension of the same kind of reasoning used by the Saracens:

> "Franceis murrunt e France en ert deserte."
> A icez moz li .XII. per s'alient.
> Itels .C. milie Sarrazins od els meinent
> Ki de bataille s'arguënt e hasteient,
> Vunt s'aduber desuz une sapide. [989–93]

["The French shall die and France will be deserted." / As soon as he has spoken, the Twelve Peers assemble. / They take a hundred thousand Saracens along with them, / Who jostle and prod one another in their eagerness to start the battle, / They go arm themselves in a pine grove.]

Just as the Saracens do not calculate the spiritual reinforcement available to the Christians from their faith, so Oliver's equation, "They are many, but we are few," ignores this dimension. Throughout the debate Oliver insists on the concrete, purely military interpretation: "Fust i le reis, n'i oüssum damage" (l. 1102; Were the king here, we would have suffered no harm).

Roland, on the other hand, consistently and with variety appeals to a progressively more elaborate framework of spiritual and metaphysical values that reinforce the Franks, making them superior to the Saracens. Yet he too com-

mits the "materialist" fallacy, albeit a slightly more spiritual version of it, by insisting that the battle will be primarily a human affair, little different from others they have fought. Not once does he entertain the possibility of their mortality.

The predications of Roland and Oliver are necessarily on an infinitely more profound level than those of the Saracens in the previous scene. On the outcome of this debate rests the interpretation of the spiritual meaning of Roncevaux, or, rather, it is the second step in the process of establishing that value—one of the primary projects of the work. This fact, as in the case of the Saracen discourses, allows the audience to make a provisional and immediate evaluation of the arguments advanced by the two Frankish heroes.

Oliver's reasoning grounds itself on empirical observation and envisions a purely material resolution of the situation:

> "Cumpainz Rollant, kar sunez vostre corn,
> Si l'orrat Carles, si returnerat l'ost." [1051–52]

["Comrade Roland, do sound your horn, / Charles will hear it and the army will turn back."]

> "Cumpainz Rollant, l'olifant car sunez,
> Si l'orrat Carles, ferat l'ost returner,
> Succurrat nos li reis od sun barnet." [1059–61]

["Comrade Roland, do sound the oliphant, / Charles will hear it and he will make the army turn back, / The King with all his knights will come to our assistance."]

> "Cumpainz Rollant, sunez vostre olifan,
> Si l'orrat Carles, ki est as porz passant.
> Je vos plevis, ja returnerunt Franc." [1070–72]

["Comrade Roland, sound your oliphant, / Charles, who is going through the pass, will hear it. / Then, I promise you, the Franks will return."]

To act upon the logic of Oliver's predication would be to condemn the Christian–Saracen encounter at Roncevaux to the status of one of the innumerable border skirmishes mentioned in chronicles of the period, but whose details and significance have long since been lost.[39]

More importantly, in terms of the Roncevaux mythos, Oliver's reasoning represents an impossibility, an abstract- rather than a concrete-potential: if it were followed, Roncevaux would then have no potency as a site or as a text—and we have seen that the two are coextensive. This does not mean that Oliver's role in the debate is without significance—far from it—but it does mean that the emphasis of the debate must fall on Roland's discourses, his predications, which are longer, more varied, and less divergent from the mythic valence of place. It is through Roland's predications that we begin to see the textual valorization of Roncevaux as a site of universal significance, especially when his arguments are measured against the Saracen predications of the previous section.

Like the Saracen heroes, Roland, too, rhetorically projects meaning onto the battlefield. Unlike the Saracens, however, Roland envisages the impending action in a temporal framework that goes beyond the mere present; he assumes

a future audience for whom the battle will have significance. In so doing, of course, he demonstrates a world view in which the idea of *historia*, of anteriority as a significant component of the meaning of the present, is of prime importance. Even in the narrative present, then, the narrative future, when the battle will have become a song about the battle, is foreseen:

"Or guart chascuns que granz colps i empleit
Que malvaise cançun de nus chantet ne seit!
Paien unt tort e chrestïens unt dreit.
Malvaise essample n'en serat ja de mei." AOI [1013–16]

["Now let everyone take care to strike great blows / So that bad songs not be sung about us! / Pagans are wrong, Christians are right. / I shall never be cited as a bad example."]

"Malvaise cançun"/"malvaise essample": these terms establish a definite progression in the levels of consciousness of the battle potential expressed by the characters. The Saracens envisage no possibility of a negative outcome of the battle; Oliver raises the spectre of a purely military one, "vencuz," "damage." Only Roland raises the hermeneutic question, as it were; only he sees the impending battle in terms of textual potential: good song versus bad song. If the Saracens seek to destroy the Word, Roland wants to assure it. Hence it is Roland, in this first section, who evokes the index potential of the battle-as-text. Historical event by itself has no hermeneutic valence; only when transposed into text can it attain levels of meaning.

Rodolphus Glaber set forth the principle of history-as-exemplum by which the world of time and man, on the one hand, and the celestial world to come, on the other, may be conjoined and presented to consciousness by means of textualization. According to this view, the historical events of the world, when set down in writing, constitute a microcosm which will reveal how all things in the world, especially when viewed as a structure similar to the structure of the Gospels, are placed at the service of man in order that he may discover a knowledge of God and the process by which faith insinuates itself into man's soul.[40]

Roland's discourses demonstrate a consciousness not found in the predications of the other characters in this section, an awareness of the event-as-anteriority, the event-as-exemplum, precisely the characteristic identified by Eriugena and Rodolphus Glaber as the message of John's Passion Gospel.[41] Roland, then, stands out from the other characters as the only one for whom the battle site possesses alterity, for whom it represents a potential text-site.

By asserting that their actions will be observed and judged, Roland implicitly calls attention to other texts of the event. In this connection, it is important to note that the *Guide*'s account of Roland's passion and death, quoted earlier, resembles his own account of the reasons for and hardships of battle, particularly in his emphasis on suffering extremes of cold and heat and bodily scourging:

"Ben devuns ci estre pur nostre rei:
Pur sun seignor deit hom susfrir destreiz
E endurer e granz chalz e granz freiz,
Sin deit hom perdre e del quir e del peil." [1009–12]

["We must make a stand here for our king: / One must suffer hardships for one's lord / And endure great heat and great cold, / One must also lose hide and hair.]

Yet we can see here why Roland, like the others, remains too much concerned with the material world. For, if Oliver's discourses resemble the Saracens' by his emphasis on purely physical matters, Roland's resembles theirs in his exalted prediction of the exploits he and the Franks will accomplish on the battlefield:

"Quant jo serai en la bataille grant
E jo ferrai e mil colps e .VII. cenz,
De Durendal verrez l'acer sanglent.
Franceis sunt bon, si ferrunt vassalment,
Ja cil d'Espaigne n'avrunt de mort guarant." [1077–81]

["When I shall be in the great battle, / Striking a thousand and seven hundred blows, / You'll see Durendal's steel all bloody. / The French are good, they will strike courageously, / Those from Spain shall have no safeguard against death."]

There are important differences between Roland's discourse and that of the Saracens, however. Whereas the Saracen predictions are introduced by the hypothetical marker "se" (if), Roland's are marked by the temporal conjunction "quant," (when). The future tense still marks them as hypothetical, but the awareness of event-as-anteriority already introduced by Roland and corroborated by the audience's knowledge of the event invests his predication with the certitude of historical fact: the audience, believing in the historicity of the event, could believe that this was, in effect, what did happen.

Roland's heroic assertions function at two levels of temporality: future from his perspective, anterior from the audience's. This dual perspective, the same frame which allowed the audience to reject the Saracen predictions, works to confirm Roland's claims; they are not falsifiable: every single claim made by Roland will come true.

On the other hand, we know that Roland's predictions will *not* be realized in the way he now thinks. The context in which he advances his claims, a context of total military victory, aided by God, is as erroneous an interpretation of the Roncevaux mythos as Oliver's or Chernuble's. Measured against the "architext" of Scripture, Roland's predication shows him making the same mistake as the disciples and followers of Christ, who took the triumphal entry into Jerusalem for the real triumph to come at Golgotha. Without the opposition between apparent worldly defeat and real spiritual triumph, there can be no sacralization of site.

By intending Roncevaux as a worldly victory, without the epistemological valence of the victor-as-victim theme that invested the *Guide*'s account, Roland demonstrates that he has yet to attain the knowledge of the martyr who understands the oppositional interplay of triumph and humiliation necessary for salvation.[42] As yet, he grasps only the importance of the event, not its significance. This suggests that the narrative strategy of the work derives not from any intention to represent simply what was known of the event, but from a more subtle and exemplary purpose: to represent the unfolding consciousness of the principal character regarding the event and, in so doing, to render its significance evident to the audience.

The exemplary model is that of the education of the martyr, the gradual weaning away of the warrior from his single-minded pursuit of battle for its own sake, or for the sake of purely secular concerns. The martyr's knowledge tells him that the significance of the event comes only with the death that will transform life into text, neutral ontological fact into intentional textual sign.

"All texts are preterite," Walter Ong has recently said. "Unlike utterance, a text is assimilated . . . after its utterance (its 'outering') is over with. A text is not a living potential in the human interior. . . . [I]t is a thing out of the past."[43] Roland, the one character who has raised the issue of textualization ("malvaise cançun"/"malvaise essample," ll. 1014, 1016), will have completed his self-predication/self-realization only when he comes to recognize that his futurity must coincide with the story's anteriority: in the closure of death as textualized life that marked Christ's self-predication (John 12 : 23–28).

As it is, Roland still believes in the possibility of the traditional heroic assertion, an attitude necessary for the literal postulation of the battle at this juncture. For the narrator and the audience, secure in their foreknowledge of the event, this possibility may be viewed only through the filter of ironic distancing:

> Rollant est proz e Oliver est sage:
> Ambedui unt merveillus vasselage,
> Puis que il sunt as chevals e as armes,
> Ja pur murir n'eschiverunt bataille;
> Bon sunt li cunte e lur paroles haltes. [1093–97]

[Roland is worthy and Oliver is wise: / Both have amazing courage, /Since they are mounted and armed, / They will not shrink from battle even if it means death; / Both counts are worthy and their words noble.]

The dialectic of events will oblige Roland to probe more deeply for the meaning of the battle in the next phase.

A Dialectics of Predication: Turning Point

From the end of the first horn debate to the beginning of the second, in *laisse* 127, the physiognomy of the battle undergoes a profound change. It begins well enough, for Roland, at *laisse* 93, on a note of ironic reversal of the boastful predications made earlier by the Saracens.

Laisses 93–108 recount the first victorious phase of the battle for the Franks. In this section, Roland's predications appear to be on the way to successful realization, for from *laisse* 93 to 104 the twelve Saracen peers meet their Frankish counterparts in single combat. One by one, in exactly the same order as in the original sequence of discourse predication, the twelve Saracen peers go down to defeat in a physical disconfirmation of their earlier assertions.

Roland kills the first and last of them; Oliver and Turpin defeat the second and third, and Oliver downs the penultimate one as well. The last of the Saracen peers, Chernuble, must go to Roland, for, in the earlier discourse predication sequence, Chernuble had given an explicit description of how he would kill Roland with his sword:

Ce dist Chernubles: "Ma bone espee ai ceinte,
En Rencesvals jo la teindrai vermeille.
Se trois Rollant li proz enmi ma veie,
Se ne l'asaill, dunc ne faz jo que creire.
Si cunquerrai Durendal od la meie." [984–88]

[Chernuble said: "I am wearing my good sword, / I shall stain it red at Roncevaux. /
If I find worthy Roland in my path / And do not attack him, then may I not be
worthy of belief. / But I shall conquer Durendal with my sword."]

In *laisse* 104 the two warriors do meet, and the narrative emphasizes the
skill with which Roland uses his sword, mentioned by name, to vanquish the
Saracen. It would be difficult to imagine a more forcefully ironic negation of
Chernuble's original boast—nor, taking it as a metonymy, for the very enter-
prise of Saracen logocentrism—than this passage, especially when we recall
that Chernuble's sword, the chief ornament of his original discourse, never
leaves its scabbard.

With the death of Chernuble, the negation of the Saracen boasts has been
accomplished. Franks and Saracens have been distinguished not only in physi-
cal terms, by the superiority of the Frankish peers over their Saracen counter-
parts, but also in terms of the effectiveness of their *language*: the Franks com-
ment on what they have accomplished, whereas the Saracens engage in vain
predictions. Valorization of word and deed thus constitutes an important part
of the Christian world view, distinguishing it from the pagan, just as it is a
major part of the textual strategy of the *Chanson.*

Having made the point that the Saracens cannot, of their own volition,
predicate Frankish defeat, the text now begins to deal with the basic mythic
given of the site: the death of the rear guard. At this point, *laisses* 109–10,
occurs the longest authorial intervention to date in the Roncevaux episode. As
often with *laisses similaires*, these two *laisses* mark an important transition.
Here, for the first time, the author reveals the extent of the military disaster
at Roncevaux.

The transformation of the physical situation of the Franks from triumph to
disaster occurs without the implication of shame or dishonor that marked the
narration of the Saracen reversals. At the purely historical level, it appears as
a function of the overwhelming numbers of the enemy, the odds evoked by the
Saracens themselves, and by Oliver at the beginning of the episode.

Significantly, given the movement of the narrative toward the symbolic and
anagogic, the defeat appears only partially the result of physical circum-
stances; or, rather, the physical circumstances serve as the agent of a more
sinister force. The first phase of the battle proved that the Saracens, by them-
selves, could not predicate Christian defeat. Now, however, as things turn
against the Franks, another form of discourse enters the picture: the language
of treachery. The defeat appears not as confirmation of the Saracen ability to
predicate the world, but as a betrayal of the Christian world view analogous to
what the heretics at Orléans attempted in Rodolphus Glaber's account.

The factor of treachery marked the narration from early in the poem—from
the moment Ganelon was introduced, in fact. Treachery is an element of the
mythos of the site found in the earliest evocation of the disaster in the Pyre-

nees recounted in the *Royal Frankish Annals*. Now, however, it ceases to be simply an element of the *historia* and begins to function as *theoria*, or commentary, by undergoing homologization with the Christian paradigm of treason: the betrayal of Christ by Judas:

> Malvais servis le jur li rendit Guenes
> Qu'en Sarraguce sa maisnee alat vendre.
> Puis en perdit e sa vie e ses membres,
> El plait ad Ais en fut juget a pendre,
> De ses parenz ensembl'od lui tels trente
> Ki de murir nen ourent esperence. AOI [1406–11]

[Ganelon rendered him (Charlemagne) ill service on the day / That he went to sell the members of his household at Saragossa. / Later he lost his life and limbs, / In the trial at Aix, he was sentenced to be hanged, / Along with thirty of his relatives, / Who were not expecting to die.]

The correlation of Ganelon with Judas—explicitly equated in the *Pseudo-Turpin*, as we saw in the last chapter—occurs here by the subtler device of associational signs: selling his condisciples, the twelve peers, hanging, and the number thirty. But even though the Oxford text shows more restraint in evoking the Judas archetype, its emotional significance is no less powerful, to say the least.

The emotional valence of Judas's treason was one of the elements of heightened connotation emphasized by the first vernacular *Passion*, that of Clermont-Ferrand. In light of Brault's observation that "the devil's presence is always acutely felt when the Saracens are around,"[44] we might bear in mind that there could hardly have been a more graphic contemporary evocation of the devil's physical presence and transforming power than that based on the possession of Judas by Satan (John 13 : 21–30), as rendered by the Clermont-Ferrand *Passion*.

> De pan et vin sanctificat 25
> toz sos fidels i saciet,
> Mais que Judes Escharioh,
> cui una sopa enflet lo cor:
> Judas cum og manjed la sopa, 26
> diable sen enz en sa gola;
> *semper* leved del piu manjar,
> tot als Judeus o vai nuncer.

[All of his faithful followers took the sanctified bread and wine, except Judas Iscariot, whose body was bloated by a crust. / After he had eaten the crust, the devil entered him through his snout. Immediately, he got up from the pious meal and went quickly to betray Christ to the Jews.]

Although Ganelon's treason is not a new factor in the narrative, having been evoked from the moment he enters the story—"Guenes i vint, ki la traïson fist" (l. 178)—it is the first time the treason has been linked to an emotional assessment of the impending disaster; it is also the first time that the function of Ganelon has been explicitly linked to its archetype: Judas's betrayal of Christ. It appears here as the last item in a *laisse* devoted to the general mourning of the Franks for the loss of the rear guard, and as a prelude to the next

laisse, 110, in which the cosmic consequences of Roland's death—in terms patterned on the cosmic manifestations attendant upon Christ's passing—are evoked as a specific prediction of the Paladin's demise exactly sixty-six *laisses* before it occurs (the christological number symbolism can scarcely be gratuitous).

Why should there be so explicit an emphasis in the two *laisses* on the emotional response of the Franks and Charlemagne to the death of Roland and the peers in a context where Ganelon is equated to Judas? The answer lies in the dynamics of the Passion.

In the last chapter we saw that the conjoined elements of witness and emotional response are essential constituents of a Passion in eleventh- and twelfth-century art and literature. They underscore the role of mourning, which was considered crucial in establishing the concreteness of Christ's death as a reciprocal implication of his resurrection: there could be no resurrection in the flesh without a real death. Mourning signified the reality of that death; witnesses accomplished the dual purpose of mourning *and* attestation. Furthermore, the witnesses in the Passion scene served as mediaries for the spectators; as interpreters within the text, as it were, for the response which the poetic image is meant to elicit from the audience.

We find the same dynamic in the *laisses* before us. The mourning of the witnesses within the text, Charlemagne and the families of the Frankish heroes, creates a phatic level of discourse, prominently stressed, which provides a perspectival extension, in the scene itself, of the consequences of the impending action. For the documentation of the historical dimension, this mimesis of mourning conveys the participatory feeling: "This really happened; the people are very upset." From that observation to the notion, "This really happened for our salvation, to save our church and shrines from the pagans," there remains a gap.

It is to fill that intervening space, to make the message immediate to the audience, that the emotional valence of the Passion is called upon. By evoking the Ganelon–Judas and Christ–Roland links, the text begins to infuse the poetic images with resonances associated with the Passion and to which the audience could respond predictably. The two narratives were thus linked affectively through the audience's conditioned response to the Passion analogy, a crucial constituent of the second-stage narrative. It was the pathos of the Passion, rather than the theological concept, that was to provide the common ground in the two narratives.[45]

A Dialectics of Predication: The Voice of the Trumpet

By *laisse* 127, all of the details of the battle which previously bore only a monovalent military connotation now possess a spiritual significance as well. No longer is the Saracen simply an enemy; he has become the devil himself, the one with whom Ganelon made his Satanic bargain, sealing it with a kiss, an inverted reference to the kiss Judas bestowed on Christ as the sign of his betrayal.

Saragossa, the one stronghold Charlemagne had not conquered, as the first *laisse* made clear, has become the seat of Satanic influence. There can no

longer be any question of incorporating it within the Christian framework; it must be destroyed and refounded:

> Un Sarrazin i out de Sarraguce,
> De la citet l'une meitet est sue,
> Ço est Climborins, ki pas ne fut produme.
> Fiance prist de Guenelun le cunte,
> Par amistiet l'en baisat en la buche,
> Si l'en dunat sun helme e s'escarbuncle.
> Tere Major, ço dit, metrat a hunte,
> A l'emperere si toldrat la curone. [1526–33]

[There was a Saracen there from Saragossa, / Half of the city is his, / It is Climborin, who was not a man of honor. / He took Count Ganelon's oath, / He kissed him on the mouth as a sign of friendship, / He also gave him his helmet and his carbuncle. / He will, he says, cover the Fatherland with shame, / And take the Emperor's crown away from him.]

But concurrent with this conclusion comes the admission that the Frankish rear guard no longer constitutes a force sufficient to realize this task. We learn that the Franks resisted four assaults by the combined Saracen forces, but that the fifth overwhelmed them, so that now only sixty of the rear guard remain. While the theme of Frankish valor persists, it is overlaid by insistence on their suffering. Roland faces the facts and, like the *homo eruditus*, prepares to admit the fallibility of his earlier vision.

He accepts the necessity of revealing the plight of the Frankish rear guard to Charlemagne—the agent of light: "Karles si est a dire 'lumeire de char'"[46]—so that the ultimate goal of the *geste* may be achieved. From this point on, Roland and Charlemagne thus work to realize, in the world, divine purpose. Agents of revelation, like the Wise Virgins in Eriugena's metaphor, they apply the "lamp of the mind" to resolve the crisis at hand.

From this stage on, Roland progressively acquires the value of the *homo eruditus* ascribed to him in the *Pseudo-Turpin* and symbolized by the traditional troping of his name as "scroll or text of wisdom": "*Rollans vaut autretant a dire* comme 'roles de sciance.'"[47]

We should note, however, that the recognition of his earlier fallibility does not come abruptly in *laisse* 127, at the beginning of the second horn debate. At the beginning of the second phase of the battle, in *laisse* 112, Marsile leads a huge army through the valley toward the Franks. "Seven thousand bugles sound the charge," making a deafening sound. Roland immediately understands this, not as an immediate physical manifestation, but as a signification of Roncevaux as the Frankish passionsite and Ganelon as the agent of treason.

> Ço dist Rollant: "Oliver, compaign, frere,
> Guenes li fels ad nostre mort juree,
> La traïsun ne poet estre celee.
> Mult grant venjance en prendrat l'emperere." [1456–59]

[Roland said: "Oliver, companion, brother, / Ganelon the traitor has sealed our death, / His treason cannot be hidden, / The Emperor will take great vengeance for this."]

In *laisse* 80, when Oliver accused Ganelon of treason, Roland rejected the

accusation on the grounds of family loyalty. At that point, he had not accepted the concept of Roncevaux as their passionsite. Now, however, he does see and accepts the consequences, just as Christ, the betrayed, foresaw and accepted the consequences of his betrayal.

The note of community in Roland's speech, of *societas* (*"compaign, frere . . . nostre mort"*), reinforces the concept of a confraternity betrayed by one whose act—the betrayal of the *societas* and *Lex*—has the ironically opposite effect of what was intended. Instead of destroying the society and its Law, the betrayal reinforces it; the betrayed take their death upon themselves as an example:

> "Bataille avrum e forte e aduree,
> Unches mais hom tel ne vit ajustee,
> Jo i ferrai de Durendal, m'espee,
> E vos, compainz, ferrez de Halteclere.
> En tanz lius les avum nos portees!
> Tantes batailles en avum afinees!
> Male chançun n'en deit estre cantee." AOI [1460–66]

["We shall have a bitter and hard-fought battle, / Never has anyone seen such an encounter. / I shall strike with my sword, Durendal, / And you, comrade, strike with Halteclere. / We've carried them in so many places! /Ended so many battles with them! / Unworthy songs must not be sung about them."]

Reversing his earlier attitude, Roland here rallies his men to fight to and for the end, their end. Like Christ in the Conversation with Nicodemus, he accepts the necessity of death as the secret of life, textual life, the only kind open to the epic hero. This time when Roland urges Oliver to fight valiantly so that "male chançun" will not be sung about them, it is in full recognition that the ending envisaged, the *afinement*, will not be the ending of the battle—"*tantes* batailles en avum afinees!"—but the closure of a text, the story of their life.

The textualization and revelation envisaged here cannot occur if the situation of the Franks remains concealed, as Oliver urges repeatedly during the second horn episode. Once again, he remains at the level of appearances when, like the Saracens, he equates their reduced and weakened state to dishonor. For Oliver, the literalist, only the physical triumph of sound fighting forces seems to count:

> Jamais Karlon de nus n'avrat servise.
> ..
> Vostre proëce, Rollant, mar la veimes!
> Karles li magnes de nos n'avrat aïe.
> *N'ert mais tel home desqu'a Deu juïse.*
> Vos i murrez e France en ert hunie. [1727, 1731–34]

[We shall never again be of service to Charles. / . . . A bad thing for us, Roland, has been your prowess! / Charlemagne will have no more help from us. / Never again until Judgment Day shall there be such a man (as he)! / You will die here and France will be dishonored.]

Oliver's despair arises from his having already resigned himself not just to his death—he is not a coward—but to his dishonor and to the ultimate defeat

of the whole Frankish army. He already speaks of Charlemagne as though he were dead (l. 1733).

By his own admission in both debates, Oliver has a limited tolerance for risk: "Kar vasselage par sens nen est folie" (l. 1724; There is no folly in sensible heroics). Like the Saracens, Oliver predicates a faith based upon material surety. The dialectical position he advances rests on an error that Augustine exposed when he argued that, as may be seen in Job, the strength of Christian faith must be in direct inverse correlation to the material reasons for predicating it.[48]

Like Job in his despair, Oliver wants to go back in time to wars that are gone and days when Charlemagne did not seem so far away. Like Job, he feels that now he is covered with ridicule and shame (Job 30 : 1), and as Job accuses God, "I know it is to death that you are taking me" (30 : 23), so Oliver accuses Roland, "Franceis sunt morz par vostre legerie" (l. 1726; The Franks are dead because of your senselessness).

In the dialectics of man's attempt to fathom God's knowledge as outlined by Saint Augustine in chapter 28 of book 10 of *The Confessions*, Oliver's situation is plotted. It is the normal recoiling of the Christian from the life of trial and warfare imposed by God on man in the search for His knowledge.

> What man wants trouble and hardship? You command that they be endured, not that they be liked. No man likes what he endures. . . .[H]e prefers rather that there be nothing to endure. In the midst of adversities, I desire prosperous days; in the midst of prosperity, I dread adversity. Between these two, is there no middle ground where the life of man is not a trial?[49]

God's answer, as given in Job and as elaborated by Saint Augustine, is clear: in the life of faith there can be no easy way, no middle ground. The disconfirmation of Oliver's position at the level of *theoria* rests on a very firm tradition of Christian scripture, and it is that tradition which Roland's actions and Turpin's commentary will mediate in the remainder of this scene and in the third and final sequence of the Roncevaux episode.

Laisse 132, immediately following Oliver's discourse, introduces the element that opposes this debate to the first one, raising it to a new level of signification and indicating the distance that has been traveled in developing the meaning of site since the beginning of the episode. It is at this point that Turpin intervenes, the Turpin who has been consistently valorized during the first two phases of this sequence. At this moment, the two narrative threads, the manifest one of historical denotation and the immanent one of anagogical connotation, begin to converge.

Turpin is the first character within the poem to predicate the real, historical valence of Roncevaux and the metaphoric role of the trumpet as revelation. In *laisse* 132 he ends the debate between Oliver and Roland by asserting that while sounding the horn can bring the rear guard no material aid, it is the best course, for it will bring Charlemagne back to renew the battle and bring about the final defeat of the Saracens (ll. 1742–45). Contemporary commentaries on Revelation equated the trumpets of the Apocalypse with the predication of the Church triumphant, the weight and force of the Law.[50] Turpin clearly recognizes the symbolic nature of the impending confrontation between Charle-

magne and Baligant and becomes the first person to postulate the olifant as a complex signified and signifier. That he should perceive at once the historic and the anagogic significance of the trumpet, its textual and intertextual valence, naturally befits his sacerdotal office, which, especially in his function as warrior archbishop, operates on both planes.

In the second part of the *laisse* he introduces the theme of death and burial: the decorous transition from this world to the next (ll. 1746–51). The main army, he declares, will return to seek out and give proper burial to the rear guard. In short, it will establish Roncevaux as an important necropolis for those Franks who died defending the faith. Turpin's predication is the first one to be uttered at the level of *récit* which will subsequently be ratified literally rather than ironically. It also coincides point by point with the connotation of locus, the site Roncevaux that we saw to have existed by the early twelfth century. Most importantly, however, Turpin articulates the whole concept of Roncevaux as revelation. And immediately following his speech, Roland puts the olifant to his mouth to sound it for the first time.

The Olifant in Text and Context

Three *laisses* describe Roland's blowing of the horn. Each one stresses a different aspect of the action. The longest of them, the second one (*laisse* 134), provides vivid details of the physical cost to Roland of the effort needed to perform this truly superhuman act; an act so numinous, in fact, that the text treats it with unaccustomed self-consciousness. The importance of the horn blasts to the course of the narrative at this point, and the fact that, in blowing the horn, Roland wounds himself mortally, inscribe this act on the literal level of the *récit* so indelibly that the reader tends to miss the significance of the "language of the horn."

Roland's gesture in sounding the horn three times cannot simply be seen as a detail of the narrative like so many others. Too much emphasis has been placed on the sounding of the horn, both in this episode and in the one at the beginning of the battle, for it to be read only—as Oliver would have it—on the literal level. The divine origin of the horn and the ultimate disposition of the olifant in the poem both argue an index value to this sign far greater than its purely literal function would warrant. We recall, for example, that after Roland's death it is borne into the final battle as the Frankish standard (*laisse* 217).

We have already seen the importance granted to the olifant by the *Guide* and the extent of its contribution in that text to the site value of Roncevaux. Clearly the horn must have been a more complex signifier in the eleventh and twelfth centuries than we recognize today. To understand the language of the olifant in the Oxford version—and its contribution to the theosis of Roland— it might be helpful to examine the complex of intertextual allusions that contribute to the textual signification of this sign.

In his commentary on these *laisses*, Gerard Brault observed that the sounding of the horn is at once a *de profundis* (Psalm 130) and an association with the "Last Judgment trumpet at whose fearful sound the dead would rise from the grave to meet their Maker."[51] While these allusions may indeed be appo-

site, we can identify a much more tightly knit connotation system of horn imagery in the Old and New Testaments. This rich fund of horn symbolism in theophanic, messianic, and Apocalypse texts equates the horn with revelation and deliverance; in short, with the symbolic role of Christ as protector and deliverer of the faithful from God's enemies. In Revelation, the trumpet and sword together become the literal and figurative language seen and heard by John, and subsequently interpreted as the warriors of the Church Militant who do battle against Antichrist and the agents of Satan.[52]

In contemplating the language of the horn, we need to remember that in this period the ages of the world were reckoned in "Apocalypse Time," whereby historic periods appeared as different stages in the evolution of "the hostile world." Biblical and historical leaders such as Abraham, Moses, Joshua, Constantine, and Charlemagne could be seen as prefigurations of or successors to Christ as deliverer and protector of the faithful from the various forms of Antichrist. They became the eponymous markers for a cosmic chronology of opposition between Word and world that ran from the beginning of the world to the Last Judgment. In this chronology, the Saracens of the recent historical period (and the present—speaking from the perspective of the twelfth century), succeeded to the Egyptians of the Old Testament as oppressors of the faithful.[53]

The first trumpet blast in the Old Testament occurs as a prelude to the Theophany on Sinai, Exodus 19 : 16. During this divine revelation, the covenant with the Jews, their charter of election and salvation, is unveiled in the form of laws, the Decalogue and the Book of the Covenant, which make manifest the inexorable connection between submission to God's will and salvation. Yahweh tells Moses (Exodus 19 : 13) that the signal for the people to go up to the mountain to meet God will be the sounding of the *shofar*, or ram's horn. Three verses later, the scene is described:

> Now at daybreak on the third day there were peals of thunder on the mountain and lightning flashes, a dense cloud, *and a loud trumpet blast*, and inside the camp all the people trembled. Then Moses led the people out of the camp to meet God, and they stood at the bottom of the mountain [my italics].[54]

The ram's horn symbolized submission because of its connection with the sacrifice of Isaac in Genesis 22. The text specifically mentions that the ram provided by God as a substitute for Isaac in recognition of Abraham's submission was caught by its horns in a bush (Genesis 22 : 13). This is why the *shofar*, or trumpet of Exodus 19 : 13, 16, must be a ram's horn, to indicate submission.

These textual loci figure prominently in the salvation/submission/messianic symbolism of the New Testament in the Middle Ages. Zachariah, the father of John the Baptist, prophesies the coming of Christ in the Benedictus, Luke 1 : 68–79. Here he refers to Christ as the "horn of Salvation" (rendered by Jerome as "cornu salutis"), using the Greek word *kéras*, which represents the Hebrew *Qran* of Genesis 22 : 13.[55]

Qran meant both "horn" and "power," an ambiguity that was in part responsible for the association of Moses as a type for Christ. In Exodus 34 : 29 Moses comes down from his theophany on the mountain of Sinai with the two tablets of Testimony in his hands; "he did not know that the skin on his face was radiant after speaking with Yahweh." Jerome translates in the Vulgate: "et ignorabat quod *cornuta* esset facies sua ex consortio sermonis Domini."

Christ, Luke's *cornu salutis,* also came away from his theophany with a radiant face, and Moses and Elijah—along with Peter, James, and John, the three principal disciples whose connection with the Roncevaux material we noted earlier—were present at the Transfiguration. Gertrud Schiller has commented on the link provided between the Transfiguration as part of the progressive evidence that Christ is the Messiah and "his advance towards the Passion, which is foreshadowed in the synoptic Gospels [immediately] before the account of the Transfiguration."[56]

In the Benedictus, Luke specifically equated the advent of the "horn of salvation" and the new covenant which gave mankind "knowledge of salvation." Christ's Passion and his role as Messiah, both partially revealed in the Transfiguration, are accomplished in the Crucifixion and Resurrection as perfected acts completing the Old Testament exempla which prefigured them: the sacrifice of Isaac was fulfilled in Christ's actual death and the Old Testament example thereby transcended; Christ the Messiah transcends Moses, the leader, the man who did not have to see *per speculum aenigmatate* because he was "the man Yahweh knew face to face" (Deuteronomy 34:10).

The christological troping of the Isaac story makes it a locus classicus for Passion, Salvation, and Apocalypse imagery, as Schiller has pointed out: "Isaac was seen as an allusion to Christ's sacrificial Death; his preservation from death prefigures Christ's victory over death. At a later date, the ram was seen as a prototype of the Lamb of God who suffers for mankind and Isaac, shouldering his wood as he makes his way up the hill, as the prototype for Christ carrying his cross."[57]

The dynamic synthesis of these themes—the horn as signal and as power (*shofar* and *Qran*)—occurs in Revelation. Here synesthesia dominates the text—and its medieval illustrations—as the language attempts to convey the coalescence of word in image, sound in meaning: trumpet has become voice, and voice, sword. Meaning is seen as well as heard. John, the witness, is described as turning to *see* the voice, "the voice like a trumpet," and that voice is a reiteration of the the Transfigured Christ: "[O]ut of his mouth came a sharp sword, double-edged, and his face was like the sun shining with all its force" (1 : 16).[58]

This theophany gives way to another, also introduced by "the voice like a trumpet," which, as in the case of the Theophany on Sinai, is accompanied by thunder and lightning issuing from a throne before which stood "a Lamb that seemed to have been sacrificed." The Lamb opens the scroll by breaking the seven seals. Seven trumpets are then blown to unleash retribution on the world for those men who failed to heed the Word. With the sounding of the seventh trumpet, "voices could be heard shouting in heaven, calling, 'the kingdom of the world had become the kingdom of our Lord and his Christ, and he will reign for ever and ever'" (11 : 14).

The language of both the Vulgate and the Anglo-Norman translation causally equates the sounding of the trumpet with the creation of the voices telling the completion of the making of the Kingdom of God: "Et septimus angelus tuba cecinit: et factae sunt voces magnae in caelo dicentes: Factum est regnum huius mundi, Domini nostri et Christi eius, et regnabit in secula saeculorum: Amen."

The beginning of the reign of God here signaled by the seventh trumpet occasions yet another evocation of the Sinai Theophany: "Then the sanctuary of God in heaven opened, and the ark of the covenant could be seen inside it. Then came flashes of lightning, peals of thunder and an earthquake, and violent hail" (11 : 19). At this moment occurs the apocalyptic combat which we saw to have been commemorated at Le Puy and on the Gascon side of the Cize, immediately opposite Roncevaux on the Spanish side of the mountain. The woman, adorned with the sun, gives birth to the male child; the dragon appears and "war broke out in heaven, when Michael with his angels attacked the dragon" (12 : 7). We have seen that commentators on Apocalypse, from Beatus of Liebana on, repeatedly linked the Saracens with the dragon in this combat.

Now with these contextual facts in mind, if we return to the text of the Oxford version, we may better understand how it uses the language of the trumpet. *Laisse* 110, the transitional moment between the first and second phases of the battle, inaugurated the anagogical troping which characterizes the second battle sequence of the Roncevaux episode.

In lines 1423–35, this *laisse* describes a repetition in France of the celestial manifestations unleashed by the sounding of the seventh trumpet in Revelation; it also makes specific reference to a site commemorating the apocalyptic battle of Saint Michael, thereby introducing an association of the Archangel with Roland and Roncevaux that will persist until Roland's apotheosis in *laisse* 176. In *laisse* 110, *Saint Michel del Peril* represents a pilgrim site; in *laisse* 176, *Saint Michel del Peril* is the archangel himself; such specific references to site and person firmly inscribe the image of Revelation in the rhetorical structure of the poem.

The text itself gives an apocalyptic reading to the celestial manifestations—darkness, thunder, lightning, rain, earthquakes, and violent hail:

> Dient plusor: "Co est li definement,
> La fin del secle ki nus est en present!" [1434–35]
>
> [Many say: "This is the end of all things, / The end of the world is upon us."]

And even though the author intervenes to give the correct interpretation, "Co est li granz dulors por la mort de Rollant" (1437), in the last line of the *laisse*, the connection has been made and Revelation firmly established as a subtext for the Roland/Roncevaux episode, providing a contextual matrix to guide the audience's interpretation of the meaning, the *theoria*, of the action.

This procedure of indirection, of textual indirection, will continue throughout the episode until the moment of Roland's death, when it yields to direct intervention from the celestial realm as Gabriel—the Archangel of the Annunciation (also the angelic messenger who announced John the Baptist's coming to Zachariah)—and Saint Michael descend to perform Roland's apotheosis.[59]

The death of Roland announced in *laisse* 110 begins at the moment he sounds his horn for the second time, in *laisse* 134, but will not be accomplished until *laisse* 176. The horn scene, then, falls midway between the apocalyptic reading of the death and the death scene itself. Each of these critical passages serves as a moment of disclosure, revealing the path—and the distance he has come on it—toward the sacralization of being Roland achieves at

Roncevaux. In *laisse* 134, the second and longest of the three devoted to sounding the horn, he experiences a typological transfiguration that helps us to understand the narrative transformation of the third and final part of the battle, marked by a progressively more symbolic *récit*, and Roland's ultimate apotheosis.

The biblical examples of horn imagery showed two connotations—the horn as signal and power (*shofar* and *Qran*)—synthesized most notably in the text of Revelation. If we look at the three *laisses* where Roland sounds the olifant, we find, in fact, a consistent iteration of the double function of horn as signal and horn as transfigured power: *shofar* and *Qran*. When the biblical texts stress the horn as signal, they note the effect of the signal, the message communicated, on the participants who hear it. In the other instance, the horn as power, the texts stress the heightened connotation imparted to the individual by the event and signified by the numinous quality or irradiation he experiences. In these three *laisses*, we find both uses conflated, exactly as in Revelation.

Note that each kind of horn image, *shofar* and *Qran*, itself possesses a dual expressivity: immanent and manifest, literal and figural. In its quality as literal horn—made *of* and from horn—the *shofar* symbolized submission by analogy with the story of Isaac, the sacrificial victim who prefigures Christ. It thus possessed the capacity to signify both as sound and as image (like the letter in Scripture which Patristic tradition identified with flesh). Even as it expressed human submission and obedience to divine will—in Exodus and Joshua the horn is sounded at Yahweh's express command—it also *revealed* the presence of divine power, and often a military power directed against "the hostile world."

The *Qran* also signified rhetorically by conflating literal and figural signification—*historia* and *theoria*—in one expressive gesture where divine presence briefly imprints itself on the human visage, making the flesh discourse. This signification appears to the audience, not to the transfigured person who serves as the mediary for revelation: "et ignorabat quod cornuta esset facies sua ex consortio sermonis Domini" (Exodus 34 : 29).

Now when Roland sounds the olifant, he both signals to Charlemagne and expresses his submission to the divine, rather than the human predication of the battle as he reasoned it out in the preceding debate. Turpin correctly interpreted the trumpet blast as a signal for the beginning of the definitive battle with the Saracen forces, and thus, proleptically, an annunciation of the coming victory (ll. 1744–45). The two movements are not a contradiction, but rather the recognition of a paradox taught again and again in the Hebrew Bible—often in theophanies preceding battles, as in Joshua—that strength and victory lie in submission to and recognition of divine power. The horn as *shofar* expresses the oxymoronic quality of the Christian warrior: strength in weakness. Roland had not learned this lesson at the beginning of the battle; now he literally trumpets it.

The reciprocal exchange of function between Roland and the olifant that takes place in the course of the scene drives home the message: he loses physical strength and vitality—but gains in symbolic power—as the horn gains force. The three *laisses* stress the extraordinary force of the instrument, and the progressive feebleness of the man:

133

[*the man*] Rollant ad mis l'olifan a sa buche,
 Empeint le ben, per grant vertut le sunet.
[*the horn*] Halt sunt li pui e la voiz est mult lunge,
 Granz .XXX. liwes l'oïrent li respundre. [1753–56]

[Roland has put the olifant to his mouth, / He sets it well, sounds it with all his might. / The hills are high, and that voice ranges far, / They heard it echo thirty great leagues away.][60]

134

[*the man*] Li quens Rollant, par peine e par ahans,
 Par grant dulor sunet son olifan.
 Par me la buche en salt fors li cler sancs,
 De sun cervel le temple en est rumpant.
[*the horn*] Del corn qu'il tient l'oïe en est mult grant. [1761–65][61]

[Count Roland, with pain and suffering, / With great agony sounds his olifant. / Bright blood comes gushing from his mouth, / The temple bursts in his forehead. / The sound of the horn he is holding carries very far.]

135

[*the man*] Li quens Rollant ad la buche sanglente,
 De sun cervel rumput en est li temples.
 L'olifan sunet a dulor e a peine,
[*the horn*] Karles l'oït e ses Franceis l'entendent.
 Ço dist li reis: "Cel corn ad lunge aleine!"
[*the man*] Respont dux Neimes: "Baron i fait la peine!" [1785–90]

[Count Roland's mouth is bleeding, / On his forehead, the temples burst. / He sounds the olifant in agony and pain, / Charles hears it and his French listen hard. /Then the King said: "That horn has a long breath (carries a long distance)!" / Duke Naimes replies: "That baron's putting all his might into it!"]

In this exchange, the horn—as Duke Naimes's observation makes clear— imprints itself on Roland both literally and figuratively in that ironic reversal of worldly (manifest) meaning we have come to associate with passion imagery. The horn symbolized the submission to self-sacrifice typified in Christ's Passion. In sacrificing himself by sounding the horn so powerfully that it splits his head, Roland does not commit self-destruction but rather self-predication: in marking himself with the horn, he reveals a new being, a being transfigured by the sacrificial deed in the manner of the martyr or of Christ himself. He has at once expressed his difference from the others and provided a graphic image of that difference on his own person. Like the horn itself, Roland signifies his transformation both visually and sonorously. The irradiation undergone by Moses and Christ in their theophanies takes the form, in Roland's case, of the bloody stigmata—the ruptured temple and bleeding mouth—imprinted by the *shofar* become *Qran*.

The lexical terms employed by these three *laisses* also accord with the typological reading. Two names denote the instrument Roland sounds: *olifan* and *corn*; each appears three times over the three *laisses*; although the central one, 134, uses *olifan* once only and *corn* twice. As in the Bible, we have a dual terminology; we also find dual connotations. Power or might, associated with the idea of irradiation, the image of shooting forth rays, was one meaning of

the Hebrew *Qran*, and similarly, of the Latin *cornus*—by which *Qran* and *kéras* were rendered—the etymon of Old French *corn*.

Laisses 134 and 135 specifically use *corn* rather than *olifan* in lines where the force or power of the instrument is underlined:

> Del corn qu'il tient l'oïe en est mult grant. [l. 1765]
>
> [The carrying power of this horn he holds is very great.]
>
> Ço dist li reis: "Cel corn ad lunge aleine!" [l. 1789]
>
> [Thus said the king: "This horn has a mighty blast."]

Personified attributes such as "aleine" (breath) and "voiz" (voice) convey the power ascribed to the horn in more than just physical terms, suggesting the connotation "message," "instruction":

> Halt sunt li pui e la voiz est mult lunge. [l. 1755]
>
> [High are the peaks and its voice is far-reaching.]

It is in Revelation, as we saw, that the sound of the horn appears as a voice that instructs as well as signals, although in all the biblical texts the voice of the horn belongs to the register of divine discourse.

Finally, how do the characters themselves read the language of the horn? Brault says that "Charles is in doubt as to the sound of the Olifant,"[62] but his assertion runs directly counter to the textual evidence. In all three *laisses* the sound of the trumpet is immediately equated with combat by the reliable characters: Charlemagne in *laisses* 133–34, and Naimes in *laisse* 135:

> Ço dit li reis: "Bataille funt nostre hume!" [l. 1758]
>
> [The King said: "Our men are giving battle!"]
>
> Ce dist li reis: "Jo oi le corn Rollant!
> Unc nel sunast se ne fust cumbatant." [1768–69]
>
> [The King says: "I hear Roland's horn! / He'd never sound it if he weren't fighting."]
>
> Respont dux Neimes: "Baron i fait la peine!
> Bataille i ad, *par le men escïentre.*" [1790–91]
>
> [Duke Naimes replies: "A worthy baron is causing himself great anguish! /There's a battle there, *that much I know.*"]

Well, why shouldn't the intended audience read the horn correctly? During their debate, Roland, Turpin, and Oliver all assumed that the message would be properly interpreted by the receivers, although only Turpin postulated the full import of the act. And yet the poem allows for the possibility of misreading the horn; it inserts a problematic interpretation at a crucial moment, and this misprision permits the audience to realize more forcefully than ever the importance of Roland's gesture, on the one hand, and the extent of Ganelon's perfidy, on the other.

Three characters hear the horn and debate its meaning in Charlemagne's camp: Charlemagne himself, Duke Naimes, and Ganelon. They are symmetrically balanced with the three who debated and were present at the sounding of the horn: Roland, Turpin, and Oliver. Just as the senders were divided two-to-one as to the meaning and advisability of sounding the horn, so the receiv-

ers are divided two-to-one over the meaning and necessity for answering it. Linking the two groups are the three blasts of the olifant; three "voices" with at least that many levels of meaning: one for the audience; one for Charlemagne and Naimes; one for Ganelon.

Ganelon, like the Saracens earlier, postulates an erroneous meaning to the horn sound, but unlike the Saracens, he does so consciously. This manifest perversion of what he knows to be the true meaning of the olifant reiterates his earlier misrepresentation of the truth of the mission to Marsile when he reports back to Charlemagne in *laisse* 54. In this case, he goes even further, as though in order to reconfirm his treason or to justify it he denigrates Charlemagne, using the same language as the Saracens earlier, and adumbrates an unflattering portrait of Roland and his previous exploits. Ganelon's language conveys the basic material for exactly the kind of "malvaise cançun" that Roland has insisted must not be sung about the Twelve Peers (ll. 1013–14).

Eugene Vance observes that, "We should not be surprised that Ganelon, who has betrayed the norms of his society, should use language differently from other men in the poem."[63] What makes Ganelon's language different—in fact, he often uses the same kind of language as the Saracens—does not lie at the level of manifest sign so much as at the level of immanent intelligibility. He is the only one, except for Blancandrins and Marsile, in a slightly different context, who intends to conceal the truth, to reverse the dialectic of revelation that Roland devotes his energies to demonstrating.

Motivated by the same jealousy that the Clermont-Ferrand *Passion* ascribes to Judas,[64] Ganelon also betrays Roland by words; instead of trying to use the language model that reflects and confirms God's purpose, he links himself with a negative model intended to conceal or controvert the "Spirit of Truth."

As so often in this section, Revelation and its commentaries provide the context of *theoria* by which Ganelon's epistemological transgressions may be understood. In his commentary on "the beast and his image" in Revelation, Augustine argues that the beast is the "ungodly city itself and the community of unbelievers set in opposition to the faithful people and the city of God." The image of the beast, however, would represent Christians who pretend to believe but in fact betray the faith and the faithful by speaking the language of the unbelievers, the language of the beast. "'His image' seems to me to mean his simulation, to wit, in those men who profess to believe, but live as unbelievers. For they pretend to be what they are not, and are called Christians, not from true likeness, but from a deceitful image."[65]

Ganelon allows himself to do what Paul says the true believer should not: "Be not yoked with unbelievers" (2 Corinthians 6 : 14). His language and actions consistently link him with the unbelievers in an effort to subvert not just the faith of his own kind but also the *caritas* so necessary for there to be a foundation of social belief and trust within the linguistic community of believers.[66]

Ganelon's attempted perversion of the song of Roland occurs in *laisse* 134, the central *laisse* of the first horn scene and the one in which Roland literally sounds the opening bars of his own song by blowing the horn in such a way that he splits his head open in a direct equation of speech (communication) and gesture. In other words, the honesty of his speech may be measured by its

physical consequences for him, consequences which are self-inflicted and could have been mitigated by less effort. The resultant physical cost becomes a justification for believing his other words and gesture.

This was, of course, a prime argument in the ratification of Christ's teaching: his willingness to valorize it by his own death, a death which also could have been mitigated by less effort. And just as the cross remained after Christ's death as a tangible sign, a synecdoche for the whole Passion, and a prized relic, so the olifant, now said to be split in sympathetic identification with Roland's head—as the *Guide du Pèlerin* showed—existed as an authenticating relic of Roland's speech act.

Roland's gesture at the beginning of *laisse* 134 thus stands as a stark contradiction to Ganelon's treacherous enunciation at the end of the *laisse*. Unlike Roland's "speech act," Ganelon's cannot be ratified by a corresponding gesture. On the contrary, his language is disconfirmed both at the level of *historia* and *theoria*: by its failure to correlate with the reality of the characters it describes as we know them, that is, Charlemagne and Roland; by its emulation of the discourse of types whose treacherous valence the audience knows: the Saracens and Judas in the Passion Gospels; and by the equation of his speech in this *laisse* with his immediate denunciation by Naimes (l. 1792), arrest by Charlemagne (*laisse* 137), and subsequent trial and death (*laisses* 271–89). In all three categories, the disconfirmation of Ganelon's discourse in *laisse* 134 forms a symmetrical antithesis to Roland's discourse, the sounding of the olifant. The rhetoric of affirmation proves more powerful, because more submissive, than its negative counterpart in this exemplary narrative.

Ganelon's transgression cannot be viewed simply as a question of truth versus falsehood, however. If the rhetoric of affirmation—the use of language to attempt to "see through a glass darkly" by trying to find the path of ascent—constituted a principal means of transcending the spatial category of *historia*, then Ganelon's attempt to pervert this language must be shown to exclude him not only from the possibility of seeing the truth himself, but also of predicating meaning-as-truth for anyone within his community.

In other words, his self-willed speech act becomes the instrument excluding him from the *societas*, the linguistic community where faith provided the competence for understanding. Just as Roland's self-willed act becomes an act of supreme meaning, redefining the coherence of the community by postulating a new sacrificial predicate, so Ganelon's act constitutes an ironic parody of Roland's passion. We see this in the grotesque humiliation to which he is subjected following his arrest in *laisse* 137:

> Cil le receit, s'i met .C. cumpaignons
> De la quisine, des mielz e des pejurs.
> Icil li peilent la barbe e les gernuns,
> Cascun le fiert .IIII. colps de sun puign;
> Ben le batirent a fuz e a bastuns,
> E si li metent el col un caeignun,
> Si l'encaeinent altresi cum un urs. [1821–27]

[The head cook takes charge of him, he assigns this duty to a hundred of his men / From the kitchen, the surest and the toughest. / They pluck out his beard and his mustache, / Each strikes him four blows with his fist; /They thrash him soundly

with rods and sticks, / They put an iron collar around his neck, / And chain him up like a bear.]

To understand this summary humiliation, we must call to mind the parallel with Judas and the way in which Judas's perversion of the rhetoric of affirmation was represented. Earlier, we spoke of the moment during the Last Supper, according to John's version, when Judas took the sop of bread and wine Christ offered to him as a sign of his betrayal. The same act of communion that bound the disciples and Christ in a spiritual community becomes parodic in Judas's case and assumes the opposite meaning. The bread and wine of the communion supper become a wine-soaked sop such as was thrown to the dogs; Judas's partaking of it marks his *ex*clusion from the fellowship, a logical consequence of the actions performed with his lips, the same the devil passes through to enter his soul as the sop enters his mouth.[67]

Ganelon, too, participates in the same communal activity—that of predicating meaning for the horn—as Duke Naimes and Charlemagne. But the import of his statement is precisely the opposite of theirs: he betrays his exclusion from the community with the same lips that kissed the Saracen Satanic representatives in concluding the pact of betrayal, and which then perverted the truth of the mission to Marsile by presenting a false report to the king upon his return, and which later sealed Roland's doom by nominating him to the rear guard. As the other participants measure the enormous disparity between Ganelon's perversion of the truth and what they know to be the historical reality, he stands, like Judas in a similar moment, fully revealed. The humiliation at the hands of Charlemagne's cooks simply ratifies in a graphic way what has occurred at a much more profound level of meaning.

Charlemagne and Naimes perceive the correct meaning of the horn, the sense intended by Roland and Turpin. Since the only link between the two groups is the horn itself, or rather its voice echoing among the mountains and valleys, the immediately correct interpretation by Charlemagne and Naimes must, as we saw earlier, be seen in the context of revelation. For the emperor, the sound of the horn is literally an awakening to the significance of his premonitory dreams, particularly the one recounted in _laisse_ 56, where the historical givens of the subsequent actions are cleverly represented in the kind of symbolic language used for dreams in medieval literature.

This symbolic language offers an open semantic field for interpretation, functioning, at the moment of the dream, on two levels: one for the audience, whose privileged prereading of the legend makes the dream polyvalent, but another for the participants, for whom the enigma will generally remain unresolved until the moment of the foreshadowed action has come to ratify the dream; the event then assumes the status of a revelation. The enigmatic quality of the dream language for the participant absolves him from the necessity of acting upon the information until the meaning has been revealed, but at that point, he may act with the assurance that his action corresponds to the divine intention conveyed through the language of the oneiric experience.[68]

Carles se dort, li empereres riches.
Sunjat qu'il eret as greignurs porz de Sizer,
Entre ses poinz teneit sa hanste fraisnine.

Guenes li quens l'ad sur lui saisie,
Par tel aïr l'at estrussee e brandie
Qu'envers le cel en volent les escicles.
Carles se dort, qu'il ne s'esveillet mie [my italics]. [718–24]

[Charles, the mighty emperor sleeps. / He dreamed he was at the main pass of
Cize, / He was holding his ashen lance in his hands. / Count Ganelon seized it from
him, / He twisted it and brandished it so violently /That its splinters fly toward
heaven. / *Charles sleeps on, he does not wake up.*]

For Charlemagne, the horn, sounding in the clear light of day, signals the
realization of the dream prediction in all its details. As usual with divine in-
tention, meaning exists before the event that will manifest it to man. The
language of God was enigmatic, latent meaning, requiring the language of
manifest event to become comprehensible. The meaning of Roncevaux has
been sown in Charlemagne's mind by the oneiric premonition which is divine
in origin, but this meaning does not become legible until the event transforms
it into syntax, as it were. In this the text follows Saint Paul, Saint Augustine,
Scottus Eriugena, and Hugh of Saint Victor, all of whom asserted in various
ways that God made intelligible to man his invisible power and dignity through
the symbolism of objects and events in the world.[69]

Charlemagne is the only character in the poem for whom the correct reading
of the horn sign does not involve admitting to an earlier misprision of the
impending events. Rather, his realization in this passage involves a transposi-
tion of the latent valence of the site, Roncevaux/Cize, from the category of the
irréel to the *réel.* "As greignurs porz de Sizer" (l. 719), along with "Guenes li
quens," are the two concrete details in the dream language, allowing the au-
dience to seize its significance immediately, and Charlemagne, subsequently.
The transition of the dream premonition from virtual to concrete, from meta-
phor to message which the horn accomplishes for Charlemagne is precisely
what the text of the poem, the text as horn, realizes for the audience.

In the case of Duke Naimes, the horn does impose a recognition of his earlier
misreading of the significance of the event. Like the other characters, except
Charlemagne, he erroneously predicated the meaning of the impending course
of events. Without Naimes's excessive reliance on *caritas,* at the expense of
experience, during the earlier counsel scenes, Ganelon would not have been
able to have his views prevail. As Charlemagne's chief counselor, Naimes
wielded his authority to valorize Ganelon's representations of the Saracen in-
tentions. In *laisse* 16, he predicates a very convincing interpretation of the
Saracen situation: a totally fallacious one. More importantly, the text equates
his view to his approbation of Ganelon's words:

Aprés iço i est Naimes venud.
Meillor vassal n'aveit en la curt nul
E dist al rei: "Ben l'avez entendud,
Guenes li quens ço vus ad respondud;
Saveir i ad, mais qu'il seit entendud. . . ." [230–34]

[After that Naimes came forward. / There was no better knight at court, /And he
said to the King: "You've heard him well, / Count Ganelon has given you his opin-
ion; / There's wisdom in what he says, provided that it be understood."]

The same is true of *laisse* 62, where he valorizes Ganelon's view at the expense of Roland's and urges his confirmation as leader of the rear guard:

> Aprés iço i est Neimes venud.
> Meillor vassal n'out en la curt de lui
> E dist al rei: "Ben l'aves entendut,
> Li quens Rollant, il est mult irascut. . . ." [774–77]

[After that Naimes came forward. / There was not a better knight at court than he, / And he said to the King: "You've heard him well, / Count Roland is very angry."]

So it is in recognition of the web of deception woven by Ganelon's words on the earlier occasions that Naimes now rejects the treacherous interpretation of the horn put forth by Ganelon in *laisse* 134. For the first time, prompted by his correct reading of the trumpet message, he recognizes the disjunction between the manifest meaning of Ganelon's discourse and its immanent intelligibility. In effect, he measures Ganelon's words against the voice of the horn as revelation, correctly interpreting Ganelon's perversion of the truth as testimony to his guilt:

> "Cil l'at traït ki vos en roevet feindre.
> Adubez vos, si criez vostre enseigne,
> Si sucurez vostre maisnee gente:
> Asez öëz que Rollant se dementet!" [1792–95]

["That man has betrayed him who commands you to pretend (you have heard nothing). / To arms, shout your battle cry, / Go to the aid of your noble men: / You can plainly hear Roland's lament!"]

Here, as in *laisses* 16 and 62, Naimes's counsel prevails, but now he is guided by the voice of the trumpet and not by Ganelon's words. Naimes's call to action repredicates the valence of text-event: no longer is Ganelon—the historical agent of betrayal—the motivating force of the battle. Henceforth, it is the Trumpet, the voice of revelation, the traditional precursor of theophany, which figures the significance of the battle for participants and audience alike in a symbolic fusing of historical denotation and anagogic connotation that transforms the third and final phase of the battle at Roncevaux into an unambiguously symbolic narrative.

The horn sequence goes far toward postulating that alterity of Roncevaux that we noted at the beginning of the chapter. If we now move on to consider the nine *laisses* devoted to Roland's death scene in light of the horn episode, we find a rather different kind of discourse from what we began with, one incorporating a much more explicit revelation of Roland's spiritual agony. In effect, the somewhat enigmatic language of the trumpet is here translated into a *confiteor*. For the imperfect vision that marked Roland's progress in the earliest stages of the battles now gives way to a discourse free from the blindness of the predication in the first scene and without the *mise-en-cause* of the second. The language of the trumpet—especially the third and feeblest blast, in *laisse* 156—has enabled a trio of Frankish warriors to rout the Saracens and allowed Roland quite accurately to claim a new identity for Roncevaux: "Cist camp est vostre, mercit Deu, vostre e mien" (l. 2183).

Roncevaux as Text and Monument of Roland's Passion

We saw that Roland's death was foretold in *laisse* 110, a passage that has been described as "l'une des plus belles pages de la poésie épique."[70] Twenty-four *laisses* later, he suffers his death wound by rupturing his temples while sounding the olifant; forty-two *laisses* after the description of the death wound and sixty-six *laisses* after its prediction Roland finally dies, and three "archangels," Cherubim, Saint Michael, and Gabriel, bear his soul to heaven. This dramatic finale occurs in *laisse* 176, the last of a sequence of nine *laisses* devoted to the death scene, a sequence which further subdivides into three scenes: one dealing with the olifant; one with the sword, Durendal; and the final one to Roland's last prayer.

With so elaborate a preparation and structure, we might expect that the narrative of the death scene would take place as anticipated by the *récit* itself. In fact, everything prior to *laisse* 168, the beginning of the death sequence, leads us to expect that the death of Roland will proceed much like the deaths of Oliver and Turpin, where Roland played an important role as comforter and mourner.

We scarcely anticipate an abrupt shift in narrative strategy when we reach Roland's death scene, yet that is precisely what we find. Quite unexpectedly, the closure transforms not simply the ontological status of the hero, from life to death—that has been anticipated—but his functional status, that is, how he is represented in the text, as well. This could hardly take place without a corresponding change in narrative mode.

The nine *laisses* devoted to Roland's death offer us less the spectacle of cessation of being than of transformation or, to use the more medieval term, of *translatio*, both in its religious and rhetorical sense. He ceases to be what the preceding narrative has primarily shown him to be—that is, a warrior, a leader, and a human of imperfect vision—and becomes what the *Guide du Pèlerin*, Dante (*Paradiso* 18), and other medieval authorities took him for, a martyr-saint.

I do not mean to suggest that the two states are mutually exclusive or somehow oppositional; they are, in fact, connected in an implicational relationship by the progress of the text. Nor do I wish to suggest that there has been no advance preparation for the *translatio*; the details of the numerological symbolism cited above prove the contrary. Nonetheless, it is a fact, and one insufficiently commented, that the *translatio Rotholandi* that occurs in the nine *laisses* devoted to his death is an obvious progression only *after the fact*, that is, it does not *have* to take the form it does, nor even occur at all so far as the expectations created in the earlier part of the text are concerned. Indeed, we saw a very effective sacralization of Roland in the *Pseudo-Turpin* without the *translatio* that we find here. In the *Pseudo-Turpin*, the sacralization remained at the level of event, of *récit*, whereas in this text it is an effect of discourse.

In traditional critical terminology, what we witness in the Oxford version of the death scene is a transition from *lexis* to *logos*, from focus on the act of verbal representation of the hero in the context of *historia* to that of representation of his consciousness.[71] This implies the orientation of the narrative to a new dimension of the mythos, and consequently a revision of the narrative project as we thought we understood it up to this point.

What occupies the narrative in the death sequence is less representation of a historical event, Roland's death, than the representation of a conscious event, the way Roland died. For it is the hero's intention of death that determines his sacralization. Representation of paradigmatic consciousness, spiritual intentionality, becomes the central concern of the *geste* at this point, and we know from our study of Eriugena's conception of theosis in chapter 1 why this must be so. Even so, it may be useful to turn to Saint Augustine, particularly the *Confessions*, to understand precisely how the text uses discourse to convey this *translatio*.

First, however, let's see why any alteration in the mode of *récit* may be perceived as necessary from the standpoint of the poem itself. As already noted, the text posits Roland's death as a given long before it occurs. In the meantime, a number of other significant characters die, some of whose deaths, such as Oliver's and Turpin's, we see in detail. Whatever symbolic value they may subsequently be perceived as possessing, they belong to the temporal/historic narrative sequence. They are, in short, part of the *récit* as imitation of a nonverbal reality, the Battle of Roncevaux. Clearly, if Roland's death occurs simply as part of this sequence, it will be, like the others, a temporal, event-bound phenomenon. We would hardly be able to explain, satisfactorily, why it appears in the text in the form it does or why it requires the participation of angelic messengers.

But death could be treated in another way in the Christian tradition; Christ's life and the saints' lives that imitated it taught that a significant Christian death, while occurring in time, as part of a life sequence, could call that whole sequence and the time of its *historia* into question; it could transcend time and enter eternity. Christ's death and those of the saints also taught the lesson of salvation of class by an exemplary member. Although the results of these lessons might be conveyed in narrative form, as the Crucifixion and Resurrection is a narrative, the preparation for them—as represented in the sermon on ends or the Jerusalem ministry in the Gospel—requires not a *récit* of events but a representation of consciousness, a revelation of intentionality. Thus for Roland's death to transcend the temporality of the historic event and for it to be the exemplum which will guarantee the salvation of the warriors who died with him, the representation of his death must correspond to an episteme of spiritual consciousness by which the Christian transforms the anecdotal and contingent exterior life to a representation of an essential mental state. Saint Augustine dealt with this problem in terms of his own narrative *translatio* in book 11 of the *Confessions*.

Very briefly, we recall Augustine's saying that God's grace consists—in respect to the question of our comprehension of life as purpose—in allowing man to apprehend, in the multiplicity of his human acts, a coherent pattern relating human deeds to divine purpose. Coherence, however, is a phenomenon of expressive language, a textual phenomenon, and it requires the individual to recast his deeds, his past, into a discourse whose referentiality will be that of progress toward perfectibility, not of event but of intention. Augustine describes this as an opposition between *distention*, or life as nonverbal act, and *extension*, or life as intentionality, as verbal act. He says:

> But since "your mercy is better than lives," behold my life is a distention, or distraction. But "your right hand has upheld me" in my Lord, the Son of man, mediator

between you, the One, and us, the many, who are dissipated in many ways, upon many things; so that by him "I may apprehend, in whom I have been apprehended," and may be gathered together again from my former days, to follow the One; "forgetting the things that are behind" and not distended *but extended*, not to things that shall be and shall pass away, but "to those things that are before"; not purposelessly, but purposively, "I follow on for the prize of my supernal vocation," where "I may hear the voice of your praise," and "contemplate your delights," which neither come nor go.[72]

Augustine underlines the importance of the Logos as the paradigm of life-as-verbal-consciousness by weaving seven quotations from Psalms into his exposition. This helps to drive home the concept of extension as a recapitulation of one's life, recasting and ordering the secular events to provide a coherence, but one which is *not* that of human wisdom or logic, let alone human ambition or goals. The extension conceived by Augustine is an effort to expand the mind in one final gesture of humility and self-abnegation, one final thrust toward the infinity of the One.

The closure of such an exemplary life, then, will be an act of verbal consciousness, an *explicit* that is a *dis-closure*, in the individual's own words, of the coherent intentionality of the hitherto perceived disparate jumble of acts that make up a life. If the life in question exists as a narrative already, then the recapitulative extension Augustine speaks of as the final re-cognition of that life may in fact be a narrative of a narrative, an image of an image; but just as in the real-life situation Augustine describes, the final narrative must still be a dialectical retelling of the preceding story, not simply a mirror image.

Furthermore, the main character, hitherto perceived as circumscribed by a *récit* focused on event, must now emerge as at least an adjunct narrator telling his own story, not from the perspective of event but from that of consciousness and purpose. We will then find an account of what we have just witnessed from the standpoint of an individual growing toward perfection. If persuasive, this *translatio narrationis* can constitute a closure in which the hero himself provides an icon of the preceding narrative, a retelling of his own story whose subject is the prior and present consciousness of the Subject, the speaker. This discourse on the narrative, or infratext, the expression of the hero's own perception of his acts, many of which we have witnessed from a third-person narrative viewpoint earlier, offers a perspective hitherto unavailable to us and makes explicit motivation that could previously only be assumed.

This infratext really serves as an interpretant (in Peirce's sense, a mental image) of the preceding narrative, a commentary which must be taken into account in determining the meaning of the whole.[73] We will now be required to reinterpret the preceding text from the standpoint of its interpretant and to see in it a signification not previously apparent, or rather, to discover that the altered reference which the infratext brings to the narrative will force us to develop (by retroreading) significations which were latent—intentionally embedded by the author who foresaw this closure—but which require the altered reference of the closure for their full ratification and development.

The purpose of the infratext is given by Augustine: it guarantees the universality of the whole narrative and assures that it is "extended not to things that have been and will pass away," but purposively to eternal things "that are

before" and "which neither come nor go." The change in register in the *récit* necessary to accomplish this, by comparison with the preceding narrative, will be toward a greater degree of subjectivity, a valorization of the discourse of the hero as an end in itself rather than as an ancillary to the narrative context.[74] Dramatically, it provides a summation of that in the story and character which will transcend the physical act of its closure and endure to the present, the moment of reading.

In other words, the final scene must be memorable. It has somehow to attain the status of a textual monument valorizing the word-as-deed of the hero; to provide the putative first-person summation of consciousness which will serve to support the claim that the hero "really lived" and was indeed exemplary, different, sacred.

This is even more important in the case of works, like the *Roland*, where the hero's death comes not at the end of the work but as a prelude to it. In that case, the text itself has time to present, in Augustine's terms, a demonstration of that in the hero's life which is exemplary and eternal and therefore worthy of surviving into and motivating the present reading or telling.

Such a coda to the life of the hero, a continuation of the narrative after his physical death, is absolutely essential to document the transition from life to *vita*. In the context of the *vita*, the hero's own words, his own thoughts as represented by the first-person summation of consciousness incorporated in his death scene, constitute prized relics of life, providing the audience of the *vita* with an impression of direct contact with the subject.

Before we examine Roland's death scene, it will be useful to look briefly at an analogue of this *translatio narrationis* in the Old French, *Vie de Saint Alexis*, where we find a similar use of the autobiographical infratext incorporated in the third-person narrative of the *Life*. This is the most skillful use of the device prior to the Oxford version of the *Roland* that I have found.

Although the intertextuality between the *Alexis* and the *Roland* has long been noted, the idea that Alexis's *chartre*, the letter that he writes about his life, might be taken as an icon of the *vita* as a whole, symbolizing his consciousness and, above all, the transition from distension to extension, has not been noted, at least to my knowledge.[75] Without according to this poem the attention it deserves, let us quickly note the role played by the *chartre*, Alexis's autobiographical letter, in respect to the rest of the *Vie*.

Thirty-four years after dedicating himself to God and seventeen years after returning, unrecognized, to his parents' house in Rome to live as a beggar, Alexis feels himself on the point of death. He asks one of the servants for ink and parchment and then sets down his life:

Escrit la carta tute de sei medisme,
Cum s'en alat e cum il s'en revint. [284–85][76]

[He writes the whole letter himself, / About how he went away from there and how he returned.]

The document cannot be disclosed yet, however. He keeps the letter to himself and, as his end approaches, refuses to speak at all. For those around him, even though they are his closest relatives, he remains enigmatic and unrecognized to the end:

Tres sei la tint, ne la volt demustrer
Nel reconuissent usque il s'en seit alet. [286–87]

[He held the letter against himself, did not wish to reveal it / They don't recognize him until he has gone.]

The text carefully prepares the death scene as the moment of recognition, of dis-closure of Alexis's identity at two levels, the spiritual (*theoria*) and the human (*historia*). Within the *récit*, God sets in motion the discovery/death scene as a numinous event by warning the city of Rome that it will be destroyed unless the holy man living unrecognized within its midst is found. The emperor and the pope seek him out.

Meanwhile, of course, Alexis has written his letter, which remains concealed "usque il s'en seit alet." The moment of death, then, has been chosen for the disclosure, and thus marks, for obvious symbolic reasons, the dissolution of the ironic distance that has separated audience from participants heretofore, when the audience knew Alexis's identity while the characters did not. From the death scene to the end, both the audience and the surviving characters must participate, as we shall see in a moment, in a hermeneutics of the sacred, as they learn to know *Saint* Alexis.

They begin this lesson with a reading of his own words, words officially designated as those of a saint, since the text applies that beatific epithet to Alexis for the first time at the moment of his death, just prior to his discovery by the pope and the emperor—his spiritual and political fathers on earth—and Euphemian, his biological father. The son/Son will thus teach the lesson of the Father to the fathers and children, thereby reaffirming the linguistic community of the Logos as well as enlightening it. The reading of Alexis's *chartre* constitutes his real death scene, but one that recapitulates his life, since everyone in the work discovers who Alexis is and what he has been only at the moment of his death and thanks to his own (written) words. The reading of the letter thus provides a celebration of Alexis's death as revelation by postulating the conditions by which the disparate signs of his life may be interpreted in a coherent pattern identifiable as that of a holy life, a saint's life. But as in all holy lives, the beginning is in the end.

The letter ends with Alexis's death. At the moment when the reading of the letter has been completed, two physical remnants of Alexis exist: the letter, which represents his consciousness, and his *cors*, the body that performed the intentions. The interpretation of the *chartre* and of the deeds must be undertaken by the *vita*, the text we are reading.

In fact, the whole death scene becomes a debate over the meaning of Alexis's life occasioned by the reading of the *chartre* in the presence of the dead body. The symbolism of the Christian concept of the flesh as logos, life as articulated intentionality could hardly be more strikingly illustrated than by the double image of Alexis's corpse and the autograph text of his life which the dead hand will release only to the pope, himself a saint, Saint Innocent. No wonder the *chartre* is treated as a relic and termed "a precious jewel" (d'icele gemme, l. 378). Parenthetically, we should recall the legend of the dead hand of Roland refusing to release his signifiers, Durendal and the olifant, except to Charlemagne—also a saint.

The *chartre* fulfills a double function of authentication: in its capacity as relic, it valorizes the deeds of Alexis as a conscious submission of human will to divine purpose. In this sense it is more than a mute, corporeal relic; it is an imprint of the *mens et voluntas*, the soul which we have seen carried off to heaven. As Alexis's purported account of his life, it is the originary text confirming the authenticity of the *Vie,* our text. Just as Alexis's corporeal self exists in the *récit,* his own *récit,* the genesis of ours, exists as a confirming artifact within the text. At the same time, the conspicuous incompletion of Alexis's *chartre* justifies the necessity for the *Vie.*

Most important, though, the *Vie* completes the *chartre* by instructing the audience in the hermeneutics of sanctity: how we must read the significance of Alexis. The story cannot end as the *chartre* does, with the account of the life deeds of Alexis. This would be to deny the essential message of the Christian episteme that death is but a transition, not an end, and that the litmus test of the true saint is what his death can tell us about the value of his life. Without the interpretation of the *Vita,* the *chartre* would be teleologically incomplete; it could not function generically as Christian literature, that is, as a didactic genre containing within itself the requisite commentary for it to serve as apocrypha, as parascripture. Conversely, without the *chartre,* the *vie* would not possess the filiation with the sacred subject, the word as relic, whence derived its mystical authenticity.[77]

The reading of the *chartre* makes explicit what we have recognized all along: that the characters around Alexis are foils for the audience. Just as the *chartre* provides the icon for the text within the text, Alexis's family serves to reflect the continuum of audience responses to the *Vie.* As Virgil reminds Dante in *Purgatorio* 3.38–39, "Che se possuto aveste veder tutto, / Mestier non era parturir Maria" (For if you had been able to see all, / There was no need for Mary to give birth).

The medieval church was profoundly conscious of the need for guidance in interpreting the word. The responses of the family, with the possible exception of the bride, all misread the lesson of the *chartre* in one way or another because they all emphasize the past, "what might have been if only we had known, etc." It is the pope who must step in to show that the correct reading of the *chartre* is that which detemporalizes it by removing it from its past context and projecting it into spirituality. Instead of emphasizing distension and distraction of life in the world, the family should see the extension of an earthly life into the celestial sphere whence, because of the kind of life lived on earth, it can intercede for the family and the audience. This is the reading given by the pope.

If we remember the sequence of events in the *Alexis,* we recall that it is only after the correct reading of the *chartre* has been determined—thanks to the mediation of the pope—that the *cors,* Alexis's body, takes on the value established by the *chartre.* Its value so determined, the body then receives the same epithet, "gemme" (jewel, ll. 557, 586), used earlier for the *chartre* itself. This should not surprise us, for it is the *chartre* that reveals the soul that animated the *cors.* Without the testimony provided by the *chartre,* the *récit* could not have rejected so authoritatively the alternate readings of the *cors* provided by the members of Alexis's family, nor could it have given us a *vita* so confident

in its assertion that Alexis's life is an exemplum of how, by extension, we may triumph over the distension of the world, distension which the *Alexis* equates with misreading and misinterpretation.

Returning now to Roland's death scene, we may perhaps be in a better position to understand the nature of its literarity, its status as a textual recasting of the signs of Roland's life posited in the preceding narrative. At last we can see why the recast life signs can only be correctly interpreted as intentionality, when, in the manner of a saint or Christ, Roland takes his own death upon himself. While we do not find a written icon of the narrative in the Oxford *Roland*, we do find a confession, a spoken summation of Roland's life in his own words. We also find a rather dramatic setting for the dis-closure, and one that can be interpreted only in terms of religious ritual.

The dramatic events of Roland's death scene do not occur in the same setting as the rest of the battle. They begin with his removal from the battlefield proper to a hill on which stand two trees and four marble blocks. The sequence divides naturally, by the subject matter treated, into three moments or scenes, each one recounted in three *laisses*.[78]

The scene opens with a funerary tableau, a moment of stasis occasioned by the apparent "death" of Roland, who upon arriving on the hilltop faints from his exertion. The setting of this first evasion of temporality by the *récit* is highly symbolic. First, the significance of the hilltop itself: theophanies in Scripture tend to occur on hilltops; the cult of Saint Michael, as we saw, affected high places; and many of the important events of Christ's life took place on hills.[79] Secondly, the seven elements placed on the hill—four marble blocks, two trees (as in the stylized illustrations of Christ's hilltops), and Roland—reproduce the number, if not the nature, of the seven basic elements of a contemporary crucifixion scene.[80] In the last chapter, we saw the importance attached to septiform symbolism.

The most striking fact of the tableau represented in *laisse* 168, however, and repeated at the beginning of *laisse* 169, is the image of Roland lying between four marble *perruns* (hand-hewn square blocks). The image of a ritual lying-in-state comes to mind, and, given the context of sacrificial oblation which the Judas-Ganelon/Christ-Roland axis of opposition has established from *laisse* 110 on, we can safely assume a symbolic valence for the funerary tableau so carefully described.

The detail shows that Roncevaux-as-site—now divided into two distinct spaces, the battle site and the death site, just as we found in the *Guide du Pèlerin*—appears now as a commemorative locus, or rather, we see the stage being set for the authenticating event which will form the object of the commemoration.[81]

In fact, the *perruns* represent the enduring markers of the death site which will subsequently constitute the basis for constructing the chapel dedicated to Roland on this site, just as the scene itself, incorporated into the larger narrative, will serve as a legendary foundation for the *Chanson*. Think also of Roland's body (which the text tells us later was taken elsewhere) bounded by the marble markers, which, like the text itself, are artistically wrought: "Quatre perruns i ad luisant de marbre" (l. 2272; There were four shining marble blocks there). Like Christ's tomb itself, they will remain to mark the absence of the sacred presence, a sacred presence which the text shows in its plenitude.

At the moment, however, the funerary tableau serves to trigger a misreading of Roland which recalls the earlier misreading of his intentions, at various moments, by Ganelon, Oliver, and others. Like these misprisions, the new one will be corrected by one last blow not of, but with the horn. As so often in the poem, malicious misreading of a privileged character brings about an ironic reversal of the intended predication.

Besides ourselves, a Saracen watches Roland. He runs up to the apparently lifeless hero, seizes his body and sword, then announces:

> "Vencut est li nies Carles!
> Iceste espee porterai en Arabe." [2281–82]

> ["Now Charles' nephew has been vanquished! / I will carry his sword to Arabia."]

However problematic Roland's value as signifier, it does not include that of "vanquished." As though to show just how incompetent a speaker of the heroic idiolect the Saracen is, Roland contradicts the Saracen physically by killing him and then verbally by giving three successive readings of himself in which his valence as a sacred signifier becomes ever more apparent. In this theosis, we see just how ironic the Saracen's misprision of Roland, Durendal, and the olifant was. We also witness a carefully plotted recapitulation of the exchange of signification between Roland and his attributes: in the successive passages, Roland's disclosure takes place with and through the horn and sword.

First the horn. We saw how Roland used the olifant in the second horn sequence for reciprocal signification: Roland sounded the horn, and the horn marked Roland with a heightened connotation, that of *martyr Christi*. Now, as part of the category of last acts, the horn acquires further anecdotal meaning by again "speaking" for Roland when he uses it to contradict the Saracen's characterization of him as "vanquished."

The force of the blow on the Saracen's head "records" the incident on the horn by splitting it. In this way, the anecdote establishes an equivalence between Roland and the object that becomes one of his symbolic attributes: each has been ruptured by the other. The horn marked Roland when he blew it in *laisses* 134–35, and he reciprocates here; together they achieve a significance they might never have attained individually. They have succeeded in marking the text with heightened connotation: whoever looked at the olifant, suspended as a relic in Saint Seurin at Bordeaux, would see it as a sign of Roland's life *and* the manner of his death. The *Guide du Pèlerin* demonstrated vividly how the relic as signifier of life *and* death—in short, of *vita*—constituted a cultural unit of reciprocal implication: the relic signified the text, the text valorized the relic; the one metonymized Roland, the other metaphorized him.

The sword is the ostensible subject of Roland's discourse in the second scene (*laisses* 171–73). But just as Durendal repeatedly rebounds off the stones against which Roland strikes it, so his discourse deflects from sword to swordsman in a manner which creates a reciprocal exchange of value between the two. This represents something new in the text. Unlike the horn, where the reciprocal value exchange with the hero plays a significant role almost from the beginning of the battle, the sword has not been obviously linked to Roland by one particularly noteworthy scene. Durendal plays an important

role throughout, but not one that alters the connotation of the hero, until now.

Suddenly the sword, obedient to Roland's commands throughout the previous events, asserts itself. It contradicts not only Roland's will, but also his interpretation of the story he tells.

Afraid that the sword will fall into Saracen hands after his death, Roland tries to destroy it by beating it against stone blocks. As he performs this act, he utters a lament which in fact amounts to an autobiography of all the campaigns he has fought in with the sword and all the victories they have won together. Obviously, the functionality of both speaker and sword receives considerable reinforcement from the recital. Some of the exploits Roland recounts occur nowhere else in the legend.

As readers, we recognize that Roland's recapitulation of these exploits at the moment he tries to destroy the instrument with which he accomplished them brings about the opposite of what he intended: instead of destroying the sword, the divine instrument with which he "wrote" the deeds of his *historia* on the world, he now uses the same instrument in a doubly signifying way. The blows on the rock strike our ears (or our eyes), recording yet another chapter of the *geste* of Roland and Durendal. The sword also splits the rock, which, like the horn, becomes a relic signifying the *geste*. Roland thus records his (and Durendal's) deeds in stone, and the stone "tablet" becomes a monument to the text.

In all of this, Roncevaux—as site and text—also gains yet another christological sign. Matthew 27 : 51 records that the rocks were split at Golgotha by the cosmic upheavals at the moment of Christ's death, and Peter the Deacon's *Book of Holy Places* (1137) records that at Calvary "the mountain is cleft," and that below it "is Golgotha, where Christ's blood fell on the cleft stone."[82]

But Roland still attempts to efface the record of his earthly ambitions. And this brings us to yet another level of irony in the scene: the self-abnegation inherent in the rhetoric of his discourse and in the attempt to efface the symbol of his glory makes both appear more significant in the text, but significant of God's grace, rather than of Roland's worldly honor. We find in this autobiographical statement a reprise of the submission symbolized by the language of the horn in *laisses* 133–36, that is, the concept of strength through weakness.

Roland's long autobiographical speech appears in *laisse* 172, the second of the three devoted to the sword. The discourse begins with a flattering and moving apostrophe to the beauty and value of Durendal. The initial movement honors the beauty and divine provenance of the instrument that we ordinarily assume to be an attribute of Roland. As part of the rhetoric of self-effacement, however, Roland metonymizes himself to the sword. From the beginning of the discourse, the sword has being and identity. Roland only introduces himself obliquely as the anonymous "cunte certaignie" in l. 2320. Not until the moment when he recounts Charlemagne's placing the sword around his waist, at God's command, does Roland use the first person, thereby assuming a subjective personal existence in his own account.

Thus, even though the discourse uses the first-person singular ten times in the eighteen-line speech, the "je" always defines itself as predicated by the controlling trinity of subjects which constitutes the real matter of the speech: God, Charlemagne, and the sword. In this hierarchy, Roland comes last on the

chain of signifiers; each has existed prior to him and will continue to do so. Roland could hardly offer a better example of renunciation of the *distentio*, or fragmentation of consciousness, in worldly concerns that Augustine saw as necessary for a confession.

And yet, by the same token, the discourse valorizes the speaker, as this kind of confession must, by recasting the *historia* of deed into an intentional *theoria*. The pronoun subject "je," so obvious in the central section of the discourse, occurs almost exclusively in the twelve lines forming the central section of the speech. These twelve lines recapitulate the conquests made by Roland with Durendal, and they correlate with the twelve blows he strikes on the three rocks while attempting to shatter the sword. The message could not be clearer: Roland sees himself as no more than a servant of God, Charlemagne, and the sword they have entrusted to him. He has justified their confidence by committing the exploits listed in the twelve lines; then, he ends the autobiography as he began it, with the effacement of the "je," succeeded by the speaking subject's glorification of God, Charlemagne, and Durendal. We can hardly ignore the rhetorical efficacity of such humility, however: at the end of the discourse, Roland stands triply signified in an equation of value predicates that sets him truly apart from his peers.

Thanks to the *Alexis*, we know why Roland himself must utter this recapitulation of life-as-consciousness. What we have learned of the mental state of the hero through his own words, as it were—we must bear in mind that for the Middle Ages, Roland was a real person—could only have been conveyed by objective narrative; the idea of participation, of direct contact with the sacred logos, the mentality of the theosized being, would not have come through. We would not have had the icon of the *Chanson*, the autobiographical words uttered by the hero himself, an icon which valorized the rest of the narrative. As it is, we see that Roland clearly has moved toward the overcoming of self and time in the world requisite for Augustine's notion of *extensio*.

He is not there yet. Like Balaam's ass refusing to proceed despite the blows rained upon its flanks by its impercipient master, Durendal refuses to yield to Roland's bidding and shatter. Instead, it occasions the final insight on Roland's part necessary for his ultimate triumph.

At the end of the scene, in *laisse* 173, Roland strikes the twelfth and final blow of the sword on the stone. This blow of enlightenment splits the stone, leaving a mark of the whole scene on the stone—transformed by this stroke into a monument to the text, as the rock on Golgotha called up Matthew 21 : 57 to the twelfth-century pilgrims. The gesture splitting the stone ends with a vertical movement as the sword rebounds and points to the sky: "cuntre ciel amunt est resortie" (l. 2341; It rebounds upward toward heaven). "Ciel," "amunt," "resortie," these three indices underline the verticality of the sword's movement in contrast to Roland's *willed* act which was the *down*ward stroke.

The scene began with an assertion that Roland's vision had failed: "ço sent Rollant que la veüe ad perdue" (l. 2297; Roland feels that he has lost his sight). This proved a help rather than a hindrance for the inner probing required by the autobiographical discourse, but it also proved accurate figuratively as regards the disposition of the sword. In attempting to destroy with his hands

what his mind and words assert is not subordinate to him, but just the reverse, Roland shows that he still cannot fully intellect divine purpose. Now, however, thanks to the sword's independent revelation by the imperious extension toward heaven that constitutes its thrice vertical movement, Roland suddenly *sees:* "Quant veit li quens que ne la fraindrat mie" (l. 2342; When the count sees that he will not shatter it).

What he sees is the necessity for him to follow the lead of the sword and turn his attention, for his final gestures and words, "cuntre ciel amunt." And he will do this in the final three *laisses.* But first, for the remainder of *laisse* 173, he addresses the sword one last time, in a discourse where the self has been totally subordinated to the act of making manifest the presence of the sword as sacred object. In these lines, the sword undergoes a *translatio* from military arm to militant relic; both literally and figuratively it becomes a *gemme,* as the *chartre* and the *cors* were *gemmes* in the *Alexis.* The sword as relic now stands as a metaphor of the transformed hero. Just as the sword, we learn, contains holy relics within to signify its potency, so the hero, we have seen, contains a sacred inner being that defines his value as a warrior, a *miles Christi.* And it is that value that the last three *laisses* of the death scene will dis-close.

Just as the final sword stroke of his career ends with the sword pointing to heaven, so Roland's final discourses and gestures will be toward heaven. To achieve this, the *récit* becomes what it narrates: a semiosis of verticality whose implications are present and future. In this final scene, Roland's consciousness, revealed by the consonance of word and gesture, fulfills Augustine's requirements for *extensio:* past and future become fully fused in the willing of self in submission to God.

Preparing himself by prayer, Roland once more mentally wills that stasis of unitary coherence in which temporal things have been purged and only those facets of his life which yield intelligence of divine purpose are present. In the final short prayer Roland utters, we see his consciousness "extended, not to things that shall be and shall pass away," but "to those things that are before"; namely, the Resurrection themes of Old and New Testament:

> "Veire Patene, ki unkes ne mentis,
> Seint Lazaron de mort resurrexis
> E Danïel des leons guaresis,
> Guaris de mei l'anme de tuz perilz
> Pur les pecchez que en ma vie fis!"
> Sun destre guant a Deu en puroffrit,
> Seint Gabrïel de sa main l'ad pris. [2384–90]

["Loyal Father, you who never failed us, / who resurrected Saint Lazarus from the dead, / and saved your servant Daniel from the lions: / now save my soul from peril / for the sins I committed in my lifetime!" / Then he held out his right glove to God, / Saint Gabriel took it from his hand.]

The prayer shows Roland intently focusing, "not purposelessly, but purposively . . . on the prize of [his] supernal vocation," that is, heaven, where he "may hear the voice of [God's] praise," and "contemplate [his] delights which neither come nor go."

To emphasize the correctness of the three readings that Roland has given of himself and his arms in response to the misreading of the Saracen, more immediately, but also of Ganelon and Oliver, the heralds of heaven, Saint Michael, Cherubim, and Gabriel, descend to take his outstretched hand and transport his soul to the celestial realm, thus confirming his translation from life to *Vita*.

Notes

Chapter 1. The Discourse of History

1 Described as a humanist activity, history writing involved: "certain men bringing their curiosity and talent to bear on humanity itself. In their view, the works and deeds of humanity, under the providence of God—the God of the Bible . . . comprised a 'universe' other than the physical one: the human universe of sacred history. . . . [T]hey were working out a theology that was firmly tied to the teaching of scripture—scripture whose *historia* was at the basis of clerical education." M. D. Chenu, *Nature, Man, and Society in the Twelfth Century: Essays on New Theological Perspectives in the Latin West*, ed. and trans. Jerome E. Taylor and Lester K. Little (Chicago: University of Chicago Press, 1968), p. 163.

2 Ibid., p. 177.

3 Richer, *Histoire de France (888–995)*, ed. Robert Latouche, 2 vols. (Paris: Champion, 1930–37), vol. 1, p. vii.

4 "Gallorum congressibus in volumine regerendis imperii tui, pater sanctissime Gerbert, auctoritas seminarium dedit." Ibid., "Prologus," p. 2. "Orbis itaque plaga, quae mortalibus sese commodam praebet, a cosmographis trifariam dividi perhibetur, in Asiam videlicet, African et Europam. . . . usque ad terrae umbilicum . . . " 1. 2.

5 Ibid., 1. 1: "Quarum singulae cum proprias habeant distribuciones, Europae tamen partem unam quae Gallia a candore vocatur, eo quod candidioris speciei insigne eius oriundi praeferant, in suas diducere partes ratum duxi"; 1. 2: "Gallia ergo et ipsa in tria distincta est: in Belgicam, Celticam, Aquitanicam."

6 Ibid., 1. 3: "Omnium ergo Galliarum populi innata audatia plurimum efferuntur, calumniarum impatientes. Si incitantur, cedibus exultant efferatique inclementius adoriuntur. Semel persuasum ac rationibus approbatum, vix refellere consuerunt."

7 Ibid.: "Unde et Hieronimus: Sola, inquit, Gallia monstra non habuit, sed viris prudentibus et eloquentissimis semper claruit."

8 Chenu, *Nature, Man, and Society*, p. 175.

9 I. P. Sheldon-Williams, "The Greek Christian Platonist Tradition from the Cappadocians to Maximus and Eriugena," in *The Cambridge History of Later Greek and Early Medieval Philosophy*, ed. A. H. Armstrong (Cambridge: Cambridge University Press, 1970), p. 444 (hereafter cited as Sheldon-Williams, *CHLGEMP*).

10 Ibid., p. 446.

11 Richer, 1. 3: "Hos omnes populos, et si natura feroces, ab antiquo fere per omnia prospere egisse, et cum pagani essent, historiae tradunt. Post vero, a sancto Remigio baptizati, adprime clara semper et illustri victoria emicuisse feruntur. Quorum quoque primus rex christianus Clodoveus fuisse traditur. A quo per succedentia tempora imperatoribus egregiis res publica gubernata fuisse dinoscitur usque ad Karolum, a quo historiae sumemus initium."

12 Cf. Gregory of Nyssa's doctrine of man as having originally been created in the image and likeness of God so that

he might in the Image, as in a mirror, see and know the transcendent God, otherwise invisible and unknowable, and so conform himself to him. Man was then created a second time as corporeality in the sensible world. He is still in the image of God . . . but now his nature reflects not only what is above, but what is below. . . . Plurality and composition come with corporeality, which was no part of the original image but "comes from outside." . . . The purpose of the second creation was to provide man with a means of knowing God in his immanence when the Fall, by obscuring the Image, should have concealed the knowledge of him in his transcendence. (Sheldon-Williams, *CHLGEMP*, p. 450)

13 "Ac totius exordium narrationis aggrediar, breviter facta orbis divisione Galliaque in partes distributa, eo quod eius populorum mores et actus describere propositum sit." Richer, "Prologus," p. 4.

14 By *Romanesque*, I mean the period of cultural and historical development beginning around the year 1000 and running until the middle to late twelfth century. The term was originally coined in the early nineteenth century to denote a particular architectural and sculptural style preceding the Gothic. Since then, Romanesque has been generalized to denote a period concept. It designates a form of expression, found in literature and art, very much preoccupied with the symbolic telling of stories with a historical basis.

See William Gunn, *An Inquiry into the Origin and Influence of Gothic Architecture* (London: Longman's, 1819), pp. 6, 80, n. 7; M. F. Gidon, "L'invention de l'expression Architecture Romane par Gerville (1818)," *Bulletin de la Société des antiquaires de Normandie* 42 (1934): 268–88; Paul Frankl, *The Gothic: Literary Sources and Interpretations through Eight Centuries* (Princeton: Princeton University Press, 1960), pp. 507–08. See also S. G. Nichols, "Romanesque Imitation or Imitating the Romans?" in *Mimesis from Mirror to Method: Augustine to Descartes*, ed. John D. Lyons and S. G. Nichols (Hanover: University Press of New England, 1983).

15 "Si qua vero aliorum efferantur, ob incidentes rationes quae vitari non potuerunt id evenisse putetur." "Prologus," p. 4

16 "Les caractéristiques de la période romane peuvent se ramener à deux principales: l'unité et le sens de la présence de Dieu. Ces deux notions sont liées au christianisme dont l'extension en Europe forme la chrétienté. . . . Plus une pensée—signifiée par l'écriture ou la parole—est d'origine spirituelle, plus elle est à la fois universelle et encyclopédique, échappant ainsi au temps et à l'espace." M.-M. Davy, *Initiation à la symbolique romane* (Paris: Flammarion, 1977), p. 35.

17 "Le génie médiéval est à base monastique. Or l'idéal monastique est à la fois absolu et total, c'est-à-dire qu'il embrasse toutes les réalités indépendamment de leur origine." Ibid., p. 35.

18 Richer, 3. 43: "ab ipsa Divinitate directus est Gerbertus, magni ingenii ac miri eloquii vir, quo postmodum tota Gallia acsi lucerna ardente vibrabunda refulsit."

19 Richer, 3. 45. Through the efforts of his brilliant pupil Fulbert of Chartres, Gerbert also contributed, albeit indirectly, to the prestige of Chartres as a great center of learning in the eleventh century.

20 Thus, from Aachen he writes to Gerbert in Rheims, inviting Gerbert to become his teacher:

We desire you to show your aversion to Saxon ignorance by not refusing this suggestion of our wishes, but even more we desire you to stimulate Our Greek Subtlety to zeal for study, because if there is anyone who will arouse it, he will find some shred of the diligence of the Greeks in it. Thanks to this, we humbly ask that the flame of your knowledge may sufficiently fan our spirit until, with God's aid, you cause the lively genius of the Greeks to shine forth.

And Gerbert answers in part:

Our august emperor of the Romans art thou, Caesar, who, sprung from the noblest blood of the Greeks, surpass the Greeks in empire and govern the Romans by hereditary right, but both you surpass in genius and eloquence. (*The Letters of Gerbert with his Papal Privileges as Sylvester II*, trans. and with an introduction by Harriet Pratt Lattin [New York: Columbia University Press, 1961], letters 230, p. 295, and 232, p. 297)

21 For an extremely lucid demonstration of the role of symbolic forms in Romanesque art, see Davy, *Initiation à la symbolique romane*, chap. 2 and particularly chap. 3.

22 In bk. 3, chaps. 46–47, Richer lists some of the authors taught by Gerbert. Greek works occupy an important place in his curriculum.

23 Sheldon-Williams, *CHLGEMP*, p. 463.

24 "Justissima studiosorum fratrum querimonia, interdumque propria saepius permotus, cur diebus nostri temporis non quispiam existeret, qui futuris post nos multiplicia haec quae videntur fieri tam in Ecclesiis Dei, quam in plebibus, minime abdenda qualicunque styli pernototione mandaret: praesertim cum, Salvatore teste, usque in ultimam extremi diei horam, sancto Spiritu cooperante, ipsa facturus sit in mundo nova cum Patre." Rodulfi Glabri, *Historiarum Sui Temporis, Libri Quinque.* J.-P. Migne, *Patrologia Latina* (Paris, 1853), 142. 612D–613A (hereafter cited as Migne, *PL*).

25 Yves Christe, *Les grands portails romans: Etudes sur l'iconologie des théophanies romanes* (Geneva: Droz, 1969), p. 132. See pp. 51–56, 132–33, 159, 161, 170–74, 177–85 for a commentary on the relationship of Eriugena, Cluny, and Rodolphus Glaber. M. F. Hearn observes:

> *The Celestial Hierarchy* of Dionysius the Pseudo-Areopagite had been introduced into the West only in the ninth century, most importantly through the Latin translation and commentary written by John Scott Eriugena (815?–877?), the great scholar of the court of Charles the Bald. A copy of Eriugena's treatise had been given to the library of Cluny in the tenth century by Abbot Mayeul, who is recorded as having spent many nights passionately reading it. In the early eleventh century, Raoul Glaber, in his *Historia sui temporis*, attested to continued interest in this treatise at Cluny as well as others related to it—the *Ambigua* of Maximus the Confessor and the writings of the Cappadocean fathers, all of which had been absorbed by Eriugena in his major treatise, *De Divisione Naturae*. (*Romanesque Sculpture: The Revival of Monumental Stone Sculpture in the Eleventh and Twelfth Centuries* [Ithaca: Cornell University Press, 1981], p. 187)

26 John Marenbon, *From the Circle of Alcuin to the School of Auxerre: Logic, Theology and Philosophy in the Early Middle Ages* (Cambridge: Cambridge University Press, 1981), chaps. 3, 4.

27 Eriugena, *Omelia Iohannis Scoti Translatoris Ierarchiae Dionisii*, chap. 14: "*Fuit homo missus a deo, cui nomen erat Iohannes. Ecce aquilam de sublimissimo vertice montis theologiae leni volatu descendentem in profundissimam vallem historiae, de caelo in terram spiritualis mundi pennas altissimae contemplationis relaxantem.*" *Homélie sur le prologue de Jean*, trans. and ed. Edouard Jeauneau (Paris: Les Éditions du Cerf, 1969), pp. 268, 270.

28 Cf. St. Gregory of Nazianzen: "The language of Scripture does not reveal the truth directly, but a half-concealed version of it. This is because the sensible world from which it draws its illustrations is an imperfect copy of the intelligible: it displays shadows, and the intelligible world images, of the sole reality, which is God. Similarly, the Old Testament displays shadows, the New images, of the ultimate Truth who is the incomprehensible God." Sheldon-Williams, *CHLGEMP*, p. 439.

29 *Historiae*, "Praefatio,"

primitus duntaxat ostensurus, quanquam salus annorum a mundi origine perno-

tata secundum Hebraeorum historias a Septuaginta interpretum translatione discrepet. Illud tamen certissime commendamus, quod annus incarnati Verbi millesimus secundus ipse sit regni Henrici Saxonum regis primus. Isdem quoque annus Domini millesimus fuit regni Rotherti Francorum regis tertius decimus. Isti igitur duo in nostro citra marino orbe tunc Christianissimi atque praemaximi habebantur. Quorum primus, videlicet Henricus, Romanum postmodum sumpsit imperium. Idcirco vero illorum memoriale seriei temporum stabilivimus. (Migne, *PL* 142. 614A)

30 "*Historia* designated the contents and accordingly the manner of thinking of a whole religious structure. The religion of Christ was not based on logic but on a series of facts arranged in a history, a history that one must read—in the technical sense of the medieval *lectio*—according to an appropriate method . . . " Chenu, *Nature, Man, and Society*, pp. 165–66.

31 Ibid., p. 185. He continues: "the one essential part adhered to by this theology was the destiny—the predestination—of the Roman Empire. . . . [A]ll agreed on placing the Roman Empire at the end of a succession of ancient empires as a providential preparation for the age of Christ, in the course of history as well as in the geography of salvation. . . . The crucial role of this destiny was the role which the empire played in unifying mankind, rendering all men open to the workings of grace."

32 On Eriugena's sources, see *Jean Scot Commentaire sur l'Evangile de Jean*, trans. and ed. Edouard Jeauneau (Paris: Les Éditions du Cerf, 1972), p. 100, nn. 2–3.

33 *Historiae*, 1. 1: "Multiplicibus figuris formisque Deus conditor universorum distinguens ea quae fecit, ut per ea quae vident oculi, vel intelligit animus, sublevaret hominem eruditum ad simplicem Deitatis intuitum. In his ergo perscrutandis pernoscendisque primitus claruere Patres Graecorum Catholici mediocriter philosophi." Migne, *PL* 142. 613C.

34 *Historiae*, 1. 1; Migne, *PL* 142. 613C–614D.

35 I. P. Sheldon-Williams, "Eriugena's Greek Sources," in *The Mind of Eriugena*, ed. John J. O'Meara and Ludwig Bieler (Dublin: Irish University Press, 1973), p. 12.

36 *Historiae*, 1. 1: "Ab his igitur evidentissimis complexibus rerum patenter et pulcherrime silenterque praedicatur Deus, quoniam dum *stabili motu* in sese vicissim una portendit alteram, suum principale primordium praedicando, a quo processerunt, expetunt, ut in illo iterum quiescant." Migne, *PL* 142. 615A–B.

37 " . . . cum uero a uerbo [theo Theos] deducitur currens recte intelligitur; ipse enim *in omnia* currit et nullo modo stat sed omnia currendo implet, sicut scriptum est: 'Velociter currit sermo eius.' Attamen nullo modo mouetur. De deo siquidem ueriscime dicitur motus stabilis et status mobilis. Stat enim in se ipso incommutabiliter nunquam naturalem suam stabilitatem deserens, mouet autem se ipsum per omnia ut sint ea quae a se essentialiter subsistunt. Motu enim ipsius omnia fiunt." *Periphyseon (De Divisione Naturae), Liber Primus*, ed. I. P. Sheldon-Williams (Dublin: Institute for Advanced Studies, 1978), pp. 60–61 [= Migne, *PL* 122. 452C–D].

38 *Historiae*, 1. 1: Migne, *PL* 142. 615A.

39 Rudolf Allers, "Microcosmos from Anaximandros to Paracelsus," *Traditio* 2 (1944): 319–407.

40 This exposition follows closely Allers's article, p. 323.

41 Ibid.

42 Ibid.

43 Ibid., p. 324.

44 "Rationes omnium rerum dum in ipsa natura uerbi quae superessentialis est intelliguntur aeternas esse arbitror. Quicquid enim in deo uerbo substantialiter est quoniam non aliud praeter ipsum uerbum est aeternum esse necesse est ac per hoc conficitur et ipsum uerbum et multiplicem totius uniuersitatis conditae principalissimamque rationem id ipsum esse. Possumus etiam sic dicere: Simplex et multiplex rerum

omnium principalissima ratio deus uerbum est. Nam a Grecis logos uocatur, hoc est uerbum uel ratio uel causa." *Periphyseon (De Divisione Naturae), Liber Tertius*, ed. I. P. Sheldon-Williams (Dublin: Institute for Advanced Studies, 1981), pp. 78–79 [= Migne, *PL* 122. 642A].

45 Clifford Geertz, "Religion as a Cultural System," in his *Anthropological Approaches to the Study of Religion* (London: Tavistock, 1966), p. 3.

Chapter 2. *Historia* and Theosis

1 Matt. 17:1–8; Mark 9:2–8; Luke 9:28–36.

2 "[I]n spiritualis uisionis montem hoc est altitudinem. . . ." *De Divisione Naturae*, 3. 13, ed. I. P. Sheldon-Williams (Dublin: Institute for Advanced Studies, 1981), p. 124 (variant). Migne, *PL* 122. 662A. Translation from *Periphyseon, On the Division of Nature*, ed. and trans. Myra L. Uhlfelder (Indianapolis: Bobbs-Merrill, 1976), p. 176 (hereafter cited as Uhlfelder).

3 Yves Christe, *Les grands portails romans: Etudes sur l'iconologie des théophanies romanes* (Geneva: Droz, 1969), p. 170.

4 1 *Ambigua* 6. 31. Quoted by Sheldon-Williams, *CHLGEMP*, p. 430.

5 This passage is generally read as a two-dimensional metaphor without reference to the scriptural and patristic subtexts which impart three-dimensional depth to it, thereby increasing its significance. Rodulfi Glabri, Cluniacensis Monachi, *Historiarum sui Temporis Libri Quinque*, bk. 3, chap. 4:

> Igitur infra supradictum millesimum tertio jam fere imminente anno, contigit in universo pene terrarum orbe, praecipue tamen in Italia, et in Galliis, innovari ecclesiarum basilicas, licet pleraeque decenter locatae minime indignuissent. Aemulabatur tamen quaeque gens Christicolarum adversus alteram decentiore frui. Erat enim instar ac si mundus ipse excutiendo semet, rejecta vetustate, passim candidam ecclesiarum vestem indueret. Tunc denique episcopalium sedium ecclesias pene universas, ac caetera quaeque diversorum sanctorum monasteria, seu minora villarum oratoria, in meliora quique permutavere fideles. (Migne, *PL* 142. 651CD; trans. based on Edmond Pognon, *L'An mille* [Paris: Gallimard, 1947], p. 89)

6 *Historiae*, 2. 5, "*De portento Aurelianae urbis mirabili.*" Migne, *PL* 142. 643A–635C; Pognon, *L'An mille*, pp. 68–69.

7 *De Divisione Naturae*, 1. 9. Sheldon-Williams, vol. 1, pp. 52–54; Migne, *PL* 122. 449A–D; Uhlfelder, p. 11.

8 *De Divisione Naturae*, 1. 10:

> "*Cum uero solare lumen aeri misceatur tunc incipit apparere ita ut in se ipso sensibus sit incomprehensibilis, mixtum uero aeri sensibus possit comprehendi.*" Ac per hoc intellige, diuinam essentiam per se incomprehensibilem esse, adiunctam uero intellectuali creaturae mirabili modo apparere ita ut ipsa, diuina dico essentia, sola in ea, creatura intellectuali uidelicet, appareat. . . . Per corpora ergo in corporibus, non per se ipsum, uidebitur. Similiter per intellectum in intellectibus, per rationem in rationibus, non per se ipsum, diuina essentia apparebit. (Sheldon-Williams, vol. 1, pp. 54, 56; Migne, *PL* 122. 450AB, C; Uhlfelder, p. 12)

9 *De Divisione Naturae*, 1. 9: "Nam huic rationi conuenit quod idem Maximus ait quia *Quodcunque intellectus comprehendere potuerit, id ipsum fit*. In quantum ergo animus uirtutem comprehendit, in tantum ipse uirtus fit." Sheldon-Williams, vol. 1, p. 54; Migne, *PL* 122. 449D–450A; Uhlfelder, p. 11.

10 *Historiae*, 1. 1: "seu etiam qui rerum eventusque vel plura contigerunt memoranda tam in sacris Ecclesiis, quam in utroque populo primitus ad illud totius quondam orbis imperium principale, scilicet Romanum, convertimus stylum." Migne, *PL* 142. 616A.

11 Rodolphus offers an interesting testimony to the extent to which the fates of Orléans and Jerusalem were considered to be interrelated in the *Histories*. Book 3, chapter 7 recounts the destruction of the Anastasis (Church of the Holy Sepulchre) in Jerusalem by a Saracen caliph in 1018, and its subsequent rebuilding at the instigation of the Saracen's mother, a secret Christian convert named Mary(!). The inspiration for the destruction of the Anastasis, he says, did not originate with the Saracen chief, but rather with the Jews in Orléans! They sent a letter "in Hebrew writing" to the Saracen leader urging him to destroy the Christian holy place. Once the plot had been carried out, the cause was discovered: the messenger who carried the letter to the Saracen confessed, and retribution was exacted from the Jewish community in Orléans. Only after the punishment of the alleged conspirators in Orléans can the happy ending occur in Jerusalem. This symbolic connection between the fate of Jerusalem and Orléans receives further support, as we shall see later, in book 3, chapter 8.

12 On the two Jerusalems, see Ernst H. Kantorowicz, *The King's Two Bodies: A Study in Medieval Political Theology* (Princeton: Princeton University Press, 1957), pp. 83–85.

13 "Once the Emperor [i.e., Constantine] had written this letter, the work began to take shape, and over the true memorial of salvation was built the New Jerusalem, facing the far-famed Jerusalem of old time. . . ." #33: "A New Jerusalem." Translated from Eusebius's *Vita Constantini* by John Wilkinson, *Egeria's Travels* (London: SPCK, 1970), p. 167.

14 For a more comprehensive elaboration of this equation, see my article: "The Interaction of Life and Literature in the *Peregrinationes ad Loca Sancta* and the *Chansons de Geste*," *Speculum* 44 (1969): 51–77.

15 Rome, too, possessed an analogous spiritual and political valence which could, by *translatio* and *renovatio*, be manifested elsewhere. First Constantinople, then Aix-la-Chapelle claimed status as a second Rome. In Charlemagne's capital, the claim assumed literal and physical dimension by the emperor's building program. Aside from copying the Lateran palace, Charlemagne incorporated pieces of the Italian building brought from Italy into the reconstruction.

16 Kantorowicz, *The King's Two Bodies*, p. 84.

17 Text and translation from *The Penguin Book of Latin Verse*, ed. Frederick Brittain (Baltimore: Penguin Books, 1962), pp. 127–28.

18 From the *Vita Constantini*, trans. Wilkinson, pp. 164, 166, 167.

19 *Urbs beata Jerusalem*, stanza 6: "Omnis illa Deo sacra et dilecta civitas / Plena modulis in laude et canore jubilo / Trinum Deum unicumque cum favore praedicat." Brittain, *Latin Verse*, p. 128.

20 Ibid., stanza 7: "Hoc in templo, summe Deus, exoratus adveni / Et clementi bonitate precum vota suscipe, / Largam benedictionem hic infunde jugiter." Brittain, *Latin Verse*, p. 128.

21 *De Divisione Naturae*, 1. 12:

Although Divine Nature is designated by many names—e.g., Goodness, Essence, Truth, and others of the kind—Divine Scripture most often uses the name *God*. . . . The etymology of this name is from the Greek, either from the verb *theoro*, "see," or from the verb *theo*, "run"; or, as is more likely, since one and the same meaning is inherent, it is correctly said to be derived from both. For when *Theos* is derived from *theoro*, it means "Seer," because He sees in Himself everything endowed with being; whereas He beholds nothing outside Himself since there is nothing outside Himself. (Sheldon-Williams, vol. 1, p. 60; Migne, *PL* 122. 452BD; Uhlfelder, p. 14)

22 *Homily on the Prologue to John*:

The light of divine knowledge [*cognitio*] retired from the world when man deviated from God's commandments [in the Fall]. Therefore it is in a double manner that the eternal light (i.e., Christ-as-Word] announces itself to the world; through Scripture and through created things. For divine knowledge can only be renewed in us by *letters of Scripture and by the image of created things*. Study the words of Scripture and, in your soul, understand the meaning: by this you will know the Word. *With your bodily senses, observe the forms and beauty of tangible things; in them you will apprehend the Word of God* [my italics]. (*Homélie sur le prologue de Jean*, ed. and trans. Edouard Jeauneau [Les Éditions du Cerf: Paris, 1969], pp. 254–57)

23 Saint Evurtius's feast day is celebrated September 7. Thought to be a fourth-century bishop of Orléans, little is known about him for certain now. Such was not the case in the eleventh century, nor in the twelfth, when the author of the *Guide du Pèlerin de Saint-Jacques de Compostelle* wrote the following account, which shows an aspect of the legend that illustrates even more strikingly the theosis of this saint:

> Revenant en arrière, nous engagerons ceux qui vont à Saint-Jacques par la route de Tours, à aller voir à Orléans le bois de la Croix et le calice de saint Euverte, évêque et confesseur, dans l'église Saint-Croix. Un jour que saint Euverte disait la messe, la main de Dieu apparut au-dessus de l'autel, en l'air, sous une apparence humaine ["apparuit super altare in altum dominica dextera humanitus videntibus illis qui aderant"] aux yeux des assistants, et tout que le pontife faisait à l'autel, la main divine le faisait également; quand il traçait sur le pain et le calice le signe de la croix, la main le traçait de même quand il élevait le pain et le calice, la main divine élevait également un vrai pain et un calice. Le saint sacrifice terminé, la très sainte main du Sauveur disparut. D'après cela nous devons comprendre que tandis que chaque prêtre chante la messe, le Christ le chante lui-même. (ed. and trans. Jeanne Vielliard [Mâcon: Protat Frères, 1969], pp. 58, 59)

24 Nichols, "The Interaction of Life and Literature," p. 77, n. 14.

25 Jerzy Pelc, "Semiotic Functions as Applied to the Analysis of the Concept of Metaphor," in his *Studies in Functional Logical Semiotics of Natural Languages* (The Hague: Mouton, 1971). Hoyt Alverson extends Pelc's concept of metaphor to include the intentionality of the propounder of a metaphor in *Mind in the Heart of Darkness: Value and Self-Identity among the Tswana of Southern Africa* (New Haven and London: Yale University Press, 1978), pp. 198–200.

26 *Historiae*, 2. 12: "Hisque daemonum fallaciis epravatus, coepit multa turgide docere fidei sacrae contraria, dictaque poetarum per omnia credenda esse asserebat." Migne, *PL* 142. 644B.

27 Ibid. "Quod presagium Joannis prophetiae congruit; quia dixit Satanam solvendum, expletis mille annis, de quibus in tertio jam libello prolixias tractabimus." Migne, *PL* 142. 644C.

28 Meyer Schapiro, "Two Romanesque Drawings in Auxerre and Some Iconographic Problems," in his *Romanesque Art* (New York: Braziller, 1977), p. 308.

29 Ibid.

30 Eriugena, *Homélie*, ed. Jeauneau, sec. 1, ll. 1 and 16–18, pp. 200, 206.

31 Ibid., sec. 18, ll. 15–19, pp. 288, 290.

32 *Historiae*, 3. 1: "Claruere tamen ab eodem anno, tam in Italia quam in Galliis, utrorumque ordinum viri, quorum vita et operatio queunt posteris imitabilia informare exempla." Migne, *PL* 142. 645A.

33 *De Divisione Naturae*, 3. 3:

> Sapientia nanque proprie dicitur uirtus illa qua contemplatiuus animus, siue humanus siue angelicus diuina aeterna et incommutabilia considerat, siue circa primam omnium causam uersetur, siue circa primordiales rerum causas, quas Pater

in uerbo suo semel simulque condidit, quae species rationis a sapientibus theologia uocitatur. Scientia uero est uirtus, qua theoreticus animus, siue humanus, siue angelicus, de natura rerum, ex primordialibus causis procedentium per generationem inque genera ac species diuisarum per differentias et proprietates tractat, siue accidentibus succumbat siue eis caret, siue corporibus adiuncta siue penitus ab eis libera, siue locis et temporibus distributa siue ultra loca et tempora sui simplicitate unita atque inseparabilis, quae species rationis Physica dicitur. (Sheldon-Williams, vol. 3, pp. 48, 50; Migne, *PL* 122. 629AB)

34 *De Divisione Naturae*, 5. 38. Migne, *PL* 122. 1011AB; Uhlfelder, p. 346.

35 *De Divisione Naturae*, 5. 38: "non solo naturaliter insito appetitu, sed etiam reipsa et experimento ad sola naturalia humanitatis bona, quae in Christo subsistunt, ascendent. . . ." Migne, *PL* 122. 1012A; Uhlfelder, p. 347.

36 *De Divisione Naturae*, 5. 38: "Non enim ait Scriptura: Faciamus hominem imaginem et similitudinem nostram, sed *ad imaginem et similitudinem nostram.* Ac si plane diceretur: Ad hoc faciamus hominem, ut, si praeceptum nostrum custodierit, imago nostra et similitudo fiat. Non ergo sapiens factus est, sed capax, si vellet, sapientiae." Migne, *PL* 122. 1013CD; Uhlfelder, p. 349.

37 Meyer Schapiro, "The Romanesque Sculpture of Moissac II," in *Romanesque Art* (New York: Braziller, 1977), p. 240.

38 Ibid., p. 237.

39 Ibid., pp. 110, 241.

40 R. I. Moore, *The Origins of European Dissent* (London: Allen Lane, 1977), pp. 25, 250–52. Emile Amann and Auguste Dumas, *L'Eglise au pouvoir des laïques (888–1057)*, vol. 7, *Histoire de l'Eglise*, ed. Augustin Fliche and Victor Martin (Paris: Bloud et Gay, 1948):

[à cause de] la profonde horreur qu'inspirait l'hérésie manichéenne, la répression en fut terrible. Jusqu'alors les hérétiques, justiciables seulement de la contrainte ecclésiastique, n'avaient été frappés que d'une peine canonique. Rompant avec une tradition presque millénaire, les princes séculiers jugèrent utile de faire périr par le feu les hérétiques condamnés par l'Eglise. C'est le roi de France, Robert le Pieux, qui, le premier, entra dans cette voie. (p. 462)

41 Moore, *European Dissent*, pp. 250–52, provides background indicative of the unusual role played by Robert. The *Gesta Synodi Aurelianensis* agrees with Rodolphus's account by and large, but places less emphasis on the king's role: Bouquet, *Recueil des historiens de Gaule et de la France*, vol. 10, pp. 536–39.

42 The *Gesta* gives the names of the two clerks as Stephen and Lisois. Further explanation for the gravity of the betrayal derives from the assertion that Stephen had been the personal confessor of Queen Constance. She is reported to have translated the symbolic blindness of this cleric in physical terms by striking out his eye with a stick as he left the church were they had been tried. (Moore, *European Dissent*, p. 29.) Adémar de Chabannes, who recounts the heresy in book 3, chapter 59, of his *Chronicon* (c. 1028), underlines the connection between heresy and Revelation when he terms the Orléannais heretics "messengers of Antichrist" (nuntii Antichristi). *Chronique*, ed. Jules Chavanon (Paris: Picard, 1897), pp. 184–85.

43 *Historiae*, 3. 8: "Si qui vero postmodum hujus perversitatis sectatores fuerunt reperti, simili ultionis vindicta ubique fuerunt perditi. Praeterea venerabilis catholicae fidei cultus, exstirpata insanientium pessimorum vesania, ubique terrarum clarior emicuit." Migne, *PL* 142. 664A.

44 La fin du xe siècle vit . . . renaître le manichéisme, qui, dans les siècles suivants, devait donner à l'Eglise de graves soucis. On ne sait trop comment parurent dans l'Europe occidentale des doctrines qui autrefois avaient été le propre de l'Orient et

qui depuis longtemps semblaient tombées en sommeil. Une hypothèse vraisemblable soutient qu'elles ont pris une vie nouvelle dans les écoles où l'on s'exerçait à la dialectique: quelques maîtres, en étudiant les théories des anciens hérésiarques, finirent par s'y prendre; ils s'en pénétrèrent et les transformèrent en se les appropriant. Parmi leurs auditeurs, ils firent des disciples qui les répandirent dans les masses populaires. (Amann and Dumas, _L'Eglise au pouvoir des laïques_, p. 459)

Adémar de Chabannes, 3. 59, refers to the heretics as Manichaeans, but, as Moore points out, most modern commentators assume they were Bogomils or Cathars (_European Dissent_, pp. 26, 30, 294, n. 6).

45 _Historiae_, 2. 11: "Et, sicut haereses caeterae, ut cautius decipiant, Scripturis se divinis, quibus etiam contrariae sunt, palliant." Migne, _PL_ 142. 643C.

46 _Confessions_, 10. 3, trans. John K. Ryan (New York: Doubleday, 1960), p. 230.

47 _The Jerusalem Bible_, Alexander Jones, ed. (New York: Doubleday, 1968), p. 320.

48 It is interesting to see how the three stages of humankind described by Gregory of Nazianzen and Pseudo-Dionysius constitute the dialectic of the _historia_ here. Although the stages from Pagan to Jew to Christian were seen as perfective and historical, they also corresponded to stages in the evolution of human consciousness. Recidivism might therefore be anticipated as well as hostility toward the more perfect on the part of those still in less "advanced" stages. Jews, being closer to the "Truth," could be expected to view Christianity, the third stage, as a greater threat than would the "Saracens," who remained in the first stage—somewhat anachronistically. See Sheldon-Williams, _CHLGEMP_, pp. 445–46.

49 The Scriptures are supplemented by the oral tradition, which depends for its survival upon the fidelity of the disciple to his master. Orthodoxy is related to heresy as health to disease, and indisposition incurred when the Divine Logos, i.e., _theologia_, is displaced by the human logos, i.e., _reason uncontrolled by faith_. The vehicle of the Tradition, both written and unwritten, is the Church, which is both the agent and the witness of the diffusion of enlightenment through the world. (Sheldon-Williams, "St. Gregory Nazianzen," _CHLGEMP_, p. 439)

50 M. F. Hearn, _Romanesque Sculpture_, has analyzed the tympanum of Beaulieu Abbey, as from the perspective of an antiheretical iconographic program which "reflects the concern of the abbot of Cluny, Peter the Venerable, about a group of heretics who were related in beliefs to the Albigensians" (pp. 186, 179–80). Yves Christe, _Les grands portails romans_, p. 132 (also in the chapter "La Transfiguration," pp. 96–104), and Hearn, pp. 187–89, have pointed out the indebtedness of Peter the Venerable to Eriugena and through him to Pseudo-Dionysius, Gregory of Nyssa, and Gregory of Nazianzen. A fine book by another art historian, Linda Seidel, appeared while my own work was in production: _Songs of Glory: The Romanesque Façades of Aquitaine_ (Chicago: University of Chicago Press, 1981). While not specifically concerned with identifying the philosophical bases of the façades she treats, Seidel does make a persuasive case for linking the narrative and moral concepts of the monumental art works to their counterparts in chronicles and _chansons_ of the period. She, too, notes the consonance of narrative techniques in the different media.

51 _De Divisione Naturae_, 5. 26. Migne, _PL_ 122. 916D–917C. See also Christe, _Les grands portails romans_, pp. 56–57. Summary quoted from Uhlfelder, p. 316. Christe makes a clear correlation between the Moissac tympanum and Cluniac writing, particularly that of Rodolphus Glaber:

C'est cependant dans le domaine des formes et des images que la spiritualité clunisienne s'est exprimée le plus intensément. Comme j'essaierai de le montrer . . . le Christ des tympans de Moissac et de Charlieu est à la fois la source et le point de convergence du mouvement des évangelistes qui, autour de la mandorle, se

cambrent et brusquement se figent dans une adoration qui les aveugle. Sans en référer à Jean Scot qui dans les *Ambigua* et le livre V du *De divisione* avait décrit cette "reversio" de la manière la plus éclatante, *on trouve évidemment dans les écrits clunisiens, et en particulier chez Raoul Glaber, des images analogues* que les sculpteurs pouvaient en outre traduire par la seul force de leur génie. Le "style" de traitement de l'espace et de la figure adoptés coup sur coup à Moissac, à Charlieu et à Angoulême présentent cependant des points de rencontre trop évidents avec le texte érigénien pour que de telles analogies soient simplement fortuites. . . . (p. 133)

52 *De Divisione Naturae*, 5. 26. Migne, *PL* 122. 919A–C. Summarized in Uhlfelder:

All rational beings, even sinful ones, seek God, the highest Good, for all seek their cause. They never desire evil, but since they are often mistaken and deceived, they take the wrong path to their goal. When the perverse motions of the irrational soul are corrected, it is moved to seek its cause and to enter into paradise. Because the ultimate object of desire and longing is unattainable by any creature, the longing and motion are eternal. The soul forever seeks and in a marvelous way finds what it seeks; it does not find what it cannot find. That is, the soul finds God through theophanies, but God as He is in Himself, it cannot find, for He is beyond the contemplation of any creature. (p. 371)

53 The technique of composition based upon a contrast of symmetry and asymmetry whereby two narrative elements are set off by showing them to be discoordinate with one another has been commented on by Meyer Schapiro. For him, the technique constitutes a characteristic feature of Romanesque sculptural composition which he terms "discoordination." "By discoordination, I mean a grouping or division such that corresponding sets of elements include parts, relations, or properties which negate that correspondence. . . ." "The Sculpture of Souillac," *Romanesque Art*, p. 104.

54 *Historiae*, 3. 8: "Primitus tamen fideles hortamur universos ut interim mentes illorum praesagium serenet Apostoli, qui praevidens in futuram hujusmodi cautelam intulit. *Oportet*, inquit, *haereses esse, ut ii qui ex fide sunt probentur.*" Migne, *PL* 142. 660D.

55 Rodolphus does not specifically say that the council took place in the cathedral at Orléans, but the Acts of the Council of Arras, held in 1025, to try heretics, graphically describes the use of the church for such trials: "Tertia vero die, quae Dominica habebatur, Segmentatus episcopus cum suis archidiaconis, paratis crucibus et textus evangelicis, circumfusa totius cleri ac populi multitudine, synodum celebraturus in ecclesia Beatae Mariae progreditur, impositaque antiphona Exsurgat Deus, totum psalmi hujus cursum expleverunt." Acta synodi Atrebatensis in Manichaeos. Migne, *PL* 142. 1271BC. We shall return to this text at the end of the chapter.

56 *Historiae*, 3. 7: "Hoc enim diu est quod sectam, quam vos jam tarde agnoscitis, amplectimur, sed tam vos quam caeteros cujuscunque legis vel ordinis in eam cadere exspectavimus; quod etiam adhuc fore credimus." Migne, *PL* 142. 660B.

57 Ibid.: "In hoc igitur permaxime istorum insipientia deprehenditur, atque ipsi omni scientia ac sapientia vacui pernoscuntur, cum negent creaturarum auctorem universarum, scilicet Deum." Migne, *PL* 142. 660D.

58 Ibid. Migne, *PL* 142. 661AB.

59 Ibid.: "Si qua vero res procaciter ab eo deviando in deterius cecidit, caeteris jure manentibus documentum preabuit." Migne, *PL* 142. 661B.

60 Ibid.: "Soli etiam homini datum est, prae caeteris animantibus fore sese beatius, quoniam quidem et illum duntaxat, si caruerit, omnibus fieri devenire miserius. Quem videlicet conditionis ordinem caute ab initio providens omnipotentis bonitas Conditoris, cernensque saepius eumdem videlicet hominem deserendo supera, involvi nimium infimis, fecit proinde plura identidem pro tempore ad eruditionem illius

gratia erectionis prodigia." Migne, *PL* 142. 661C.

61 Ibid. Migne, *PL* 142. 662B–D. Also "Sed cum ipse Omnipotens in quodam creaturarum medio, videlicet in homine, suam expressisset imaginem. . . . Ad cujus potiorem etiam reformationem idem Conditor personam filii suae Deitatis misit in mundum, sui praeformatam sumere imaginem" (col. 663A).

62 Ibid. Migne, *PL* 142. 663BC.

63 *Acta synodi Atrebatensis in Manichaeos*, chapter 14. *De imagine Salvatoris in cruce.*

> Est vero alia hujus ratio: simpliciores quippe in ecclesia et illiterati, quod per Scripturas non possunt intueri, hoc per quaedam picturae liniamenta contemplantur, id est, Christum in ea humilitate, qua pro nobis pati et mori voluit. Dum hanc speciem venerantur, Christum in cruce ascendentem, Christum in cruce passum, in cruce morientem, Christum solum, non opus manuum hominum adorant. Non enim truncus ligneus adoratur, *sed per illam visibilem imaginem mens interior hominis excitatur*, in qua Christi passio et mors pro nobis suscepta tanquam *in membrana cordis inscribitur*, ut in se unusquisque recognoscat quanta suo Redemptori debeat; dum videlicet juxta Salvatoris sententiam, quae postulat imago Caesaris, reddantur Caesari, et quae Dei, Deo. (Migne, *PL* 142. 1306BC)

64 Kantorowicz, *The King's Two Bodies*, p. 65.

65 Ibid.

66 Figure 4, catalogue number 25; Ernst G. Grimme, *Der Aachener Domschatz*, vol. 42, *Aachener Kunstblätter*, 2d. ed., ed. Peter Ludwin (Düsseldorf: Schwann, 1973).

67 Kantorowicz, *The King's Two Bodies*, p. 67.

68 "Diuina siquidem scriptura mundus quidam est intelligibilis, suis quattuor partibus, ueluti quattuor elementis, constitutus." Eriugena, *Homélie*, ed. Jeauneau, sec. 14, ll. 5–7, p. 270.

69 Kantorowicz, *The King's Two Bodies*, p. 64.

70 Ibid., pp. 71–73.

71 This mosaic formed part of a large composition, a triumphal arch, with Christ and the apostles in the center and two groups of three figures on either side. Charlemagne's group stands on the right side, from the spectator's viewpoint, while opposite, on the left, one finds another group: Christ bestowing the keys on Pope Sylvester I and the labarum on Constantine. The labarum was a Roman military standard decorated with gold, jewels, and the effigy of the general commanding the army. Constantine transformed it into the imperial standard, according to Prudentius, by replacing the secular ornamentation with a crown, a cross, and a chi-rho. Christ placed the labarum, in this representation, in Constantine's right hand. The whole mosaic emphasized the parallelism between Constantine and Charlemagne, and the two popes. For a discussion of the iconography and an illustration of the entire composition, see Richard Krautheimer, "The Carolingian Revival of Early Christian Architecture," in his *Studies in Early Christian, Medieval, and Renaissance Art* (New York: New York University Press, 1969), p. 236.

72 "Munjoie escrient, od els est Carlemagne. / Gefreid d'Anjou portet l'orieflambe: / Seint Piere fut, si aveit num Romaine, / Mais de Munjoie iloec out pris eschange. AOI." *Chanson de Roland*, 3092–95 (Brault's edition).

73 Kantorowicz, *The King's Two Bodies*, p. 72.

74 *Historiae*, 1. 5: "Erat autem instar speciei hujus mundanae molis, quae videlicet in quadam rotunditate circumsistere perhibetur, ut dum siquidem illud respiceret princeps terreni imperii, foret et documentum, non aliter debere imperare vel militare in mundo quam ut dignus haberetur vivificae crucis tueri vexillo." Migne, *PL* 142. 625D–626A.

75 Kantorowicz, *The King's Two Bodies*, p. 61.

76 Ibid., p. 62.

77 "Otton II tient un globe crucifère, tandis que sur sa tête, la Main du Père dépose un diadème." Gérard Cames, *Byzance et la peinture romane de Germanie* (Paris: Picard, 1966), p. 40; "Die Hand Gottes senkt sich vom Himmel herab und krönt das Haupt des jungen Kaisers." Grimme, *Der Aachener Domschatz* (no. 74), p. 34.

78 Cf. Sheldon-Williams, "Eriugena's Greek Sources," in his *The Mind of Eriugena*, p. 12. This image is reinforced in a poem, *Aulae Sidereae*, by Eriugena in which he describes Charles the Bald enthroned in his cathedral, from which he *sees* all, as a kind of terrestrial surrogate for God's all-seeing eye:

> Ipse throno celso fultus rex prospicit omnes
> Uertice sublimi gestans diadema paternum,
> Plena manus sciptris enchiridon aurea bactra. [98–100]

Michel Foussard, "*Aulae Sidereae*: vers de Jean Scot au Roi Charles," *Cahiers archéologiques* 21 (1971): 79–88.

79 Uhlfelder, p. xxviii.

80 *De Divisione Naturae*, 2. 23. Sheldon-Williams, vol. 2 [Dublin: Institute for Advanced Studies, 1972], pp. 100–02; Migne, *PL* 122. 570A–C. Passage summarized by Jean A. Potter in Uhlfelder, pp. 118–19.

81 Uhlfelder, p. xxxi.

82 "L'onction communique un caractère religieux, sacerdotal, mais le rite du couronnement reste un instant décisif de la cérémonie. La couronne est un symbole où s'exprime la personnalité juridique de l'Etat. Le peuple doit fidélité à la couronne, accessoirement à celui qui la porte; c'est d'ailleurs la définition du quatrième concile de Tolède: 'Ce qui fait le roi, ce n'est pas sa personne, c'est le Droit." Jean-Pierre Bayard, *Le sacre des rois* (Paris: Vieux Colombier, 1964), p. 109.

83 An example of the climate of opinion in which the king represented the rational approach to resolving difficulties in the world may be seen in the attempts, recounted by Rodolphus and others, made in the early eleventh century by various monarchs to use the authority of their office to inaugurate an era of peace. Rodolphus himself recounts a "summit" meeting between Henry II, "the Holy," of Germany, and Robert the Pious on 10 August 1023. *Historiae*, 3. 2. Migne, *PL* 142. 649A–D. ". . . sed viri eruditissimi illud uterque in mente habens: *Quanto magnus es humilia te in omnibus. . . .*" (col. 649BC).

84 C. R. Dodwell proposed Trier instead of Reichenau as the locus for the Liuthar Group responsible for this illumination: C. R. Dodwell and D. H. Turner, *Reichenau Reconsidered: A Re-Assessment of the Place of Reichenau in Ottonian Art* (London: The Warburg Institute, 1965), p. 29. Even if one accepts Dodwell's hypothesis, our main points remain unchanged. Gerbert knew both places well. On Gerbert's visits to Trier, see Lattin, *The Letters of Gerbert*, letters 162, 170.

85 Ibid., letter 230, p. 294.

86 Ibid., letter 232, p. 297.

87 Ibid., p. 298.

88 Kantorowicz, *The King's Two Bodies*, p. 62.

89 *De Divisione Naturae*, 2. 23. Uhlfelder, p. 119.

90 *Historiae*, 3. 8: "in regno proprio Christi ovium pestem." Migne, *PL* 142. 659D.

91 Ibid. "Ut autem cognovit rex, scilicet Robertus, ut erat doctissimus ac Christianissimus, tristis ac moerens nimium effectus, quoniam et ruinam patriae re vera et animarum metuebat interitum . . . " (col. 659D). "Quibus compertis, tam rex quam pontifices tristiores effecti interrogaverunt illos secretius . . . " (col. 660A).

92 Lattin, *The Letters of Gerbert*, letter 232, p. 297.

93 *Historiae*, 3. 8: "ut universa quae illius dispositioni incommutabiliter obediunt, continue serviendo auctorem praedicent." Migne, *PL* 142. 661B.

94 *Acta synodi Atrebatensis in Manichaeos* (text quoted above, n. 63).

95 *Historiae*, 3. 8: "Praeterea venerabilis Catholicae fidei cultus, exstirpata insanientium pessimorum vesania, ubique terrarum clarior emicuit." Migne, *PL* 142. 664A.

Chapter 3. Charlemagne Redivivus: From History to *Historia*

1 "La visite qu'Otton III fit au tombeau de Charlemagne est l'événement le plus spectaculaire de l'an 1000." Robert Folz, *Le souvenir et la légende de Charlemagne dans l'empire germanique médiéval* (Paris: Les Belles Lettres, 1950), p. 87.

2 Sulpicius Severus, *Chronicorum*, 2. 34. I am indebted to my colleague Charles T. Wood for drawing my attention to the parallels between Otto's invention of Charlemagne's tomb and Saint Helena's invention of the True Cross and the Cave of the Anastasis. The parallels become even more evident when one recalls subsequent medieval traditions where Charlemagne appears as the discoverer, or rediscoverer, of the True Cross; see, for instance, the illumination of this scene (with Roland and Oliver standing behind Charlemagne) in Paris, Bibliothèque Nationale, MS Fr. 573, fol. 148v.

3 "Tous les lieux, tous les temps portent egalement les symboles du Christ que chaque temps formule." Michel Foussard, "*Aulae Sidereae*: vers de Jean Scot au Roi Charles," *Cahiers archéologiques* 21 (1971): 82.

4 "*In solio regio*": for a discussion of the controversy regarding the translation of this phrase in the late nineteenth century, see Folz, *Le souvenir de Charlemagne*, pp. 91–92. Note, however, that in the most recent edition of Thietmar's *Chronicle*, the editor, Robert Holtzmann, opts unequivocally for "Thron" as the appropriate translation for "solium."

5 Karoli imperatoris ossa ubi requiescerent, cum dubitaret, rupto clam pavimento, ubi ea esse putavit, fodere iussit, quousque hec in solio regio inventa sunt. Crucem auream, que in colo eius pependit, cum vestimentorum parte adhuc imputribilium sumens, cetera cum veneracione magne reposuit. (Robert Holtzmann, ed., *Thietmari Merseburgensis Episcopi Chronicon*, 4. 47, in *Monumenta Germaniae Historica, Scriptores rerum germanicarum, nova series*, vol. 9, 2d ed. [Berlin: Weidmannsche Verlag, 1955], pp. 185, 187; hereafter cited as *MGH, Scriptores*)

6 Post multa itaque annorum curricula tertius Otto imperator veniens in regionem, ubi Caroli caro jure tumulata quiescebat, declinavit utique ad locum sepulturae illius cum duobus episcopis et Ottone comite Laumellensi; ipse vero imperator fuit quartus. Narrabat autem idem comes hoc modo dicens: Intravimus ergo ad Carolum. Non enim jacebat ut most est aliorum defunctorum corpora, *sed in quandam cathedram ceu vivus residebat*. Coronam auream erat coronatus, sceptrum cum mantonibus indutis tenens in manibus, a quibus jam ipse unguli perforando processerant. Erat autem supra se turgurium ex calce et marmoribus valde compositum. Quod ubi ad eum venimus, protinus in eum foramen fragendo fecimus. At ubi ad eum ingressi sumus odorem permaximum sentivimus. *Adoravimus ergo eum statim poplitibus flexis a jenua*; statimque Otto imperator albis eum vestimentis induit ungulosque incidit, et omnia deficientia circa eum reparavit. Nil vero ex artibus suis putrescendo adhuc defecerat, sed de summitate nasui sui parum minus erat, quam ex auro ilico fecit restitui, abstrahensque ex illius ore dentem unum, reaedificato tuguriolo abiit. (*Chronicon Novaliciense*, 3. 32, in *MGH, Scriptores*, vol. 7, p. 106)

7 Quibus diebus Otto imperator per somnum monitus est ut levaret corpus Caroli Magni imperatoris, quod Aquis humatus erat, sed vetustate obliterante, ignorabatur locus certus, ubi quiescebat. Et peracto triduano jejunio, inventus est eo loco, quem per visum cognoverat imperator, *sedens in aurea cathedra, intra arcuatam speluncam, infra basilicam Marie, coronatus corona ex auro purissimo, et ipsum*

corpus incorruptum inventum est. Quod levatum populis demonstratum est. Quidam vero canonicorum ejusdem loci, Adalbertus, cum enormi et procero corpore esset, coronam Caroli quasi pro mensura capiti suo circumponens, inventus est strictiori vertice, coronam amplitudine sua vicentem circulum capitis. Crus proprium etiam ad cruris mensuram regis demetiens, inventus est brevior, et ipsum ejus crus protinus divina virtute confractum est. Qui supervivens annis XL, semper debilis permansit. Corpus vero Caroli conditum in dextro membro basilicae ipsius retro altare sancti Johannis Baptistae, et cripta aurea super illud mirifica est fabricata, multisque signis et miraculis clarescere cepit. Non tamen sollempnitas de ipso cogitur, nisi communi more anniversarium defunctorum. (Adémar de Chabannes, *Chronique*, ed. Jules Chavanon [Paris: Picard, 1897], pp. 153–54)

8 Frank Kermode, *The Genesis of Secrecy* (Cambridge: Harvard University Press, 1979), p. 98.

9 See, for example, Peter Bloch, "Das Apsismosaik von Germigny-des-Près: Karl der Grosse und der Alte Bund," in *Karolingische Kunst*, ed. Wolfgang Braunfels and Hermann Schnitzler, vol. 3 of *Karl der Grosse: Lebenswerk und Nachleben* (Düsseldorf: Schwann, 1966), pp. 234–61.

10 "Car le geste de saint Boniface versant l'huile sainte sur la tête de Pépin avait pour résultat de faire du Carolingien l'élu de Dieu, en même temps que l'élu du peuple. Sur ce point, nul doute non plus: renouvelé des temps bibliques, le sacre reprenait nécessairement aux yeux des contemporains son antique valeur. . . . Tel Saül, tel David, Pépin était l'oint du Seigneur. . . ." Louis Halphen, *Charlemagne et l'empire carolingien* (Paris: Albin Michel, 1968), p. 30. For a more detailed account of the influence of the Hebrew Royal Period of the Old Testament on the spirituality and political life of the Carolingians, see André Vauchez, *La spiritualité du Moyen Age Occidental, VIII^e–XII^e siècles* (Paris: Presses Universitaires de France, 1975), pp. 10–18.

11 Edmonde-René Labande, *Spiritualité et vie littéraire de l'Occident, X^e–XIV^e siècles* (London: Variorum Reprints, 1974), first two chapters: *"Mirabilia Mundi*: Essai sur la personalité d'Otton III." Reprinted from *Cahiers de civilisation médiévale* 6 (1963): 297–313, 455–76. See also, Christopher Walter, "Papal Political Imagery in the Medieval Lateran Palace," *Cahiers archéologiques* 20 (1970): 155–76, and 21 (1971): 109–36.

12 Adémar situates his account of the invention of Charlemagne's tomb in the midst of a report concerning the successful efforts to Christianize the central European countries of Hungary, Poland, and "Sclavania." The success of these efforts was due to Saint Adalbert of Prague, who was martyred, and King Stephen of Hungary, with the help, or at least the promise of assistance, of Otto.

13 *Chronique*, ed. Chavanon, p. 152.

14 Folz, *Le souvenir de Charlemagne*, p. 93.

15 O. B. Hardison, Jr., *Christian Rite and Christian Drama in the Middle Ages* (Baltimore: Johns Hopkins, 1965), p. 178.

16 Richard Krautheimer, *Studies in Early Christian, Medieval, and Renaissance Art* (New York: New York University Press, 1969), pp. 108–09.

17 Adémar de Chabannes, 3. 47: "Tamen redincepta basilica, non fuit amplius similis priori nec pulchritudine nec magnitudine quam Helena, mater Constantini, regali sumptu perfecerat." *Chronique*, ed. Chavanon, p. 170.

18 John Wilkinson, *Egeria's Travels* (London: SPCK, 1971), p. 242.

19 *Vita Constantini*, 3. 25, in *Eusebius*, trans. John Bernard (London: Palestine Pilgrims' Texts Society, 1896), p. 3.

20 Rodolphus Glaber, *Historia*, 3. 7; Adémar de Chabannes, 3. 47.

21 Cf. Notker Balbulus, Monk of St. Gall, *Gesta Karoli Magni*, 2. 9, in *MGH, Scriptores*, vol. 12, pp. 64–65.

22 "Peter the Deacon's Book on Holy Places," quoted in Wilkinson, *Egeria*, pp. 180–81.

23 *MGH, Scriptores*, vol. 4, pp. 447–49. See Folz, *Le souvenir de Charlemagne*, pp. 24–25, for a discussion of the *Translatio Sanguinis*.

24 Ibid., pp. 24–25.

25 *MGH, Scriptores*, vol. 3, p. 708, chap. 23. See Folz, *Le souvenir de Charlemagne*, pp. 135–37.

26 All Charlemagne's political ideas, his conception of a new Empire, and of his own status were based upon the image of the first Christian emperor. Numerous documents testify to the parallel which time and again was drawn between the Carolingian house and Constantine: the scribes of the papal chancellery . . . referred to [Charlemagne] as the "New Constantine"; the crown which Constantine was supposed to have given to Pope Sylvester was allegedly used in 816 by Stephen V for the coronation of Charlemagne's son, Louis the Pious; Aix-la-Chapelle was in Carolingian terminology a *Nova Roma*, like Constantinople in the phraseology of the fourth century. (Krautheimer, *Studies in Art*, pp. 235–36)

27 Ibid., chap. 13.

28 Ibid., p. 115.

29 Ibid., chap. 8. See also Geneviève Bresc-Bautier, "Les imitations du Saint-Sépulcre de Jérusalem (IXᵉ–XVᵉ siècles)," *Revue de l'histoire de la spiritualité* 50 (1974): 319–42.

30 Krautheimer, *Studies in Art*, p. 141.

31 Ibid., p. 111.

32 Ibid.

33 Ibid., p. 109.

34 Ibid., p. 107.

35 Ibid., p. 111.

36 Ibid., p. 109.

37 Ibid., p. 108.

38 Ibid., p. 107.

39 *Chronique dite Saintongeaise*, ed. André de Mandach (Tubingen: Niemeyer, 1970), p. 330. Cf. also, "Karles si est a dire 'lumiere de char' car il anluminoit tous les rois terriens d'esnor et de preece." *La Traduction du Pseudo-Turpin du manuscrit Vatican Regina 624*, ed. Claude Buridant (Geneva: Droz, 1976), p. 122.

40 *The Penguin Book of Latin Verse*, ed. Frederick Brittain (Baltimore: Penguin Books, 1962), p. 146. Line 10, "dextrae Dei tu digitus" (the finger of the right hand of God), makes explicit a role for Christ that Charlemagne will come to fulfill when cast as the strong right arm of God.

41 Quoted by Hardison, *Christian Rite and Christian Drama*, pp. 178–79.

42 Ibid., p. 178.

43 "'Non solum,' inquit Rotolandus, 'Dei filius a mortuis resurrexit, verum etiam omnes homines qui fuere ab inicio usque ad finem sunt resurgendi ante eius tribunal . . . '" ("The Son of God did not come back from death alone," said Roland, "but that all men who have been born since the beginning of the world and will be until the end will be resuscitated on the day of Judgment . . . "). *Historia Karoli Magni et Rotholandi*, ed. C. Meredith-Jones (Paris: Droz, 1936), chap. 17, p. 159.

44 *Life of Charlemagne*, chap. 31, trans. Samuel Turner (Ann Arbor: University of Michigan Press, 1960), p. 60.

45 Dompnus vero piissimus et gloriosissimus imperator Karolus, dum Aquisgrani hiemaret, anno septuagesimo primo etatis sue, regni autem quadragesimo septimo, subacte autem Italie quadragesimo tercio, imperii vero quarto decimo, rebus humanis excessit XV kal. februarii, sepultus Aquis in basilica Dei genitricis, quam ipse construxerat. Corpus ejus aromatizatum et in sede aurea sedens positus est

in curvatura sepulchri, ense aureo accinctus, evangelium aureum tenens in manibus et genibus, reclinatis humeris in cathedra, et capite honeste erecto, ligato aurea cathena ad diadema; et in diademate lignum Crucis positum. Et repleverunt sepulchrum ejus aromatibus, pigmentis, balsamo et musgo et thesauris. Vestitum est corpus ejus indumentis imperialibus, et sudario sub diademate facies ejus operta est. Sceptum aureum et scutum aureum, quod Leo papa consecraverat, ante eum posita, et sigillatum est sepulchrum ei. (*Chronique*, 2. 25, ed. Chavanon, p. 105)

Note the care Adémar takes to date Charlemagne's death according to his different qualities as man, king, and emperor.

46 For a description of the sketch, see A. Wilmart, *Codices Reginenses latini* (Bibliothecae Apostolicae Vaticanae codices manu scripti recensiti, Rome, 1945), vol. 2, pp. 47–49. The sketch was identified as Adémar's by Danielle Gaborit-Chopin, "Un dessin de l'église d'Aix-la-Chapelle par Adémar de Chabannes dans un manuscrit de la Bibliothèque Vaticane," *Cahiers archéologiques* 14 (1964): 233–35. See also Helmut Beumann, "Grab und Thron Karls des Grossen zu Aachen," in *Karl der Grosse: Das Nachleben*, ed. W. Braunfels and P. E. Schramm (Düsseldorf: Schwann, 1967), pp. 9–38; for the sketch, pp. 36–38.

47 Folz, *Le souvenir de Charlemagne*, pp. 49–50, 93.

48 Jean-Pierre Bayard, *Le sacre des rois* (Paris: Vieux Colombier, 1964), pp. 101–20.

49 *Dictionnaire d'archéologie chrétienne et de liturgie*, ed. dom F. Cabrol and dom H. Leclercq (Paris: Letouzy, 1913), vol. 3, col. 743.

50 On the relationship of the ambulatory reliefs at Saint-Sernin to the construction of the basilica, see Thomas W. Lyman, "Notes on the Porte Miègeville Capitals and the Construction of Saint-Sernin in Toulouse," *The Art Bulletin* 49 (1974): 25–36, particularly pp. 27–28, 30, 31.

51 Ernest Rupin, *L'Abbaye et les cloîtres de Moissac* (Paris: Picard, 1897), p. 24.

52 An interesting study of the consequences of this policy on the Carolingian art may be seen in such articles as Bloch, "Das Apsismosaik von Germigny-des-Près."

53 May Vieillard-Troïekouroff, "La Chapelle du Palais de Charles le Chauve à Compiègne," *Cahiers archéologiques* 21 (1971): 89–108: "L'évocation poétique que Jean Scot fait de la chapelle palatine de Charles le Chauve, montre qu'il s'agirait, si on en fait un commentaire archéologique suivi, d'une copie assez fidèle de la chapelle d'Aix" (p. 90).

54 Foussard, "*Aulae Sidereae*," pp. 79–88.

55 Eriugena, *De Divisione Naturae*, bk. 2. Migne, *PL* 122. 572C. Cf. Foussard, "*Aulae Sidereae*," p. 80: "L'édifice construit sur le nombre huit manifeste ainsi la course des astres, l'harmonie qui les unit dans la sagesse créatrice, l'histoire du salut et du Sauveur; mais ce ne sont là qu'indications pour le profane, pour le *rudis* que Jean Scot presse de s'envoler et de franchir 'le spectacle des sens' afin de pénétrer 'l'harmonie des réalitiés sous la conduite de la sagesse' (vers 16–18)."

56 Foussard, "*Aulae Sidereae*," p. 84.

57 Rita Lejeune and Jacques Stiennon, *La légende de Roland dans l'art du moyen âge* (Bruxelles: Arcade, 1966), vol. 1, p. 139b.

58 Ibid., pp. 142b–143a.

59 Ibid., p. 143a.

60 Summer McKnight Crosby, "Abbot Suger, the Abbey of Saint-Denis, and the New Gothic Style," in *The Royal Abbey of Saint-Denis in the Time of Abbot Suger*, ed. S. McK. Crosby et al. (New York: Metropolitan Museum, 1981), p. 19.

61 Bayard, *Le sacre des rois*, p. 254.

62 Bibliothèque Nationale, Lat. 9654. Reproduced in Robert Folz, *Le couronnement impérial de Charlemagne* (Paris: Gallimard, 1964), pl. 14.

63 Foussard, *"Aulae Sidereae,"* p. 82.

Chapter 4. *Historia* and the Poetics of the Passion

1 Recent studies of the Charlemagne window fix its date at about 1225. For a detailed description of the window and a new interpretation of the panels, see Clark Maines, "The Charlemagne Window at Chartres Cathedral: New Considerations on Text and Image," *Speculum* 52 (1977): 800–23. Emile Mâle's discussion of the window is still readily available in *The Gothic Image* (New York: Harper Torchbook, 1958), pp. 347–52.

2 For a description of the Charlemagne history window at Saint Denis, see Louis Grodecki, *Les Vitraux de Saint-Denis: étude sur le vitrail aux XIIe siècle*, vol. I (Paris: CNRS, Arts et métiers graphiques, 1976), "Les vitraux perdus de la première croisade et de Charlemagne," pp. 115–21. Grodecki dates these windows to the mid-twelfth century on the basis of style, iconography, and archaeological detail. More detailed iconographic and stylistic studies of the window will appear in volumes 2 and 3 of Grodecki's comprehensive survey of the windows at Saint Denis.

3 "de materialibus ad immaterialia excitans." *De Administratione*, 34. 74. 2. *Abbot Suger on the Abbey Church of Saint-Denis*, ed. and trans. Erwin Panofsky (Princeton: Princeton University Press, 1946), pp. 74–75 (2d ed., ed. Gerda Panofsky-Soergel, [Princeton, 1979]).

4 The legend of Charlemagne's incestuous union with his sister was recounted in the eleventh-century life of Saint Gilles, the *Vita Sancti Aegidii*. The text may be found today in the *Acta Sanctorum*, 9 September, 299–304. The Oxford version of the *Roland* mentions an account of the battle of Roncevaux and its aftermath by Saint Gilles (ll. 2095–98, Bédier's edition), and the *Karl der Grosse* of the Stricker ("Rhapsode"), c. 1250, mentions a legend whereby Saint Gilles was apprised of the details of the battle at Roncevaux by an angel sent by God and wrote them down to give to Charlemagne. Similarly, the twelfth-century *Kaiserchronik* states that Charlemagne confessed his sins to Saint Gilles. The exact nature of the sin is not spelled out in vernacular literature, however, until later, in such works as the *Karlmagnus Saga* in Iceland and the Occitan *Ronsasvals*.

5 Modern scholars, both literary and art historical, have tended to view "history" as secular. Panofsky, for example, considered the kind of material found in the Charlemagne window as secular (see *Abbot Suger*, p. 195, n. 8). His view rejects that of the majority of commentators. See also Grodecki's discussion of the Charlemagne window at Saint Denis mentioned above. We should note that the Abbé Delaporte categorically denied the religious connotations of the Charlemagne window in his famous monograph, published in 1926: "si le grand empereur a eu dans notre cathédrale les honneurs d'une verrière, il est moins redevable à sa sainteté qu'à son rôle politique et à la gloire qui entourait son nom." Yves Delaporte and Etienne Houvet, *Les vitraux de la cathédrale de Chartres* (Chartres: Houvet, 1926), p. 314.

6 Henri Focillon, *L'Art d'Occident*, vol. 2, *Le moyen âge gothique* (Paris: Livre de Poche, 1965), pp. 236–37.

7 "Pervading Suger's writings and physically manifested in the luminosity of the new windows was the philosophy of Pseudo-Dionysius the Areopagite. . . . Given the prevailing belief that there was a direct historical connection between Saint Denis and the Apostle Paul, it is not surprising that both the Epistles of Paul and the Neoplatonic philosophy of Pseudo-Dionysius inspired the iconographic program devised for the choir windows." Jane Hayward, "Stained Glass at Saint Denis," in *The Royal Abbey of Saint Denis in the Time of Abbot Suger*, ed. S. McK. Crosby et al. (New

York: Metropolitan Museum, 1981), p. 63. See also Panofsky, *Abbot Suger*, 2d ed., pp. 19–25.

8 Georges Duby, *Le temps des cathédrales, l'art et la société 980–1420* (Paris, Gallimard, 1976), p. 36.

9 The ironic interplay whereby symbols emptied of physical content could realize a plenitude of meaning derived from one of the basic representational subjects of the period: the Resurrection. The portentous significance of the Resurrection at this time was incessantly and invariably figured by an "empty" container: the tomb and the sarcophagus.

10 Eriugena, *De Divisione Naturae*, 1. 10: "per intellectum in intellectibus per rationem in rationibus, non per seipsam diuina essentia apparebit." Migne, *PL* 122. 450C.

11 Ibid., 3. 10.

12 The three texts which have been identified as forming the basis for the iconographic program of the window are the *Historia Karoli Magni et Rotholandi* (or *Pseudo-Turpin*), the *Vita Sancti Aegidii*, and the *Descriptio qualiter Karolus Magnus clavum et coronam Domini a Constantinopoli Aquisgrani detulerit*. All of these texts have late eleventh- or early twelfth-century proveniences, although the dates of the first and third are still disputed. For a discussion of the *Descriptio*, see Robert Folz, *Le souvenir et la légende de Charlemagne dans l'empire germanique médiéval* (Paris: Les Belles Lettres, 1950), pp. 179–81. See also Maines, "The Charlemagne Window."

13 For a discussion of the late nineteenth- and twentieth-century controversy regarding the dating of the *Historia*, see André de Mandach, *Naissance et développement de la chanson de geste en Europe*, vol. 2, *La Chronique de Turpin* (Geneva: Droz, 1963), pp. 11–14. In vol. 1, *La geste de Charlemagne et de Roland* (Geneva: Droz, 1961), Mandach provides effective evidence to reestablish the probability of an eleventh-century date for the earliest versions of the *Historia*. Although it seems difficult to believe that some form of the *Historia* would not have existed in the late eleventh century, the question of dating really does not affect the premises of this chapter. By the same token, the controversy over the order of composition of the *Historia* and the *Chanson de Roland* is immaterial to this chapter and the next.

14 Henri Focillon, *The Art of the West* (London: Phaidon, 1963), p. 69.

15 Louis Grodecki, *L'Architecture Ottonienne* (Paris: Armand Colin, 1958), p. 291. One analogy used to convey the part/whole relationship in the twelfth century was that of the human body, where each part has a function independent of the others but necessarily connected to the whole body. The basilica of Saint James at Compostela is so described in the chapter devoted to "De ecclesiae mensura" of the *Guide du Pèlerin de Saint-Jacques de Compostelle*, 4th. ed., ed. Jeanne Vielliard (Mâcon: Protat Frères, 1969), pp. 86–92.

16 "Friedrich Nietzsche, Rhétorique et langage," ed. Philippe Lacoul-Labarthe and Jean-Luc Nancy, *Poétique* 5 (1971): 124.

17 See, for example, Henri Focillon, *L'an mil* (Paris: Armand Colin, 1952); L. Grodecki, *L'Architecture Ottonienne*; Herwin Schaefer, "The Origin of the Two-Tower Façade in Romanesque Architecture," *The Art Bulletin* 27 (June 1945): 85–108; Carol Heitz, "Architecture et liturgie processionnelle à l'époque préromane," *Revue de l'Art* 24 (1974): 30–47; Jean Hubert, "Introïbo ad altare," *Revue de l'Art* 24 (1974): 9–21.

18 Grodecki, *L'Architecture Ottonienne*, pp. 309–10; Schaefer, "The Origin of the Two-Tower Façade," p. 85.

19 "Le culte de la croix était au Haut Moyen Age d'une exceptionnelle intensité. L'hypogée des Dunes de Poitiers en porte témoignage. Pour l'époque carolingienne, la place de la croix au milieu de la nef est attestée, outre à *Centula*, à Reims et à Corvey ainsi qu'à Fulda et à Saint-Denis." Heitz, "Architecture et liturgie processionnelle," p. 46, n. 19.

20 Ibid., pp. 30–47.

21 Ibid., p. 35.

22 Ferdinand Lot, *Chronique de l'Abbaye de Saint-Riquier* (Paris, 1894).

23 Heitz, "Architecture et liturgie processionnelle," pp. 35–36.

24 [U]ne même communion mêlait toute l'assistance, le jour de Pâques, dans l'*Anastasis*, la Rotonde de la Résurrection bâtie autour du Saint-Sépulchre. Plus d'une donnée apparente d'ailleurs la *Turris Sancti Salvatoris* de *Centula* à son ainée de Jérusalem . . . la position à l'Ouest de l'antéglise du Sauveur rejoint celle de l'*Anastasis* au sein du complexe architectural élevé près du Saint-Sépulchre. L'*altare sanctae Crucis* dans la nef se situe à peu près comme le Golgotha par rapport au Saint-Sépulchre . . . il me semble difficile de contester la parenté entre la *Turris Salvatoris* et L'*Anastasis*. L'antéglise neustrienne est cependant une approximation plutôt qu'une copie littérale. (Ibid., p. 33)

25 "[U]t in nostro opere gratiam septiformem Sancti Spiritus demonstremus." Ibid., p. 36. We might note also that celebrants and participants performed, in effect, a mimesis, with their own bodies, of Christ's sacrifice. Collectively, they form a huge cross-shape within the structure of the church; individually, each person took a place on that Cross in imitation of Christ. In this way, they reinforce their identity with the human part of Christ and the benefits his sacrifice was seen as winning for them. But they also marked the *difference* between Christ, the sacrificial victim, and themselves, the beneficiaries.

26 "La force qu'Aristote appelle rhétorique, qui est la force de démêler et de faire valoir, pour chaque chose, ce qui est efficace et fait de l'impression, cette force est en même temps l'essence du langage; celui-ci se rapporte aussi peu que la rhétorique au vrai, à l'essence des choses; il ne veut pas *instruire*, mais transmettre à autrui une émotion, une appréhension subjective." Lacoul-Labarthe and Nancy, "Friedrich Nietzsche, Rhétorique et langage," p. 111.

27 For a discussion of Eriugena's use of Genesis as an extensive concept, see Brian Stock, "The Philosophical Anthropology of Johannes Scottus Eriugena," *Studi Medievali*, 3d series, 8 (1967): 1–57; particularly, pp. 12–46. The following passages illustrate the ideas at work: "Time and eternity are not absolutes, eternally opposed, but relatives, mutually interdependent" (p. 39). "Two new paradises have emerged. . . . The pair are for [Eriugena] the inner and outer qualities of man. Only the inner state, *imago*, was truly paradise. The second, outer state, *similitudo*, is a paradise towards which man can direct himself on earth, and merges with the eschatological paradise which is the return of all things to their original states. For this conception of paradise, however, man must have an historical reality. The second idea has no meaning if man is not an existential creature in a physical as well as a metaphysical sense. At the end of time, the two paradises again become one. *Diversitas* becomes *unitas*" (p. 43).

28 Vexillum regis uenerabile cuncta regentis
O crux sancta micans super omnia sidera caeli,
Mortifero lapsis gustu quae sola reportas
Antidotum uitae fructum suspensa perhennem,
Te colo, te fateor, uenerans te pronus adoro.
Christus, principium, finis, surrectio, uita,
Merces, lux, requies, sanctorum doxa, corona,
Pro seruis dominus redimendis hostia factus,
In te suspendens per lignum toxica ligni
Purgauit clausae reserando limina uitae. [ll. 1–10]

The Letters and Poems of Fulbert of Chartres, ed. and trans. Frederick Behrends (Oxford: Clarendon Press, 1976), p. 244.

29 See, for example, the illumination of Louis the Pious depicted as Defender of the Faith with cross and shield underlying the text of Hrabanus's poem: Nationalbibliothek, Vienna, Cod. 652 f 3v. Although frequently reproduced, this illumination may be most readily seen in such works as Friedrich Heer's *The World of Charlemagne* (New York: Macmillan, 1975), p. 257.

30 *Die Elfenbeinskulpturen aus der Zeit der karolingischen und sächsischen Kaiser, VIII–XI Jahrhundert,* 4 vols. (Berlin: Cassirer, 1914–20).

31 See, for example, Scottus Eriugena, *Homélie sur le prologue de Jean,* ed. and trans. Edouard Jeauneau (Paris: Les Éditions du Cerf, 1969), pp. 200ff.

32 The primacy of John as the privileged intimate of Christ is a widespread medieval belief. The following passage from Eriugena's *Homily on the Prologue to John* suggests the rhetorical force of this belief:

> O bienheureux Jean, ce n'est pas sans raison qu'on t'appelle Jean. Le nom Jean est hébreu; il se traduit en grec par [O Echarísato], ce qui veut dire "Celui à qui une grâce a été accordée." Car à quel théologien a-t-il été accordé ce qui t'a été accordé, à savoir de pénétrer les mystères cachés du souverain Bien, et de mettre à la portée de l'intelligence et de la sensibilité humaines les vérités qui t'ont été révélées et manifestées? A qui donc, encore une fois, fut accordée grâce si grande et si excellente? (2. 1; pp. 209–11 in Jeauneau)

33 "La *théoria* se présente le plus souvent comme l'élaboration théologique d'un texte biblique [*historia*]. Jean Scot déclare qu'il ne doit pas y avoir conflit entre les deux: *PL* 122, 501C,11–12." Ibid., p. 203, n. 6.

34 I prefer the term *cruciform semiosis* to a more traditional formulation such as *cruciform symbolism* for its accuracy in describing the kind of triadic sign production we have seen at work. It intends a sign system, used in a wide variety of ways in the period we have been examining, to convey the pervasiveness and signification of Christ's Passion as a means of "reading" the world as a divine construct.

Thanks to the polysemous nature of the Cross—at once referent, signified, and signifier—cruciform semiosis, as we have repeatedly seen, operates both on the plane of expression and on that of content.

Just as the early Christian and medieval philosophers viewed the Crucifixion as giving transcendent meaning to disparate and hitherto unrelated objects—Christ, the cross, Golgotha, the Tree of Life, Adam, the Fall, Mary, John the Baptist and John the Evangelist, the Bronze Serpent, the Lance of Longinus, etc.—so cruciform semiosis provided a principle of coherent composition for verbal and visual art; an authorization to juxtapose and analogize heterogeneous elements such as the development of a Galician shrine dedicated to Saint James of Compostela, and the life and death of a Frankish hero (Roland).

Cruciform semiosis also assured the homogeneity of the artistic production in this period by creating formal and thematic similarities between different kinds of art forms and subjects, e.g., hagiography, stained glass windows, architecture, liturgical rites, painting, epics, chronicles, lyric poetry. Yet cruciform semiosis did not mean that artists and audience in this period saw the "same" work everywhere. Even if the ultimate purpose were to show the pervasiveness of the same event, the Passion, the very concept of the augmentative aesthetic, with its combinatory principle of unifying disparates, guaranteed a diversity to the art of the time. It is precisely the variety of Romanesque art, which yet demonstrates a powerful coherence, that makes it so interesting to us.

Finally, because it is a connotative, analogizing principle of sign production, cruciform semiosis relies upon a homogeneous social milieu and a specific historical period during which artists and audience alike share the same or highly similar horizons of knowledge and expectation. As for the term *semiosis,* I follow Peirce's definition: "by 'semiosis' I mean an action or influence which is, or involves, a cooper-

ation of *three* subjects, such as a sign, its object, and its interpretant, this tri-relative influence not being in any way resolvable into actions between pairs." Charles Peirce, *Collected Papers of C. S. Peirce*, ed. Charles Hartshorne and Paul Weiss (Cambridge, Mass.: Harvard University Press, 1931–58), vol. 484.

35 "La Passion du Christ," ed. Gaston Paris, *Romania* 2 (1873): 295–314.

36 John 3 : 16: "So that everyone who believes in him may not be lost but may have eternal life."

37 For a comprehensive description of the term *Anakephalaiosis* and its principal root, *Kephalē*, in classical and New Testament times, see Gerhard Kittle, ed., *Theological Dictionary of the New Testament* (Grand Rapids, Mich.: Eerdman's Publishing, 1965), vol. 3, pp. 673–82, and particularly pp. 679–82.

38 Clifford Geertz, "Religion as a Cultural System," in his *Anthropological Approaches to the Study of Religion* (London: Tavistock, 1966), p. 3.

39 Schiller, *Iconography of Christian Art* (Greenwich, Ct.: New York Graphic Society, 1972), vol. 2, p. 135.

40 Ibid.

41 Jules Viard, ed., *Les Grandes Chroniques de France*, vol. 3, *Charlemagne* (Paris: Société de l'histoire de France, 1933).

42 See my article "Historical Illusion and Poetic Reality in the *Chansons de Geste*," *French Review* 43 (1969): 23–33. This is very much the spirit that led the Abbé Delaporte to make the statement quoted in n. 5 above.

43 Tulpinus Dei gratia Remensis archiepiscopus ac sedulus triumphalis Karoli Magni in expeditione Hispanie socius Leobrando Aquisgranensi decano, salutem in Christo.
 . . . ut vobis scriberem qualiter imperator noster famosissimus Karolus Magnus Hispaniam et Galiciam a potestate Sarracenorum liberavit, mirabilium gestorum apices, ejusque laudanda super Hispanie Sarracenis trophea, que propriis oculis intuitus sum XIIII annis Hispaniam perambulans, et Galiciam, una cum eo et exercitibus suis, pro certo scribere vestreque fraternitati mittere non ambigo. Magnalia enim que rex gessit in Hyspania, in nullis plene chronicis sufficienter inveniuntur divulgata, et, ut mihi scripsistis, ea plenaria repperire vestra nequivit fraternitas. (*The Pseudo-Turpin*, ed. H. M. Smyser [Cambridge: Medieval Academy, 1937], pp. 55–56)

44 Later versions of the *Historia*, particularly the translations, "read" "Turpin's" self-inscription as it was intended. They base the "truth" of their version on his authority:
 por ce si n'an doit l'an mie douter qu'ele ne soit voire, car cil sans doute qui le mistrent an estoire furent partout la ou ce fust fait et le veirent a lor iauz, por ce si an sommes plus par aus certien et plus seurement ancommançons a traitier l'estoire et les mervoilleus faiz le grant Karlon de cui nus ne puet trop dire, ne nus n'an dist onquens tant bien de la moitie comme il an fu. (*La Traduction du Pseudo-Turpin du manuscrit Vatican Regina 624*, ed. Claude Buridant [Geneva: Droz, 1976], p. 86)

45 Hincmar, archevêque de Reims, en écrivant au IXe siècle la vie de saint Rémi, raconte ainsi la cérémonie du baptême:
 "Comme Rémi et Clovis arrivaient au baptistère, le clerc qui portait le chrême est arrêté par le peuple, en sorte qu'il ne put parvenir à la fontaine baptismale. A cette fontaine bénite, par la volonté divine, il manquait donc le Saint-Chrême. Et comme la foule du peuple empêchait d'entrer dans l'église ou d'en sortir, le saint Pontife, levant au ciel les yeux et les mains, se mit tacitement à prier en répandant des larmes. Et soudain une colombe plus blanche que la neige, apporta dans son bec une petite ampoule, pleine de Saint-Chrême, dont l'odeur suave, bien supérieure à celle de l'encens et des cierges, frappa tous les assistants. Le saint Pontife ayant pris cette petite ampoule, la colombe disparut. . . ."

Cette origine miraculeuse de la Sainte-Ampoule a d'importantes répercussions. Elle confirme le roi dans son rôle divin et le fait bénéficier d'un sacrement bien particulier, à lui seul réserver. Elle donne à la ville de Reims le privilege de sacrer les rois. (Jean-Pierre Bayard, *Le sacre des rois* [Paris: Vieux Colombier, 1964], p. 49)

46 [C]aminus stellarum quem in celo vidisti, hoc significat quod tu cum magno exercitu ad expugnandum gentem paganorum perfidam, et liberandum iter meum et tellurem, et ad visitandam basilicam et sarcofagum meum, ab his horis usque ad Galleciam iturus es, et post te omnes populi a mari usque ad mare peregrinantes, veniam delictorum suorum a Domino impetrantes, illuc ituri sunt, narrantes laudes Domini et virtutes eius, et mirabilia eius quae fecit. A tempore vero vitae tuae usque ad finem praesentis seculi ibunt. . . . (*Historia Karoli Magni et Rotholandi ou Chronique du Pseudo-Turpin*, ed. C. Meredith-Jones [Paris: Droz, 1936], pp. 91, 93; hereafter cited as *Historia*)

47 "Itaque Gallecia in primis temporibus a Sarracenis expedita virtute Dei et beati Iacobi, et auxilio Karoli, constat honesta usque in hodiernum diem in fide ortodoxa." Ibid., p. 175.

48 See Edmond Pognon, *L'an mille* (Paris: Gallimard, 1947), p. 89.

49 Vielliard, ed., *Guide du Pèlerin*, pp. 47, 109. We should recall, in this context, that the *Guide du Pèlerin* constituted the fifth book of the *Liber Sancti Jacobi*, while the *Historia Karoli Magni* formed the fourth book. The Codex Calixtinus, preserved in the cathedral archives of Saint James of Compostela, and dating from the twelfth century, has been generally accepted as the oldest and therefore the preferred manuscript of the *Liber*. See Meredith-Jones, ed., *Historia Karoli Magni*, p. 42, for a discussion of the Codex Calixtinus.

50 See *Karl der Grosse: Lebenswerk und Nachleben*, vol. 4, *Das Nachleben*, ed. Wolfgang Braunfels and Percy Ernst Schramm (Düsseldorf: Schwann, 1967).

51 Tres apostolicas sedes principales prae omnibus sedibus in orbe merito religio christiana venerari praecipue consuevit, romanam scilicet, gallecianam et ephesianam. Sicut enim tres apostolos, Petrum videlicet, et Iacobum et Iohannem, prae omnibus apostolis Cominus instituit, quibus sua secreta ceteris plenius, ut in evangeliis patet, revelavit, sic per eos tres has sedes prae omnibus cosmi sedibus reverenda[s] constituit. Et merito hae sedes dicuntur principales, quia sicut hi tres apostoli dignitatis gratia ceteros praecesserunt apostolos, sic loca illa sacrosancta in quibus praedicaverunt, et sepulti fuere, dignitatis excellentia omnes totius orbis sedes iure praecedere debent. *Iure Roma sedes apostolica prima ponitur, quia eam princeps apostolorum Petrus praedicatione sua et proprio sanguine et sepultura dedicavit.* Compostella namque sedes secunda merito dicitur, quia beatus Iacobus qui inter ceteros apostolos praecipua dignitate et honore et honestate maior post beatum Petrum extitit, *et in celis primatum super illos tenet, prius martirio laureatus eam sua praedicatione olim munivit, sepultura sua sacratissima consecravit, et miraculis adhuc perlustrat, et indeficientibus beneficiis indesinenter ditare non cessat.* Tercia sedes rite Ephesus dicitur, quia beatus Iohannes evangelista in ea evangelium suum, scilicet: In principio erat verbum, eructavit, coadunato episcoporum concilio quos ipse per urbes disposuerat, quos etiam in apochalipsi sua angelos vocat. Eamque suis praedicationibus et miraculis et baselica, quam in ea aedificavit, immo propria sepultura eam consecravit. Si ergo aliqua iudicia aut divina aut humana in aliis sedibus orbis sua gravitate discerni forte nequeunt, in his tribus sedibus tractari et diffiniri legitime et iuste debent. (*Historia*, pp. 173, 175)

52 *Historia*, p. 201: "Et statim, Tedrico recedente, in hac confessione et prece beati Rotolandi martiris anima beata a corpore egreditur, . . . "
Le Guide du Pèlerin, ed. Vielliard, p. 78. "Deinde apud Blavium in maritima, beati

Romani presidia petenda sunt, in cujus basilica requiescit corpus beati Rotolandi martiris, qui, cum esset genere nobilis, comes scilicet Karoli Magni regis, de numero .XII^cim. pugnatorum ad expugnandas gentes perfidas zelo fidei septus, Yspaniam ingressus est."

53 Schiller, *Iconography of Christian Art*, vol. 1, p. 15. Cf. "The miracle of Aaron's rod was thought of as a prefiguration of God's choice of Mary and her Virgin motherhood," vol. 1, p. 41. And also, vol. 1, p. 54: "Aaron's rod, from the story of his calling to the priesthood, is a symbol of election and its flowering in the night was interpreted as alluding to the miracle of Christ's birth."

54 *Historia*, p. 111. "Die vero illa agitur utrorumque pugna in qua occisi sunt quadraginta Christianorum milia, et dux Milo, Rotolandi, genitor, cum his quorum hastae fronduerunt, ibi palmam martirii adeptus est. . . ."

55 Schiller, *Iconography of Christian Art*, vol. 2, p. 128.

56 Ibid., p. 130.

57 Ibid.

58 Tunc gigas, audito hoc verbo, miratus est multum, dixitque ei: Rotolande, cur tot verba inania mihi profers? Impossibile est ut homo mortuus denuo ad vitam resurgat.—Non solum, inquit Rotolandus, Dei filius a mortuis resurrexit, verum etiam omnes homines qui fuere ab inicio usque ad finem sunt resurgendi ante eius tribunal. . . . Et ipse [Deus], qui plures mortuos ante suam passionem suscitavit, facile a mortuis resurrexit, et a morte nullatenus teneri potuit, ante cuius conspectum mors ipsa fugit, ad cuius vocem mortuorum phalans resurrexit. (*Historia*, pp. 159, 161)

59 "And Yahweh answered him, 'Make a fiery serpent and put it on a standard. If anyone is bitten and looks at it, he shall live.' So Moses fashioned a bronze serpent which he put on a standard; and if anyone was bitten by a serpent, he looked at the bronze serpent and lived." Numbers 21 : 8–9.

60 *Historia*, p. 153.

61 "Cuius vox tunc usque ad Karoli aures, qui erat hospitatus cum proprio exercitu in Valle Karoli, loco scilicet qui distabat a Rotolando VIII miliariis versus Gasconiam, angelico ductu pervenit." *Historia*, p. 193.

62 Basic to the concept and function of *historia* in the Middle Ages, or at least the part that concerns us, is what Eugene Vance has called "the commemorative act." Commemoration plays a crucial role in that aspect of medieval culture focused on the past as at once the origin and interpreter of the present. Vance defines *commemoration* as a medieval cultural phenomenon in the following terms: "By 'commemoration,' I mean any act, whether ritual or not, aimed at recapitulating, in the name of the community, an event which is either past or timeless, for the purpose of rendering it real and signifying part of the *hic et nunc* of lived reality." "Roland et la poétique de la memoire," *Cahiers d'études médiévales* 1 (1975): 103–15.

63 Habebat ipse adhuc quandam spatam suam secum, accione pulcherrimam, acumine fortissimam, fortitudine inflexibilem, nimia claritate resplendentem, nomine Durenda. Durenda interpretatus durum ictum cum ea da, vel dure cum ea percute Sarracenum, quia frangi ullo modo nequit. Prius deficiet brachium quam spata. Quam cum evaginasset, et manu eam teneret, intuitus eam lacrimosis vocibus dixit: O gladius pulcherrimus, non more furbidus sed semper lucidissimus, longitudine decentissimus, latitudine congruus, fortitudine firmus, manutentente eburneo candidissimus, CRUCE AUREA SPLENDIDISSIMUS, superficie deauratus, pommo berillino decoratus, litteris carissimis magno nomine Dei, Alpha et [Omega] sculptus, acumine legitimus, Dei virtute circundatus. . . ." (*Historia*, xxii, 189, 191)

A sixteenth-century illustration from Guillaume Cretin's *Recueil sommaire des chroniques françoyses* clearly shows the "Alpha et Omega" incised on the blade of

Durendal: Rita Lejeune and Jacques Stiennon, *La légende de Roland dans l'art du moyen âge*, vol. 2 (Brussels: Arcade, 1966), pl. 508.

64 Because iconographic representation of this scene requires Baudoin to be shown with a container for the water—indicating what he is trying to do—some scholars, e.g., Rita Lejeune and Jacques Stiennon, *La légende de Roland dans l'art du moyen âge*, feel that there exists a version, now lost, in which Baudoin did find water. This conjecture transforms an important element of christological symbolism into a banal act of comfort hardly worthy of having a panel of the Charlemagne window devoted to it. I follow Maines, "The Charlemagne Window at Chartres," in rejecting Lejeune's and Stiennon's interpretation.

65 Et statim, tedreico recedente, in hac confessione et prece beati Rotolandi martiris anima beata a corpore egreditur, et ab angelis in perhenni requie transfertur, ubi regnat et exultat sine meta, choris sanctorum martirum dignitate meritorum annexa. *Historia*, p. 201.

Indicative of the force of the Passion tradition in the representations of such scenes is the fact that, unlike the Oxford *Roland*, all the versions of the *Historia* portray Roland's death scene as having a witness and mourner, Thierry, who arrives immediately after Baudoin's departure. We saw the function of the witnesses and mourners, Mary and Saint John, in the iconographic representations of the Passion. Thierry fulfills much the same function in this instance. Indeed, some later manuscript illuminations show both Baudoin and Thierry beside the dying Roland, e.g., *Les Grandes Chroniques de France* (London, British Museum, MS Royal 16 G VI, f. 179 r).

Chapter 5. Roncevaux and the Poetics of Place/Person in the *Song of Roland*

1 One need think only of the descriptions of famous medieval battles by Joinville, Froissart, Commynes, etc., to recognize the force of what we don't find in the case of Roncevaux. From the eleventh and early twelfth centuries—to take only works from the same period as the early versions of the Roncevaux material—we have very specific descriptions of battles told from the perspective of military strategy. In the case of the Battle of Hastings, for instance, we have the Bayeux Tapestry and the prose and poetic narratives of Guy of Amiens, William of Poitiers, and Orderic Vitalis.

2 Joseph Bédier, *Les légendes épiques*, vol. 3 (Paris: Champion, 1921), p. 303. Bédier's lead has been followed up by D. J. A. Ross of Birkbeck College, London. In a series of articles, he has shown the unsuitability of the terrain at Roncevaux for the kind of battle described. His articles demonstrate the contradictions and inconsistencies of the Oxford text and of other versions when viewed from this sole perspective. See D. J. A. Ross, "L'Originalité de 'Turoldus': le maniement de la lance," *Cahiers de civilisation médiévale* 6 (1963): 127–38; "Gautier del Hum, An Historical Element in the *Chanson de Roland?*" *Modern Language Review* 61 (1966): 409–15; "Before Roland: What Happened 1200 Years Ago Next August 15?" *Olifant* 5 (1978): 171–90.

Marcel Baiche recently used the unsuitability of the terrain at Roncevaux for the military exploits described to propose an entirely different site for the battle, the pass at Siguer, a small town in the central Pyrenees, near Andorra. "1200 ans après, chaque chose à sa place: Charlemagne, L'Andoree et Roncevaux," *Occitan/Catalan Studies* 1 (1980): 7–14.

3 *The Song of Roland, An Analytical Edition*, ed. Gerard J. Brault (University Park: Pennsylvania State University Press, 1978), vol. 2, *Oxford Text and English Translation*; hereafter cited as Brault. All line references to the Oxford *Roland* will be to this edition.

4 The *Royal Frankish Annals* report that

Although the Franks were obviously their betters in arms and valor, they never-theless suffered a defeat due to the unfavorable terrain and unequal method of fighting. In this engagement a great many officers of the palace, whom the king had given positions of command, were killed; the baggage was plundered, and the enemy was able to vanish in all directions because he knew the lay of the land. To have suffered this wound shadowed the king's view of his success in Spain. (G. H. Pertz, *MGH, Scriptores*, vol. 1, p. 159. Quoted by Menéndez-Pidal, *La chanson de Roland et la tradition épique des Francs*, 2d. ed., trans. I.-M. Cluzel [Paris: Picard, 1960], p. 526)

Written in all probability between 817 and 830, Einhard's account incorporates and enlarges upon that of the *RFA*. In his *Vita Karoli*, Einhard reports that while Charlemagne

was in the Pyrenean mountain range itself, he was given a taste of Basque treach-ery. Dense forests, which stretch in all directions, make this spot most suitable for setting ambushes.

At a moment when Charlemagne's army was stretched out in a long column of march, as the nature of the local defiles forced it to be, these Basques, who had set their ambush on the very top of one of the mountains, came rushing down on the last part of the baggage train and the troops who were marching in support of the rearguard and so protecting the army which had gone on ahead. The Basques forced them down into the valley beneath, joined battle with them and killed them to the last man. They then snatched up the baggage, and, protected as they were by the cover of darkness, which was just beginning to fall, scattered in all directions without losing a moment. In this feat the Basques were helped by the lightness of their arms and by the nature of the terrain in which the battle was fought. On the other hand, the heavy nature of their own equipment and the unevenness of the ground completely hampered the Franks in their resistance to the Basques. In this battle died Eggihard, who was in charge of the king's table, Anselm, the Count of the Palace and Roland, Lord of the Breton Marches, along with a great number of others. What is more, this assault could not be avenged there and then, for, once it was over, the enemy dispersed in such a way that no one knew where or among which people they could be found (chap. 9; *Eginhard, Vita Karoli Magni Impera-toris*, ed. Louis Halphen [Paris: Champion, 1923], pp. 28–31)

5 Jeanne Vielliard, ed., *Le Guide du Pèlerin de Saint-Jacques de Compostele*, 4th ed. (Mâcon: Protat Frères, 1969); hereafter cited as Vielliard, *Guide*.

6 In era dcccxvi uenit Carlus rex ad Cesaraugusta. In his diebus habuit duodecim neptis, unusquisque habebat tria milia equitum cum loricis suis, nomina ex his Rodlane, Bertlane, Oggero spata curţa, Ghigelmo alcorbitanas, Olibero et episcopo domini Torpini. Et unusquisque singulos menses serbiebat ad regem cum scolicis suis. Contigit ut regem cum suis ostis pausabit in Cesaraugusta; post aliquantu-lum temporis suis dederunt consilium ut munera acciperet multa, ne affamis peri-ret exercitum, sed a propriam rediret, quod factum est. Diende placuit ad regem pro salutem hominum exercituum ut Rodlane belligerator fortis cum suis pos-terum ueniret. At ubi exercitum portum de Sicera transiret in Rozaballes a genti-bus sarrazenorum fuit Rodlane occiso. (Martin de Riquer, *Les chansons de geste francaises*, 2d. ed., trans. I.-M. Cluzel [Paris: Nizet, 1957], p. 71)

7 Elie Lambert, "Roncevaux et ses monuments," *Romania* 61 (1935): 34–35. The do-nation may have been a forgery, but the point remains that Roncevaux was consid-ered an important enough site to have either been desired by the monks of Conques or thought of as an appropriate donation for them.

8 Lambert's translation of the relevant lines of the poem:

L'évêque Sanche promoteur de cette oeuvre, fonda en l'honneur de la Vierge Mère de Dieu au pied de la plus haute montagne dans les Pyrénées un hôpital pour le salut des pèlerins. Quand ce prélat de Pampelune fonda cet hôpital dans les monts immenses, il fut très largement aidé dans ces dépenses par l'illustre roi d'Aragon Alphonse. . . . [C]e fut en l'an de l'Ere mille cent soixante-dix [1132] que commença l'édification de cet hôpital qui sert d'abri à ceux qui suivent la route. . . . (Lambert, "Roncevaux et ses monuments," p. 20)

9 Ibid., pp. 20–21.
10 For the text of the charter, see Lambert, "Roncevaux et ses monuments," p. 30.
11 Vielliard, *Guide*, chap. 3, p. 6.
12 Rita Lejeune, "Le Mont-Saint-Michel-au-Péril-de-la-Mer, *La Chanson de Roland*, et le Pèlerinage de Compostelle," *Millénaire monastique du Mont-Saint-Michel*, vol. 2 (Paris: Le Thielleux, 1967), pp. 411–33.
13 We may gain some idea as to just how powerful a sacred aura hung over the Cize from the fact that it was considered the highest mountain in the Pyrenees until 1832, when the Pic d'Anéto, quite far to the east, was officially identified as the highest peak in the chain. The tallest summit near Roncevaux is 1,570 meters, less than half the height of the Pic d'Anéto. See *Les Pyrénées*, ed. François Taillefer (Toulouse: Privat, 1974), p. 314.
14 Vielliard, *Guide*, p. 24, and also for the next quotation.
15 Lambert, "Roncevaux et ses monuments," pp. 32–33.
16 Vielliard, *Guide*, p. 24.
17 Ibid., p. 26. Note that "potentissimus" possessed sacred rather than militaristic connotations at this time. See Hippolyte Delehaye, *Sanctus: essai sur le culte des saints dans l'antiquité* (Brussels: Bollandistes, 1927), chap. 1, "Le vocabulaire de la sainteté."
18 Vielliard, *Guide*, p. 26.
19 See Alphonse Didron, *Christian Iconography* (New York: Ungar, 1968), pp. 178–87. On the dedication of rocks and high places to Saint Michael, see ibid., pp. 181–82.
20 "Hic tanta fortitudine repletus fuit, quod petronum quemdam ut fertur, *in Runciavalle*, a summo usque deorsum, sua framea per medium, trino ictu scilicet, scidit, et tubam sonando, oris sui vento similiter per medium divisit. Tuba vero eburnea scilicet scissa *aput Burdegalem urbem, in basilica Beati Severini habetur*, et *super petronum in Runciavalle* quedam ecclesia fabricatur." Vielliard, *Guide*, p. 78.
21 Ibid., pp. 78, 80.
22 Brault, *Song of Roland*, vol. 1, p. 62.
23 Lambert, "Roncevaux et ses monuments," p. 40. Lambert gives other legends of this sort as well, p. 41ff.
24 Marcel Durliat, "Pèlerinages et architecture romane," *Les dossiers de l'architecture* 20 (Jan–Feb. 1977), p. 24.
25 Ibid.
26 Ibid.
27 Ibid., p. 25.
28 This fascinating text—a sermon preached by a monk named Garsias around 1064—describes the symbolic relationships of the different parts of the rebuilt abbey at Saint-Michel-de-Cuxa. In effect, this commentary offers a hermeneutics of site where, for example, the towers dedicated to Saint Michael are seen as protecting the part of the church dedicated to the Virgin and in which the grotto at Bethlehem is roughly reproduced. A living tableau of Revelation is clearly suggested by the text:

 & disposite in sanctum Domini opus a foris super reverenda martyrum Valentini, Flamidiani, atque confessoris Nazarii corpora ad locum nunc condigne venerantur, pulchro & arcuato opere beatae genitricis Mariae & archangelorum Dei in crypta quae ad praesepium dicitur extruxit Ecclesiam, ita ut ex utroque virginis latere

summi Dei angeli tantae Dei matris gloriam laudibus sive meritis in obsequium novae salutationis a dextris eius Gabriel conceptum partus nuntiet, ac a sinistris virginalis gloriae plenitudinem splendidus Raphael affirmet. Ad pedes etiam seu in sinu causa famulatus circumsepsit, & hinc inde martyres sepelivit, qui de se vel languentium salute dicerent: Ecce iste Deus, fortitudo nostra. *A facie autem Reginae, ut est terribilis ac divinus Michael, tamquam ad tuitionem sui filium ante tempora natum fidelibus & omnibus ad se venientibus assignavit dicens*: Invenietis infantem pannis involutum & positum in praesepio. Ergo ut altitonanti decentia in verae fidei confessione domus possideret maternum partus. . . .

[[And], for the Lord's holy work, from the entrance over the reverend bodies of the martyrs Valentinus, Flamidianus, and Nazarius the confessor, at the place where now they are most worthily venerated, over the vault, he constructed a church of the Blessed Mother Mary and the archangels of God, which is called The Manger, in such a way that from each side of the Virgin the most exalted angels of God announce the glory of the great mother of God for her praises or for her merits; on the right, Gabriel heralds the offspring conceived in obedience to his novel greeting, and on the left a brilliant Raphael declares the fulness of her maidenly glory. At her feet, or in her bosom, he surrounded her with the martyrs, buried here and there for the sake of their service, who say concerning themselves or for the salvation of the weak: Behold God, our strength. *Facing the Queen is Michael, as he is, dreadful and prophetic, as if for her protection, and he points out the son too soon born to the faithful and to all coming to him, saying: "You will find an infant wrapped in swaddling clothes and placed in a manger."* Therefore, in order that a house fitting to the one thundering on high in acknowledgement of the true faith might hold the Mother's Son. . . .] This section of the text was translated for this book by Ronald Pepin, Greater Hartford Community College. (Appendix 222 of Pierre de Marca, *Marca Hispanica*, ed. Etienne Baluze [Paris: Toulouse, 1688], col. 1080. The entire text of the sermon runs from col. 1072 to 1082)

29 The dates are Durliat's. Olivier Beigbeder, *Forez-Velay Roman* (Paris: Zodiaque, 1962), says that the first stone of the shrine of Saint Michael was laid in 962 and that the dedication took place in 972. Like Durliat, he credits Bishop Godescalc with having brought back the cult of Saint Michael from his pilgrimage to Compostela. "Or saint Michel était le protecteur des soldats luttant contre les Arabes" (p. 91).

30 To choose Saint Michael meant choosing his text, Revelation. One of the enormously popular texts in tenth-century Spain was the commentary on Apocalypse by Beatus of Liebana, a Spanish monk who died in 798, and whose tremendously influential work was certainly completed in its first form by 776. Influenced by earlier commentators on Apocalypse, especially Saint Augustine in book 20 of his *De Civitate Dei*, Beatus saw in the eighth-century incursion of the Moslems in Spain ample proof of Augustine's notion that Apocalypse is now. The beast from the abyss is the Saracens and persecutors of the Church. Commenting on the vision of the woman in the sky, he says that she is the Church (6.2.1). The dragon is the devil and his pseudoprophets attacking the Church and precipitating society into Gehenna. For Beatus, a scriptural text like Revelation is a symbol to be commented in terms of human history: the struggle between the forces of the devil and of the Logos. He interprets Antichrist as the overseer of three kings: the king of Egypt, the king of Africa, and the king of Ethiopia (6.2.16). The male child born of the woman is male because he must be strong for combat ("fortem ad pugnandum"). Many other glosses might be cited as pertinent to our concerns both with texts and sacred sites. *Beati in Apocalipsin, Libri Duodecim*, ed. Henry A. Sanders (Rome: American Academy, 1930).

31 *Historia Karoli Magni et Rotholandi*, ed. C. Meredith-Jones (Paris: Droz, 1936), p. 173.

32 Ibid., p. 171.

33 Fern Farnham, "Romanesque Design in the *Song of Roland*," *Romance Philology* 18 (1964–65): 143–64. Charles F. Altman, "Interpreting Romanesque Narrative: Conques and the *Roland*," *Olifant* 5 (1977): 4–28.

34 Marcel Durliat, "Les crénelages du clocher-porche de Moissac et leur restauration par Viollet-le-Duc," *Annales du Midi* 78, no. 77–78 (Apr.–July 1966): 433–47, and in particular, p. 440. In a letter dated 10 February 1979, M. Durliat assured me that "le personnage sculpté sonnant de l'olifant est bien une sculpture authentique du xii^e siècle. C'est d'ailleurs un des éléments sur lequel s'est appuyé Viollet-le-Duc pour justifier sa représentation des crénelages du porche de Moissac."

35 Altman has shown how "the juxtaposition of similar formal elements creates a context within which differences are highlighted. The use of repeated detail, designed to reinforce a notion of dual segmentation and to induce comparison of the paired subsegments, depends on a process which we might call *intratextual rewriting*, whereby the material of one scene or line is reused in a corresponding location." "Interpreting Romanesque Narrative: Conques and the *Roland*," *Olifant* 5 (1977): 19. Linda Seidel also equates form and theme in comparing Aquitainian church façades and the *Chanson de Roland* in chapter 3 of her book *Songs of Glory* (Chicago: Univ. of Chicago Press, 1981).

36 The horn scenes that punctuate the second part of the battle are the best known ones, *laisses* 128–35, and another in *laisse* 156, too often ignored, which precipitates the final rout of the Saracens from the battlefield and initiates the last phase of Roland's combat, the death of Turpin, and Roland's own death scene.

37 "But men can ask questions, so that they may clearly see the invisible things of God, 'being understood by the things that are made'. . . . *Nor do things answer men who ask unless they are men of judgment*. They do not change their voice . . . when one man merely looks at them and another both looks and questions, so as to appear one thing to this man, another to that. . . . [I]t speaks to all, but only those understand who compare its voice taken in from outside with the truth within them." *Confessions*, bk. 10, chap. 6 (para. 10), trans. John K. Ryan (New York: Doubleday, 1960), p. 235. Augustine's point is that looking and questioning without struggling for an answer from within simply do not aid humans in rising above the level of historical and material contingency. Only the kind of agonistic looking and seeing, as described in our first chapter, results in understanding, in "spiritual seeing." Roland will reach this level, but not until later.

38 Brault, vol. 1, pp. 180–81.

39 We may find the fallacy in Oliver's reasoning explained by Augustine in chapter 4, book 19 of *De Civitate Dei*. Oliver urges prudence, but Augustine points out that while prudence teaches us to recognize evil, it does nothing to remove it.

> What shall I say of that virtue which is called prudence? Is not all vigilance spent in the discernment of good from evil things, so that no mistake may be admitted about what we should desire and what avoid? And this it is itself a proof that we are in the midst of evils, or that evils are in us; for it teaches us that it is an evil to consent to sin, and a good to refuse to consent. *And yet this evil to which prudence teaches and temperance enables us not to consent, is removed from this life neither by prudence nor by temperance.* (Saint Augustine, *The City of God*, vol. 2, trans. and ed. Marcus Dods [New York: Hafner, 1948], p. 304)

40 See chap. 1, pp. 12–13.

41 Johannes Scotus Eriugena, *Homélie sur le prologue de Jean*, ed. and trans. Edouard Jeauneau (Paris: Les Éditions du Cerf, 1969), chap. 1. Also, Rodolphus Glaber, *Historiae*, 1. 1.

42 Lines 1077–81 (quoted above) and other passages in this scene illustrate the extent to which Roland remains very much attached to things of this world—particularly

the joy of combat—at this juncture. John 12 : 25–28, a classic text on the incompatibility of renunciation and love of things in the world—for their own sake—demonstrates the mistake Roland continues to make at this juncture, and which obscures his understanding of the kind of renunciation required.

> Anyone who loves his life loses it. Anyone who hates his life in this world will keep it for eternal life. If a man serves me, he must follow me; wherever I am, my servant will be there too. If anyone serves me, my Father will honor him. *Now my soul is troubled. What shall I say: Father save me from this hour?* But it was for this very reason that I have come to this hour. (John 12 : 25–28)

43 Walter Ong, "Maranatha: Death and Life in the Text of the Book," in his *Interfaces of the Word: Studies in the Evolution of Consciousness and Culture* (Ithaca: Cornell University Press, 1977), p. 232.

44 Brault, vol. 1, p. 198.

45 Early medieval commentaries on Revelation linked the function of witness to the Passion context in a manner cogent for our discussion. In Revelation 11 : 3–4, the Voice like a trumpet tells John: "I shall send my two witnesses to prophesy (in the holy city) for those twelve hundred and sixty days, wearing sackcloth. These are the two olive trees and two lamps that stand before the Lord of the World. Fire can come from their mouths and consume their enemies if anyone tries to harm them. . . ." Beatus of Liebana equates the two witnesses with the Law and the Gospel ("lex et evangelium," 5.11.2), which govern the time between the Passion of Christ and the coming of the Antichrist: "id est, lex et evangelium a Domini passione usque ad antichristum . . . haec omne tempus est a passione Domini usque ad antichristum" (5.11.2 and 4). The witnesses are also Christians and martyrs (5.11.5): "Qui sunt enim testes domini nisi Christiani? Qui Graece dicuntur martyres, hoc Latini testes, quia in passione testimonium Christo reddent. Non dixit, faciam mihi testes, quasi modo non sint, sed dabo duobus testibus meis. Hic presentibus dixit, legi et evangelio. . . ." These witnesses suffer the persecution of the beast, are humiliated and killed, and after three and a half days are then called to heaven (Revelation 11 : 11–12). Finally, apropos of the earthquake in *laisse* 110, Beatus identifies the earthquake of Revelation with persecution, a recapitulation of the coming of God (5.13.12): "id est persecution; recapitulatio est enim, sicut iam diximus, in adventum Domini. In illa hora qui *in tecto est, non descendat tollere quicquam de domo*" (Matthew 24 : 17). (13): "hora est enim omne tempus." *Beati in Apocalipsin*, ed. Sanders, pp. 445–46.

46 Claude Buridant, ed., *La Traduction du Pseudo-Turpin du manuscrit Vatican Regina 624* (Geneva: Droz, 1976), p. 122.

47 Ibid.

48 Although, then, our present life is afflicted, sometimes in a milder, sometimes in a more painful degree, by the death of those very dear to us, & especially of useful public men, *yet we would prefer to hear that such men were dead rather than to hear or perceive that they had fallen from the faith*, or from virtue—in other words, that they were spiritually dead. Of this vast material for misery the earth is full, and therefore it is written, "Is not human life upon earth a trial?" (Job 7 : 1). (Saint Augustine, *The City of God*, 19. 8, trans. Dods, vol. 2, p. 312)

49 *Confessions*, 10. 28 (para. 39), trans. Ryan, p. 255.

50 "Par les set aungeles, ki se aparilierent a soner lur busines, sunt entenduz tuz les mestres de Seinte Eglise, ki serrunt treske a la fin. Par les busines, la science de lur aprise. Par le chaunt des busines, lur prechement. . . ." *Apocalypse Anglo-Normande*, ed. Yorio Otaka and Hideka Fekui (Osaka: Centre de Recherches Anglo-Normandes, 1977), chap. 8, p. 192.

51 Brault, vol. 1, p. 216.

52 *Apocalypse Anglo-Normande*, ed. Otake and Fekui, chap. 1, p. 184.

53 Joachim of Flora's *Expositio in Apocalypsim* works this out in a most detailed manner in the twelfth century, although the concept goes back at least as far as Augustine's exposition on the ages of the world, and Beatus of Liebana's commentary on Apocalypse equates Antichrist with successive Saracen princes and contemporary oppression of the faithful in the West: Joachim's analogies are most instructive in terms of the questions that concern us.

> Ensuite, si nous passons au second temps placé sous l'autorité du Fils . . . nous trouvons ceci: le premier temps date de Zacherie, père de Jean-Baptiste, et dura jusqu'à la mort de saint Jean l'Evangéliste; le second va jusqu'à Constantin; le troisième va jusqu'à Justinien; le quatrième va jusqu'à Charlemagne, empereur, qui vécut aux jours du pape Zacharie. De ce moment date le début du cinquième temps qui dura jusqu'à l'heure présente. . . . Et comme, dans cette même période du premier état, les Assyriens et les Macédoniens écrasèrent les Juifs, nous voyons aujourd'hui les Sarrazins attaquer la chrétienté, et nous verrons bientôt surgir les faux prophètes qui doivent suivre ces fauteurs de désastres. . . . (Joachim de Flore, *Expositio in Apocalipsim*, chap. 5. Quoted from *L'Evangile éternel*, vol. 2, trans. Emmanuel Aegerter [Paris: Rieder, 1928], pp. 105, 106)

54 In the language of the Vulgate, these verses appear as follows: "[C]um coeperit clangere buccina, tunc ascendant in montem" (19:13). "Iamque advenerat tertius dies, et mane inclaruerat: et ecce coeperunt audiri tonitrua ac micare fulgura, et nubes densissima operite montem, clangorque buccinae vehementius perstrepebat: et timuit populis qui erat in castris. Cumque eduxisset eos Moyses in occursum Dei de loco castrorum steterunt ad radices montis" (19:16–17).

55 Luke 1 : 68–71: "Benedictus Dominus Israel, quia visitavit, et fecit redemptionem plebis suae: ET EREXIT CORNU SALUTIS NOBIS: in domo David pueri sui. Sicut locutus est per os sanctorum, qui a saeculo sunt, prophetarum eius: *Salutem ex inimicis nostris, et de manu omnium qui oderunt nos.*" As a liturgical text, and therefore often recited, the Benedictus was a particularly well-known passage.

56 Gertrud Schiller, *Iconography of Christian Art* (Greenwich, Conn.: New York Graphic Society, 1972), vol. 1, p. 146.

57 Ibid., vol. 2, p. 4.

58 Revelation 1:10: " . . . et audivi post me vocem magnam tamquam tubae. . . ." (12): "Et conversus sum ut viderem vocem, quae loquebatur mecum. . . .'' (16): "[E]t habebat in dextera sua stellas septem: et de ore eius gladius utraque parte acutus exibat: et facies eius sicut sol lucet in virtute sua."

59 *Laisse* 110 reinforces this intertextuality by toponymic reference. Lines 1428–29 name the cardinal points of the Kingdom of France affected by the apocalyptic manifestations. The premier locus cited is Saint Michel del Peril, a sanctuary commemorating the text-event of Revelation. Whether this Saint Michel was the Norman shrine or Saint Michel-de-Cize, on the opposite side of the mountain from Roncevaux—as Rita Lejeune recently argued with impressive evidence (article cited above, n. 12)— the sense is clear. "Ço est li granz dulors por la mort de Rollant" is an assertion of the correlation of Roland's passion with the corpus of Scripture by which the significance of historical events was established.

60 Frederick Golden, *The Song of Roland* (New York: Norton, 1978), p. 102.

61 As more space is devoted to describing Roland's effort in blowing the horn, less space need be given to the actual horn sound. The first four lines do not simply describe Roland's effort; they demonstrate the force of the blast by the effect produced on him. This ability of the narrative to signify reciprocally characterizes the horn sequence at all levels.

62 Brault, vol. 1, p. 427, n. 20.

63 Eugene Vance, *Reading the Song of Roland* (Englewood Cliffs: Prentice-Hall, 1970), pp. 32–33.

64 The Clermont-Ferrand *Passion* links the betrayal of Christ to the fear and envy of two categories of opponent: a group of nonbelievers (Jews) and a single, apostate believer (Judas) from within Christ's immediate circle (sts. 20–21). In the same manner, the *Roland* ascribes his betrayal to the fear and envy of two categories of opponent: a group of nonbelievers (Saracens) and a single, apostate believer (Ganelon) from Charlemagne and Roland's immediate circle.

65 Saint Augustine, *De Civitate Dei*, 20. 9, trans. Dods, vol. 2, pp. 366–67.

66 Saint Augustine, *Confessions*, 10. 3 (para. 3): "But because 'Charity believes all things' (1 Corinthians 13 : 7) *among them whom it unites by binding them to itself*, I too, O Lord, will confess to you in such a manner that men may hear, although I cannot prove to you that I confess truly. *But those men whose ears charity opens to me believe me.*" Trans. Ryan, p. 230.

67 The Clermont-Ferrand *Passion* specifically links the parodic role of Judas in the Last Supper and his self-excluding speech act:

> De pan et vin sactificat 25
> toz sos fidels i saciet,
> *mais que Judas Escharioh*
> *cui una sopa enflet lo cor:*
>
> Judas cum og manjed la sopa, 26
> diable sen enz en sa gola;
> *semper* leved del piu manjar,
> *tot als Judeus o vai nuncer.*

68 For a recent study of dreams in the *chansons de geste*, see Herman Braet, *Le songe dans la chanson de geste au XIIe siècle*, Romanica Gandiensia, vol. 15 (Ghent, 1975), especially chap. 4, "Le langage des songes." For the dream as *chant* in the *Roland*, see my article, "The Generative Function of *Chant* and *Récit* in Old French Epic," *Olifant* 6 (Spring/Summer 1979): 305–25.

69 Braet, *Le songe dans la chanson de geste,*" pp. 114–15. Cf. Romans 1 : 20: "Ever since God created the world his everlasting power and deity—however invisible—have been there for the mind to see in the things He has made."

70 René Louis, "La grande douleur pour la mort de Roland," *Cahiers de civilisation médiévale* 3 (1960): 62–67.

71 On this subject, see Gérard Genette, "Frontières du récit," *Communications* 8 (1966): 152–63, and *Introduction à l'architexte* (Paris: Seuil, 1979).

72 *Confessions*, 11. 29 (para. 39), trans. Ryan, p. 302.

> Sed quoniam melior est misericordia tua super vitas, *ecce distentio est vita mea*, et me suscepit dextera tua in domino meo, mediatore filio hominis inter te unum et nos multos, in multis per multa, ut per eum adprehendam, in quo et adprehensus sum, et a veteribus diebus colligar sequens unum, praeterita oblitus, non in ea quae futura et transitura sunt, *sed in ea quae ante sunt non distentus, sed extentus, non secundum intentionem sequor* ad palmam supernae vocationis, ubi audiam vocem laudis et contempler delectationem tuam nec venientem nec praetereuntem. (*S. Augustini Confessionum*, Loeb Edition [New York: Macmillan, 1912], pp. 278, 280)

73 As Umberto Eco has shown, the reflecting on the sign postulated by the interpretant opens up a vast array of possible meanings for the text. At this stage the work becomes a cultural unit with an unlimited number of possible uses and meanings. In a very real sense, this reciprocal exchange between text production and cultural arti-

fact has been the main field of inquiry of the present book. It has sought to show how a number of different and initially separate sign systems became mutually related by "the continual shiftings and alignments of cultural units via the function of interpretants. Culture continually translates signs into other signs, and definitions into other definitions. . . ." See U. Eco, *A Theory of Semiotics* (Bloomington: Indiana University Press, 1976), pp. 68–72.

74 Like Christ in his rhetorical manifestation as *Anakephalaiosis*, or Recapitulation (Ephesus 1 : 10, glossed by Kittel as "to sum up," "to give a comprehensive sum"), the hero becomes the subject/Subject of his own story. *Anakephalaiosis* was the rhetorical model for uniting historical and anagogic signification in a biography, once Saint Paul had argued that Christ was the Recapitulation of human and divine history. In its analogical usage, *anakephalaiosis* becomes a symbolic assumption by the hero of his own story in his own words, a predication of life as logos. In short, a symbolic recapitulation of the way in which the unity of language and the unity of divine intention ("sacramentum voluntatis suae," Ephesus 1 : 9), can correlate in story/history.

75 For an excellent recent study, see Evelyn Birge Vitz, "*La Vie de Saint Alexis*: Narrative Analysis and the Quest for a Sacred Subject," *PMLA* 93 (1978): 396–408. See also the first chapter of Karl Uitti, *Story, Myth and Celebration in Old French Narrative Poetry, 1050–1200* (Princeton: Princeton University Press, 1973).

76 *La Vie de Saint Alexis*, ed. Christopher Storey (Geneva: Droz, 1968).

77 The circularity of confirmation evident here is that of the relic and the reliquary transposed to the level of word and Logos. The *Vie* as text mediates and presents the *chartre* as authentic saintly word, just as the figural reliquaries of the tenth and eleventh centuries or the arm and bust reliquaries of Charlemagne and other saints represented the whole body of which they contained only a part, but part sufficient, by the mystery of God's grace, to bestow the whole saintly virtue on those who prayed before the statue of Sainte Foy at Conques.

78 The change in physical setting corresponds with a change in register in the *récit*, particularly remarkable in the higher incidence of discourse, entailing a resultant change in the mix of discourse and narrative. As a result, we find a greater emphasis on the present tense and on the immediacy of "action," since word becomes, in a real sense, act.

79 The association of Christ with hilltops came to be something of a topos in artistic representations. This tendency dates from a rather early period, for all of the exterior scenes in the twelve scenes from the life of Christ depicted in the seventh-century Gospel Book of Saint Augustine show Christ on a hilltop, often with two trees (typologically equated with witnesses; see n. 45 above). These scenes are from an illumination in the Saint Augustine Gospel (Northern Italy, seventh century): Corpus Christi College, Cambridge, MS 286, fol. 129v.

80 On the textual authority of Revelation 11 : 3–4, the two trees may symbolize the two witnesses of Crucifixion scenes. Beatus of Liebana glosses the trees/witnesses as "lex et evangelium" (*Beati in Apocalipsin*, 5.11.2, ed. Sanders).

81 Marble pillars at martyr sites is a well-attested sign in Christian archaeology. Worshipers practiced commemorative oblation on the death sites of martyr and confessor saints from an early period. See *Le Dictionnaire d'archéologie chrétienne et de liturgie* 1², s.v. "Autel."

82 John Wilkinson, *Egeria's Travels* (London: SPCK, 1971), p. 181. See the *Corpus Christianorum*, vol. 175, pp. 94–103, and Migne, *PL* 173. 1115–34.

Index

Aachen, *see* Aix-la-Chapelle
Aaron's rod, 136
Abelard, Peter, 168
Abraham, 181
Acts of the Apostles (*Actus Apostolo-rum*), 4, 162. *See also* Bible, the
Adalbert (canon at Aix-la-Chapelle), 67, 68
Adalbert, Saint, 218*n*12
Adémar de Chabannes, 30, 212*n*42, 213*n*43; and "invention" of Charlemagne's tomb, 67–69, 71, 74, 78, 79–82, 88, 89, 94, 96, 100
Agon: agonistic assertion of individuality (hero), 136; agonistic basis of *historia*, 33–35; agonistic narrative, 40, 43, 51, 53, 139; good vs. worldly, 33; man the subject of, 38, 39, 50–51, 148; narrative theosis as, 30–33, 52
Agonistic hermeneutics, *see* Hermeneutics
Aigoland (Saracen king), 136
Aix-la-Chapelle (Aachen), 72, 86, 127–28, 129, 133, 149, 175; Charlemagne reliquary and tomb at, *see* Charlemagne; -Jerusalem-Rome-Constantinople axis, 70, 75, 78, 133; Palace School at, 82; Palatine Chapel at, 54, 66, 70–75 passim, 79–81, 88, 94, 96, 107, 129; as "Second" Rome (*Nova Roma*), 20, 75, 210*n*15, 219*n*26
Albigensians, 218*n*50
Alexandria, 72, 73
Alexis, Saint, 195–98, 201, 202
Allers, Rudolph, 12
Alphonso the Warlike, king of Navarre and Aragon, 152–53
Alsace: Charlemagne window in, 88
Altman, Charles, 162, 165
Alverson, Hoyt, 29

Ambigua (Maximus the Confessor), 15, 207*n*25
Anagogy, 18, 106, 114, 118; anogogic connotations of Roland setting, 155, 157, 159, 164, 174, 179–80, 183, 191; of Charlemagne iconography, 95, 100; of *historia*, 13, 132, 134; interrelationship of historic and anagogic elements, 70, 94, 105, 123, 124, 131, 140, 141, 147; of Last Judgment, 109; and narrative meaning, 100–101; as opposed to history, 110, 116, 120, 135, 168; Rodolphus's concern with, 22, 42, 63; of Turpin's life and text, 129
Anastasis (Church of the Holy Sepulchre, Jerusalem), 77, 79, 100, 107; Charlemagne's association with, 66–74, 131, 132; "copies" of, 74; destruction and reconstruction of, 32, 41, 52, 71, 131–32, 210*n*11; Saint Helena's discovery of, 66, 69, 70, 100; symbolism of, 71, 72, 73, 80. *See also* Jerusalem
Andrew, Saint, 161
Angilbert, Saint, 107
Annunciation, the, 76, 119, 183
Anthropology, *see* Philosophical anthropology
Antichrist, 40, 41, 181, 212*n*42, 232*n*30, 233*n*45. *See also* Beast, the
Apocalypse, the, 110, 134, 151, 160, 161; commentaries on, 31–32, 179, 183, 231*n*30, 234*n*53; as misreading, 40–49; symbolism in, 181, 182. *See also* Revelation
Apocrypha, 29, 30, 162, 197
Architecture, ecclesiastical, 77, 86–87, 105–10; symbolism of, 70–71, 74–75, 80, 82, 101–05, 160
Arculfus (Frankish pilgrim), 74
Aristotle, 59, 60